'Photos of the Gods'

THE PRINTED IMAGE
AND POLITICAL STRUGGLE
IN INDIA

Christopher Pinney

REAKTION BOOKS

For Jean and Tom

Published by
REAKTION BOOKS LTD
79 Farringdon Road
London EC1M 3JU, UK

www.reaktionbooks.co.uk

Published with the assistance of the
GETTY GRANT PROGRAM

First published 2004
Copyright © Christopher Pinney 2004

Printed in Hong Kong

British Library Cataloguing in Publication Data

Pinney, Christopher
 'Photos of the Gods': the printed image and political
 struggle in India
 1. Idols and images – Political aspects – India
 2. Printing – India – History – 20th century
 3. Photography – India – History – 20th century
 4. Photography – Political aspects – India
 5. Photography – Religious aspects – Hinduism
 6. India – Politics and government – 1947–
 I. Title
 320'.0954'09045

ISBN 1 86189 184 9

os of

gods'

contents

Introduction: The possibility of a visual history

The mishaps that can result from such a 'physiognomic' reading of artistic documents are clear enough. The historian reads into them *what he has already learned* by other means, or what he believes he knows, and wants to 'demonstrate'.[1]

Can one have a history of images that treats pictures as more than simply a reflection of something else, something more important happening elsewhere? Is it possible to envisage history as in part determined by struggles occurring at the level of the visual?

This is the central question I pursue in this study. Its specific focus is the production of chromolithographs within India from the late 1870s onwards. These pictures could easily be used to produce a narrative that conforms with what we already know about India, serving as evidence of what (as Carlo Ginzburg suggests) we have proved 'by other means'. What, however, if pictures have a different story to tell, what if – in their luxuriant proliferation – they were able to narrate to us a different story, one told, in part, on their own terms?

This is what I have struggled to achieve here: not a history of art, but a history made by art. The visuals in this study are not 'illustrations' of some other force, and it is not a history *of* pictures. Rather it is a study of how pictures were an integral element of history in the making.[2] Picasso told Getrude Stein in 1914 that it was Cubism (rather than the French Army) that had invented camouflage:[3] this book makes a similar claim for the relation between visual schemata and the wider social world in late nineteenth- and twentieth-century India. I try to make the case for visual culture as a key arena for the thinking out of politics and religion in modern India. Rather than visual culture as a mirror of conclusions established elsewhere, by other means, I try to present it as an experimental zone where new possibilities and new identities are forged. This is not an ordered laboratory with a single script: the reverse is true – divergent political, religious and commercial interests ensure a profound contingency to all outcomes. However, I hope to show that in this sometimes bewildering zone new narratives are established that may be quite disjunct from the familiar stories of a non-visual history. Two clear examples of this, examined in more detail later in the book, are the affective intensity of new nationalist landscapes (the actual 'look' of the emergent nation)

and the prominence of revolutionary terrorism in the popular imagination.

In trying to rearrange Indian history so that a central place can be found for the visual, I have found inspiration in Boris Groys's provocative account of the elision of the aesthetic with the social and political in mid-twentieth century Russia,[4] and also in recent writing by anthropologists of Melanesia. Scholars such as Roy Wagner and Marilyn Strathern have investigated the manner in which certain cultural practices treat images as compressed performances. They have suggested that, for Melanesians, images are not representations in the sense of a screen onto which meaning is projected. Rather, 'the experience [of an image's] effects is at once its meaning and its power'.[5] I explore the usefulness of this insight in an Indian context below. In so doing I also develop a critique of conventional approaches to aesthetics and argue for the notion of 'corpothetics' – embodied, corporeal aesthetics – as opposed to 'disinterested' representation, which over-cerebralizes and textualizes the image. Conventional notions of aesthetics will not get us very far. Of much more use is an appreciation of the concern with images' efficacy. The relevant question then becomes not how images 'look', but what they can 'do'.[6]

Alongside the question of images' powers, we should also consider their 'needs': the technology of mass-picture production documented here was grounded in a cultural field that routinized these needs. Addressing the 'wants' of pictures is a strategy advanced by W. J. T. Mitchell as part of an attempt to 'refine and complicate our estimate of their power'.[7] Mitchell advocates that we invite pictures to speak to us, and in so doing discover that they present 'not just a surface, but a *face* that faces the beholder'.[8]

IMAGES, POLITICS AND HINDUISM

Within Hindu practice, the enormous stress on visuality endows a great range of images with extra-

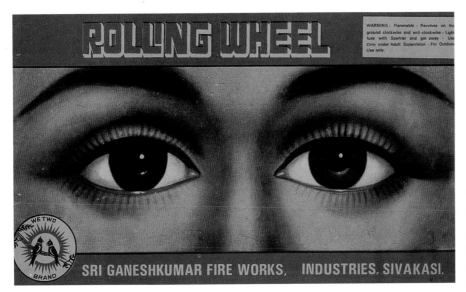

ROLLING WHEEL

WARNING : Flammable - Revolves on the ground clockwise and anti-clockwise - Light fuse with Sparkler and get away - Use Only under Adult Supervision - For Outdoor Use only.

SRI GANESHKUMAR FIRE WORKS, INDUSTRIES, SIVAKASI.

1 Firework packaging, printed in Sivakasi (1992). The prevalence of eyes in Indian popular imagery is a reflection of the importance of seeing, and being seen.

ordinary power. A key concept here is the notion of *darshan*, of 'seeing and being seen' by a deity, but which also connotes a whole range of ideas relating to 'insight', 'knowledge' and 'philosophy'. Its role at the centre of Indian Hindu scopic regimes will be referred to many times during this study. *Darshan's* mode of interaction (especially as practised by the rural consumers described in chapter 7) mobilizes vision as part of a unified human sensorium, and visual interaction can be physically transformative (illus. 1). Lawrence Babb has described how in various Hindu traditions 'seeing' is conceived of as an 'outward reaching' process: 'seeing itself is extrusive, a medium through which seer and seen come into contact, and, in a sense, blend and mix'.[9] More recently Arvind Rajagopal has made a similar point: 'one is "touched" by *darshan* and seeks it as a form of contact with the deity'.[10]

Visuality and other embodied practices have played a central role in the constitution of Indian public culture. Sandria Freitag has suggested that in India it was the religious and political procession that carved out a public sphere in colonial India.[11] To this performative realm we might add the much larger (mass-produced) visual field described in this book.

A practice that has privileged the power of the image and visually intense encounters, which have implicit within them the possibility of physical transformation, forms the backdrop against which a new kind of history has to be written.

Besides this central theme, there is a further thread that I hope runs clearly throughout this book. This concerns the relationship between religion and politics and its changing configuration. Recent writings on India have described a new popular religious-nationalistic imaginary as a product of a specific time and specific technologies. Many analysts have, for instance, stressed the ways in which South Asians have used new electronic media to circulate their vision of the political choices facing India. The narrative generated by such approaches has conjured an opposition between a threatening super-modernity and a Nehruvian modernity rooted in a commitment to a secular state. The story presented here complicates this narrative and suggests a much greater depth to what are often seen as recent struggles.

The juxtaposition of a series of painted episodes from the *Ramayan* with, at the bottom, the actors who portrayed Ram and Sita in the 1987 Doordarshan television serialization of this epic embodies this historical

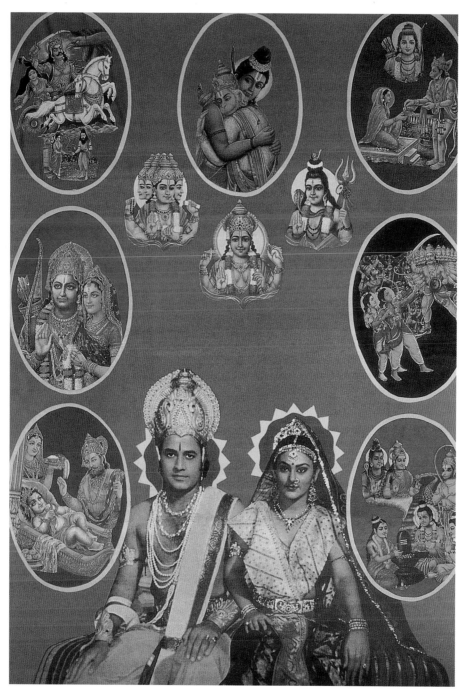

2 Scenes from the *Ramayan* (*c.* 1995), colour print with photographic portrait of actors at the bottom. The 1987 television serialization of this great Hindu epic had a significant impact on the political culture of India.

interpenetration (illus. 2). This television broadcast is widely accepted as a key event (a 'flash point or moment of condensation') in India's movement towards the Hindu right, leaving in its wake a 'politics after television'.[12] What may seem an incongruous mismatch of media makes perfect sense to the consumer of this picture for whom the painted images sit happily with the televisual image. The Doordarshan serial's aesthetic, after all, was derived from that of chromolithography. Both the actors shown subsequently accepted Bharatiya Janata Party invitations to become involved in their campaign to build the *Ramjamnabhumi mandir* (temple of Ram's birthplace) on the site of the Babri *masjid* (mosque) in Ayodhya, Uttar Pradesh; Deepika, the actress who played Sita, became a BJP member of parliament. In December 1991 Hindu activists destroyed the Babri *masjid*. In the ensuing disturbances many hundreds of Indians died. The account presented here aims to give this complex and consequential entanglement of images and politics a (longer) history. It needs this history not to excuse, or create the alibi of *déjà vu*, but as the precondition of a correct prognosis.

During the colonial period politics and religion were conceptually titrated into separate domains, politics being placed under strict surveillance and religion conceptualized as autonomous. As Sandria Freitag puts it, the colonial state 'labeled issues related to religion, kinship, and other forms of community identity as apolitical – as private, special interest, and domestic and therefore not requiring the attention of the state and its institutions'.[13] Then, in large part because of the practice of colonial censorship and proscription, an authorized 'religion' became the vehicle for a fugitive politics. Indians were able to do things under the guise of 'religion' that they were not able to do in the name of 'politics'. But these two domains were now (to recall Adorno's phrase), 'torn halves of an integral freedom, to which however they do not add up'.[14] Incapable of being recombined they were realigned in a new deadly form. Visual culture was perhaps the major vehicle for this reconfiguration.

THE 'TOTAL ART' OF HINDUISM?

This book also seeks to explore the idea of a 'total art' – the collapse of the social into the aesthetic – in the context of modern Indian history. This is a perspective recently advanced by scholars of the former Soviet states, such as Boris Groys, Vladislav Todorov and Alla Efimova, who have stressed the central role of the aesthetic in sustaining the Soviet era: communist regimes created 'ecstatic aesthetic environment[s] – grandiose marches, parades and mass campaigns . . . a kind of libidinal stimulation, an abundance of affect . . . '.[15]

The Groys model, however, presupposes the existence of a totalitarian state in which elites are able to impose their vision in all areas of practice.[16] This could not be further from the experience of India in which certain characteristics of the colonial state engendered a tenacious gulf between the mass of the population and the political elite. Ranajit Guha has argued that there was 'a structural split' between the elite and subaltern domains of politics: 'vast areas in the life and consciousness of the people' remained unknown and unknowable to the elite.[17]

One manifestation of this was the distance between elite secular forms of nationalism and a popular messianism. The contrast with the Stalinist Soviet Union is clear. Rather than a skilled elite sweeping everything before it, in India the elite was confronted with a population that it largely failed to recognize or understand. The 'total art' of Hindu India is thus not as 'total' as the aesthetic presented by Groys.

The political effectiveness of images was in large part the result of their ubiquity. The scale of consumption was equally important to the nature of what is consumed, for the performative reunification of the fragmented signs of the nation occurred untold hundreds of millions of times through the repetitive gestures of the devotee facing his domestic chromolithographs, and through that same individual's awareness that around him numerous other citizens-

in-the-making also possessed images coded in the same style.

In certain respects there are parallels between what Benedict Anderson terms 'print capitalism' and the genre of images I have been considering here. Both are involved in the construction of public spaces and arenas of consciousness that are intimately linked to 'nationalism' and both create a sense of commonality through a reflexive awareness of the collective enter-prise of worshipping gods and affirming political leaders. Many of the functions borne by print in Anderson's account are assumed by mass-disseminated images in India. And yet the fundamental differences are striking.

Although no causal connection is suggested, Anderson notes that in Western Europe the imagined communities that are nations appear historically at a time when religion is waning: 'the eighteenth century marks not only the dawn of the age of nationalism but the dusk of religious modes of thought'.[18] He argues that nationalism emerges, firstly, from the decompo-sition of great sacral cultures bound together by eternal sacred languages whose signifiers were God-given, rather than arbitrary, and secondly through the decomposition of kingly rule in which dynasties were set apart through their claim to divine priority.

These changes occur against a, perhaps even more significant, background of a new temporal order in which what Walter Benjamin termed 'Messianic time' ('a simultaneity of past and future and in an instant-aneous present') gives way to a new notion of an 'homogenous, empty time'.[19] It is this 'more than anything else', Anderson claims, that made it possible to '"think" the nation'.[20]

Anderson concludes that 'the very possibility of imagining the nation only arose historically when, and where [the belief in the privileged status of certain script languages, the divine power of kings and the collapsing of cosmology into history] all of great antiquity, lost their axiomatic grip on men's minds'.[21] Although it is *European* disenchantment that is described here, it is this which provides 'modular'

packages of nationalist aspiration and which by the second decade of the nineteenth century had become 'a "model" of "the" independent national state . . . available for pirating'.[22] And, although Anderson has subsequently sought to distance anti-colonial Asian and African nationalism from the 'modular' European form, he still roots the success of such nationalism in totalizing appropriations of the 'census, map and museum'. He notes that 'the intelligentsias found ways to bypass print in propagating the imagined commu-nity'[23] and cites the example of mass-produced prints distributed to primary schools by the Indonesian Ministry of Education, some of which represented Borobudur in the guise of an archaeological theme-park, effaced of the Buddhist sculpture that encrusts the site and devoid of any human figures.[24] For Anderson they are messages sent downwards by the state to the masses: Borobudur as state regalia or logo, disseminated to every school.

The contrast with the images examined here is instructive: Anderson's images are vehicles of a total-izing bureaucratic certainty; the Hindu images are expressive of much more locally based cosmologies.[25] In this popular Indian domain, time was still messianic, scripts had indexical and non-arbitrary power and kings were – in many cases – at the centre of the moral and ritual universe.

This decentralization and diversity is another central theme of the book. The images described here were created for a number of reasons: political, commercial and devotional. Further, they mobilize a number of very different styles whose emergence, growth and attenuation I will trace historically. The erasure of this diversity under labels such as 'calendar art', together with a general dehistoricization, make it easier to link these forms with general propositions about the cultural context that produces it. By contrast, a nuanced history of these images complic-ates, and in some cases destroys, many of these easy propositions. Simultaneously, however, different kinds of relationship between images and social reality will become apparent.

1 indian images under the shadow of colonialism

The images described in this book begin to emerge in the 1870s and exist in a relationship of both continuity and disjunction with earlier image practices in India. Many of those discussed and reproduced here are chromolithographs, that is colour images printed from multiple stone blocks developing the original lithographic process invented by Alois Senefelder in Munich in 1798. The design was applied to the fine limestone stone block used in the process with any greasy substance (such as a coloured wax) and fixed in the stone through a variety of different techniques. The stone was then damped with water and greasy ink was applied. This was repelled by the water and adhered only to the design, leaving a reverse image on any paper pressed on the stone for printing.

Lithography's chief advantage was that designs could be applied fluidly to the surface of the stone: there was no need for engraving, etching or cutting in relief. Later chromolithographs using multiple colour blocks, and occasionally the application of varnish, produced images of an extreme tactility. Colours were rich and heavy with an astonishing depth and sensuality. Disparaged by the aesthetic elite, in both Europe and India ('complete with complicated German-gilt frames, these things were horrible', opined the English lithographer Barnett Freedman in the 1930s),[1] they were powerful vehicles for the mediation of faith and sentiment.

Not all the images discussed in this book are chromolithographs. Some, such as the earliest Calcutta Art Studio prints, are single-colour lithographs and many of the 1930s political images discussed in chapter 6 are also black and white. Various non-lithographic images are discussed immediately below. Some picture publishers, including S. S. Brijbasi, continued to produce beautiful and archaic multiple stone chromolithographs until the 1950s but other companies were quicker to adopt photographic offset processes. While noting these technological transformations where historically relevant, I have chosen to continue to refer to them as 'chromolithographs'. I have done this because their colour range and tactility continues to perpetuate

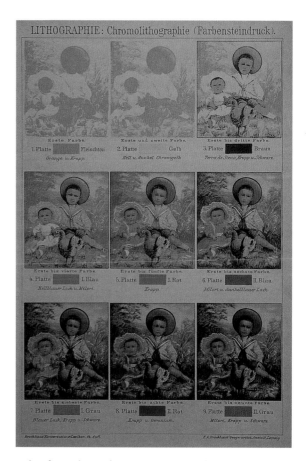

3 Plate from a late-19th-century German publication demonstrating the effects of successive colours in a nine-block chromolithograph image.

a repertoire established through conventional multiple block colour lithography: technological refinement has been used to reinforce pre-existing conventions.

Lithography was first used in India in the 1820s and Graham Shaw has argued that its impact was more significant than the introduction of typography in the 1550s. Lithography was immediately appreciated for its cheapness, portability and relative ease of production, and the widespread ownership of presses by Indians in the following decade played an important role in 'democratizing print in South Asia'.[2]

Despite this, many kinds of Indian mass-produced images continued to circulate independently of this

technological breakthrough. What may be the earliest visual record of the domestic use of pictures of deities in India appeared in 1832 with the publication of Mrs S. C. Belnos's *Hindoo and European Manners in Bengal* (itself a prime exemplar of the potentiality of lithography). In plate 14, 'Interior of a Native Hut' (illus. 4), prepared by her French lithographer husband, a devotional painting ('ill-executed … on paper') is shown stuck to the wall behind the cooking hearth. Next to this image is what has been described as a terracotta female cult-figurine.[3]

Images like this emerged as a particular concern in missionary accounts that stigmatized what they saw as Hindu fetishism. A late nineteenth-century London Missionary Society tract, in a chapter titled 'Idols, Idols Everywhere', enunciated the threat posed to an austere iconoclasm by the proliferating fecundity of Hindu images:

> Benares is the great centre of the idol-making business, though in all parts of India the trade flourishes. Potters the day through may be seen in the sacred city moulding images of clay for temporary use. Sculptors also may be found producing representations of the gods in stone or marble. Carpenters, moreover, make great wooden idols for the temples; and workers in metal – goldsmiths, coppersmiths, and brass-workers – turn out more or less highly-finished specimens in their respective metals.[4]

Mechanical mass-reproduction facilitated dissemination through potentially infinite pathways, but it is clear that pre-lithographic images also 'travelled'. Itinerant bards and storytellers played an important role in disseminating visual traces of the divine. A memorable example of this occurs in Mahatma Gandhi's *Autobiography*, in which he recalls an incident from his childhood in Gujarat in the 1870s that has 'clung to [his] memory':

> somehow my eyes fell on a book purchased by my father. It was *Shravana Pitribhakti Nataka* [a play

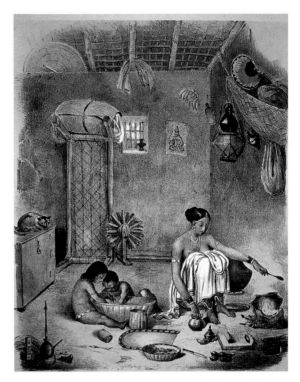

4 Mrs S. C. Belnos, 'Interior of a Native Hut', a lithograph published in *Hindoo and European Manners in Bengal* (London, 1823). A mass-produced, hand-painted image can be seen on the wall at the back.

about Shravana's devotion to his parents]. I read it with intense interest. There came to our place about the same time itinerant showmen. One of the pictures I was shown was of Shravana carrying, by means of slings fitted for his shoulders, his blind parents on a pilgrimage. The book and the picture left an indelible impression on my mind. 'Here is an example for you to copy', I said to myself. The agonized lament of the parents over Shravana's death is still fresh in my memory.[5]

There is evidence here of overlaps between different media technologies and scopic regimes: the image of Shravana carrying his blind parents in slings is still available from the Bombay-based Sharma Picture Publication in the form of a chromolithograph. But

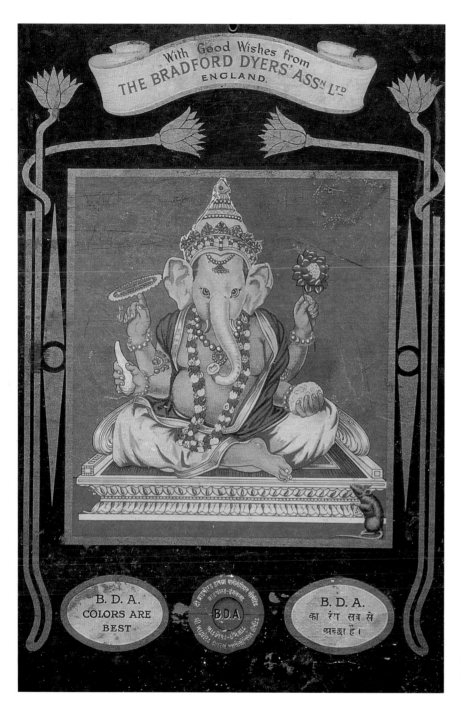

5 Advertising placard for Bradford Dyers' Association depicting Ganesh (c. 1900), chromolithograph on card. Such pictorial trade-marks were widely used by foreign retailers in 19th-century India.

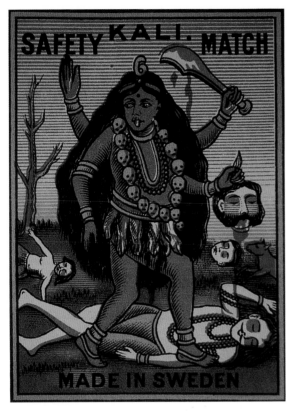

6 Matchbox label (c. 1900). The design would have facilitated the customer's request for a 'box of Kali'.

homes in the vicinity of Madras. In the front room of a house might be found images narrating the life of Krishna: 'These pictures are gorgeous and grotesque native productions, being paintings on glass that can be bought in almost every fairly large bazaar'. The occasional print might also be spotted and 'perhaps a cutting from some English illustrated paper'. But these, Padfield noted, 'appear very much out of keeping with the surroundings; far more suitable and at home are the glaring labels from the Manchester cotton goods that one sometimes sees adorning the walls or doors or shutters.'[6]

This 'suitability' reflected foreign entrepreneurs' wily recognition of their customers' cultural expectations. The manufacturers of cotton piece goods branded their products with pictorial trademarks and it was understood that consumers relied on these when making their selections in local bazaars (illus. 5). A good sense of their importance is given in the United States Government Department of Commerce Special Consular Report on British India, published in 1915 and designed to enable American entrepreneurs to 'enter foreign trade preparedly'.[7] The report highlighted the importance of 'pictorial advertising' in a country like India where consumers were likely to be illiterate: 'Goods intended for popular sale ought to be marked with some distinctive pictures which could be easily remembered. For instance, cotton piece goods are distinguished by labels in which Indian deities, tigers or other animals, dancing girls, etc., are displayed in attractive colours.'[8] The report also lists 'Hindu mythology, Hindu romantic drama, temples … occasionally … the King-Emperor of India and European actresses' as among other popular trademarks (illus. 6). In many cases, the report concluded, 'the particular attractiveness of these pictures may have quite as much to do with the sale of such goods as the quality of the cloth itself'.[9]

alongside such continuities, chromolithographs and other industrially produced images clearly facilitated profound transformations in patterns of worship and of political practice.

Nineteenth-century India was increasingly pervaded by images. These were hand-made and mass-produced, local and exotic, religious and commercial. A systematic overview of their terrain is difficult to acquire, but several compressed descriptions and other fragments provide great insight into the complex flux that increasingly characterized late colonial scopic regimes. Writing between 1885 and 1895, the Reverend J. E. Padfield of the Church Missionary Society described the extraordinary mixture of image styles and media to be found in some wealthy Hindu

The allure of colour and the powerful effects of images are a strong theme in the final chapter of this book where an account is given of rural consumers' devotional engagement with images over the last two decades. In the central Indian village described in that chapter, these images are known as 'photos of the gods' (*bhaguan ke photo*). They are not seen as the rarefied manifestation of a painterly tradition, but are, rather, centrally situated in the vibrant everyday visual culture of modern India. The judgements that are made about images focus on questions of efficacy and their ability to intervene in the world, rather than formal aesthetic criteria. Chromolithography finds its main market in early twenty-first century India among rural consumers who need direct access to tangible and powerful gods.

Yet, as will soon become clear in the following history, in the nineteenth century some British colonialists saw new representational techniques as a means of dismantling the Hindu world-view. Perceiving the great mass of Indians as inhabiting 'an era before art',[10] and to be interested in images only as 'idols', colonial art-educators sought to transform the intimate and interested engagement of the devotee into the disinterested and rationalized response of colonial political subjects to the image as 'art'. The history that follows is, in part, set against colonial attempts to turn devotional images into 'art' and popular chromolithography's rejection of this denial of religious efficacy.

Edward Moor's *Hindu Pantheon*, which had been published in 1810, can be seen as an early charter for some of the representational transformations the colonial state sought to effect. The frontispiece[11] depicts a brass cast of Ganesh (illus. 7), the elephant-headed son of Shiv who is commonly invoked at the beginning of orthodox Hindu texts. There are obvious transformations of media – the brass cast of Ganesh astride his mount (a rat) is rendered by line, and this medium allows the syllable '*aum*' (transliterated idiosyncratically) to appear in a sunburst above the

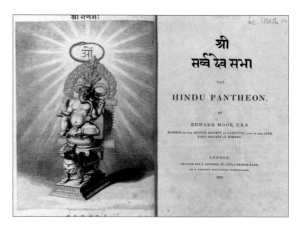

7 Frontispiece to Edward Moor, *The Hindu Pantheon* (London, 1810). Depiction is transformed from the reproduction of powerful deities into a technical problem of representation.

statue. But more significant is the cultural transposition of Ganesh from the space of Hindu devotion into the space of representation. The diagonal line running from right to left along which Ganesh looks can be thought of as a realist tangent, a deliberate (mis)alignment that transforms what might otherwise be a flat hieratic signifier of divinity into a representational conundrum to which the rules of single-point perspective can be applied. This slight rotation serves to displace the sculpture into a different European space of representation. This displacement is metonymic of a much broader representational transformation in which the world, as Anuradha Kapur suggests in Heideggerean vein, 'is seen . . . as a mathematically regular ordering of time, space, and human action'[12] informed by a 'disinterested' aesthetic.

However, this colonial 'aesthetic' might be better conceptualized as an 'anaesthetic'. This is the argument advanced by Susan Buck-Morss. Using Walter Benjamin's 1930s 'Work of Art in the Age of Mechanical Reproduction' essay as her starting point, she constructs a history of the 'alienation of the corporeal sensorium'. Kantian aesthetics – predicated on the distance or absence of the body – marks an inversion and denial of earlier aesthetics born, as Terry Eagleton has noted, as 'a discourse of the body'.[13] In its original

ancient Greek formulation, *aisthitikos* denoted 'perceptive by feeling' and revealed the original field of aesthetics as 'corporeal, material nature'.

This earlier, different, practice of aesthetics – which I propose we call 'corpothetics' – was also, importantly, synaesthetic, mobilizing all the senses simultaneously. 'Anaesthetics' is the result of the 'numbing' and deadening of the sensorium. Following Benjamin, Buck-Morss emphasizes the role of the shocks of industrialization and modernity in this process of attenuation. In colonial India, the 'anaesthetization' of what was formerly 'perceptive by feeling' was an intrinsic element in transformations of idols into 'art'.

THE 'POWERS OF EUROPEAN ART'

The realignment of Ganesh into this new space of representation alerts us to some colonizers' conversional desires, but we should not confuse desires with outcomes. In India attempts to undermine the sacrality of images only served to make the Gods appear more 'real'.

Advocates of art schools, such as Richard Temple, positioned perspective as part of a larger scientistic project that they imagined would make Indians 'modern' and 'rational'. There are various candidates for India's first 'western' art school. Several individuals and organizations established institutions from 1798 onwards that sought to disseminate what were perceived as imported visual techniques in India.[14] In the 1850s, however, pre-existing art schools in Madras, Calcutta and Bombay came under the direct control of the department of public instruction. Mitter pointedly notes that for the East India Company 'the scientific scrutiny of nature was a sacred act'.[15] Programmatic statements by those seeking to encourage the foundation and growth of colonial art schools stressed their role in inculcating a 'scientific' progress alongside the contribution they might make to the development of public 'taste'. A technical convention – single-point perspective –

emerged as the key that would unravel an Indian resistance to the 'powers of observation'. Writing in 1880, Temple noted that 'the instruction' in art schools 'embodied the principles applicable to art in all climes and the practice most approved in European art'.[16] The ability to '[draw] objects correctly'[17] would in turn, it was hoped, foster an analytic re-orientation that would have profound consequences. Hence the stress on 'science'; perspective as a rigorous analytic tool would help fracture what Hegel referred to as the Hindu 'dreamworld':

[Art Schools] will teach them one thing, which through all the preceding ages they have never learnt, namely drawing objects correctly, whether figures, landscape or architecture. Such drawing tends to rectify some of their mental faults, to intensify their powers of observation, and to make them understand analytically those glories of nature which they love so well.[18]

Alongside those who argued for a dis-enchantment effected by 'Cartesian perspectivalism'[19] were advocates of a re-enchantment – at the level of allegory – through the medium of history painting. Lord Napier, Governor of Madras, urged in a celebrated lecture in 1871 the development of an Indian style 'that deals with the ideal and allegorical' in which 'the virtues, the graces . . . and other abstract conceptions and agencies are clothed in human forms which owe their majesty or their terrors to the Artist'.[20] The epic *Mahabharata* and *Ramayana* contained, he declared, 'the most inexhaustible and diversified stores of pictorial representation which any country possesses':

All that is needed to promulgate their beauty and complete their fame is that, in their purer and nobler passages and with the powers of European Art, they should engage the service of the national pencil as they have fastened on the national memory and animated the national voice.[21]

European art worlds endowed history painting with a moral gravity denied to other genres and it was the attempt to export this genre to India that laid the groundwork for the emergence of what we might think of as Indian 'magical realism'. This might also be seen in part as an inadvertence on the part of the dominant colonial culture, which while expounding its superior technology failed to recognize the potency of its 'other side', that is its own infatuation with myth and the extramundane. It is also in part the consequence of the inevitable slippage that occurred during the translational passage of the concept into a colonized society in which 'religion' was increasingly being called upon to do the work of politics. Images that might remain largely 'allegorical' in the salons of Europe, inhabited a politically more challenging terrain in India.

INDIAN MAGICAL REALISM

A clear sense of the impact of the 'powers of European Art' is conveyed by O. Chandu Menon's observation in his 1888 novel *Indulekha*:

> Before the European style of oil painting began to be known and appreciated in this country, we had – painted in defiance of all possible existence – pictures of Vishnu as half man and half lion ... pictures of the god Krishna with his legs twisted and turned into postures in which no biped could stand ... Such productions used to be highly thought of, and those who produced them were highly remunerated, but now they are looked upon by many with aversion. A taste has set in for pictures, whether in oil or water colours, in which shall be delineated men, beasts, and things according to their true appearance, and the closer that a picture is to nature, the greater is the honour paid to the artist.[22]

Menon's invocation of the realist transformation that engulfed oil painting in India in the late nineteenth century was intended to persuade those of his critics who wondered how he could assemble a successful novel that described 'only the ordinary affairs of the modern life without introducing any element of the supernatural'.[23] Just as, he claimed, new representational idioms were collapsing the distance between 'pictures' and 'nature' and creating an aversion for older schemata, so a new literature that was 'true to natural life' would dissolve the ground on which stood older narratives, 'filled with the impossible and the supernatural'.

Menon articulated what might be termed the 'modular' version of realism.[24] The modular version as it operates within the novel, according to Fredric Jameson, took as its 'historical function' the 'systematic undermining and demystification, the secular "decoding", of ... preexisting inherited traditional or sacred narrative paradigms'.[25]

In *Indulekha*, however, as Meenakshi Mukherjee has argued, the intention had been forgotten as early as the end of the novel, the last lines of which echo a quite different genre, the *purana* or mythological narrative: 'All the characters mentioned ... have reached the summit of human happiness, and now may God bless us and all who read this tale'.[26] This process of forgetting and the non-fulfilment of realism's 'historic function' can be seen inscribed even more vividly in Chandu Menon's exemplar, popular visual representation.

Temple and others certainly desired the displacement of the mythic into the realist, but, after a brief period of strategic mimicry and 'sly civility', Indian artists would develop something quite different, something akin to a visual 'magical realism'. This term was first used by Franz Roh to label post-Expressionist painting in Germany.[27] It achieved its currency, however, in Latin America where, partly through Alejo Carpentier's articulation of the 'marvellous real', it came to describe a genre of hybrid, anti-positivist, post-colonial literature. Carpentier essentialized

the marvellous real as a response to the peculiarly marvellous reality of South America, but in his articulation of a hybridized baroque – a more generalized cultural phenomena with which the ontologically valorized marvellous real intersected – we can unravel a set of insights that will help in understanding popular Indian visual culture.

Although the baroque was, for Carpentier, a 'constant of the human spirit', it needs also to be understood as a reaction to a spatial rationality. The baroque 'is characterized by a horror of the vacuum, the naked surface, the harmony of linear geometry';[28] it 'flees from geometrical arrangements'.[29] Carpentier sees Bernini's St Peter's basilica in Rome as exemplar of baroque; it is like a caged sun, 'a sun that expands and explores the columns that circumscribe it, that pretend to demarcate its boundaries and literally disappear before its sumptuousness'.[30] To Carpentier's stress on the creole and hybrid nature of magical realism we can add Luis Leal's observation that magical realism is an 'attitude towards reality' and not just as a literary genre,[31] and Amaryll Chanady's claim that magical realism 'acquires a particular significance in the context of Latin America's status as a colonized society'.[32] In Chanady's perceptive reading of magical realism as a response to the '"rule, norm and tyranny" of the age of reason'[33] one can hear echoes of Partha Chatterjee's claim that the nineteenth-century Bengali elite found in the rediscovery of popular aesthetics an escape from the 'prisonhouse of colonial reason'.[34] At various points in the ensuing narrative we will encounter images and genres that might be usefully thought of as magical realist in Chanady's sense. These images are responses to colonialism and refusals of a certain technology of representation. The late 1920s style associated with artists in the Rajasthani town of Nathdvara, for instance, might be seen as a post-perspectivalism that attempts to 'flee from geometry'.

'ABSORPTION' AND 'THEATRICALITY'

Buck-Morss's archaeology of aesthetics may also prove useful for our understanding of mass-picture production in India over the last 120 years, for here we will encounter images produced within and mediated by 'anaesthetizing' discourses, and those produced within and mediated by sensory practices. If we envisage this as a continuum, rather than a dichotomy, we can place images produced in Calcutta in the late nineteenth century nearer the 'anaesthetized' end, and the popular twentieth-century 'magical realist' images can be placed at the other end. It is the numbing of the human sensorium that makes the colonial mimicry of earlier images so compatible with conventional art-historical exegesis: a literature on the products of these early presses already exists. It is the sensory immediacy of the later images that makes them so intractable to conventional analysis and regard: the analysis of these images is in its infancy.

Images whose power is evaluated in terms of efficacy are difficult to understand from the viewpoint of conventional aesthetics. Aesthetic discourse is still, inappropriately, brought to bear upon popular representational practices and, since it misses the point of them, is inevitably forced to decry their various deficits. The questions asked by neo-Kantian aesthetics are – in this context – the wrong ones.

The central Indian villagers whose pictures are discussed in the final chapter of the book do not surround them with reified discourses. Rather, they speak of a depicted deity's efficacy, and link the origination of the image to their own biographies. The significance of images is expressed by rural consumers not through the efflorescence of words around an object, but a bodily praxis, a poetry of the body, that helps give images what they want.

This corporeal relationship with images (what Adorno called 'somatic solidarity') resists 'predatory reason'[35] in rather the same way that in Lyotard's dichotomy 'figure' resists the 'linguistic-philosophical

closure' of discourse. For Lyotard, the figural is 'relatively free of the demands of meaning', indeed it is not the arena for the production of meaning but a space where 'intensities are felt'.[36]

This corporeality and resistance to 'reason' is the source of an endless series of misunderstandings. In an Indian context one of the starkest condemnations of popular art's corporeality has come from Walter Spink, who in 1978 reviled it for its 'voluptuous[ness]' which seems 'marvelously camp to the western eye bemused by such highly sentimentalised and "realistic" religious productions'.[37] The invocation of voluptuousness (the *Shorter Oxford English Dictionary* definition of which is 'gratification of the senses [and] imparting a sense of delicious pleasure') and its association with kitsch is instructive, for theoretical writing on kitsch stresses a similar embodied immediacy, defining it as the inverse of disinterested and disembodied aesthetics. Tomas Kulka, writing from the high ground of Kantian disdain, suggests that kitsch differs radically not only from 'good' art but also from 'bad and mediocre' art, for it is a sensory phenomenon set apart from ordinary aesthetic discrimination. For Kulka, kitsch is dependent on motifs that are 'stock emotions that *spontaneously* trigger an unreflective emotional response'.[38]

The role of this corporeal immediacy in constructing popular contemporary North American religious art as 'kitsch' – and hence disavowed as 'art' – has recently been powerfully analysed by the art historian David Morgan. In addition to a disavowal founded on these images as 'interested', 'engaged' and 'extrinsically purposive',[39] they are also seen to embody a 'sentimentality'. This is associated with a female embodied emotionality, which is contrasted with a virile Kantian austerity.[40]

The story of how a numbed sensorium was brought back to life is one of the central concerns of this book. If 'anaesthetics' is about the discursive investigation and assessment of meaning, sensory aesthetics is about the relationship between the body and the image. This dichotomy becomes particularly clear in the contrast between colonial mimicry and magical realist images. The European art whose colonial shadow was cast over India had passed through engagements with vanishing points that incarnated corporeal viewers[41] to a practice that implied a 'transcendent point of vision that has discarded the body . . . and exists only as a disembodied *punctum*'.[42] Norman Bryson's arguments parallel those of Michael Fried, who observes the rise of what he calls the 'supreme fiction' of an absent beholder in late eighteenth-century French painting. This disembodied 'absorption' was exported to India and can be seen as an attempt – in tandem with the art schools' stress on 'naturalism' – to deny the magical origin of images. Later 'magical realist' paintings, by contrast, assumed an embodied 'corpothetics', by which I mean the sensory embrace of images, the bodily engagement that most people (except Kantians and modernists) have with artworks.

In Michael Fried's work the driving forces of change in European art – from French eighteenth-century history painting through to modernism – are strategies that deny the presence of the beholder through strategies of 'absorption'. Drawing in detail on Diderot's critical commentaries, an increasing disparagement of paintings that acknowledge the presence of the beholder emerges. Such acknowledgements usually involved direct eye-contact between the picture's subject and the beholder, a relationship Diderot disdained. His hostility to this mutual awareness of picture and viewer can be seen as a means of establishing a 'privileged' art as the antithesis of ritual art (that is, art whose sole *raison d'être* is to act as a conduit between beholder and deity). Likewise, for Fried, 'good' art is art that negates the presence of the beholder. Making a link between his study of eighteenth-century French art and 1960s modernism, he concludes that mediocre work has a 'theatrical' relation to the beholder, whereas the 'very best recent work' is 'in essence *anti*-theatrical'.[43] The emergence of modern art, Mitchell writes in his valuable gloss:

is precisely to be understood in terms of the negation or renunciation of direct signs of desire. The process of pictorial seduction Fried admires is successful precisely in proportion to its indirectness, its seeming indifference to the beholder, its antitheatrical 'absorption' in its own internal drama.[44]

Absorption, indirectness and history painting were part of the package exported by the colonial state into its Government Art Schools in the nineteenth century and we will encounter some silhouettes of these early anaesthetics. The 'supreme fiction' of the absent beholder becomes – in colonial India – a mark of western 'distinction' and a marker of distance from Hindu 'idols', from the fetish that was the common origin of all art. However, whereas in Fried's account 'absorption' marked an irreversible shift towards a desirable indirection, in popular Indian art its tenuous hold was quickly lost as consumers started to demand images stripped of this 'supreme fiction', insisting instead on images that fundamentally addressed their presence and invoked a new corpothetics.

In India the reawakening of the human sensorium went hand in hand with the insertion of mass-produced images into spaces of Hindu worship. This relocation had a twofold characteristic, involving movements towards, on the one hand, sacralized spaces and, on the other, domestic spaces. Thus there was a movement from mundane spaces such as the art schools into domestic spaces of worship and temples where images had a different work to perform. The need to demonstrate appreciation through explanation was replaced by bodily gestures and the look of the devotee. This entailed new forms of physical intimacy with images and an increasing irrelevance of formal 'anaesthetized' discourse.

The hold of absorption and history painting was tenuous and reached its apogee in the work of Ravi Varma (1848–1906), the Indian painter most amenable to the western genre of art-historical evaluation. Partly this is the result of his own self-mystification in Vasarian mode but it is, more importantly, the result of his adoption of a painterly style that strove for the 'supreme fiction'. His most art-historically celebrated works are those that look past the beholder. Ravi Varma's characters behave as if they had heard and ingested Diderot's command: 'think no more of the beholder than if he did not exist. Imagine, at the edge of the stage, a high wall that separates you from the orchestra. Act as if the curtain never rose'.[45] We shall see that it was this that his imperial patrons so admired. Conversely it is this (dominant) element of Ravi Varma's work that is so utterly invisible in the subsequent archive of Indian popular visual culture. The fragments of his work that do survive are those 'theatrical' or corpothetic images which unequivocally acknowledge the beholder's presence. In these images the beholder is a worshipper, drinking the eyes of the deity that gazes directly back at him.

'A SECRET OF THEIR OWN COUNTRY'

In Bombay, by the 1920s, Temple's conversional fantasy was long dead. W. E. Gladstone Solomon, the Principal of the J. J. School of Art in Bombay, encouraged the process of 'Indianization'. This was eulogized by Sir George Lloyd, the Governor of Bombay, who noted, when opening an exhibition of students' work, that 'successful artistic work cannot be achieved without inspiration, and inspiration can come only when the artist is working on lines natural to him, and endeared by inheritance and tradition'.[46] Discussing the school's curriculum, Solomon denied the claim that the work of the school was 'not Indian'. Some head and figure studies, he conceded, 'might almost have been painted by French or British students', but this is simply a reflection of the 'grammar of the universal language of Art'.[47] For Solomon, the language was part of a training that would place students in 'a stronger position for working out their own salvation'.[48]

Western representational techniques were no longer the vectors of a wholesale chronotopic transformation.

Instead they had become one among many tools, a means of revitalizing 'inheritance and tradition' rather than overturning it. With their own means of salvation to hand, students were choosing the 'Indian point of view', a conclusion shared by Bombay's Nationalist press. Surely, Solomon pleads, 'Indians are the best judges of what is Indian'.[49]

Temple's chronotopic revolution also implied a necessary disenchantment, a failure of the Hindu gods, which Ruskin had referred to as 'an amalgamation of monstrous objects'.[50] But Solomon revels in the dissemination of ever more potent gods into the public space of Bombay. In 1921 the School of Art was commissioned by the Prince of Wales Reception Committee to paint the 'pylons' with which the streets had been decorated with '170 figures of Deities, each seven feet in height':

> Then indeed it was a portentous spectacle to see the marshalling of multifarious emblems, tokens, ornaments, 'vehicles', and other insignia of an interminable line of Celestial Incarnations. Some of these were endowed with the usual complement of limbs, while others flourished arms like wind-mills. There were triple-faced, monkey-faced, vulture-faced Deities. There were some who rode on tigers, on lions, on eagles, on snakes, and some who used the lotus as a spring board for the stars.[51]

The art schools had been established with the intention that naturalism would vanquish Indian art, as suggested by Temple's hope that 'such drawing' would 'rectify some of their mental faults'.[52] But a very different vanquishing had occurred since, as Solomon wrote, invoking a remarkable set of metaphors:

> the shell that encloses the fruit . . . is so truly Indian that even the Western buildings in which the different departments of the School are housed almost seem, to knowledgeable eyes, to have been draped by the hands of their Indian students with invisible 'saris' . . . In the depths

of their dark eyes are the fires of enlightenment, but it is a Secret of their own Country that they are engaged in unravelling in the School of Art.[53]

It is this unravelling – undertaken by the wider commercial picture production industry – that the following chapters will trace.

2 staging hinduism: Lithographs and popular Theatre in calcutta, 1870-1885

I gathered from the print-shops of Calcutta several popular pictures – highly coloured – among them the Goddess of Learning, who, with her Greek robe and pile of books, resembles some medieval personifications of Grammar. Mahadar [*sic*],[1] bearing Sati on his shoulder, – a giant with flowing beard and hair, toiling, staff in hand, between steep and rugged cliffs, – is a fair image of St. Christopher. Jagadhatri, the Universal Nurse, seated on her lion, recalls Una. Devaka, father of Krishna, flying with the new-born babe into the wilderness to escape King Kansa, is notable for the beautiful and exquisitely haloed head of the child, which seems to have come from an old Italian canvas.[2]

The two earliest commercial Indian-run presses, the evidence suggests, both commenced publication, completely coincidentally, in 1878. They lay on opposite sides of India (Bengal and Maharashtra) and there is no evidence that they were aware of each other's initial products. The Calcutta Art Studio has attracted more attention and its output is discussed in this chapter. The Chitrashala Press in Poona, near Bombay, which is much less well known, is discussed in the following chapter.

The Calcutta Art Studio was started by Ananda Prasad Bagchi (1849–1905) with the help of four fellow ex-students of the Calcutta School of Art: Nabokumar Biswas, Phanibhushan Sen, Krishna Chandra Pal and Yogendranath Mukhopadhyaya.[3] The first two of these were established artists and the Studio would also employ portraitists such as Jaladhi Chandra Mukherjee, Pramathalal Mitra and Sashi Kumar Hesh.[4] When Bagchi left the Studio (sources suggest variously between one and two years after its founding) the remaining four partners bought up the shares. Phanibhushan and Yogendranath left in 1910 and Krishna Chandra in 1920, leaving the business, which at this time was increasingly threatened by cheap Ravi Varma Press images, in the sole hands of Nabokumar. In the late nineteenth century, however, their coloured lithographs (illus. 8) threatened a market previously supplied by hand-painted Kalighat *pats* and woodcuts.

Printing flourished in Calcutta at the end of the eighteenth century and was characterized by a diversification of control: commercial printing-shops and newspapers thrived in addition to Government and missionary presses.[5] By the end of the eighteenth century Calcutta was also the major clearing house for pictures: 'Many of these were oils, but in addition engravings and aquatints were readily selling'.[6] Produced for a British colonial market, it has been argued that the frequent auctions of 'gentlemen's effects' (in part the result of high British death-rates) led to the rapid diffusion of these images through the wider local population. In 1788 Thomas Daniell could observe that 'the commonest bazaar is full of prints – and Hodges' *Indian Views* are selling off by cart loads'.[7]

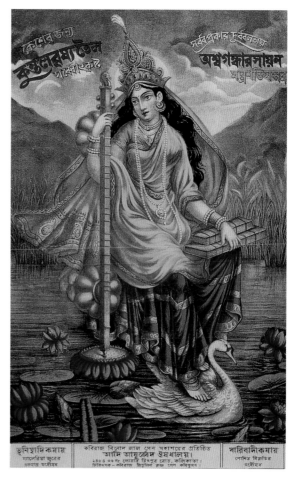

8 *Sarasvati* (c. 1878–80), a chromolithograph published by Calcutta Art Studio. An advertisement for Kaviraj Binod Lal Sen, purveyors of hair oil and tonics for general weakness.

Indians were also involved in technical and artisanal aspects of the print industry: all Daniell's views of Calcutta were stained (coloured) by 'natives'.[8]

The many streams within this cultural and aesthetic mêlée overlapped in only partial ways. One powerful new 'Indo-English' style emerged in the early nineteenth century in the rapidly expanding pilgrimage city of Kalighat, around which settled unemployed traditional scroll painters.[9] Their work, boldly and quickly executed, and initially aimed at pilgrims to the Kali temple, was by the mid-century

increasingly in competition with woodblock prints of religious themes. These chiefly emanated from the Battala neighbourhood, where numerous small printers issued books and pamphlets illustrated with woodblock prints. Battala prints could be produced more quickly and at a lower price,[10] and disseminated many of the themes and iconography of Kalighat *pats* to a wider audience across Calcutta and Bengal.

By the late 1870s lithography was also competing within this vibrant space of picture production. The Calcutta Art Studio was but one of several lithographic presses active at this time. The Chore Bagan Art Studio, located in Bhoobun Bannerjee's Lane, was also active in the 1880s. This may have been established by one Amar Nath Shaha, who is credited as the publisher of a Ganesh litho.[11] Chore Bagan issued a range of designs paralleling those of the Calcutta Art Studio and including the *Disrobing of Draupadi*,[12] images of Kali[13] (illus. 9) and of the battle between Rama and Ravana, hieratic depictions of Sarasvati and Krishna, and the ecstatic followers of Chaitanya. Other studios active in the 1880s included Chitra-Shilpi Co. of Bowbazar Street, whose output is less easy to document.

By 1888 T. N. Mukharji (Trailokyanath Mukherjee) was able to document the decline of the Kalighat *pat* industry 'owing to cheaper coloured lithograph representations of Gods and Goddesses turned out by the ex-students of the Calcutta School of Art having appeared on the market'.[14] It was the ex-students now working in the Calcutta Art Studio who seem to have been principally to blame for they turned out 'a large number of lithographic pictures every year', although even they were under threat from cut-throat English competitors who had 'made exact copies of Calcutta Art Studio pictures in colour and sent a large consignment for sale in India at one-tenth the normal price'.[15] Some lithographs clearly appropriate imagery that had been developed by Kalighat *pat* painters, but some later *pat* images seem to duplicate images with an earlier lithographic history. The patterns of influence are complex and, given the extreme difficulty of precisely dating *pats* and woodcuts, perhaps insoluble.

BHARAT BHIKSHA, OR INDIA BEGGING

The Calcutta Art Studio still occupies its original premises in Bowbazar Street (renamed Bepin Behary Ganguly Street in 1957).[16] In 1878, when the press first opened, Bowbazar lay on the borderline between the Imperial Calcutta of the Raj and the bustling Indian metropolis[17] and many of the Studio's early images reflect not only the aesthetic middle space created by the founders' experiences in the Calcutta School of Art, but also a strategic positioning between different audiences.

One of the Calcutta Art Studio's early prints is titled in Bengali *Bharat Bhiksha* (illus. 10). This might be translated as 'India Begging' or the 'Begging of India'[18] and depicts a young Indian child seated between Britannia and India portrayed as an old crone. The precise allegorical intent of the image's producer is difficult to capture, but it provides a vivid window on the nature of the cultural flows that were configuring urban Bengal throughout the nineteenth century. If the directionality of the 'gift' of the child is unclear, the child's identity as a newly reformed – 'Romanized' – India is not at all opaque.

Although the image of a reborn India would later be appropriated by Gandhi, one of whose main mouthpieces was the newspaper *Young India*, nineteenth-century intellectual[19] Bengali self-infantilization was one mark of a process of cultural conversion and auto-critique, which aspired to a civility that was rarely 'sly' in the sense deployed by Homi Bhabha.[20] Reform movements such as the Brahmo Samaj had deeply internalized Christian missionary critiques and the British imperialist 'civilizing mission', and sought to recast contemporary Hindu practices by an appeal to a purer, more austere Hinduism that was both closer to its origins and whose monotheism and anti-idolatry resonated with the dominant colonial culture.

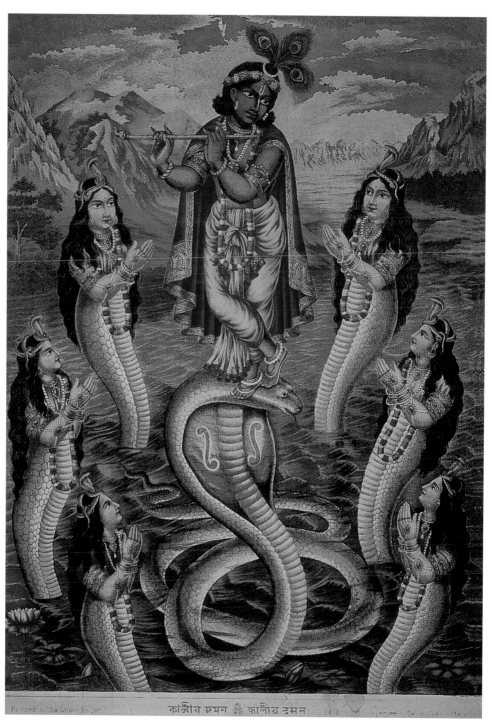

9 *Kaliya Daman* (*c.* 1878–80), a chromolithograph published by Chore Bagan Art Studio.

10 *Bharat Bhiksha* (c. 1878–80), a lithograph published by Calcutta Art Studio.

able gods and goddesses – was also blamed for keeping it submerged so long. 'Away with idolatry!', people shouted. 'Root it out, only then will the men and women of the country have new life instilled into them.' Christianity began to be preached, and, in imitation of it, the idea of monotheism. Prostrate India was made to listen to lectures – delivered at public meetings held in the Western manner – on politics, sociology, the freedom of women and widow-marriage. But the feeling of frustration and despair, instead of lessening, grew stronger. The railway, the telegraph and other products of Western civilization came into use; but these did not mend matters, because all such innovations could neither touch nor stimulate the ideals on which the life of the land depended. Since the proper remedy was not applied, the disease could not be cured. How could India, whose soul was religion, be brought to life if her religion was not resuscitated? . . . the spread of Western ideas and ideals, instead of curing the disease, was on the point of killing the patient.[21]

This complex history and the diversity of individuals and ideologies that configured the period are to be found in the Calcutta Art Studio's output. Through this we will trace some of the contradictions and recursions alluded to above, but we will also discover an attempt by a commercial concern to appeal to an audience of consumers just as broad and diverse. The expediency of commercial production and its complication of any organic relationship between the ideology of image producers and the formal content of images will be a recurrent concern in this study. In the case of the Calcutta Art Studio this is apparent in the conflicting identity of their corpus, which encompassed Hindus worshipping Kali, Brahmo Samaj followers and other reformist Hindus, supporters of the Raj, and nationalists.

The Church Missionary Society collected Calcutta Art Studio lithographs for use in loan exhibitions in the UK. One anonymous missionary saw them as

But alongside this enchantment with a western rationalism was a growing disdain for the eulogization of the colonizers' culture. This revolt was most clearly crystallized around Ramakrishna and would find a very precise articulation in the writing of one of his followers, Swami Saradananda (Sarat Chandra Chakravarty):

There arose a clamour on all sides that there never had been a national life in India; that although, thanks to the West, there was at least some sign of it, there were still many obstacles to its full growth. Deep-rooted religious beliefs were said to have smothered it. Idolatry – the worship of innumer-

modelled on Christian prototypes and believed that they should be preserved as archaeological relics of a soon-to-be-deceased popular Hinduism:

> They have great value. As authentic representations of their gods by Hindus they mark a fast fading phase in the religious history of the country – the period when by adopting Christian tactics – the people are trying to bolster up their own tottering faiths. The Hindus are even now beginning to see that these pictures so far from hindering Christianity – help it on – for the more the people can be got to realise what their gods really are – the more their hearts turn from them . . .[22]

This hopeful commentator could hardly have been more wrong: lithography was to play a key role in the reconstruction and 'syndication' of a new and powerful form of Hinduism.[23] Indeed, one could even claim that the doctrinal and historical multiplicity of practices invoked under the analytical fiction of 'Hinduism'[24] only really attains a coherence through the 'look', the persistent aesthetic, that lithography helped create.

The earliest Calcutta Art Studio images were issued in two series of 'Hindu Sacred Pictures', A & B. Series A included images of *Chaitanya Sankirtan*, *Balaka Darshan*, *Raja Harishchandra*, *The Exile of Rama*, *The Enchanted Deer* and *Annapurna*. Series B included *Madan-Bhasma*, quaintly titled in English *The Oriental Cupid in Flames* (illus. 11), and the *Exile of Sita*. Individually issued prints appeared later, and chromolithographs after these.[25] The study of extant images suggests that the Studio's artists, with their art school education, ventured first into the publication of portfolios of images, much in the tradition of earlier European artists in India, but, finding an enthusiastic market for their images as artefacts in domestic ritual, subsequently produced chromolithographs to be sold individually. We shall also see later that Calcutta Art Studio images also became vehicles for political aspirations. Indeed it was anxiety about one particular

11 *Madan-Bhasma* or *The Oriental Cupid in Flames* (*c.* 1880), a hand-coloured lithograph published by Calcutta Art Studio.

image by this press that seems to have precipitated the drafting of the 1910 Press Act, which would rigorously control picture production and circulation in the first half of the twentieth century.

THE BIRTH OF THE XENO-REAL

The argument advanced in the previous chapter will soon be developed. There it was suggested that, despite great colonial euphoria about the transformative power of observational rigour, combined with the inculcation of linear perspective, popular Indian art (re)translated these concerns into new hybrid forms that can be thought of as a type of Indian 'magical realism'. The 'indigenization' of western intellectual imports occasioned much disparaging contemporary comment and perhaps Rudyard Kipling's critique in *City of Dreadful Night* is the most memorable:

> Western education is an exotic plant . . . We brought it out from England exactly as we brought out the ink-bottles and the patterns for the chairs. We planted it and it grew – monstrous as a banian. Now we are choked by the roots of it spreading so thickly in this fat soil of Bengal.[26]

In 1870s and '80s Calcutta we can see both the strongest form of the xeno-real and the start of its translational slippage. The term 'xeno-real' I derive from an analysis by Brian Rotman of 'xeno-money'. Rotman uses this term to describe the money-as-commodity that sustains late twentieth-century global capitalism. Whereas earlier money used to circulate within nations and was theoretically redeemable, xeno-money circulates globally and is itself traded as a commodity: it has become a sign of itself, with a loss of anteriority.[27] By extension, I take xeno-real to mean the form of colonially authorized realism that circulates outside its framework of origination: it is jettisoned into the colony, where it comes (primarily) to signify itself.

This complex matter lies at the heart of one of the arguments of this book and requires further explication. The translation into India of aesthetic codes formulated in Europe occurred through what Homi Bhabha terms a 'partializing process' creating an aesthetic hybridity that deployed a *'ruse of recognition'*.[28] Realism in Europe was the product of a long struggle between different schemata, which sought an authorization through their proximity to a valorized 'nature'. Constable's desire to forget that he had ever seen a painting when attempting to capture this 'nature' in paint, and Monet's wish that he had been born blind only to suddenly receive his sight, encode an impossible yearning for an epiphanal and unmediated contact with reality.[29] The 'nature' that authorizes modular realism is without doubt a cultural production, but its power rested fundamentally upon a denial of this fact. It is this denial and the search for authorization within the space of a cultural void that grounds modular European realism. Realism in the colony, by contrast, is jettisoned into a zone that is configured by a different history. Cut off from the history of schemata that gives it its ability to speak for nature within the metropole, colonial realism becomes a xeno-real, which claims its power from its closeness to that reality that lies within the truth of colonial power. This displacement, through which it is colonial power, rather than 'nature', that provides authorization, gives colonial realism a greater instability and greater mobility. The slippage in colonial truth is mirrored in colonial realism's movement through a translational *continua*, its hybrid nature frustrating any possibility of identity and similarity.[30]

In short, the power that realism has in the metropole rests on a particular history of accretion and opposition. Once jettisoned into the new semantic field of the colony, it sheds the history that has shaped its resulting form. Cut free from 'nature', realism acquires its power from its proximity to other dominant discourses. Its articulation then becomes a matter of strategy, or accommodation, but (crucially) it

acquires a slipperiness and malleability within this new domain. It no longer signifies 'nature' in the same direct way but comes, instead, to signify (at one remove) the genre of picture-making to which it refers. It becomes a sign of itself.

It is this mimicry of what colonialism (rather than nature) authorizes as 'real' that gives many early Calcutta images their striking quality. Some images mobilized a hieratic idiom that, through their auratic iconicity, transposed ritually efficacious plaster and stone *murtis* (with which Calcuttans would previously have been familiar) into a stunning two-dimensional form on paper. Frontal images of Ganesh, Jagadhatri and Ganga Devi (see illus. 12 below) sidestep the

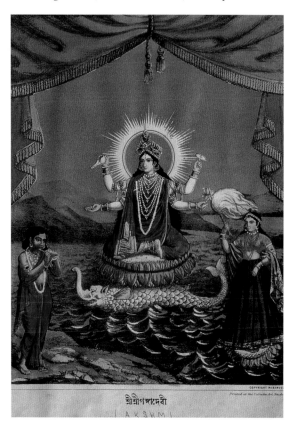

12 *Shri Shri Ganga Devi* (*c.* 1880), a chromolithograph published by Calcutta Art Studio. The handwritten English caption on this image is erroneous. This goddess appears as part of a theatrical tableau, beneath a stage curtain.

problem posed seventy years before by Edward Moor's frontispiece (see illus. 7), for there is no displacement into a new chronotope of representation. There is no attempt to operate in the new three-dimensional space of colonial realism.

However, such images are in a distinct minority. A small number of prints barely succeed in getting their subjects to participate in this new space of the xeno-real. Caught in a liminal state between the hieratic and the perspectivalized they are frozen halfway between the demands of intimate eye-contact with the devotee and the larger dramatic trajectory from which they have been extracted. Symptomatic of this is a much plagiarized image of Kali shown standing on a prostrate Shiv (see the illustration opposite).

The majority of Calcutta Art Studio images are neither hieratic nor liminal in the above sense: in most we can see the translated and displaced mimicry of the colonial xeno-real. Most striking are the deciduous northern backdrops present in many of these images: Sita is exiled in a setting reminiscent of a garden landscaped by Capability Brown; Shiv's meditation in *Madan-Bhasma* is interrupted in an Alpine setting complete with Scots pines (see illus. 11).

The mediation of the divine through the aesthetic categories of a colonial culture is striking. The enablements that *bhadralok* (Bengali middle-class) consumers acquired through this mimicry may have been akin to those obtained by earlier European elites' enthusiasm for history and mythological painting. John Berger famously suggested that these provided allegories of classical power and discernment, the ultimate emptiness of which rendered them more easily convertible to the needs of their wealthy patrons. Classicism and mythology supplied a 'system of references for the forms of their own idealized behaviour',[31] whose translatability was dependent on their vacuity. In the xeno-real there is a double (and doubly productive) emptiness.

Nala Damayanti was an image that was also treated by Kalighat painters of the period.[32] As with the myth of Harishchandra (an image of whom was also published

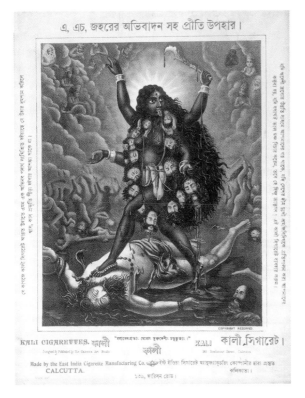

Calcutta Art Studio
chromolithograph of Kali
(*reproduced in colour on page 122*).

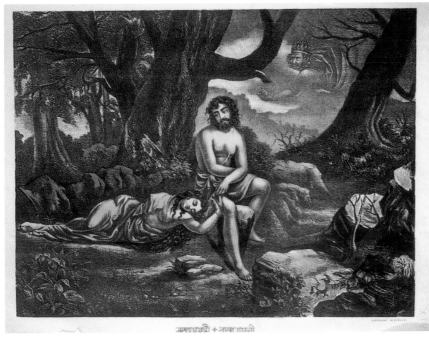

13 *Nala Damayanti* (c. 1880),
a chromolithograph
published by Calcutta
Art Studio.

by the Calcutta Art Studio), it depicts a king who has lost his kingdom and is shown at his most vulnerable and dispossessed. In the Calcutta Art Studio lithograph by Phanibhushan Sen,[33] Nala is shown reluctantly leaving Damayanti in the forest (illus. 13):

And departing, still departing he returned, again, again;
Dragged away by that bad demon, ever by his love drawn back.
Nala, thus his heart divided into two conflicting parts,
Like a swing goes backward, forward, from the cabin, to and fro.
Torn away at length by Kali flies afar the frantic king,
Leaving there his wife in slumber, making miserable moans.
Reft of sense, possessed by Kali, thinking still on her he left,
Passed he in the lonely forest, leaving his deserted wife.[34]

Nala and his wife Damayanti lost their kingdom, and even their clothes, as a result of the demon Kali's intervention. While roaming in the forest a bird flew away with Nala's last item of clothing and, while Damayanti slept, he cut her garment in two and slipped away in the night, hoping that she would then feel able to return to her father's court. The episode is narrated in the *Mahabharata* and was popularized in the English-speaking world through translations by Dean Milman and, later, Monier Williams. The story is a consideration of the destruction of a Hindu polity within modernity figured by the presence of the demon Kali, an agent of the degenerate *kaliyug*.[35]

Phanibhushan Sen's image almost certainly drew upon prints of European Renaissance images, and the natural setting for Nala and Damayanti's dilemma reconstitutes what in that European context would have been perceived as 'pastoral'. In the hybrid space of the xeno-real this forest becomes something quite different, for the 'forest' is the site of exile, of a profound unhomeliness and emptiness, rather than of pastoral belonging. The visual sign retains its formal exterior but interpretatively mutates as it passes across cultural and historical registers, from belonging to unbelonging, from the homely to the unhomely. Tapati Guha-Thakurta leads us towards a similar sense of 'partialization' when she notes that:

> only too often, the colouring took on loud, fantasised overtones, indulging in the shocking blue complexions of Rama or Krishna, the crimson of sunset skies, the pinks and purples of silken costumes or the glittering gold of ornaments . . . realism . . . was accommodated within existing iconographic conventions. What seemed alien Western influences in Indian pictures were indigenised and made to serve different ends within the framework of popular iconography.[36]

Key markers of the new 'stereotype of mythic fantasy' were fixed idealizations of women ('fair, plump, drooly-eyed . . .') and landscapes that amalgamated the apocalyptic with the utopian ('flaming skies and lakes filled with swans and lotuses').[37] The 'dilution' and 'indigenisation" that Guha-Thakurta describes can also be thought of as 'partialization', a strategic mimicry that pursues a new local agenda, creating a distinctly hybrid xeno-realism.

OF CHROMOLITHOGRAPHS AND PLAYS: ON THE 'INTER-OCULAR'

It is obvious that these images did not exist in isolation. Chromolithography was created and consumed within a wider visual culture in which there was a continual spillage between genres. The 'conversation' between the idioms of chromolithography, theatre and photography in late nineteenth- and early twentieth-century India created mutually reinforcing expectations. These different visual fields crossed each other through processes of 'inter-ocularity' – a visual inter-

referencing and citation that mirrors the more familiar process of 'inter-textuality'. In addition, strategic alliances arose between these representational forms and the realms of religious authority and emergent ideas of the 'nation' that further empowered them. Having lost its anterior referent (the kind of 'real' that might underwrite a picture hanging on a wall in Britain), the xeno-real found new forms of authorization, closer to home.

This process is explicitly clear in the case of the Calcutta images with which we are concerned here. Tapati Guha-Thakurta has argued that these marked a new stage in the Indian appropriation of a western painterly 'realism'. In view of the metaphors through which she expresses this new potency ('a sense of live dramatic enactment', 'front-stage figures', 'theatrical postures and expressions')[38] it is surprising that this astute author does not elaborate on the direct connections between these images and popular theatre of the time. The dependence of 'realism' on theatrical metaphors innocently testified to in the above account is illuminating for what it says about the simulatory traces that lie within everday English usage: in the case of 1870s and '80s Calcutta, however, the linkage is not only metaphorical and referential, it is also historically demonstrable.

Patterns of causality are difficult to establish but, as we will later see with the case of popular Hindi cinema, there is a deep and intimate relationship. In many images there are visual clues as to this relationship: some depict deities cavorting against a naturalistic backdrop but others dispense completely with such devices and frame deities within the visible paraphernalia of the theatre. Thus the Calcutta Art Studio's *Ganga Devi* (illus. 12) appears as the central part of a stilted tableau within a draped proscenium arch; similarly, Chore Bagan Art Studio's *Gopal* depicts Krishna holding a *laddu* and seated on a throne placed within an ornate Moghul archway, from which hang furled green drapes.

But much more intriguing than these transparent visual signifiers of theatrical space there is an unmistakable parallelism between the subject matter of lithographs produced in 1880s Calcutta and the mythological plays that gained in popularity during this period. Some of the parallel developments are striking: the Calcutta Art Studio's popular *Nala Damayanti* (see illus. 13)[39] immediately predated the Star Theatre's production of Girish Chandra's *Nala Damayanti* on 15 December 1883,[40] which featured trick scenes that were later to be incorporated into Parsi theatre. *Nala Damayanti* was given its last performance on 30 July 1887.[41]

There were many theatres in colonial Calcutta. The Hindu Theatre was started in 1831 by Prasanna Kumar Tagore, and two years later Nabin Chandra Basu founded another in Shyambazar.[42] Yajnik dates the origin of a recognizably modern Bengal theatrical style to the production of a social tragedy, *Kulinakulasarvasva*, in March 1857, since this 'marked the beginning of the mode of scenic representation that is now in vogue in Bengal'.[43] This was followed soon after by Bengali renditions from the canon of classical theatre. These were generally given 'not in an open space, but in theatres neatly and beautifully erected at the lower end of the drawing room, with scenic embellishment of considerable pretensions'.[44] The first permanent stage was constructed in the 'gorgeous villa' of Raja Pratap Chandra Singh and Raja Issur Chunder Singh in 1858, where, in addition to an English version of *Ratnavali*, dramatizations of the epics were presented. In 1865 Jatindra Mohan Tagore established another private theatre in which 'the scenes were singularly well painted especially the drop-scene which was ablaze with aloes and water-lillies and entirely Oriental'.[45] At this time 'almost the sole occupation of the idle rich of Calcutta was to start amateur theatres'.[46]

It was the success of these flourishing private establishments that encouraged the seminal figure of Girish Chandra Ghosh to enter the world of theatre. We have two alternative histories for Girish Chandra's early career. One source suggests that, following an early career as a bookkeeper with a mercantile firm

and several years working with another actor, Ardhendushekhar Mustafi, he established the National Theatre in 1872.[47] Here they employed the scenic artist Dharmdas Sur (and his assistant, a poor British sailor named MacLean) and put on plays such as *Harishchandra* and historical pieces including *Pratap* and *Shivaji*,[48] which became increasingly popular as 'classical translations . . . lost their hold on the popular mind'.[49]

Another source provides a contrasting account, claiming that it was not until 1879 that Girish Chandra was employed as manager of the National Theatre and, following several failures with plays by established playwrights, produced his own mythological drama *Ravana Badh* (Slaying of Ravana) on 30 July 1881.[50] This was a dramatization of Ram and Hanuman's war against the demon-king Ravan of Lanka, an episode that forms a key part of the *Ramayana*, and marked a turning point in Bengali theatre towards new, local forms of cultural expression. Girish Chandra was to play the part of Ram and the use of blank verse, which allowed for a more naturalistic delivery and a vernacular idiom, contributed to the play's immense success. Happily a detailed and remarkable account of this play exists in the American divine Moncure Daniel Conway's *My Pilgrimage to the Wise Men of the East*. Recording his 1884 visit, Conway identifies the location as the Star Theatre, which was 'occupied with Hindu Miracle Plays'.[51] Girish Chandra had left the National Theatre following a dispute and started the Star Theatre in July 1883. We can assume that he transferred his production of *Ravana Badh*. Conway went with Courteney Peregrine Ilbert (on whom more below), and his account is full of fascinating detail and gives some indication of audience responses. Because of its parallels with a later play (*Kichak Vadh*, see chapter 3), I quote at length:

The first play I saw was the combat of the hero Rama with the demon Ravana. (Ravana was a king of Ceylon who was demonized in India, and popularly given many heads . . .). The performance opened with a chorus of nymphs

beautifully draped, marching to and fro, singing an ancient ballad in praise of the hero. The terrible Goddess Kali was personated by a blackened man. She promises Ravana . . . her protection . . . We pass to the forest where Rama invokes the Goddess Durga. The nymphs sing around him in the forest. The sensational scene is where Rama is about to tear out his eye and offer it as a sacrifice to the goddess. Durga, thus far a wooden image, starts forward, prevents this sacrifice, and promises to protect Rama's wife, Sita, whom Ravana has abducted and placed with his daughter-in-law.

The conflict is for the rescue of Sita. When Ravana approaches, his daughter-in-law of course hides. A messenger warns Ravana of his peril. Ravana boasts that he has a magic arrow, and cannot be defeated. The monkey god [Hanuman], however, in disguise as a holy fakir, manages to obtain this arrow from Ravana's wife. The combat between the hero and the demons caused excitement in the audience, but it was indicated only by low vocal utterances.[52]

The battle scene is depicted in a Chore Bagan Art Studio chromolithograph dating from the early 1880s (illus. 14). Ram crouches in front of Hanuman and fires his arrow towards Ravan who sits atop a *rath* (chariot) in front of the goddess Kali. It seems highly likely that this image was inspired by Girish Chandra Ghosh's play and the scenery used therein. In the background, beyond the ranks of battling monkeys, is a cluster of Italianate buildings such as one could imagine might have been used in one of Girish Chandra's earlier Shakespeare productions[53] and then reused in *Ravana Badh*. Here we can see the xeno-real signifying itself: it is the signs of a theatrical reality recycled as the landscape in which these events occur; Italianate buildings infest Lanka, and Ravan sits astride a chariot that conforms perspectively to the point of view of a spectator on the far left of the picture. Theatre displaces nature.

14 *Ravan Vadh* (c. early 1880s), a chromolithograph published by Chore Bagan Art Studio.

Conway was so affected by 'the miracles that seem so natural at a million year's distance' that he found himself:

> floating familiarly in immemorial time. I was present at the birth and development of deities and demons, saw them take the shape in which they could engrave themselves indelibly on the human heart by charming or terrifying the senses . . . The 'Miracle Plays' are so named with naïveté and truth. It is only on the stage that demons and dragons are securely slain and justice prevails, and virtue always triumphs over vice.[54]

The above mentioned Ilbert was responsible for amending the criminal procedure code to enable Indian judges outside Calcutta, Bombay and Madras to try accused British subjects in criminal cases. This provoked a virulent outcry that led to the bill's dilution and delay, and this in turn crystallized Indian discontent with British rule. Sir Henry Cotton, writing in 1886, concluded that:

> the whole attitude . . . of Europeans in regard to the so-called Ilbert Bill, have tended far more to advance the true cause of Indian unity than any mere legislation on the lines of the original Bill

would have been likely to accomplish . . . the unreasonable clamour and rancour of its opponents, and the unexpected success which attended their efforts gave rise to a counter agitation of first-rate importance and of the most far-reaching character.[55]

During the interval Conway, Ilbert and a Bengali translator were invited by the manager to see behind the scenes:

Mr Ilbert, who supposed himself incognito, suddenly found himself the object of a patriotic demonstration. The Hindus had recognized the author of the famous Ilbert Bill for enlarging the rights of natives, and now Rama, Ravana, their retinues, and even their wives, came forward and prostrated themselves before the astonished statesman. The nymphs with the chorus stood around and made profound obeisance, and the god Agni said in good English 'See, sir, even our women, ignorant as they are, have been moved with admiration of you, for your justice to our race, and desire to pay you homage.'[56]

15 Poster advertising reception of Bepin (sic) Chandra Pal on 21 March 1908 at the Star Theatre, Calcutta.

16 Photograph of Lala Lajput Rai, Bal Gangadhar Tilak and Bepin Chandra Pal (c. 1906), the three leading 'Extremist' political leaders.

The link between Calcutta Theatre and politics was again demonstrated 25 years later when Bepin Chandra Pal, the revolutionary activist and key figure in Bengali resistance to Curzon's 1905 partition, was given a 'Presentation Night' at the Star Theatre's 1908 production of *Alladin* and *Jadukari* (illus. 15).[57] Next day the Royal Box was reserved for Pal, 'The People's Hero', at whose special request *Nandakumar* would be staged. Amrita Lal Bose, the Star's manager, declared Pal to be 'one of those of our Few Public Men who cherishes in His Heart A Love of our National Literature & Art With Political Enthusiasm!', and announced that half of the evening's takings would be presented to Bepin Chandra Pal. 'Any token of love will be acceptable!', he concluded, 'But let our patrons try to make it respectable too!!!'[58] The Calcutta Art Studio did produce portrait images of leading Bengalis, some of whom were cultural nationalists (such as Bankim Chandra Chatterjee), while others were fully engaged in political activities. But, like Surendranath Banerjea, who was depicted in a late nineteenth-century monochrome image (illus. 17), these were moderate constitutional figures pursuing gradualist strategies.[59]

Fired by the huge success of *Ravana Badh*, other Girish Chandra mythologicals followed,[60] several of which were based on episodes in the *Ramayana*.

17 Surendranath Banerjea, a late-19th-century lithograph published by Calcutta Art Studio.

Paralleling this focus, the Calcutta Art Studio published images of the exile of Rama, in which a weeping Dasaratha bids farewell to his son, *The Enchanted Deer* (or *Maya Marg*), which depicts Sita requesting Rama to go hunting in pursuit of a golden deer sent as a decoy by Ravana, the *Exile of Sita* and an image of Sita in captivity in Lanka following her abduction.

'I FOUND THE REPRESENTATION THE SAME AS THE REAL'

Perhaps the most remarkable incident during Girish Chandra's tenure at the Star Theatre was the visit of Ramakrishna Paramahansa to a performance of *Chaitanya Leela*[61] on 24 September 1884, an event which led to a rapprochement between the previously morally marginalized public theatre and religious respectability. A detailed account is given in Mahendranath Gupta's *Sri Sri Ramakrishna Kathamrita* (generally known as the *Kathamrita*), which was translated by Swami Nikhilananda as *The Gospel of Sri Ramkrishna* and which intercuts what appear to be sections of the original play script with Ramakrishna's reactions and recurrent lapse into *samadhi* (a yogic state of trance).

The sixteenth-century *sannyasi* Chaitanya founded a new sect focused on the worship of Radha and Krishna. The most public sign of the sect's devotion was *sankirtan* ('united praise'), which Farquhar described, along with *nagarkirtan* ('town praise'), in the following words:

> He and his followers would sit together for hours, singing hymns in praise of Krishna with instrumental accompaniment, until they lost themselves in ecstasy and love . . . Then they would sally out, drums beating and flags flying, and would march through the streets dancing and singing to Krishna with such contagious joy and holy rapture that the whole town would be swept along on the tide of devotion.[62]

Chaitanyaite practices were to experience something of a revival following Keshab Chandra Sen's commissioning of Bijay Krishna Gosvami, a descendant of one of Chaitanya's companions, to introduce *sankirtan* and *nagarkirtan* into Brahmo Samaj practice.[63]

Chaitanya Leela, which capitalized on this renewed interest (illus. 18), was a hugely successful play and Ramakrishna's experience as a spectator was to play a part in the new relationship between the public theatre and religious respectability since, according to Mukherjee:

> it was now fully realized that the much condemned public theatre, the supposed haunt of all the rejected elements of the society, the truant young men and the fallen women, could also be a centre for religious teachings and preachings, knowledge

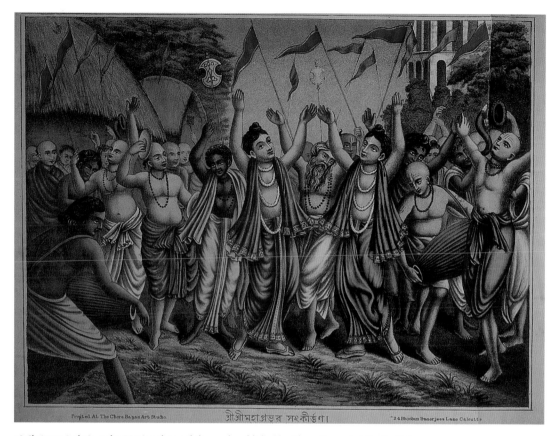

18 *Chaitanya Leela* (c. early 1880s), a chromolithograph published by Chore Bagan Art Studio, Calcutta.

and enlightenment, the moral and spiritual welfare of the common man.[64]

He concludes dryly that Ramakrishna's visit (and subsequent praise of the cast afterwards) was a unique event, 'a saint in the Hall of Satan!' Yet this did not simply bestow respectability on popular theatre. It is probable that a much more profound validation had occurred since, as Mukherjee records, 'Sri Ramakrishna was so moved by the play that he fell into a state of *samadhi* or divine ecstasy'[65] and the attainment of such states of yogic oblivion had by this stage become defined as Ramakrishna's response to divinity: 'In religious ecstasy he would pass into that form of trance which is called in Hinduism *samadhi*.

When this came on him, he became unconscious. When he was in this condition, the best doctors could find no trace of pulse or of heart-action.'[66] Most often, Ramakrishna fell into *samadhi* before the image of the goddess Kali in the Dakshinesvara temple, where he had become assistant priest shortly after its construction in 1855. This state of *samadhi* became a testament – almost a guarantee – of the immanence of Kali's presence within the Dakshinesvara *murti*: he expounded the potency of idols[67] – 'he believed it to be living and breathing and taking food out of his hand'.[68] Ramakrishna's devotional ecstasy is a hugely popular subject in current Bengali chromolithograph production (illus. 19). His deity-like qualities are also very clear in many of these images. Ramakrishna,

19 Kali induces *samadhi* in Ramakrishna, a calendar image *c.* 1999 from Calcutta. A modern image that has been continuously reprinted since the 1950s, showing the 19th-century sage.

often with his devotee, The Mother, is always shown frontally when depicted in front of the image of Kali. In other images ordinary worshippers are shown in profile or obliquely. The identification with Kali is made more explicit in images where Kali is shown touching and blessing the heads of Ramakrishna and The Mother, or they are represented as part of a triptych with Kali at the centre. This later image takes the form of a formal shrine-like structure and also a physiognomic merging in which the faces of the two devotees coalesce with the goddess's central visage. Frequently Ramakrishna is depicted seated on a lotus, or as part of a *trimurti* (three-form) structure incorporating The Mother and Swami Vivekananda.

Ramakrishna's attendance at the *Chaitanya Leela*, his lapse into *samadhi*, and his blessing of the cast backstage afterwards led Binodini Dasi, who played Chaitanya,[69] towards a life of asceticism. According to Binodini's own account, 'the most divine of beings granted me refuge at his feet', and she recalled how 'cleansing with his touch my sinful body, he blessed me, "Ma, may you have chaitanya!"'[70] From this date onwards she moved away from 'the glare of the footlights . . . to a life of renunciation and quiet religious pursuits'. The consequence of Ramakrishna's validation of the religious presence embodied in the imagery and narratives of popular mytho-dramas would have been more diffuse, but no less powerful.

As early as the first scene Ramakrishna was overcome with 'divine ecstasy' before entering deep *samadhi*.[71] During the next scene, in which a Brahman woman bathing on the banks of the Ganges at Navadvip chants the name of Hari to ensure Chaitanya's return, he cried out and 'shed tears of love', saying to his companions 'Don't make a fuss if I fall into an ecstatic mood or go into *samadhi*'.[72] He once again entered *samadhi* during a scene in which Chaitanya is invested with the Brahmanic sacred thread and dons a *sannyasi*'s ochre robe.

The final scene of the play, which related Chaitanya's encounter with two ruffians, Jagai and Madhai, was also to form the subject matter of lithographs published by the Calcutta Art Studio and Chore Bagan Art Studio during this period. Swami Nikhilananda renders the remarkable event thus:

Sri Ramakrishna was in an ecstatic mood. Nitai embraces both Jagai and Madhai, and sings a song to the two ruffians.

Nimai speaks to Sachi of his desire to enter the monastic life. His mother faints and falls to the ground.

At this point many in the audience burst into tears. Sri Ramakrishna remained still and looked intently at the stage. A single tear appeared in the corner of each eye. The performance was over.

Sri Ramakrishna was about to enter a carriage. A devotee asked him how he had enjoyed the play. The Master said with a smile, 'I found the representation the same as the real.'[73]

In December 1884 Ramakrishna visited the Star Theatre again and watched a play about Prahlada. Before the performance Girish said 'I often ask myself, "Why bother about the theatre anymore?"', to which an anxious Ramakrishna replied, 'No, no! Let things be as they are. People will learn much from your plays.'[74] Following periods of *samadhi* during the play itself, Ramakrishna declared to Girish:

I found that it was God himself who was acting the different parts. Those who played the female parts seemed to me the direct embodiment of the Blissful Mother, and the cowherd boys of Goloka the embodiments of Narayan himself. It was God alone who had become all these.[75]

As Mukherjee noted, Ramakrishna's engagement with popular drama was a crucial event, since it transformed orthodox evaluations of the theatre as a space for divine experience. Rather than being the

'haunt of all the rejected elements of the society', the theatre was transformed into a space of righteousness, of moral and spiritual instruction for the masses.[76] Bhaskar Mukhopadhyay has perceptively suggested that one might see here the transformation of an originary 'Western theatre', as a sign of colonial purity, into a hybridized *jatra* or local theatrical-devotional performance.[77]

The *Kathamrita* also records Ramakrishna's endorsements of various ritual images, many of which may have been the products of the Calcutta Art Studio, Chore Bagan Art Studio and other presses. Summarizing events on 28 July 1885, the text describes a visit by Ramakrishna and his disciples to the home of Nanda Bose, an aristocrat of Baghbazar, who was known to have many pictures of gods and goddesses in his house. Upon arriving the group discovered 'Pictures of gods and goddesses were hanging on all sides'. Among these were images of Vishnu with four arms, at the very sight of which Ramakrishna was overwhelmed with ecstasy: 'he sat down on the floor and remained a few minutes in that spiritual mood.' Other images depicted Rama blessing Hanuman, Krishna standing with his flute and Vamana and Narsinha, two further Vishnu avatars:

> Sri Ramakrishna then saw pictures of Dhumavati, Shodasi, Bhuvanesvari, Tara and Kali. He said: 'All these portray the terrible aspects of the Divine Mother. If one keeps these pictures, one should worship them. But you must be lucky, to be able to hang them like that on the wall.' At the sight of Annapurna's picture, Sri Ramakrishna exclaimed with great fervour, 'Grand! Grand!' The next picture was one of Radhika as a monarch. She was seated on a throne in the nikunja grove, surrounded by her women attendants. Sri Krishna guarded the entrance of the grove as her officer. Next was Sri Krishna's picture. Then came a picture of Sarasvati, the goddess of learning and music. It was in a glass case. She was in ecstatic mood, playing melodies

on the vina. After seeing the pictures, Sri Ramakrishna went to the master of the house and said: 'I am very happy today. It is grand! You are a real Hindu. You have these pictures instead of English ones. I am surprised! . . . These are very large pictures. You are a real Hindu.' [Nanda replies]: 'I have European pictures also.' [Ramakrishna responds, smiling]: 'They are not like these. I am sure you don't pay much attention to them.'[78]

This responsive excess, in which Ramakrishna defines Hindu-ness by the possession of pictures of deities, provides a great insight into the new space of authorization that was emerging in Calcutta as the xeno-real made new attachments and linkages with popular practices, which would in turn transform it. It is not clear whether Nanda Bose's pictures were original oil paintings or chromolithographs, but there is a striking parallelism between the pictures described in the *Kathamrita* and the products of the Calcutta and Chore Bagan art studios. For instance, Calcutta Art Studio printed coloured images of Dhumavati, Shodasi (illus. 20), Bhuvanesvari, Tara and Kali. Ramakrishna also defines an explicitly ritual ground for these images and endows them with agency: the fierce goddess images listed above demanded worship. They had needs, had wants.[79] What Richard Temple referred to as the 'powers' of European art were being put to new and unexpected uses.

The Calcutta-produced images we have surveyed in this chapter reveal their embeddedness within the particular religious and historical experience of Bengal. The authority they acquired arose from their intimate connection with other forms of cultural expression (most notably theatre) and forms of middle-class spirituality that articulated critiques of colonial morality. Clearly these early images were being called upon as part of what was, inevitably, the political project of being 'a real Hindu'. The politics of Calcutta images during this early period were subtle

20 *Shorhasi and Chinnamosta* (*c.* early 1880s), a chromolithograph published by Calcutta Art Studio. Shorhasi (Shodasi) was one of the many goddesses displayed in Nanda Bose's house.

and complicated. The politics of the Chitrashala Press, in western India, also founded in 1878 and the subject matter of the next chapter, were much more transparent.

श्री समर्थ रामदास.

3 peshwas, parrots and bombs: lithographs and politics in western india, 1870-1885

Picture production in Calcutta, and in Poona in Western India (which forms the subject of the present chapter), dominates the opening section of this book because it was in these two places that the majority of early printed images were produced.[1] In both cities, as a matter of complete coincidence, major lithographic presses came into existence, almost certainly, in the same year, 1878. But the nature of these presses was very different, and this difference reflected contrasts in the political climate and history of the two cities.

Calcutta had developed as a colonial city, the political centre and major trading port in the emergent Indian Empire. Bengali urban culture and politics was closely entwined, albeit in a conflictual way, with colonial practices. The 'enemy', to invoke Ashis Nandy's phrase, was 'intimate': internalized as an interlocutor in an 'unhappy consciousness' of modernity.[2] The historical experience of Poona had been quite different. During the seventeenth and eighteenth centuries, first under Shivaji and the Mahrattas, and then the Peshwas, Poona was effectively the fulcrum of an Indian-controlled empire. From 1820 the British used it as the summer capital of the Bombay Presidency, but Poona's martial independence retained a powerful vigour in the local historical imagination.

THE CHITRASHALA STEAM PRESS

In an outstanding study of elite Indian artists' responses to colonialism, Partha Mitter makes the surprising claim that, unlike in Mexico, and with the exception of the early phase of the Gandhian movement, 'there was no revolutionary environment for the artists to be drawn into'. Further, with the exception of two artists (Nandalal Bose and Ravishankar Rawal), their art did not serve any 'directly political ends'.[3] Much of this present study is concerned to show that mass-produced art in colonial India was, on the contrary, intimately engaged in a series of political (and sometimes revolutionary) struggles. It is at the Chitrashala Press,

where (so its own history boasts) the first bomb in the Deccan was manufactured, that this engagement is first seen.

In 1879, one year after the founding of the Chitrashala Press, a petty government clerk in Poona, Vasudeo Balvant Phadke (illus. 21), led an uprising that would anticipate the revolutionary terrorism that would come to mark India in the first half of the twentieth century. Like B. G. Tilak, Phadke was a Chitpavan Brahman and was motivated in part by 'the growing Hindu revivalist mood among Poona Brahman intellectuals'.[4] With a band of forty supporters, including not only fellow Brahmans but also tribal Ramoshis, Phadke had hoped to secure sufficient money from dacoities (banditry) to establish a Hindu Raj. Richard Temple, now Governor of

हुतात्मा वासुदेव बळवंत फडके.
जन्म सन- संग्राम सन- बलिदान सन-
१८४५ १८७९ १८८३

21 *Hutatma Vasudev Balvant Phadke* (c. 1920). Panvel, Colaba, Bombay. Phadke, a Chitpavan Brahman from Pune, led a revolt of subaltern Ramoshis in 1879.

Bombay, concluded that Phadke had acted 'in imitation of the tactics pursued by S[h]ivaji . . . against the Mogul Empire'.[5]

In a celebrated minute written in the same year as Phadke's abortive revolt, Temple elaborated in more detail a British consensus about the Deccan, the region of western India at the heart of which lies Poona. In what Cashman terms 'a classic statement of the conspiracy theory',[6] Temple stressed what – from the perspective of the colonial state – appeared to be a prison of historical awareness, in which the past produced an ever-bounteous flow of metaphors for the present:

> Throughout the whole of the Deccan, the mind of the people is . . . affected by the past associations of Maratha rule, which, so far from being forgotten, are better remembered than would ordinarily be expected, and by the long retained memory of the Maratha uprising against the Mohomedans . . . This memory constantly suggests the analogy between the position of the British and that of the Moguls in the Deccan.[7]

Under the charismatic Shivaji, the Marathas displaced Mughal rule from much of central and north India. Long after his death in 1680 Shivaji remained a potent force in much popular historiography, becoming a mythic warrior king who pushed back the furthest limit of Islam's progress. In his historical afterlife he came to embody, for many Hindus in Maharashtra, a vision of decisive force as the enabler of a morally pure Hinduism. Temple suggests that this mythicization helped put in place a conceptual infrastructure that allowed the corrupt present to be read as a mirror of a more perfect past: British domination was an echo of Mughal domination and required a similar response.

The nationalist political landscape of late nineteenth- and early twentieth-century Western India was dominated by two figures: B. G. Tilak and G. K. Gokhale. Gokhale believed Indian interests

22 Bal Gangadhar Tilak, a turn-of-the-century chromolithograph printed at Chitrashala Press, Poona.

could be advanced by working inside British colonial instituitions and through negotiation and assimilation. Tilak, who was labelled 'extremist' to Gokhale's 'moderate' by the colonial press, worked on the outside through inflammatory journalism and the promulgation and organization of new forms of religious/political mass action (illus. 22). A pioneer of the use of 'religious orthodoxy as a method of mass contact',[8] Tilak came from an orthodox Chitpavan Brahman family, the same caste from which the Peshwas, the successors to the Mahrattas, were drawn. His lasting legacy was the Ganpati festival. Started in 1894, this celebration of the deity Ganesh was intended to provide a means for Hindus to affirm their public presence and is still widely celebrated throughout central and north India as an integral part of seasonal ritual activity.

The Chitrashala Press was started in 1878 by Vishnu Krishna Chiplunkar (illus. 23),[9] a remarkable figure who has been described as 'probably the single most important personal influence on [Bal Gangadhar Tilak's] thinking'.[10] That Chiplunkar viewed the publication of journalism and chromolithographs as complementary endeavours is indicated by N. C. Kelkar, a later editor of the *Mahratta*, Tilak's newspaper, who, writing in 1908, noted that he 'established two printing presses, the *Arya-Bhushan* for the use of the two newspapers [the *Mahratta* and *Kesari*], and the *Chitrashala* for the purpose of encouraging fine arts'.[11]

Although Kelkar's 1930s pamphlet biography of Chiplunkar suggests that the press was not opened until 1880,[12] the Chitrashala's own official Marathi memorial publication dates this event to August 1878.[13] Chiplunkar started an influential literary and political

23 Vishnu Krishna Chiplunkar, the founder of Chitrashala Press. From Kanitkar's *Chitrashalecha Itihas*.

magazine, *Nibandha Mala*, in 1874, the contents of which exploded 'like a bombshell'.[14] The official displeasure that Chiplunkar's publication incurred resulted in a posting – in effect a banishment – to Ratnagiri, which Chiplunkar, to assuage his ill father, accepted. His father's death 'served to eliminate the conflict between his natural inclinations and his filial duties',[15] and he resigned from Government service and returned to Poona.

Kanitkar's Marathi history suggests that the three partners in the press, which was but a small part of Chiplunkar's wide portfolio of political and aesthetic projects, were Chiplunkar, Balkrishna Pant Joshi and Shankar Tukaram Shahigram. A new manager was appointed in 1883, the year of Chiplunkar's death, and proceeded to buy out the two remaining partners, Balkrishna and Shankar.

The earliest print issued by the press was, according to Chiplunkar himself,[16] a small image of the historical figure Nana Phadnavis (see below), but the press's first commercial success had its origins in a painting made in 1874 depicting Ram with Sita, Lakshman, Hanuman and others. Balkrishna Pant (one of the partners in Chitrashala) saw a photographic version of the print produced by the Poona photographer Raja Ram Rangoba and immediately arranged for a large colour print of this to be produced at Chitrashala. The resulting image, titled *Rampanchayatam* (Ram's assembly), is a sumptuous print that extends some of the conventions of traditional south Indian bronze statuary into the realm of lithography (illus. 24).[17] Its startling materiality is even more bewitching than that of most Calcutta Art Studio images, whose reception has been discussed in the previous chapter. Kanitkar's Marathi history of the press notes that the print found immediate popularity, selling two thousand copies in a month. Another print entitled *Shivpanchayatam* (illus. 25) followed and was similarly popular; copies were purchased, Kanitkar notes, by residents of far-off villages.[18]

In either 1878 or 1880 – depending on which account one accepts – Chiplunkar started a monthly

24 *Rampanchayatam* (1878?) by Chitrashala Press, Poona. One of the press's earliest images.

man, Mr Balkrishna Wasudev Joshi, was a draughtsman in the Government Photo-Zinc Office; and the taste as well as the industry displayed by him in making his museum highly impressed Vishnu Shastri, who immediately hit upon a scheme for putting up a lithographic press for bringing out historical and other pictures of purely Indian interest.[20]

Inspired by this collection a portrait of Sawai Madhav Rao and a new, enormous image of Nana Phadnavis were prepared. Richard Cashman has suggested that the Peshwas (chief ministers) – Brahmans who effectively ruled the later Maratha empire – were 'the most visible symbols of Kshatriya Brahmans', that is those

25 *Shri Shankar*, also known as *Shivpanchayatam* (1878?) by Chitrashala Press, Poona.

magazine, *Kavyetihas Sangraha*, which featured historical narratives juxtaposed with images of those that animated this history. These images were the figural arm of the nostalgia for the days of Shivaji and the Peshwas that was also evoked through Tilak's journals and the New English School.[19] Nostalgia for this period of opposition to Islamic rule was, as Temple had suggested, simultaneously an aspiration from liberation from British colonial rule. It was while searching for suitable illustrations for this journal that Chiplunkar:

came across an amateur artist in Poona whose hobby it was to make a collection of interesting paintings, pictures, sketches and maps. The gentle-

who had infused traditional priestly values with a martial prowess.[21] The Peshwas as a category represented this ideal fusion of spirit with power, but some individual Peshwas were better exemplars than others. Madhav Rao, the subject of a very early Chitrashala print, was respected not just for his military abilities but also for his puritanical, though just, rule. Baji Rao II (not pictured by Chitrashala), on the other hand, was a womanizer, drinker and coward.[22]

Nana Phadnavis was the chief minister to the young Madhav Rao II and the *de facto* ruler of Poona and the Maratha empire for twenty years. Madhav Rao II had been installed as the Peshwa in 1774 when only one month old and from this date the *phadnis* (chief accountant)[23] acted as guardian and power broker. The death of Madhav Rao II in 1795 destabilized his role and he died in 1800. The huge Chitrashala litho (illus. 26), numbered 'No.33', is titled (in both English and Marathi):

26 *Nana Phadnavis* (1884) by Chitrashala Press, Poona. A hero figure for Chitpavan Brahmans such as Chiplunkar and Tilak.

Balaji Janardhan alias Nana Fadnavis [*sic*], Prime Minister to the Peshwa, Madhav Rava II, Copied from an English original painting drawn for Sir C.W. Malet Bart, the then British Representative in the Poona Court, and now an heirloom in the family of the said Minister. Born:– May 4th, 1741 A.D.. Died:– March 13, 1800 A.D. Printed at the 'Chitra Shala' Press, Poona. 1884.

The earlier painting from which this is 'copied' is by James Wales and dates from 1792.[24] Wales, who had previously exhibited at the Royal Academy in London, had journeyed to Bombay the year before and this study was in turn used as a model for a much larger composition made by Thomas Daniell between 1800 and 1805, after his return to England, and depicting Sir Charles Warre Malet concluding a treaty with the Marathas;[25] this subject was also drawn upon for a Chitrashala print.

Comparing the Chitrashala lithograph with the Wales portrait (illus. 27), it is clear that the Chitrashala artist has simply extracted the Nana Phadnavis portrait from the larger group and made minor changes to the costume. Archer and Lightbown suggest that the Wales portrait was presented to the Royal Asiatic Society (in whose possession it remains) in 1854.[26] The Chitrashala text, which refers to a family heirloom, and also a reference in Kelkar's biography of Chiplunkar, implies that the image remained accessible in Poona.[27]

Following the success of the *Rampanchayatam* and *Shivpanchayatam*, Chitrashala produced more than a hundred large-format coloured lithographs within a few years.[28] Reconstructing the sequence of publication from extant images, it becomes apparent that the first 40 prints were issued in the years up to 1884. Some of these images, for example that of *Durga* (the first print numbered 'No.14'), are exceptionally beautiful large lithographs, which are certainly comparable to the finest products of the Calcutta Art Studio. One of the images ('No. 23 *Balaji*') would have been of regional appeal: the rest depict a representative sample

27 James Wales, *Madhu Rao Narayan, the Mahratta Peshwa, with Nana Fadnavis and Attendants* (1792, oil on canvas). The original composition from which the Chitrashala artist extracted *Nana Phadnavis*.

28 *Narsinha*
(*c.* 1880s) by
Chitrashala Press,
Poona.

of deities popular throughout central and north India (*Radhakrishna, Dattatreya, Ganesh, Krishna, Ram, Shiv* etc.). Many of these images clearly mark the impact of single-point perspective and of European modes of landscape representation. *Gopigajham*, which depicts a small group of *gopis* (cowgirls) complaining to Yashoda about Krishna's behaviour, places the large figure of Yashoda on the right in front of a perspectival extravanganza, a cluster of buildings whose perfectly aligned and depicted structures leap at the eye as though from a textbook on perspectival technique. In other lithographs the hybridity has a bizarre touch: in one print in the distance, behind a tree in which Krishna sits playing his flute, can be seen a long multi-arched bridge at each end of which there are street lights.

Other devotional images show Krishna creating *maya* (illusion) as he dances with the *gopis*. There are two Chitrashala lithographs from 1882–3 treating this subject and both set the central figures within European landscapes. In *Murlidhar*, Krishna plays his flute for four attentive *gopis* while an oversize shepherd listens in a wood in the distance. Krishna looks decidedly displaced in this northern deciduous context. An 1882 print conveys a similar sense of exotic landscape and it is clear that the artist has incorporated life-study drawings into his final composition for the poses of the *gopis*: traces suggested in the folds of their saris are markedly naturalistic.

FIGURES OF RESISTANCE

Two further images from the early sequence described above were Chitrashala's explicit contribution to the wider process of political and historical reinterpretation that Chiplunkar's other projects, such as the New English School and the newspapers *Mahratta* and *Kesari*, were also advancing. The first of these, the print numbered '24', depicts *Khandoba* (illus. 29), a warrior god who, for those activists clustered around

29 *Khandoba* (c. 1880s) by Chitrashala Press, Poona.

Chiplunkar, embodied the Kshatriya values that had constituted the ideal Deccan. In the Chitrashala image he is depicted, as elsewhere in popular tradition, 'as a Kshatriya on horseback, brandishing a sword to thwart the demons'.[29]

Khandoba is not only violent but also highly sexualized: he has two wives and various mistresses and is accompanied by a dog, an echo of his affinity with the fierce form of Shiv, 'Kal Bhairav'. He is described as a 'god of war' and 'territorial guardian of Maharashtra'.[30] In later nineteenth-century Poona, however, these were not self-present characteristics. Rather, they sprang from a field of difference structured through his opposition to the *bhakti* (devotional) figures of Tukaram and Vitthal.

This opposition between on the one hand a Kshatriya (warrior) martial tradition and on the other a quiescent devotional introspection was advanced, as Richard Cashman has perceptively demonstrated, by different political alliances in nineteenth-century Maharashtra. The 'moderate' M. G. Ranade represented Maratha society as a product of the *bhakti* devotional tradition.[31] Shivaji's 'pietism' founds its monument in the 'Puritan enthusiasm' of Mahratta nationalism.[32] The critique of the political strategy advocated by moderates like Ranade also entailed a critique of their historiography and a countervailing emphasis on an energized Kshatriya tradition. Thus N. C. Kelkar argued that *bhakti*'s influence in Maharashtra was regressive for it discouraged political activity,[33] a position later advanced by the historian Shivaram Laxman Karandikar.[34]

This battle over the past (which everyone understood to be also simultaneously a battle over the present) is nowhere more apparent than in the struggle over Ramdas (1608–81), the saint who is the subject of a Chitrashala print from the early 1880s (illus. 30). In the Chitrashala image he is depicted standing in the river Godavari, where he frequently meditated in his early life,[35] and is endowed with a muscular build, as befits one who was known as *samartha* (powerful).

The micro-historiography of the Ramdas cult may appear perplexing and unnecessarily recondite. However, I would suggest it was through struggles over historical interpretation and the images that accompanied these revisions that new political options in the late nineteenth century were envisioned. The Ramdas cult (in which he appears as a politically militant monk) was first developed by the historian V. K. Rajwade.[36] In the Rajwade version, Ramdas emerges as Shivaji's spiritual adviser, a *brahmachari* (renunciate) who worshipped the muscular Hanuman and rejected Vithoba. The popularizer of the phrase *Maharashtra Dharma* ('interpreted as the call to return to the ancient theocratic state'),[37] Ramdas also founded numerous monasteries in which the

30 *Ramdas* (c. 1880s) by Chitrashala Press, Poona.

value of a muscular physique was inculcated into a new generation of monks. According to N. K. Behere, a historian of the Rajwade school, 'Young men were encouraged to develop their muscles and learn stick, spear and sword practices both as offensive and defensive measures'.[38] The implied moral here was obvious: young Maharashtrians should learn from this past and act accordingly. Comparing Aurangzeb to Ravan, the king of Lanka (whom Ram had defeated with Hanuman's military support), Ramdas argued (or so Rajwade claimed) that an ideal religion could only prevail in Maharashtra in the absence of Islam. Ramdas wrote his own *Ramayan* structured around the *Yuddha Kand* (war chapter), which 'glorifies the war waged by Ram against Ravan for a righteous and just

cause'.[39] Again the implicit call to action here would have been obvious to Rajwade's and Behere's readers.

Ram and Hanuman were promoted by Ramdas (in the Rajwade version) as embodiments of a muscular and assertive Maharastra *dharma* and the existing *bhakti 'bhagwat-dharma'* was denigrated as politically ineffectual. Vithoba's qualities 'do not goad a nation to activity . . . they foster the brotherhood of man but they cannot liberate the people from bondage. They cannot destroy the foreign yoke'.[40] More recent scholarship has advanced a very different view, suggesting that Ramdas was far from political, was not Shivaji's preceptor, and founded very few monasteries.[41] We will encounter this struggle between martial action and devotional quiescence later in relation to *Kichaka Vadh*, a play by a close associate of Tilak, which was proscribed in 1910 (see chapter 4). The dichotomy in the play is precisely that also dramatized in Rajwade's historiography: is it better to pursue politics and freedom in a peaceful and conciliatory manner, or is it better to find liberation through violence? It was this very dichotomy that divided the so-called moderates and extremists, Gokhale and Ranade arguing for gradual change from within, Tilak and his followers arguing for the necessity of a violent overthrow of colonial oppression. It was this fundamental disagreement that would famously split the Indian National Congress at its Surat meeting in 1907.

Ramdas's supposed promotion of Ram and Hanuman's militant agency was mirrored by an appeal to rediscover the goddess Bhavani: 'Let Hindus worship the great goddess Kalika Bha[v]ani who is strength personified, in fact deified. She blessed Rama, and gave him strength to kill the demons. She herself killed several demons in the past.'[42] Shivaji responded to this appeal and his devotion to Bhavani would become a recurrent theme in later imagery. These prints always depict Shivaji kneeling in front of the goddess and receiving a sword (illus. 31). S. S. Karandikar records that in 1658 Shivaji purchased a 'double-edged sword of European workmanship',

which he then named 'Bhavani' suggesting, Karandikar continues, that 'Shivaji, though confident that his mission of liberating the land had been blessed by higher, unseen powers, realized that the fulfilment of that mission depended on strength in its manifold forms.'[43]

Shivaji's followers, however, understood the sword to have been the gift of Bhavani to this modern incarnation of Shiv.[44] Bhavani's sword was metonymic of a wider divine engagement with his actions. Thus, when the Muslim Afzal Khan attempted to destroy the Jejuri temple, Bhavani let loose a swarm of bees in its defence,[45] and she persuaded him in 1665 to reach a peaceful compromise with Raja Jayasingh: 'Bhavani

31 Shivaji receiving Bhavani's sword (*c.* 1950), a post-Independence representation of Shivaji's divinely approved actions.

counselled him . . . Jayasingh was also a favourite with the gods and success against him could not be secured by winning the war.'[46]

Tilak's reappropriation of Shivaji in the 1880s also entailed the parallel appropriation of Bhawani's sword as a symbol of the proximity of divine intentionality and human politics. When *Kesari* reported on the Shivaji anniversary it also printed a poem by the pseudonym *Bhavani Tarvar* (Bhavani – i.e. Shivaji's – sword) 'in which the writer had upheld hero-worship and reminded the readers of contemporary political injustice'.[47]

Such images were explicitly political, but the Chitrashala nexus also engineered new loose forms of symbolic association that permitted the transmission of a subversive political charge within the 'everyday'. One Chitrashala print depicts a woman (indicated to be Ram's mother in some versions) uncaging a parrot (illus. 32). Such an image may well have evoked episodes from epic narratives, but they also functioned within interpretative contexts that were bounded by statements such as the following (by Chiplunkar):

32 Ram (?) and his mother with a parrot (*c.* 1880s) by Chitrashala Press, Poona.

> There is a great difference between the bird who roams at will through sky and forest and the parrot who is put into a large cage of gold or even jewels! It is a great disaster when a bird whose God given power is to move wherever he pleases unrestrained on the strength of his beautiful wings must remain always chirping in a confined place! The same applies to a nation.[48]

Wolpert, who cites the above, describes it as the 'literary counterpart of Phadke's revolt', but Chiplunkar's literary revolt used the relative closure of words to rouse images from their semantic vacuity. The visual metaphor of being 'caged' was sent out to do its covert political work. Correspondingly, images of uncaged parrots (printed by Chitrashala Press as postcards, illus. 33) could be sent freely through the public mails as a sign whose intent was quite clear to sender and receiver. Slipping through the gaze of the anxious

colonial state, decorative images of caged, and uncaged, parrots were given a wake up call by Chiplunkar's journalism: he supplied the remaining half of an allegory whose pictorial infrastructure was easily disseminated.

This slippery ability to 'pass' would become of increasing importance in the early twentieth century as the anti-colonial struggle grew and as the colonial state increased its methods of control. The 1910 Press Act, in particular, would dramatically intensify state surveillance of visual and written texts and would precipitate the emergence of a whole range of mobile anti-colonial signifiers.

It is worth, in conclusion, considering why the Chitrashala Press, whose importance I have been at

33 The parrot released (*c.* 1920), a postcard printed by Chitrashala Press, Poona.

have transcended the aesthetic weakness of earlier picture publishers. However, scrutiny of these earlier presses suggests that this assertion should perhaps be reinterpreted as a claim to have superseded the explicit politicality of previous entrées into the visual imaginary of an increasingly restless, colonized, India.

An important aspect of the Ravi Varma myth concerns the revolution in popular taste that followed the founding of his Ravi Varma Press in the early 1890s.[49] Indeed it is sometimes claimed by his supporters that, although his mass-produced chromolithographs were a bastardized form of his art (and thus damaging to his reputation), these images had the great virtue of having displaced an earlier and baser class of prints – the so-called 'Poona prints'.

It is difficult to ascertain the evidence upon which the oft asserted claim concerning Ravi Varma's triumph is made. Careful study of the sources suggests that an early misconception has been simply repeated, unquestioned, by several writers over many decades. There is no doubt that Ravi Varma himself saw part of his mission to be the improvement of popular taste through the provision of superior alternatives to what he described as the 'atrocious' popular prints of the day.[50] This subjective judgement, by surely the most vested of interests, then appears in later texts attached to the locality of Poona, which, as a result of the Chitrashala Steam Press, was the centre of chromolithograph production in Western India.

Krishna Chaitanya, for instance, in a monograph first published by the Lalit Kala Akademi in 1960, spoke up in defence of Ravi Varma's chromolithographs: 'nobody today seems to have the patience to recall the atrocious representations of scenes of hell and similar themes that once formed the staple of popular art, and to remember . . . that Ravi Varma fixed at least a minimal limit of aesthetic and technical adequacy for this type of production'.[51] Echoes of this reoccur in Venniyoor's 1981 study[52]: 'at least he was able to wean the innocent public away from the so-called "Poona pictures"'.[53]

pains to stress here, has been relegated to complete obscurity by existing histories of the rise of print capitalism in India. Its political impact should have guaranteed it a more significant place than those occupied by the Calcutta Art Studio and the Ravi Varma Press. I would suggest, however, that it has been precisely this politicality and antagonism to colonial rule that led to the Press's marginalization in colonial narratives and those analyses that have reproduced many of their myths. Part of the artist Ravi Varma's appeal to his colonial patrons (as we shall see in the following chapter) lay in his claim to

So what were 'Poona pictures'? In 1894 there was evidence that Poona was one source for the distribution of German chromolithographs of nude female figures. Raja Raja Varma, Ravi Varma's brother, records in his diary *A Tour in Upper India* visiting the Bombay High Court to listen to an appeal from the City Magistrate of Poona concerning the prosecution of vendors of 'obscene pictures . . . representing nude figures of females'. The judges (Justices Jardine and Ranade) were

> of [the] opinion that naked pictures of classical subjects were not obscene, in that the artists had higher ideals than those of merely exciting the sensual appetites of the spectators. The pictures in question might have been classed among them, had it not been for the introduction into them of modern silk umbrellas and apparel which divested them of their idealism.[54]

In this disavowal of cultural 'pollution' within a particular image there is a fascinating judicial echo of the common journalistic stigmatization of the wider class of chromolithographs evident in G. W. Steevens's complaint, while viewing the 'cheap, gaudy pictures' in Jodhpur, that 'there seems to be no East without its smudge of West'.[55]

The vast majority of images originating from Poona traceable in archives are, however, far from 'atrocious'. Clearly Ravi Varma was possessed of a powerful sense of his own aesthetic mission and superiority. He was perhaps the most ardent Indian advocate of the process of conversion, of 'Romanization' to a different form of aesthetic coding, that lay within colonial truth and power. Since these codes were arbitrary, product differentiation was necessary and invective was frequently part of this process. However, accounts that privilege only this in considering his hostility to 'Poona prints' run the risk of mistaking what may also have been a largely political disparagement for a commercial antagonism.

Although in Ravi Varma there is an ideal fit between his project and colonial prescriptions for a new

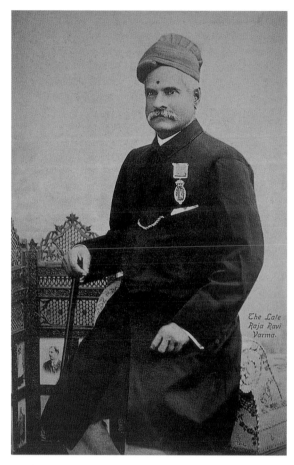

34 *The Late Raja Ravi Varma* (c. 1910), a postcard published by P. S. Joshi, Kalbadevi, Bombay. The circulation of such images demonstrates Ravi Varma's celebrity status.

improved Indian art, his politics were greatly more complex than those of either simple affirmation or rejection of the colonial state and its culture. As we shall see in more detail in the next chapter, he pursued an exemplary career of 'sly civility', balancing diverse expectations and constraints. Ravi Varma's political disparagement, therefore, may have been the result of an unease at the radical brio of the Chitpavan Brahman opposition to colonial rule that cohered around Tilak, Chiplunkar and the Chitrashala Steam Press in Poona from the late 1870s onwards.

4 Lithographs and the camera in Bombay and Delhi, 1890-1925

Between the late 1870s and the early 1890s, Calcutta and Poona were the main centres of printed image production in India. By the earliest years of the twentieth century, however, the centre of gravity had decisively changed to an axis that ran between Bombay and a small town called Lonavala, on the Bombay to Poona railway line. Central to this change in the commercial picture industry was the artist Ravi Varma (1848–1906) and the press he founded, which would continue to have a significant presence long after he had severed his connection with it. Ravi Varma was born near Trivandrum in the southern state of Kerala into a family connected by marriage to the Raja of Tanjore. From the mid-1870s onwards his dramatic paintings of scenes from the religious epics and romantic depictions of women won him medals at exhibitions in Madras, London, Chicago and elsewhere.[1] He appealed, simultaneously, to two very different audiences: early cultural nationalists who saw in his work an inspiring new national imaginary, and imperial patrons who admired his accomplished mastery of the technical conventions of European portraiture.[2]

Ravi Varma's lasting fame rests on the output of the Ravi Varma Fine Art Lithographic Press, founded in 1894,[3] which set new standards in the size, printed quality and tactility of chromolithographs. The Press was initially established in Girgaum, Bombay. When Ravi Varma sold his stake in the business in 1901 (although not severing his relationship with it until 1903) it moved out of Bombay to Lonavala, from where the press continued to issue prints by other artists with his signature, helping to sustain an endless debate about the comparative aesthetic worth of original paintings and mechanically produced prints. To an extent that I hope to show is unwarranted, Ravi Varma has become in the popular imagination the founding father of 'calendar art', the popular mass-produced art of India. In this chapter I try to place him alongside other contemporary significant practitioners and to provide an insight into the historical and cultural context that they would in turn transform.

The events described in this chapter unfold against a dramatic intensification of nationalist consciousness within India. Famines continued: it is estimated that between 1896 and 1900 alone more than nine million Indians perished. The partition of Bengal in 1905, which the new Viceroy, Lord Curzon, intended to split and weaken political opposition to British rule, had the opposite effect. The swadeshi movement gathered strength: English goods were boycotted and Manchester cloth burnt in public bonfires. The 1905 annual meeting of Congress at Benares passed a resolution supporting the boycott movement, a significant radicalization of Indian politics. Meeting in Surat in 1907, gradualists and radicals (by now labelled 'Moderates' and 'Extremists') openly split and the latter were effectively exiled from Congress for many years. Sporadic terrorist activity after 1907 was met with increased state repression and surveillance of the press. Tilak was arrested in 1908 and jailed for six years, most of which was spent in unbroken solitary confinement. Other 'Extremist' leaders were forced into exile and for much of the next ten years the 'Moderates' attempted to co-operate with the Government. The visions of India that Ravi Varma and others conjured throughout this tumultuous period became increasingly political and contested.[4]

RAVI VARMA AS MYTH

In May 1993 a huge retrospective of Ravi Varma's work was held at the National Museum in New Delhi. The star of the opening, according to press reports, was Sonia Gandhi: 'all eyes turned to her as she walked in, a well-turned out figure in her stunning off-white silk salwar-kameez'.[5] Inaugurating the exhibition, Prime Minister Narasimha Rao recalled that the first paintings he had ever seen were by Ravi Varma and claimed that both originals and chromolithographs of these paintings could be seen all over the country: 'It is ironical that you have . . . paintings of huts in palaces and paintings of palaces in huts'.[6] In Ravi Varma's

work, he continued, there was 'a unique fusion of Western techniques and Indian traditions'[7] and a reflection of the 'nationalism that was all pervasive during the freedom struggle'. After this the Director of the Gallery announced that the Secretary for Culture had authorized a special discount on the commemorative publication that would hold good for precisely one hour. One hardened journalist reported that 'the titters among the audience threatened to escalate into guffaws'.[8] Doordarshan's television news concluded its report of the event with the claim that 'Ravi Varma was the greatest artist of our time'.

Three weeks later a very different view was expressed in a letter to *The Pioneer* from the artists Bal Chabda, M. F. Husain, Akbar Padamsee, Tyeb Mehta and Laxma Goud. They condemned the attempt to foist 'the philistinism of the bourgeois' upon 'a complex and pluralistic movement' and disputed in particular the oft made claim that Ravi Varma was the 'first modern artist' in India. Such claims were the work of 'crypto-art historians' intent on promulgating an evolutionary view of art that privileged the mastery of perspective and oils and constituted 'an act of cultural cloning highly damaging to the creative spirit of man'.[9]

In all this Ravi Varma emerges as a highly charged trope, a space in which conflicting histories and aspirations are invested. The grounding of different narratives around Ravi Varma recalls Kris and Kurz's observation concerning the 'riddle of the artist', why it is that 'certain periods and cultures have been prepared to accord a special, if ambiguous, place to the creator of a work of art'.[10] This chapter is concerned in the first place with the 'special' and 'ambiguous' place that the sign of Ravi Varma has come to occupy in writings on colonial and popular culture in India. What 'riddle' does Ravi Varma embody, and what does this special and ambiguous place conceal in the wider field of popular visual culture?[11]

Ravi Varma as a sign is split into the father of modernism and the perpetrator of a devalued mass artefact. He is thus doubly disabled; we get no sense of the ways in which he was not a single individual but a fragment of a larger narrative, and in disparaging the popular we are left with a homogenized 'calendar art' that leaves no room for an understanding of the diversity of different popular imaginaries. These are simultaneously parallel and antagonistic narratives that buttress and threaten to unhinge each other. In the Ravi Varma myth, his popular appeal always lurks ready to derail him from the path of aesthetic transcendence. A 1911 account of the artist is typical: 'his pictures attained an almost unique popularity but the oleographs were executed by imperfect mechanism and soulless mechanics. The colours were laid with the worst possible taste . . .'.[12]

Disassembling the narrative of Ravi Varma as the sole founder of modern Indian art will allow us at the same time to open a space in which to appraise the diversity of equally complex 'popular' practices.

Implicit in the 'official' version of Ravi Varma is his role as the inaugurator of an inevitable process of mimetic ascendancy. It is he who first uses oil, first masters perspective, comes to 'Romanize the Indian pencil': in short it is Ravi Varma that transformed the Indian imaginary from the realm of fantasy to a historicized realist chronotope. The official version repeatedly lauds him for this: he 'gave' India its Gods in a real form, so real that they have been endlessly replicated over the past century in the clothes and jewels that Ravi Varma first bestowed. His technique emerges as a crucial mediator between two world views, between 'myth' and 'history', between the 'archaic' and the 'modern'. It is Ravi Varma who enabled the relocation of signification from a 'medieval' semioticity[13] present in all mimesis into the strategies of representation itself.

Crucial to Ravi Varma's canonization as the father of modern Indian art was the propagation by his admirers of myths concerning his struggle to acquire the art of painting. This legend was, however, to serve a dual purpose: the validation of Ravi Varma's greatness, and also the establishment of his nationalist, 'Indian' credentials, for as Geeta Kapur has observed,

'Here is not only the struggle of the artist to gain a technique but the struggle of a native to gain the source of the master's superior knowledge, and the struggle of the prodigy to steal the fire for his own people.'[14] An early part of the legend recounted by his Malayali biographers retells how he 'filled the walls of his home with pictures of animals and vignettes from everyday life, how he persisted in picture-making in spite of threats from the much-harassed domestics, and how, in these scrawls and doodles, his uncle, the artist Raja Raja Varma[15] discovered the signs of a genius in the making'.[16] In the early 1860s the young Ravi Varma moved to the court of Maharaja Ayilyam Tirunaal at Trivandrum, where he had the opportunity to meet court painters and experiment in oil.[17] John Berger has suggested that in sixteenth-century Europe oil paintings were like 'safes let into the wall', so exactly did the medium of oil come to embody commodity relations. In late nineteenth-century India we might say that the medium of oil paint stands for a materiality and substance equivalent to history itself, a chronotopic tangibility that previous representational strategies had never fully achieved: 'oils are able to simulate reality by giving a sense of the weight and volume of substancs. Bodies, flesh, jewellery, costume, furniture and architecture acquire a striking materiality, a verisimilitude.'[18]

It was in Trivandrum that Ravi Varma was also able to peruse albums of European paintings, and where he came to see Edward Moor's *Hindu Pantheon*,[19] which had been published in 1810 and retrospectively can be seen as an early charter for some of the representational transformations that Ravi Varma would very soon effect.

THE EARLIEST RAVI VARMA REPRODUCTIONS

Although suggestions had been made to Ravi Varma as early as 1884 that he should have his paintings 'oleographed',[20] it was not until 1890 that mass-produced images of his work became available in the form of photographic prints. In 1888 Ravi Varma had been invited to Ootacamund to meet the Gaekwad of Baroda, who was holidaying in this southern hill station. Here the Gaekwad commissioned the artist (at a cost of Rs 50,000)[21] to produce fourteen large 'puranic' paintings depicting events from the Ramayana and Mahabharata for his new Laxmi Vilas Palace. The palace was to take a decade to construct at a cost of £180,000 and Ravi Varma's paintings were destined for the Durbar Hall, which was later described in a 1916 guide in these terms:

The palace has a large Durbar Hall, ninety-three feet long and fifty-four feet broad, with mosaic decorations on the walls and a mosaic floor specially executed by Italian workmen, and carved wooden galleries reserved for ladies. It is well-furnished and contains bronze and marble statues of the principal members of the Gaekwad family and the past Dewans, and costly paintings of the Royal family and Hindu mythological subjects by European and Indian artists.[22]

Gulam Mohammed Sheikh has argued that in Baroda State, Ravi Varma found a blend of modernity and the 'traditional values of a model kingdom analogical to the site posited in his paintings'.[23]

Ravi Varma's paintings were completed in 1890 and were publicly exhibited before they reached the confines of this symbol of royal excess. First they were shown at Trivandrum[24] and, following Ravi Varma's departure for Baroda in November 1891, they were shown in Bombay. Venniyoor quotes ('the first biography'):

They were publicly exposed for some days and immense crowds of people assembled from all parts of the Bombay Presidency to see the paintings. They produced quite a sensation for a period, for it was the first time that subjects from the great Indian epics had been depicted on canvas so truthfully and touchingly. Hundreds

35 Ravi Varma, *Vishvamitra Menaka* (c. 1901), a Ravi Varma Press chromolithograph.

36 Ravi Varma, *Vishvamitra and Menaka*, plate reproduced from S. N. Joshi's *Half-Tone Reprints* (1911).

and thousands of their photographs were sold all over India.[25]

According to Joshi (1911) there was also a public display in Baroda before they were installed in the Laxmi Vilas Palace. Here again, 'thousands of reprints of these pictures have been sold all over India'.[26]

The only remaining trace of these photographic images – which predated the earliest products of the Ravi Varma Press by four years – is in the volume already cited above, S. N. Joshi's 1911 booklet *Half-Tone Reprints of the Renowned Pictures of the Late Raja Ravivarma*, published by the Chitrashala Steam Press, Poona, whose activities have been discussed in the preceding chapter. While the majority of plates have been prepared from Ravi Varma chromolithographs,

several of the plates are clearly based on original paintings, rather than any subsequent chromolithographic traduction. All these direct images are from the Baroda series, suggesting that these plates have been prepared from the early photographic prints whose popularity was noted in early accounts.

Vishvamitra Menaka, one of the Baroda series, was also later issued as print number 128 by the Ravi Varma Press (illus. 35). The image in Joshi's pamphlet (illus. 36), however, is clearly taken from the original oil in the Laxmi Vilas Palace. The Joshi reproduction includes the wooden crook (at bottom left) present in the original oil but absent in the chromolithograph. Several features of foliage and the line of the cliff also further indicate that Joshi's image is taken from a photograph of the original.

As a cultural phenomenon Ravi Varma is hugely important and several major issues coalesce around him that are absolutely central to the purpose of this book. However, Ravi Varma also presents something of an indissoluble bibliographic problem and the difficulty in resolving several issues limits the certainty with which some specific propositions about his printed output can be advanced.

For instance, one of the major (and certainly most often cited) sources,[27] claims that the first image published by the Ravi Varma Press was *The Birth of Sakuntala*, although the chromolithograph of this bears the serial number '13'.[28] The more plausible contender for the first image produced by the Press is an image of Lakshmi (illus. 37), which is consistently numbered 001. Regardless of these questions of priority there can be no doubt that images of goddesses and of other female icons were enormously successful and 'found their way into the *puja* rooms of Hindu households immediately'.[29]

It is likely that Ravi Varma himself directly authored just under 90 of the images that bear the Ravi Varma Press imprimatur. Images produced by the Press, however, sometimes bear much higher serial numbers,[30] suggesting that there were many hundreds of images. The 89 images whose copyright Ravi Varma sold to Fritz Schleicher would thus have formed only a small proportion of the total ultimately issued by the Press.

In other words, *most* images bearing the Ravi Varma Press imprimatur are not in fact the work of Ravi Varma. There is evidence that other artists were employed to paint under the Ravi Varma imprint. Venniyoor records that he was assisted by V. M. Dhurandhar and by M. A. Joshi from Baroda, in addition to his own brother Raja Raja Varma, and also gave commissions to an impecunious western-trained artist named Naoroji.[31] It is also clear from even a cursory examination of Ravi Varma Press lithographs that there is a wide stylistic variation between many of the

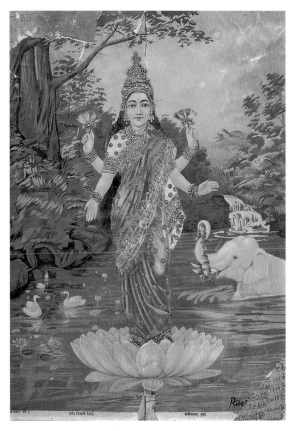

37 Ravi Varma, *Standing Lakshmi* (c. 1894), a Ravi Varma Press chromolithograph decorated with *zari*, and pasted onto board.

mass-produced prints and those oil paintings whose authorship is not disputed.[32]

The Ravi Varma Press *Kali* (illus. 39) – printed at various times as no. 68 and as no. 315 – is a good example of a later image (post 1915) that clearly has no direct connection with Ravi Varma the artist and is, in many ways, utterly opposed not only at a stylistic level, but also at what one might describe as the moral and political level. The image bears all the standard iconographic traits of this popular Bengali goddess and differs from earlier Calcutta Art Studio lithographs perhaps only in its directness and primacy of colour. It is difficult in a print like this to see what might have been the basis for the populace of Bombay's aesthetic discriminations in favour of

38 Ravi Varma, *Sita Banvas* or *Exile of Sita* (*c*. mid-1890s), a Ravi Varma Press chromolithograph.

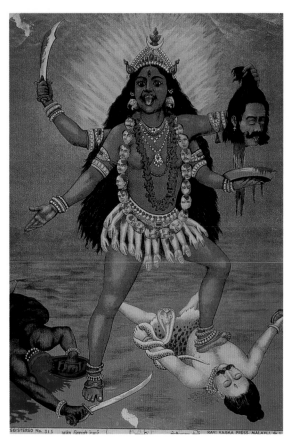

39 Kali (c. 1915) by Ravi Varma Press, Karla-Lonavala.

Ravi Varma Press products as against those of earlier studios. The Calcutta Art Studio image (illus. 90, which dates in its earliest form from 1879) makes full use of the possibilities of lithography, achieving dramatic chiaroscuro effects. The Ravi Press image by contrast features a crudely coloured central figure against a plain background and replaces the theatrical apocalyptic quality of the Calcutta image with a simplistic gore. The Ravi Varma image also came under attack in a missionary tract, *Glimpses of a Land of Sun and Sadness*, published by the Bible Churchmen's Missionary Society in the early twentieth century. The author, Beatrice M. W. Grautoff, reproduced the lithograph and commented: '"What an awful picture!" we exclaim as we look at the ferocious figure of Kali'.[33]

MAKING THE GODS MORE REAL

In chapter 1 we explored the impetus behind the establishment of government art schools in India. It had been hoped that new techniques of representation could be instilled that would facilitate a broader dismantling of the Hindu world view. Perspective would necessarily make the gods less real, it was believed, for the mythic realm they inhabited would be unable to bear the scrutiny of linear perspective and its mathematical certainty. Linear perspective was not only the technical mainstay of the representational scheme that underwrote that certainty, but was also the central totem in the repertoire of colonial signification.

However, these new representational systems disseminated by the art schools were used by Indian artists to make the gods *more* real, not less real. Techniques taught in art schools proved not to be like surgeons' knives, excising myth and abnormality, but appeared instead as something like magical wands that could be used to endow gods with a tangibility and presence that made them more immediate. Perspective and the conventions of realism did not render the gods absurd or archaic: they made them more present. As Anuradha Kapur observes, within realism, 'representationally, the past and the present almost look the same': the time of the Gods appears to be 'our' historical contemporary time.[34]

One of the effects of changes in representational codes in the late nineteenth century, as images worked within realist conventions, was a transformation in the relationship between an Indian tradition and what was authorized as believable. Realism – in its pictorial, performative and literary guises – provided a translational bridgehead from the 'mythic' to the 'historical', allowing previously disavowed individuals and narratives to inhabit the chronotope of truth. A set of closely connected new media (oil painting, theatre, chromolithography and film) became a Trojan horse at the gates of colonial truth. The truths that Indians were starting to create within these allied media could no longer be disregarded.

66 PHOTOS OF THE GODS

One detailed example of how Ravi Varma visually collapsed mythic time into the present charts a trajectory that takes us beyond his own lifetime and permits us to explore some of the unities that audiences and readers brought to bear upon his images. It also gives us an insight into the political space that connected the work of figures such as Ravi Varma (who, as I have argued, was at least as much 'imperialist' as he was 'nationalist') and 'extremist' followers of Tilak. In addition it illuminates the regional dimension of these patterns.

Later in this book, we shall see examples of explicit allegory that serve as popular visual texts for Nehruvian modernization. In these images produced at the apex of independent nationhood we will find all the terms of the allegory explicitly present. The artists responsible for these later images are ex-sign painters and I suggest that their experiences in communicating messages through advertisements significantly affected their subsequent work. But there is also, clearly, a political factor of huge importance: within Independent India the multiple terms of the allegory could be stated openly; frequently in late nineteenth- and early twentieth-century colonial India, in order to evade surveillance, only one of the terms was made visible. We might also surmise that in Ravi Varma's case this political constraint was also paralleled by his own perception of opposed nationalist and colonial markets for his work. Many of his images are masterpieces of liminality that, even more so than most images, stand on the borders of different communities of interpretation.

In the late 1870s Ravi Varma was commissioned by Maharaja Visakham Tirunaal to paint *Sita Bhoopravesam* (Sita's Ordeal; illus. 40), a work which was to be of great significance 'on his road to national recognition'.[35] Following an incident during a visit by the Duke of Buckingham, the Governor of Madras, Ravi Varma severed his relations with Visakham and after some time sold the painting to Sir T. Madhav Rao, who sought an example of Ravi Varma's work for the young Gaekwad of Baroda.

40 Ravi Varma, *Sita Bhoopravesam*, plate reproduced from S. N. Joshi, *Half-Tone Reprints* (1911).

Venniyoor records that *Sita Bhoopravesam* caused 'a sensation' in Baroda. The painting depicts the final ordeal of Sita upon her return to Ayodhya. After enduring years of captivity by Ravan, her chastity is openly questioned by Kaikeyi, who had been instrumental in ensuring the banishment of Ram. Unable to endure this final insult, Sita appeals to Bhoomi Devi, the earth mother. A chasm opens at her feet and Bhoomi Devi takes her down into this as Ram looks on in astonishment.

This is an image capable of various readings and we may suppose that its popularity was also due to the resonances it struck with those who saw it in the 1880s. Something of the connotative dazzle thrown off by the image is suggested by Venniyoor's perceptive comment: 'The look on Sita's face is an enigma: it may be anger or love, grief or pride, perhaps a shade of every emotion she had known in her life.'[36]

In the context of the feminization of a subject India in the late nineteenth century, it is plausible that Sita may have been read as a figure of the nation and its people, whose honour was also threatened by colonial interrogators. We may also see some of Ravi Varma's personal predicaments as a producer of nationalist allegories under the patronage of the British and their Indian collaborators inscribed in this image. He pursued an exemplary career of 'sly civility',[37] balancing the needs of European patrons

and local elites against his own religious and political commitments. Ranjani Rajagopal provides the following, illuminating, observation: 'When he travelled with Europeans in trains he observed their habits never coming in their way, allowing people to follow their own ways of life. He did not believe in appropriating the English way of life or speaking English since he knew that these were foreign elements that would have to return home some day.'[38]

By the time the play *Kichaka Vadh* (The Killing of Kichak) came to the attention of the Bombay Government in 1907, it had already marked out Marathi theatre as a realm deserving thorough examination. In the same year, A. C. Logan (Commissioner, Central Division, Bombay Government) had recorded that 'the performance of such plays is calculated to excite the lowest classes, who would not be reached by newspapers or meetings'.[39] *Kichaka Vadh* was performed throughout Bombay and the Deccan 'to houses packed with large native audiences'[40] until it was banned in January 1910.[41] The play focused on an episode from the *Mahabharata* that had also formed the subject matter of a series of Ravi Varma paintings, which had been circulated widely through reproductions as chromolithographs and postcards. This episode concerned the consequences of the exile of Draupadi and the Pandavas from Hastinapura for thirteen years. The first twelve of these were spent in a forest, and the final year in disguise in the city of Viratnagar. A condition of the original agreement stated that if they were discovered during this period of disguise they would be required to spend another twelve years in the forest. During this period Kichaka, the brother of Queen Sudeshna (in whose employ Draupadi then was), returned to Viratnagar and was attracted to a beautiful *sairandhri* (tire-woman) who, unbeknown to him, was Draupadi in disguise. Kichaka requested her to be sent to his harem and Yudhistira (the eldest of the five Pandavas) then faced the dilemma of revealing his identity or Draupadi's degradation. The dilemma was resolved by Bhima's decision to kill Kichaka secretly.

In addition to images of *The Stripping of Draupadi*,

Sudeshna and Draupadi and *Draupadi at the Court of Virata*,[42] Ravi Varma also painted four images listed by S. N. Joshi as 'Sairandhri no.s 1–4'. The first two of these are very similar and depict the anxious Draupadi before her encounter with Kichaka. No. 1 'represents Draupadi's grief and anguish when she is on the point of departing for Kichaka's house, in obedience to her mistress' orders'[43] and no. 2 shows her 'on her way to Kichaka's house . . . praying to the *Sun* to protect her from danger and to preserve her chastity'.[44] The other two images depict her arrival; she is shown in no. 3 with a look 'of fear and haughty disdain and contempt, mingled together at the sight of the beastly Kichaka'[45] and in no. 4, depicted in a seedy chiaroscuro, we see her 'standing by herself in helpless terror and Kichaka . . . trying all the arts of persuasion to seduce her'. This later image was certainly sold as both a chromolithograph and a postcard.[46] The chromolithograph version (illus. 42) is titled *Keechak Sairandhri* and differs slightly from the painting: the doorway is shrouded in darkness and the plate on the floor holds two bunches of grapes. The image reproduced here (as illus. 41) is a postcard (dating from c. 1910) which photographically reproduces the painting. Printed by P.S. Joshi of Bombay, it is captioned on the reverse: 'Kichaka in order to satisfy his lustful desire is encroaching upon Sairandhri's modesty'.

This door to a darkened space gives visual form to what we may suppose was in popular interpretation seen as a metaphorical opening onto the historical experience of colonial India. That this may have been the case is certainly suggested by the interpretative gloss placed upon this episode in the play to which we referred earlier. *Kichaka Vadh* was the work of Krishnaji Prabhakar (alias Kakasaheb) Khadilkar, who had taken over the chief editorship of *Kesari* following Tilak's conviction in 1908 (see below). His first play had been produced as early as 1896, and shortly before *Kichaka Vadh*, which opened in 1907, he had written *Sawai Madhavravacha Mrityu*, which dramatized the suicide of Madhavrao peshwa. Vasant Shantaram Desai highlights Khadilkar's political intentionality, noting

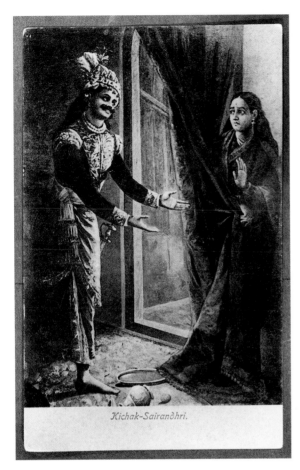

Kichak-Sairandhri.

41 Ravi Varma, *Kichak-Sairandhri* (c. 1910), a postcard published by P. S. Joshi, Bombay.

that 'he had a message to give to the people of Maharashtra who were then, like the rest of India, downtrodden by foreign rule'.[47]

The play opens with Kichaka's return to Viratnagar and focuses on the distinction between the indecisive ditherings of both King Virata and Yudhistira and the forceful decisiveness of Bhima, who, so *The Times* noted in 1910, 'wishes to strangle Kichaka regardless of the consequences':

At last Bhima and Draupadi together extract from [Yudhistira] a most reluctant permission. Bhima goes secretly to the Bairoba temple, and removing from its stand the god's idol, he takes its place. So hidden, he is present when Draupadi, abandoned by the King's guards,[48] is seized upon by Kichaka. In vain Draupadi appeals to the latter for mercy. He laughs alike at tears and menaces, and is about to carry her off in triumph when the god Bairoba is seen to rise from his pedestal. It is Bhima. He seizes the terrified Kichaka, hurls him to the floor and strangles him at Draupadi's feet.[49]

The report in *The Times* from which Chirol quotes then records that 'these things are all allegory':

Although his name is nowhere uttered on the stage or mentioned in the printed play, everyone in the theatre knows that Kichaka is really intended to be Lord Curzon, that Draupadi is India, and Yudhistira is the Moderate and Bhima the Extremist Party. Every now and again unmistakable clues are provided. The question indeed admits of no doubt, for since the play first appeared in 1907 the whole Deccan has been blazoning forth the identity of the characters. Once they have been recognized the inner meaning of the play becomes clear. A weak Government at home, represented by King Virata, has given the Viceroy a free hand. He has made use of it to insult and humiliate India. Of her two champions, the Moderates advocate gentle – that is, constitutional – measures. The Extremists, out of deference to the older party, agree, although satisfied of the ineffectiveness of this course. Waiting until this has been demonstrated, they adopt violent methods and everything becomes easy. The oppressor is disposed of without difficulty. His followers, namely the Anglo-Indians – are, as it is prophesied in the play and as narrated in the Mahabharata, massacred with equal ease.[50]

The *Times* correspondent sought also to convince his readers that this discovery of the allegorical dimensions of the performance was no mere figment

of his own imagination. Rather, his own brief ethnography of the audience suggested that they too shared this reading:

> It may be said that all this is mere fooling. But no Englishman who has seen the play acted would agree. All his life he will remember the tense, scowling faces of the men as they watch Kichaka's outrageous acts, the glistening eyes of the Brahmin ladies as they listen to Draupadi's entreaties, their scorn of Yudhistira's tameness, their admiration of Bhima's passionate protests, and the deep hum of satisfaction which approves the slaughter of the tyrant.[51]

It has been suggested that a later play of Khadilkar's displayed a similar allegorical quality: in *Bhaubandaki*, which was produced during Tilak's incarceration in Mandalay, Ramshastri, the judge in the Peshwa court was played 'in such a powerful manner that the audience thought that it was Tilak that had been portrayed'.[52]

Situating Ravi Varma's image at the nexus of theatre and politics allows us to see in great detail the new hybridized space that opens up as the 'powers of European art' operate in a wider cultural field. Rather than in the intentionality of Ravi Varma, it is in the wider nexus of representational practices and the audience's sly consumption that the 'ruse of recognition' can be seen to operate. Indian images were beginning to succeed in animating the national voice, but not in the manner originally anticipated by Napier. The gods were not simply mannequins to be remodelled within a new representational scheme; the realignment of deities along a new realist tangent created a new hybrid space of magical realist mytho-politics. This hybridity is as Homi Bhabha has suggested, a 'separate' space, 'a space of *separation* . . . which has been systematically denied by both colonialists and nationalists who have sought authority in the authenticity of "origins"'.[53]

As well as their after-life in a wider performative mytho-political realm, mass-produced images, such as those by Ravi Varma, were also appropriated at a personal and domestic level. The most dramatic sign of this is the 'dressing' of the figures in the chromolithograph. This supplementary adornment encompassed the application of sequins, glitter, and in some cases, cloth embellished with brocade (*zari*). In an example of this transformation applied to Ravi Varma's chromolithograph *Keechak Sairandhri* (illus. 42) both the central figures have been dressed: Kichaka wears red velvet and Sairandhri is adorned in a magenta sari. Both their costumes are edged with a metallic *zari* and adorned with sequins and small baubles.

Conventionally this might be termed 'anti-realist' since the application of all these materials to the

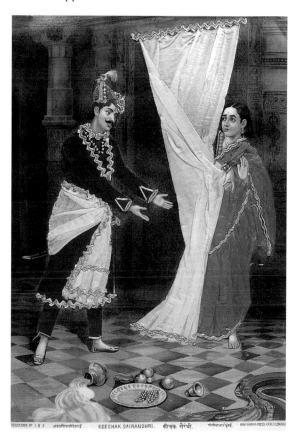

42 Ravi Varma, *Keechak-Sairandhri, c.* 1900. Ravi Varma Press chromolithograph decorated with *zari*.

picture surface destroys the illusion of the picture plane as a window. The reality effect is fractured through the sheer weight of signs of the image's coming into being. To view it as magical realism, however (see chapter 1), allows us to understand it more productively. As with Carpentier's baroque there is a 'horror of . . . the naked surface' and the hybridization of the surface of the image permits the viewer to 'flee' from the 'geometrical arrangements'[54] in which Draupadi's honour is threatened. Draupadi is here the subaltern confronted by a political force that offers to take her through the door to the vanishing point. The materialization of Draupadi as a textured mark on the surface (which is also a trace of domestic female engagement with the image) might be seen as a refusal of this journey, a turning back that creates a new space of projection, in the opposite direction, back towards the beholder. Partha Chatterjee has stressed that, for the late nineteenth-century middle-class Bengali babu, agents of the colonial state 'were not objects of respect and emulation: they were objects of fear'.[55] The complex of images that encompasses Ravi Varma's original painting, Khadilkar's play and the hybridized/customized chromolithographs of the image are all manifestations of what Joshi termed 'helpless terror'. But within this complex there is a changing dynamic. Whereas for Ravi Varma the problem is how to plot this terror within a system of representational co-ordinates, with the 'powers of European art', in popular appropriations and reworkings of the images there is evidence that it is this system of 'mathematically regular ordering'[56] that itself has become part of a system of terror from which a redemption is necessary. One of the determining elements in this emerging Indian magical realism thus becomes how to escape a horror encoded in the very language of visual representation. Surface accretions, and attempts to pull the image back away from the vanishing point of colonial reason, emerge as parallel to the attempt within Bengali drama, recorded by Partha Chatterjee, to 'escape from the oppressive rigidities of the new

discursive prose into the semantic richness and polyphony of ordinary, uncolonized speech'.[57]

D. G. PHALKE

A parallel inter-ocularity is to be seen at play in the relationship between chromolithography and film. Partha Mitter has suggested that 'Ravi Varma's spectacular canvases influenced the pioneers of the Indian cinema . . . much as Victorian art inspired the Hollywood director D. W. Griffith'.[58] There is without doubt a remarkable parallelism between the titles and themes of Ravi Varma Press chromolithographs and silent films of the first decade of Indian film production, but it is one that largely circumvents Ravi Varma himself. The mutual obsession between film and chromolithography is inscribed right from the start of the moving picture era. After a decade of experiments with documentary shorts – some of which like *Benares or Kashi* and *Ganapati Festival* (released *c.* 1911)[59] focused on places and activities of great ritual significance – a series of hugely popular narrative mythological films appeared. The first of these, which has not survived, was R. G. Torney's *Pundalik*, released at Bombay's Coronation Cinematograph on 18 May 1912.[60] The film, which was made with the technical assistance of the photographers Bourne and Shepherd, was a biography of the Marahasthrian saint. When its run was extended for a further week in response to public demand the Coronation announced that 'almost half the Bombay Hindu population has seen it last week and we want the other half to do so now'.[61] Shortly after this two further mythologicals appeared, *Savitri*[62] and *An Episode from the Ramayan*, shown at the Gaiety from 2 November 1912, which depicted 'Rama in Lanka, slaying the demon Ravana, followed by a grand procession of elephants, chariots etc'.[63] All these films preceded D. G. Phalke's much better known *Raja Harishchandra*, which was released in 1913. In Phalke's career, however, we can trace explicit contiguities between different representational stategies.

Dhundiraj Govind Phalke (*b* 1860) had studied at the J. J. School of Art in Bombay and the Kalabhavan (school of art) in Baroda. He practised as a professional photographer, magician and lithographer before making his mark as India's first feature film-maker. He developed his knowledge of film-making through correspondence with the editor of the *Bioscope* in London and during a visit to England, where he was assisted by the manager of the Hepworth Company.[64] What Ravi Varma is to chromolithography, Phalke is to film: both have acquired an unassailable iconicity as national cultural figures.

As with the early Calcutta lithographs and Girish Chandra Ghosh's mythological plays there is a simple historical conjunction through which the key producers of these various art forms came to work intimately together. The conjunction occurred over the period from about 1901 until 1911 while Phalke worked variously at Ravi Varma's Lonavala press, and subsequently managed a printing works in Bombay. Rajadhyaksha records Phalke's move to Lonavala, the site of the Ravi Varma Press, midway between Poona and Bombay, which by now was run by the German technician Schleicher to whom Ravi Varma had sold his interest in 1901. The chronological coincidence of Ravi Varma's departure and Phalke's arrival amounts almost to a succession of leadership in the field of popular visuality. Leaving Lonavala, Phalke established his own press, Phalke's Engraving and Printing Works, in Dadar and, following a visit to Germany in 1909 in search of further technological expertise, he appears to have established the Laksmi Art Printing Works in Byculla.[65] Starting in 1910 this new enterprise published a series of profusely illustrated booklets, collectively named *Suvarnamala*, coinciding with festivals such as Shivratri, Ram Navami, Krishna Asthami, Ganesh Chaturthi and Divali (illus. 43). These were available on subscription, bound with a silk ribbon, and single-colour illustrations by the artist M. V. Dhurandhar, another graduate of the J. J. School of Art who had previously worked for the Ravi Varma Press.[66]

43 Logo of The Lakshmi Art Printing Works, printed on the back cover of the 'Ramnavami' number of *Suvarnmala*, 1911. A press run by D. G. Phalke immediately before his venture into film-making.

Following his revelatory experience while watching *The Life of Christ*[67] Phalke studied cinematography and travelled to England in February 1912 to purchase equipment. His first film, *Raja Harishchandra*, was premiered on 3 May 1913 at the Coronation Cinema in Bombay. The story of Raja Harishchandra had been the subject of an earlier lithograph by the Calcutta Art Studio[68] and also of a painting by Ravi Varma, but it is in Phalke's later films that the parallelism between the printed and filmic image is most marked.

In 1917 Phalke released *Lanka Dahan* (The Burning of Lanka) at the West End Cinema at Girgaum, Bombay,[69] where it was shown every hour from 7 a.m. until midnight.[70] This was Phalke's greatest success and was a triumph for the actor A. Salunke who played both Sita and Ram. Barnouw and Krishaswamy record that when Ram appeared the audience prostrated itself before the screen.[71] It has been claimed that when it was shown in Poona the crowds almost broke down the door and that in Madras the film's takings had to be transported in a bullock cart with police

protection.[72] An account of its Bombay opening by the film-maker J. B. H. Wadia provides some sense of its huge impact upon the audience:

'Lanka Dahan' was a minor masterpiece of its time. The spectacle of Hanuman's figure becoming progressively diminutive as he flew higher and higher in the clouds and the burning of the city of Lanka in table-top photography were simply awe-inspiring.

I remember that devout villagers from nearby Bombay had come in large numbers in their bullock carts to have *darshan* of their beloved God, the Lord Rama. The roadside was blocked with the caravan of bullock carts. Many of the villagers had stayed overnight in their improvised dwellings just to see the film again the next day.[73]

Print number 307 published by the Ravi Varma Press (probably *c.* 1914; illus. 44) depicts Hanuman airborne above the conflagration engulfing Lanka and we might reasonably suppose that this served as a model for Phalke.

One year later in 1918 Phalke released *Shree Krishna Janma*, of which a portion survives in the National Film Archive in Pune. Here, a succession of familiar images appear which support the contention that Phalke created narrative filmic elaborations grounded in immediately recognizable images that had already penetrated the popular psyche of India through the mass-produced works of these earlier presses.

In 1919 Phalke continued his exploration of Krishna mythology in *Kaliya Mardan*, of which almost the whole footage survives. The film's central scene replicates an image already familiar through a Ravi Varma Press lithograph. But the influence here is not of Ravi Varma the artist, since both the chromo-lithographs of Hanuman and of Krishna subduing Kaliya (illus. 45) reflect the visual culture of the Ravi Varma Press many years after the artist had disengaged himself from it. The contiguity may thus be between different periods of Phalke's own career, firstly as a

44 *Lankadahan Hanuman, c.* early 1900s, Ravi Varma Press. Phalke may well have prepared such blocks during his time at the Ravi Varma Press.

block-maker and artist and subsequently as a film-maker (illus. 46).

We have seen that the Ravi Varma painting that became the key motif of Khadilkar's play *Kichaka Vadh* was disseminated throughout India in the form of chromolithographs and postcards. It was this mass-reproduction that in the eyes of some critics led to Ravi Varma's aesthetic downfall. Having stolen the fire of perspective he was foolishly tempted to compromise his art through lithography. The dominant myth has Ravi Varma as a reluctant participant, persuaded in the end by the need to raise popular taste and drive out debased 'scenes of heaven and hell'. Thus did he unwittingly become the 'father of calendar art',

45 *Kaliyamardan, c.* 1915. Ravi Varma Press.

46 A still from D. G. Phalke's *Kaliya Mardan,* 1918.

a point repeated *ad infinitum* at the time of the 1993 Delhi retrospective.

In fact, the evidence to be found in any Indian village (and one such is described in the final chapter of this book) tells a rather different story, for what twenty-first century peasants choose to hang on their walls owes comparatively little to Ravi Varma's work. Those images that do replicate themes associated with the artist could equally well be routed through an alternative Calcutta Art Studio or Chitrashala Steam Press lineage. Rather than Ravi Varma it is Brahman painters from Nathdvara that dominate mass picture production. An earlier consensus proposed that it was Ravi Varma 'who established the representational style, defined the parameters of the archive, and pioneered its mass reproduction': this is a thesis that now requires revision.[74]

HEM CHANDER BHARGAVA

Among the bustle of Delhi's famous Chandni Chowk market is an old painted signboard showing Hanuman flying through the air bearing herbs to the wounded Lakshman (illus. 47). This sign advertises the presence of the oldest surviving picture publishers, the firm of Hem Chander Bhargava, founded in 1900, which still occupies its original modest first-floor offices.

Hem Chander Bhargava's press, founded only eight years after Ravi Varma's, displayed a similar commercial acumen and 'sly civility' in responding to the diverse markets of late colonial India. Hem Chander was much more active than Ravi Varma in addressing other religious communities in India. Sikh and Muslim subjects figure prominently among his earliest images. However, like Ravi Varma, Hem Chander's output engaged with and reflected the parallel technologies of photography and cinematography, but it also increasingly produced images for a mass Indian market that started to repudiate some of the conventions of photography. Just as the Ravi Varma Press (especially after the artist's departure in

47 Hemchander Bhargava's signboard in Chandni Chowk, Delhi. Dating from the early twentieth century this is still displayed outside their shop.

1901) increasingly produced what might be termed 'post-perspectival' images, so Hem Chander too produced images that in appealing to new emergent markets took him further away from the 'powers of European art'.

The earliest print of which I know, number 3,[75] dates from about 1911.[76] This depicts *Their Most Gracious Majesties Emperor George V & Empress Mary* with their children at Buckingham Palace (illus. 48) and was printed at the Bolton Fine Art Litho Works in Tardeo, Bombay. This is clearly modelled on a photograph and we may surmise that the image was issued to coincide with the enthusiasm that stemmed from George V's visit with the Queen for the Durbar in 1911. It was during the Delhi Durbar on 12 December 1911 that the

King rescinded Curzon's partition of Bengal and announced the transfer of the capital from Calcutta to Delhi.[77]

This curious image reveals something of Hem Chander's commercial instincts, printing a diverse set of saleable images. There is some evidence of the earlier circulation of such royal images within the public spaces of popular Hinduism. Sidney Low's account of a tour through India with the Prince and Princess of Wales in 1905–6 reveals that royal images were offered at a 'mart for the sale of devotional literature' at the Allahabad Kumbh Mela: 'The customers can buy religious tracts, or if they prefer, ancient chromos of King Edward VII as Prince of Wales in the costume of the 'seventies – a remnant, perhaps, of the previous Royal tour.'[78] The

48 *Their Most Gracious Majesties . . .* , *c.* 1911, chromolithograph. Hem Chander Bhargava.

comparative lateness of the image in relation to Hem Chander Bhargava's date of first trading, however, suggests that initially it may have been concerned with other matters. Prestigious picture distributors such as Anant Shivaji Desai simultaneously pursued other sidelines (such as the sale of hats, fancy dress and German silver) and we shall shortly see that the first seven years of S. S. Brijbasi's existence did not involve the publication of any pictures.

The Hem Chander myth stakes a claim to a rather different series of developments that I have as yet been unable to substantiate. In this version, the company produced religious prints at their very inception in 1900. Kishorilal Bhargava claimed that they started with between eight and ten designs, one of which was the image of Hanuman depicted on their Chandni Chowk signboard. Other designs depicted Ram, Krishna, Durga, Shiv, Saraswati and Lakshmi, and it is claimed that from the start Hem Chander's designs were quite distinct from and superior to the products of Ravi Varma Press.

In addition to the George V print, the surviving images from this period depict Sikh and Muslim subjects, although their serial numbers suggest that an even larger number of Hindu images may well have been published alongside these. The earliest extant images are all chromolithographs (10 x 14 inches) printed at the Bolton Fine Art Litho Press in Tardeo, Bombay. The first 168 images appear to have been printed there before printing was switched to the British India Press, also in Bombay, who produced images of a similar size and quality. In the mid-1930s – probably in response to the superior size and quality of Brijbasi prints of the early 1930s – Hem Chander arranged for large photo-lithos (14 x 20 inches and 20 x 28 inches) to be printed in Germany. World War II terminated this arrangement and Hem Chander then had its stock photo-lithographed in Bombay (almost certainly by the Bolton F.A.L. Works).

Hem Chander's print number 7 is a highly stylized representation of Delhi's Jama Masjid (illus. 49). This again suggests Hem Chander's opportunism during

49 Jama Masjid, *c.* 1910, chromolithograph, Hem Chander Bhargava.

this period, for we can imagine this appealing to two markets – a Muslim audience who might have used it for devotional purposes, and a tourist/ traveller audience who would also have had access to photographic images such as Lala Deen Dayal's early photograph (illus. 50). The Hem Chander image bears the marks of Company style and we will soon note the sharp contrasts with later Nathdvara compositions. The Jama Masjid is drawn almost as a perspectival exercise with a degree of competence that permits us to say that the artist stood slightly to the left of where Lala Deen Dayal had earlier

50 Lala Deen Dayal, *Jama Masjid*, Delhi, *c.* 1874, Albumen print.

erected his camera. Such perspectival grids are rarely apparent in later Nathdvara images.

Other similar images from around this period (probably the mid-1920s) depict the Taj Mahal, Humayoun's Tomb, the Dargah of Nizamuddin, Mecca and Karbala, and a very large number of Koranic texts inscribed within ornate floral borders. *Karbala Moula* (no. 150) bears a close similarity to a Ravi Varma Press image (no. 741) and suggests something of the interchange of designs during this period.

There are an equally significant number of Sikh prints depicting Guru Gobind Singh and Guru Arjun Dev, among others. Three of these are worth commenting upon. The first, *Ten Sikh Goroos* (no. 24), may well be from an earlier series of prints whose further discovery might substantiate the claims made on behalf of Hem Chander Bhargava. It shows Guru Nanak flanked by his attendants Mardana and Bala surrounded by further depictions, in distinct medallions, of the gurus. No. 50, *Guru Granth Prakash* (illus. 51), portrays all the gurus together in a unified pictorial space, a meeting which, as McLeod notes,[79] could never have taken place since more than two centuries separate the first from the last of the gurus. An image like this is powerful proof of a habitus characterized by 'messianic' time for such simultaneity could be made possible only by a 'Divine Providence which alone is able to devise such a plan of history and supply the key to its understanding'.[80] Although we can provisionally date this lithograph to about 1925, it bears a close similarity to a much earlier woodcut image collected by Lockwood Kipling about 1870,[81] clearly suggesting something of the diversity of printed images that always existed alongside the enthusiasm for realism within lithography at the end of the nineteenth century.

A third image of Guru Gobind (*Goroo Gobind Singhji*, no. 37; illus. 52) by contrast exists in a state closer to what Anderson describes as 'homogenous, empty time'.[82] The scene – of Guru Gobind sitting on a *gaddi* (throne) – contrives to recreate the codes of photographic portraiture and background scenery of the

51 *Guru Granth Prakash*, *c.* 1920, chromolithograph. Hem Chander Bhargava.

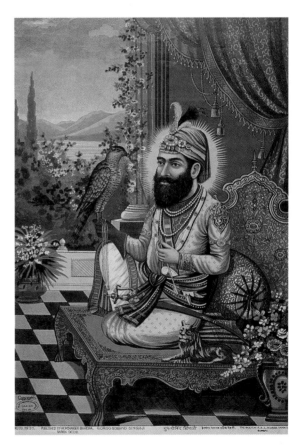

52 *Goroo* (sic) *Gobind Singhji*, *c.* 1920, chromolithograph. Hem Chander Bhargava. An image which draws upon the conventions of early studio photography.

time.[83] There is a great attention to surfaces: the sumptuous *takia* (cushion), *gaddi* and curtain drapes are carefully worked over, and the pillar, plant pots and landscape vista all suggest the paraphernalia of photographic representation of the time. These conventions were apparent in the earlier image of George V, and an intriguing local Indian parallel is reproduced by Gutman in her study of Indian photographic practice.[84] The influence of conventions associated with photography is also apparent in two further images, *Shahidi Darshan* ('Darshan of the Matryrs', no. 53) and *Guru Arjan Dev* (no. 69; illus. 53). In both these images there are five narrative episodes presented in oval or irregular medallions as though they were photographic albumen prints inset in an old-fashioned photographic album designed for cartes-de-visite and cabinet cards. This impression is compounded by the presence of floral decorations, another feature of many of these early albums.

The inter-ocular field of the scopic regime outlined in this chapter is clear. Phalke's work at the Ravi Varma Press ensured a profound intimacy between many chromolithographs and early cinematography. Hem Chander Bhargava was likewise sculpting a lithographic practice that was profoundly indebted to photographic conventions of the time. However, if (as Ashish Rajadhyaksha has argued) Phalke's refusal of perspective might be seen as an 'ethical choice', a repudiation of the colonial world picture,[85] we might also see in Hem Chander's output a similar fumbling towards a post-perspectival practice. Photography is explicitly referenced in many images but more for its surface materiality (as in *Guru Arjan Dev*) than its perspectival rationalization of the world. The scopic regime that Ravi Varma, Phalke and Hem Chander Bhargava articulate passes through an engagement with what Richard Temple had called 'powers of European art' and emerges on the other side marked by the external signs of that passage, but bearing a subtly different moral – and political – message.

The scopic regime that these different practitioners together produced was built upon technologies and

53 *Guru Arjan Dev*, *c.* 1920, chromolithograph. Hemchander Bhargava. The design replicates the appearance of some late nineteenth-century photographic albums.

conventions promulgated by the British colonial state. However, these representational techniques had been appropriated rather than fully internalized.[86] Indian art had been undeniably 'modernized' but, to recall Gladstone Solomon, it was a 'secret of their own country' that Indians were now 'engaged in unravelling'.

5 pastoral realism: the nathdvara devotional aesthetic, 1925–1935

Nathdvara, Rajasthan: Sunday 17.12.94 was *purnima* (full moon) and I made my way up to the Shrinathji temple. En route, up the narrow streets crowded with souvenir shops, I spotted only one reminder of Narottam Narayan Sharma – a framed and faded print of *Murli Manohar*. This was a faint trace in a colourful world of large gilded Shrinathjis, brilliant *pichhvai* wall hangings and small images engraved into metal or sunk in plastic frames. Shrinathji appeared in different *shringaras* (adornments), but always in the same stylized frontal depiction. Occasionally he was juxtaposed in a frame with a *goswami* (priest) or sometimes with a clock. Some picture shops were interspersed with those selling saris and the draped textiles and images produced a dense and rich mixture.

The temple is a series of inter-connecting rooms in a large *haveli* and one enters these from the courtyard in which there are numerous further souvenir shops and where devotees' shoes litter the ground. On this full moon day there were many ecstatic devotees rushing for the afternoon *darshan*.

My guide showed me several of the smaller *svarups* that lead off the main courtyard. One is a small domed temple surmounted by a painted Krishnalila (peeling

55 View from the rooftop of the artist Narottam Narayan's house, Nathdvara, Rajasthan, 1994.

54 Early photographic copy of a *ras lila pichhvai*, *c.* 1880, albumen print.

paint, and reputed to be 250 years old). In another, larger, room is Ladu Gopal, familiar through a painting by Ghasiram. In the storeroom ten lakhs rupees' worth of tinned *ghi* waits stacked up in great rectangular shiny mountains, waiting to be poured into a *ghi* well that lies under the main image. Similarly, huge piled sacks of sugar and other ingredients destined to be made into sweetmeat *prasad* (offerings) for the god to eat. Besides these are enormous weighing scales and boiling pans secured with padlocks. A huge image of Ganesh watches over all these and all new deliveries are placed in front of him so that they may double in size or value. An armed guard also waits with his rifle at the ready, ensuring that the stocks do not diminish.

Next into the main part of the *haveli* where the crowds are thickest, up some narrow stairs and along a balcony where we peer into a scene of frenzied industrial activity. Half a dozen men sit at sewing machines stitching new clothes for the images of the deity that are dressed anew every day.

Then down again, as we peer through a window at a silver and gold *chak*, a huge grinding stone used to prepare food for Shrinathji. In front of this is heaped another mountain, this time of many thousands of rupee notes and coins. We move down a narrow walkway to series of accountants' offices where records of donations are kept and to see the *gadi* of a venerated early *goswami*.

Back in the main courtyard, under the tailors' balcony we can just see the original chariot in which the *svarup* was brought from Braj during Aurangzeb's time. Then up some stairs past a long queue of devotees waiting to see the main image. To get near the image you need to join this queue, but you can easily melt into the jostling throng at the back. This great densely packed ecstatic mass collectively responded to the surging emotions that made it twitch and bend and stretch as though commanded by the glittering *svarup* itself in the distance.

I would not have visited Nathdvara had it not been for the activities of Shrinathdasji and Shyamsunderlal Brijbasi in the 1920s and '30s. It was their mass-production of images by artists from the pilgrimage centre's Brahman painting community that precipitated a revolution in popular aesthetics and would place Nathdvara painters at the centre of the commercial picture production industry for the rest of the century.

The Brijbasi brothers were based in Karachi from 1918 until Partition. After 1927 Shrinathdasji commenced a series of regular travels to Nathdvara where he was to spend many months of each year in residence working closely with painters such as Ghasiram, Khubiram and Narottam Narayan. A perusal of a modern map suggests a tortuous journey via Bombay, or Lahore, to reach this small pilgrimage centre just north of Udaipur. But in pre-Partition India, Shrinathdasji would no doubt have travelled swiftly and in comfort on the newly opened Jodhpur Bikaner Railway. This line, which opened in 1900,[1]

56 Unfinished gouache by Hiralal of Krishna in a grove, *c.* 1920. A mythopoetic landscape of symmetry.

ran from Hyderabad in Sind, just north of Karachi, through the Thar desert to Marwar, a mere 70 kilometres or so from Nathdvara.

However, Shrinathdasji Brijbasi's connection with Nathdvara was not simply the result of this fortuitous feat of engineering: there was a profounder logic to this encounter. Shrinathdasji was known in Karachi as Brijbasi (i.e. 'Brajbasi', meaning 'people [basi] from Braj') because he came from a Mathura family who were followers of the fifteenth-century saint Vallabha. Indeed, prior to picture framing, the two brothers ran a cotton yarn business in Mathura, the birthplace of Krishna in Uttar Pradesh.

VALLABHACHARYA AND BRAJ

Mathura lies at the heart of Braj, the area in which Krishna grazed his cattle,[2] and where the topography that foregrounded his various mythical deeds is still regularly reanimated through pilgrimage and dramaturgical re-enactment (illus. 58 & 59). To understand Nathdvara's connection to this fabled land we need to go back to 1479 when Vallabha was born to south Indian Brahman parents while they were fleeing from a rumoured Muslim invasion of Banares.[3] This was a time of great political turbulence and religious revival, and devotional bhakti movements were poised to make their greatest breakthroughs. Vallabha himself described it as a period in which 'the mlechchhas have surrounded all the holy places . . . [where] learned people have become mad with pride; they follow the path of sin and are bent only upon personal gain and reputation'.[4] Vallabha undertook a lengthy pilgrimage that eventually brought him to Gokul near Mathura, where Krishna appeared to him in a vision. Also during this period Vallabha became aware of the discovery of (or some accounts suggest himself discovered) the svarup (or self-made image) of Shrinathji buried in Mount Govardhan, a hill which Krishna had once used as an umbrella to shelter the

cattle of Braj from torrential rains.[5] This image was installed first in a small shrine and then in a more elaborate temple on Mount Govardhan.

Following Vallabha's death in 1531 his sect was led by his eldest son Gopinath, and then by Vitthalnath, the second son, who did much to establish the ceremonial paraphernalia of the cult and was to enjoy a close relationship with the liberal Emperor Akbar. This tolerant interlude ended with Aurangzeb's reign of destruction and in September 1670 a small party of devotees set off with the image concealed in a bullock cart in search of a new, and safer, site.[6]

They eventually secured the permission of Raja Singh, the Maharaja of Mewar, to install the image in Udaipur, but as they made their way there the chariot in which Shrinathji was being carried became stuck in deep mud and could not be dislodged. As Ambalal notes, this was taken as 'a sign from the Lord Himself [and] they decided to proceed no further and [this place] was selected as the final abode of Shrinathji'.[7] Following the erection of a temple and the installation of the image in 1672,[8] the town itself came to be known as Nathdvara ('portal of the Lord').

It is uncertain whether any artists accompanied the image from Mathura to Nathdvara. Today there are two main castes of Brahman painters resident in Nathdvara.[9] The Gaur claim to have migrated from Udaipur, and the Jangir from Jaipur and Jodhpur, and it has been suggested that such origins are 'not at all unlikely in the light of the stylistic characteristics of Nathadwara paintings'.[10]

Skelton has skilfully sketched in the background to the development of the Nathdvara style and I will briefly summarize it here. Hindu art increasingly engaged with the more naturalistic art of Persian manuscript illustration. This influence grew with the concentration of artists around Akbar's great court. With its subsequent decay and the dispersal of many of these artists to the smaller courts of provincial rulers, much of this metropolitan hybridity was exported to remote regions of Rajasthan. In some centres such as Bikaner, Mughal influence persisted.

In other areas, by contrast, it was 'quite remarkable how rapidly Mughal-trained artists . . . reverted in style to the essential characteristics of the pre-Mughal Hindu school'.[11]

Mughal and Rajput painting have been contrasted in illuminating ideal-typical terms that also suggest something of the different chronotopes that informed them. In Mughal painting there is a form of proto-realism; Mughal portraiture, for instance, presupposes some notion of an interior individual personality that can be revealed through exterior traces. Rajput painting is consistently less instantiated in such a ready-made world and reproduces ideal forms whose referents are to be found in a mytho-poetic world of natural beauty saturated with divinity (illus. 56). Skelton contrasts the Mughal portrait where 'an eye with its wrinkled lids and world-weary glance mirrored the individual personality of the sitter' with the Rajput painter who represented the same referent with 'the flowing curves of a lotus petal and thus faithfully transcribed a poetic metaphor' (illus. 57).[12]

It is clear that Nathdvara art belonged to the Rajput mytho-poetic world: Nathdvara *pichhvais* (illus. 54) were designed to 'usher the viewer into the eternal Brindaban [i.e. Braj] where only ideal values prevail'.[13] This essentialized style, articulated in part through its opposition to Mughal idioms, would emerge in the late 1920s as a powerful aesthetic/political alternative to colonial representation.

The artists to whom Shrinathdasji Brijbasi offered commissions in the late 1920s were part of a large and thriving painting community that had been settled in the town for several centuries and had played a significant part in the evolution of the regional style of art known as Mewar painting.[14]

Although Nathdvara art's mass-produced ascendancy started properly only in the late 1920s, images produced by artists spanning the Nathdvara–Mathura axis were being reproduced photograph-ically much earlier in the century. There are many images collected in Mathura and prefiguring later developments that can be positively dated as prior to

57 Unfinished sketch of Shrinathji by Narottam Narayan Sharma, c. 1930. The eyes trace the 'flowing curves of a lotus petal'.

1915. Many of these testify to the close relationship between ritual performance – in this case the *ras lila* – and devotional painting. We have already seen a similar conjunction between Bengali mythological drama and many Calcuttan chromolithographs in which the spectacle of the stage was translated onto the paper of the print. But whereas in late nineteenth-century Calcutta both chromolithography and theatre were driven with a desire to experiment with novel representational strategies, in Mathura and Nathdvara the work of the painter and actor was much more obviously driven by a set of devotional imperatives.

Two photographs reproduced here (illus. 58 & 59) were collected by Rai Bahadur Radha Krishna, the Director of the Archaeological Museum at Mathura, sometime before 1915. They were part of an extensive batch of two dozen sent to William Ridgeway (ex-President of the Royal Anthropological Institute and Disney Professor of Archaeology at Cambridge) for inclusion in the latter's treatise on dance (published in 1915 as *The Dramas and Dramatic Dances of non-European Races with Special Reference to the Origin of Greek Tragedy*) and were evidently collected in Mathura. Rai Bahadur Radha Krishna carefully documented the pictures he sent to Ridgeway, including quotations from the *Premsagar* and matching photographs of *ras lila* performances with paintings of the same events. Braj – the land of Krishna's birth – had been steadily revitalized by pilgrims from the sixteenth century onwards and it appears through these images as an enchanted realm inscribed with an affective and performative significance through mass devotion. It is this space, a bounded pastoral[15] world delimited by particular sites (Mount Govardhan, the villages of Brindaban, Nandgaon and Barsana) and its pastoral metonyms (vegetative fecundity and a topological repleteness), within which Nathdvara painting operates.

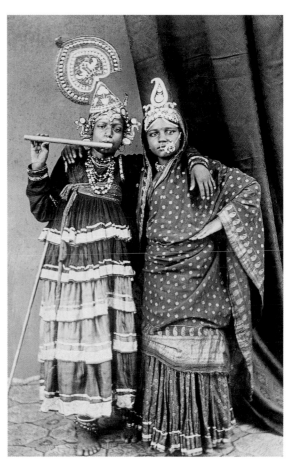

59 Studio photograph of *ras lila* participants dressed as Radha and Krishna, Brindaban/Mathura. before 1915. Albumen print on card.

58 Krishna departs with Akrur for Mathura in the Brindaban *ras lila*, before 1915. Albumen print on card.

The painted images are credited as 'From a native painting' by Ridgeway but originate in all probability from Nathdvara and may have been copied by a Mathura photographic studio, Bharat Hitaishi, which was established in 1900[16] and is known to have been selling photographic prints of paintings at around this time.[17] The photographic originals (now in the Museum of Archaeology and Anthropology, University of Cambridge) are inscribed 'Designed and painted by B.B.M.'

This juxtaposition of the performative and two-dimensional alerts us to a crucial feature of the early twentieth-century Nathdvara painting communities:

60 *Azadi ke Paigambar ki Ghosana* (Proclamation of the Proposal for Freedom). A broadside showing Gandhi at his *charkha* and listing his main teachings. Issued by the Gandhi Seva Samiti, Cawnpore, printed by Anandeshvar Press. Late 1920s.

their immersion in a performative faith in which painted images played an instrumental role. Indeed we could go so far as to claim the Brindavan *ras lila* was to the Brijbasi style what the Star Theatre's mythological plays were to the early Calcutta picture presses.

In addition to this inter-ocular domain we need also to see the Nathdvara aesthetic championed by the Brijbasi brothers in relation to the rise of Gandhian politics in the 1920s and the emergence of a powerful terrorist alternative in the early 1930s. Gandhi had returned to India in 1915 and thrown himself into public politics two years after that. The 1920s were characterized by the creation of a nationalist mass-movement with a strong peasant following strongly articulated (at least by Gandhi and Sardar Patel) within a devotional idiom. The individual, physical, body became a new site for an ethicized political practice: the production of *khadi* (homespun cloth), vegetarianism and other interventions on one's own body became a new means of performing an ideal vision of community (illus. 60). There was a powerful homology between this Gandhian practice and the Brijbasi's Vallabha imagery.[18] In 1931, however, both were confronted with a violent and popularly attractive alternative in the form of the socialist and atheistic Bhagat Singh.

After his arrival in Karachi the elder brother, Shrinathdasji, spent four years exploring business opportunities before starting the framing shop, During the early years of this business he came to appreciate the possibilities of picture publishing and after five years, in either 1927 or 1928, a decision was made to publish their own images. This was precipitated by the arrival one day in their shop of a Sindhi client bearing a photograph of his young son dressed as Krishna in a style reminiscent of Phalke's early filmic representation (illus. 64).

A travelling representative for the Berlin printers Grafima had at some point before this contacted Shrinathdasji and showed him samples of the reproductions which the firm he represented could produce. A number of original paintings were sent to Germany for reproduction as postcard-sized bromide prints.[19] A 1930 calendar, actually printed in 1928, reproduces 49 of these designs around a much larger image of what must have been the fiftieth – *Patit Pawan Ram* (illus. 65). The contrast between the beautiful colour originals (mostly 10 x 14 inches) and the small (3½ x 5 inches) bromide reproductions is striking and the reasons for choosing this means of reproduction are not completely clear. One very positive feature, which would have done much to offset their small size and subdued presence as compared with, say, Ravi Varma prints, was their overseas production. A German origin signified quality and the allure of the exotic at this time. A Brijbasi catalogue published in 1933 makes very frequent references to their superior quality: 'Pictures listed below are printed in a famous German workshop (*jermani ke ek mashahur karkhane mem*) and are by photographic machines (*photographik mashinon*) and the paper used is very good quality, thick and glossy (*chikna*).'[20] Further, they are printed in attractive colours (*akarshak rangon*) and have a 'wonderful brightness' (*gazab ki chamak*). Later in the catalogue further flourishes are added: the pictures are 'handsome' (*khubsurat*), printed in 'beautiful'

61 *Lord Krishna*, The first Brijbasi image, inspired by the photograph of a boy dressed as Krishna. First published as a bromide postcard in 1928, this image is a later copy, published in *Shrimad Bhagavad Gita* (Ahmedabad, 1950).

(*khushnuma*) colours on 'thick and excellent' (*mote aur bariya*) paper. The Brijbasis even went so far as to claim that 'other pictures in the market cannot even be compared to the shadow of our quality pictures'.

It is also common to see the phrase 'Printed as German' on later Indian-made prints. This was an attempt to appropriate the cachet of foreign printing in a manner that would not make the Indian publisher liable to any legal proceedings. Grafima was later able to produce 10 x 14 inch hand-tinted bromide prints and after 1931 larger colour offset litho prints (20 x 28 inches) came from Peter May Verlag in Dresden. Prints were also imported from Topan in Japan. These

62 The same image reworked as part of an advertising placard for
S. S. Brijbasi, c. 1930.

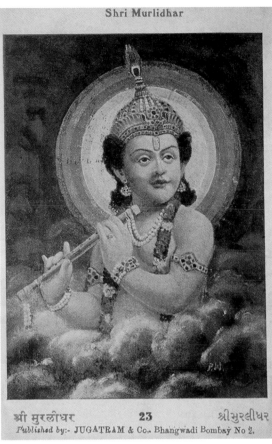

63 *Shri Murlidhar, c.* 1930, postcard published by Jugatram & Co.,
Bombay.

German supplies were suspended during the war,
however, and the firm's images were then printed in
Nagpur and Bombay.

The very first set of bromide postcard designs
printed in 1928 was registered in Calcutta in July
1928.[21] M. L. Garg, the current proprieter of Brijbasi's
Delhi branch, suggested that the early bromide
prints would largely have been used as postcards
for correspondence. The possibility that they would
have found a quite different market niche to the
technically superior colour lithographs, available
from the Ravi Varma Press among others, goes
some way to explaining why these small and
unspectacular products should have been so comm-
ercially successful. All the cards I have seen from this
period bear identical standard information on the

64 Still from D. G. Phalke's film, *Shree Krishna Janma,* 1918.

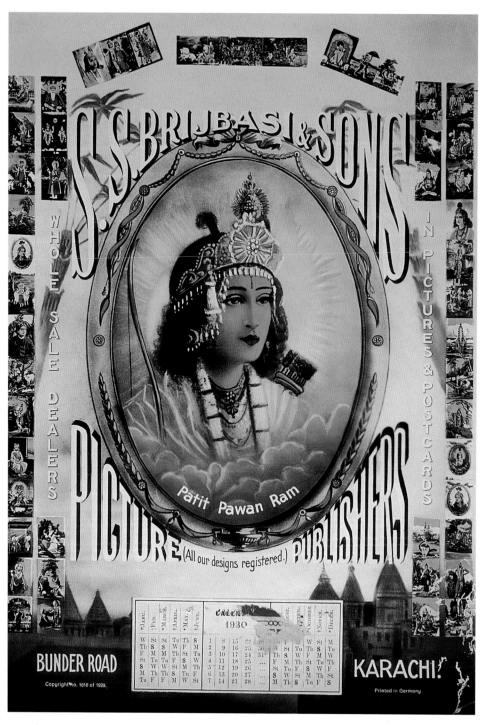

65 Brijbasi promotional calendar for 1930, printed in 1928 in Germany. Hand-coloured bromide print.

reverse ('Postcard', 'This space for communication', 'Address to be written here' and, on a vertical plane, 'This is a real photograph').

Many of the original gouaches sent to Germany for printing are still in the collection of M. L. Garg and indicate that initial print runs ranged between one and five thousand in the first few years, and that reprint orders rose as high as ten thousand by 1937. All the various instructions written on the reverse of the gouaches request that the title of the picture be printed along with the 'S.S. Brijbasi' logo, and the legend 'Printed in Germany'.

The first fifty Brijbasi images included work by the Nathdvara artists Khubiram, Ghasiram and Narottam Narayan Sharma. A couple are close copies of Calcutta Art Studio and Ravi Varma Press lithographs and some reflect the influence of reference material (such as the catalogues produced by a German company L.M.B., whose chromolithograph landscapes and flower pictures were sold through Brijbasi), which Shrinathdasji made available to the painters, but many of the images are unmistakably the products of Nathdvara artists. Most obviously there are images of Srinathji itself, but also numerous images in which deities are represented as part of an idealized Braj landscape. This is perhaps most clearly exemplified by a Ghasiram image that was later overpainted and used as the cover for Brijbasi's 1933 price list . In the next decade a distinctive Nathdvara aesthetic was to become steadily more apparent as the benefits of strategic mimicry diminished.

Ghasiram Hardev Sharma (1868–1930) was descended from a long line of painters and, after working for twelve years with twenty assistants on murals for the Raja of Zalavad, he became *mukhiya* (chief painter) in the Shrinathji temple (illus. 66). At the turn of the century Ghasiram took up oil painting. Ambalal has noted the coincidence of Ravi Varma's visit to Udaipur in 1901 and the fact that the Travancore artist was 'assisted by Ghasiram's uncle Master Kundanlal', who had studied at the Slade in London between 1893 and 1896.[22] A diary kept by

C. Raja Raja Varma, Ravi Varma's brother, describes this visit in detail and gives a rather different account of the relationship. His entry for 16 May 1901 states:

This morning a deputation consisting of some Sardars learned men of the Court called at our studio to suggest alterations [to] His Highness's orders. One of the local artists Kunnalal,[23] who had visited England once and who is awfully jealous of us, spoke disparagingly of our work and my nephew, who heard him, challenged him to try his skill with us. He was at once humbled and he departed crest-fallen.[24]

In view of the subsequent reproduction of his images by Hem Chander Bhargava and S. S. Brijbasi it is ironic that initially Ghasiram was radically opposed to the mass-reproduction of ritual art. This may have been a reflection of his uncle's pique following the rebuke from Ravi Varma's entourage in 1901. Whatever the reason he believed that 'the production of block prints would devalue paintings. Thousands of rupees worth of paintings would be sold as prints at very low prices'.[25] This resistance to mass-reproduction was described and analysed for me by Ramesh Agarwal, the grandson of Brijbasi's founder, who was subsequently the manager of the company's Bombay office:

[Nathdvara artists] were generally opposed because that would have affected their business. They especially opposed [the reproduction of] the Shrinthaji painting. They never gave it to anyone for printing. When we first printed it [in 1928] they boycotted the artist [Narottam Narayan] saying 'Why did you give that for printing?'

However, as Ramesh's son Ravi recorded, it was not long before the Nathdvara artists' fears that their livelihood would be destroyed were displaced by a recognition of the extra income and renown that mass-reproduction could bring:

66 The painter Ghasiram Hardev Sharma, *c.* 1925, albumen print.

the same time they also found an additional market – lithoprinters – and it created a greater general demand for religious items because of a greater awareness created through the spread of pictures in every household.

A Hem Chander Bhargava sample book (*c.* 1948) includes several prints of paintings by Ghasiram, probably dating from the last years of his life and published posthumously in the 1930s. They are noticeable for what to a modern eye looks a rather anaemic colour range and in many respects are very different from later Nathdvara artists such as Narottam Narayan. Ambalal stresses the revolutionary impact of his work on a style that was rapidly stagnating: 'the glowing aniline water colours imported from Europe thrilled him, and the use of transparent glowing colours thereafter became his hallmark'.[26] When contrasted with other Nathdvara painters who ventured into the mass market, however, this judgement appears somewhat puzzling. What is striking about Ghasiram's paintings as opposed to, say, Khubiram or Narottam Narayan is their very strongly marked 'traditionalist' Nathdvara identity.

In all Ghasiram's images the relation of figure to landscape is very similar to that in earlier Nathdvara images. The effect, consequently, is an immersion of relatively small figures in characteristically lush foliage-covered landscapes. Figures are also typically deployed along a single horizontal plane in the foreground of the painting. However, in Ghasiram's *Ras Lila* and *Panchabati* the influence of photographic studio conventions and foreign 'scenery' prints[27] is perhaps evident in the receding landscape on the far left of both images, which leads the eye out into the far distance.

Ghasiram's *Yogiraj Shri Krishna* (illus. 67), published by Brijbasi as a bromide card in 1928, manifests a further aspect of the hybridity that is still apparent in other early Brijbasi images. It combines the sentimentality of romantic kitsch with the dark brooding intensity and richness of Nathdvara landscapes.[28] It was images such as these[29] that earned the censure

Although they rebuked this first painter, later on they realized that it was not going to affect their market because wealthy people would still buy the paintings. Earlier the hand-made paintings used to sell at a very cheap price. Later they realized that with mass reproduction word about Shrinathji and other gods would spread – people would be more aware of religion – and in turn it would affect their market. Now the value for hand-made paintings increased. It was something that could not be bought in volume. They became very supportive of our printing because they realized that it had an effect on their own market, it [increased] the price for hand-made paintings: the value increased and at

of the Director of the Lalit Kala Akademi and co-organizer of the 1993 National Museum Ravi Varma exhibition, the painter A. Ramachandran. In an attempt to establish the aesthetic worth of Ravi Varma oils, Ramachandran decried the artist's 'oleographs' and vilified those painters who had subsequently been forced to 'incorporate popular Ravi Varma elements in their works': 'A pathetic example of this can be found in the works of Ghasiram, a traditional painter of Nathdwara, who made vulgarized versions of Radha and Krishna paintings by copying picture post-cards.'[30] Although by this stage Ghasiram was clearly producing work aimed at a specific market, it would be misleading to accept Ramachandran's criticisms. Indeed, while conceding the enormous influence of earlier commercial art in this Ghasiram image, I would argue that despite such hybrid amalgams Ghasiram, and the flood of Nathdvara artists who followed him, led to a marked 're-traditionalization' of this genre of mass-produced art.

67 *Yogiraj Shri Krishna*,
Ghasiram, *c.* 1928,
gouache.

Khubiram Gopilal was another prolific contributor to both Brijbasi's and Hem Chander Bharagava's early lists. Some of Khubiram's early images are clear copies of earlier Ravi Varma chromolithographs, such as his 'Mahalaksmi', which, apart from the characteristic fecund claustrophobia of twentieth-century Nathdvara paintings, is very similar to the Ravi Varma Press's very first print, the standing Lakshmi (see illus. 37).

S.S. Brijbasi also published paintings by Hiralal Udayram (1858–1928), who had worked with Ghasiram. Ambalal records that, in addition to Brijbasi, Hiralal's work was published by Hem Chander Bhargava, Nathmal Chandelia of Calcutta and Jaipur, and by Harnarayan and Sons, then based in Jodhpur. It was Harnarayan who was first to publish the work of the Nathdvara artist who would come to dominate popular Hindu art in the second half of the twentieth century, B. G. Sharma (see chapter 7).

If in Ghasiram's early work we can see the most obvious linkage between mass-produced images and the aesthetic of nineteenth-century Nathdvara painters, it was the artist Narottam Narayan Sharma (1896–1992; illus. 68) who from the mid-1930s came to define a new dominant Nathdvara style that was to dominate the market until the mid-1950s, when B. G. Sharma's brighter palette found national acclaim.

68 The painter Narottam Narayan Sharma, c. 1930, silver print.

PASTORALISM, PERSPECTIVE AND PHOTOGRAPHY

Narottam's work most powerfully embodies what we might term 'neo-traditionalism'. I mean by this a conscious return to an earlier representational style. The move to an earlier imaginary practice also implies a partial repudiation of perspectival techniques and the wider calculating analytic of colonialism. Narottam's work exemplifies this most clearly, but he is part of a wider movement away from the 'strategic mimicry' of early presses such as the Calcutta Art Studio.

I have suggested that my reading of the history of mass-produced Hindu ritual art shows that this early period of strategic mimicry and experiment with perspective is replaced in the late 1920s by a form of 'neo-traditionalism'.[31] In the new Nathdvara aesthetic, which very rapidly conquered the whole of India, there is less stress on a realist chronotope and fewer explicit attempts at linear perspective. Parallel to this there are a much larger number of composite images and portraiture becomes much more frontal and symmetrical. Rather than a window on reality, the images become icons whose foundational rationale is an engagement with the viewer. This can also be partly explained through the growth of an increasingly rural market for images for whom the ritual utility of images became paramount – this entails the triumph of what O. P. Joshi refers to as *darshani* images over *katha* images, that is the triumph of devotional images that permit mutual looking, over narrative images whose main function is pedagogic.[32]

Parallel to the eclipse of the picture plane in Nathdvara images there is an increasing stress on the surface, rather than depth of the image. Compositions come to be carefully framed and crowded by sympathetic landscapes. These landscapes are the antithesis of the *tour d'horizon* that Anderson suggests is

characteristic of the nationalist novel.[33] Nathdvara images are marked by a singularity, a claustrophobic specificity. The example par excellence of such a landscape is Narottam Narayan's *Murli Manohar* of 1934 (illus. 69), reputed to be the best-selling image in the history of the industry. This depicts Krishna playing the flute in a landscape that is formally similar to that in Ravi Varma's *Vishvamitra Menaka* (see illus. 35). The central figure is placed slightly to the left of the picture, and the right side of the image is filled with a waterfall. In the Ravi Varma image, however, the waterfall is distant and conventionally sublime, drawing the eye out to infinity. Narottam's waterfall, by contrast, is shunted dramatically forward and the misty clouds surrounding the full moon collapse the pictorial depth, flattening the picture dramatically and giving it a surface density and plenitude. Vishvamitra and Menaka are figures placed conventionally within a landscape (it could almost be mistaken for a tourist photograph of a couple picnicking in the Yosemite); but the landscape around Krishna in *Murli Manohar* is clearly an exudation of his central figure.

This point is made more powerfully in Narottam's image of a meditating Shiva (which appears under different titles including *Kailash Pati Shankar*; illus. 70 & 71). Here, the landscape that surrounds Shiv is literally of his own making: the river Ganges sprouts from his head as he sits high in the Himalayas, immersed in deep transcendence on a tiger-skin. The water that flows to his left (or right depending on the process used and date of the print) originates from him. All is equally part of him and thus distance and nearness lose their conventional cartographic significance: he is not a figure in landscape, but an animating force in a world of his own creation.

I have already suggested that Nathdvara painting is highly theatrical, both in Michael Fried's sense and in its clear continuity with the devotional performativity that unfolds each year in Braj. The Nathdvara imagery that Brijbasi conveyed to the rest of India takes as its reference point the landscape of Braj and addresses the spectator (in part) through the conventions of the *ras*

MURLI MANOHAR

69 Narottam Narayan Sharma, *Murli Manohar*, 1950s offset print of a *c.* 1934 image, published by S. S. Brijbasi. Reputed to be the biggest-selling image in the history of the industry.

lila, the annual performative recreation of Krishna's activities in Braj.[34] But of equal importance is the impact of photography in creating the Nathdvara/ Brijbasi allure. This is exceptionally clear in the case of *Kailash Pati Shankar*, in which the central figure of Shiv is without question modelled directly, or indirectly, via a photograph. Narottam's family are hesitant to acknowledge this, but it is clear from other of his images that he overpainted photographs.[35] The fascination and power of *Kailash Pati Shankar* lies in part in the tension between, on the one hand, the depiction of Shiv in a world he has created, and the friction that arises from his hyper-real, photographically montaged disjunction with his setting. Nathdvara painting

70 Narottam Narayan Sharma, *Kailash Pati Shankar, c.* 1935 chromolithograph published by S. S. Brijbasi.
The contrast between this and the following illustration demonstrates the dramatic impact that the lithographic artisans had on the original images from which they worked.

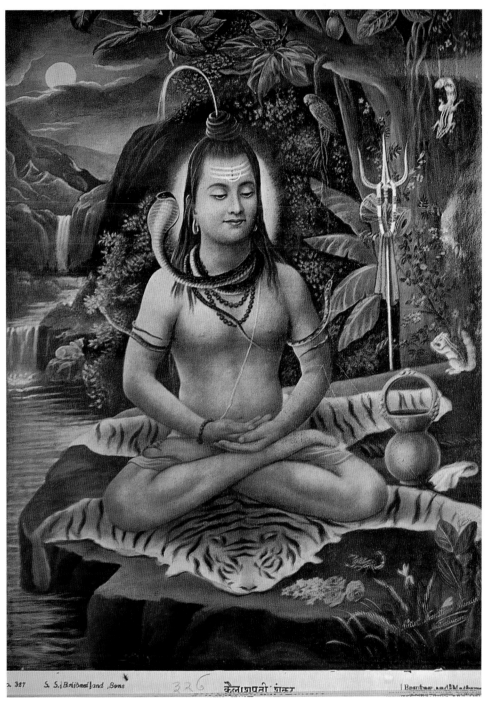

71 Narottam Narayan Sharma, *Kailash Pati Shankar*, 1950s offset print of a mid-1930s image. Published by
S. S. Brijbasi. This photo offset image is much closer to Narrottam's original conception.

simultaneously rejected the colonially authorized technology of perspective at the very moment that it adopted another technology – photography – that gave it a direct route to a hyper-reality.

Photography was eagerly embraced in Nathdvara during the nineteenth century to picture *pichhvais*, as we have seen (see illus. 54), but also *goswamis*, the priests who tend Shrinathji. Very early (*c.* 1860s–70s) carte-de-visite sized albumen prints of *goswamis*, crudely pasted onto yellow card, can still be easily found in Udaipur. Such photographs were also clearly the basis for the portraiture in early *manoratha* paintings. This highly conventionalized form of representation shows Shrinathji in various adornments with on each side, at the bottom of the picture, groups of *goswamis* and devotees attending to the *svarup*'s needs. *Manorathas* were a painterly genre,[36] which then also appeared in chromo-lithographic form. *Shrinathji ka Annkut*,[37] published by a small press in the nearby town of Kankroli, depicts eight goswamis together with four sari-clad devotees disposed symmetrically beneath the deity (illus. 73). It is clear that the *goswami*'s faces are reworkings of photographic portraits, and in some similar examples they were actual collaged photographic images.[38]

Studio photography now makes possible a variation on the picturing of this relationship between humans and the deity, for most Nathdvara photographic studios offer clients a painted backdrop depicting Shrinathji, which allows them to adopt the devotional poses associated with *manorathas* (illus. 72).

The *manoratha* also leaves a powerful trace in many of the most successful Nathdvara/Brijbasi images. Narottam Narayan's *Shree Sulyanurain*, for instance, appropriates the formal structure of the *manoratha* (illus. 74). Like Shrinathji, Satyanarayan is commonly described as an *avatar* of Krishna.[39] Narottam's image endows the central figure of Satyanarayan with Shrinathji-like direct 'theatrical' vision. The viewer is immediately hailed by his gaze and we are commanded to reciprocate. On either

72 Studio photograph (*c.* 1994) of devotees with wall-painting of Shrinathji, Nathdvara. Photography here replicates conventions established in painting and chromolithography.

side of the deity are devotees whom we see gazing upon Satyanarayan. At the bottom a local Raja receives prasad from the priest. Symmetrical banana leaves (commonly used in Satyanarayan *puja*) at the top of the picture enhance the image's fecund claustrophobia. There is thus an 'absorptive' dimension in the image, but one which serves only to lay the foundations for the central and all important theatrical gaze of the deity, who looks at us, the devotee for whom this image has been prepared.

The subsidiary absorptive figures may also be seen as playing the role of critics' recommendations displayed outside a theatre, or the enthusiastic response of reviewers to be found on the covers of some books. They confirm in the viewer of the image the expectation that the deity will be efficacious, for he has already attracted the devotions of those we can see in the image. These figures also serve as prompts, facilitating the 'locking in' of vision between devotee and god that early cinema also struggled to perfect.

The Nathdvara/Brijbasi style is strongly marked by its hybridization of photography for its own devotional and theatrical purposes. We should also keep reminding ourselves of the creational moment

73 *Shrinathji ka Annkut, c.* 1950. Print published by Raghunath Paliwal & Co., Kankroli, Rajasthan. A chromolithographic example of the *manoratha* genre.

SHREE SATYANARAIN

74 Narottam Narayan Sharma, *Shree Satyanarain*, 1950s offset print of mid-1930s image. Published by S. S. Brijbasi.

of Brijbasi (the disseminator of the most significant popular style in twentieth-century India): a man enters their shop bearing a photograph of his son dressed as Krishna and asks for it to be framed.

PASTORALISM AND POLITICS

Just as Anderson's newspaper reader is 'continually reassured that the imagined world is visibly rooted in everyday life' through the observation of 'exact replicas of his own paper being consumed' else-where,[40] it is my suggestion that the Nathdvara-style

chromolithographs that proliferated in the 1930s produced a similar effect through the semiosis created by their inter-ocularity and, of course, through their sheer ubiquity. The prints collectively, through their many hundred million acts of consumption, consolidate an internally referential landscape that came to exist in parallel throughout India. We are confronted with not so much a temporal 'traverse'[41] as a spatial shadow, an ideal space and time that runs alongside everyday reality.[42]

We have already had some sense of the enduring popularity of images such as *Kailash Pati Shankar* through the variety of different versions that have appeared over the years. Far harder to document is the way in which images entered everyday spaces. The anthropologist McKim Marriott's photographs from the 1940s and '50s in rural Uttar Pradesh and urban Maharashtra are one of the few records we have of this everday penetration. A 1952 photograph of a Brijbasi bromide postcard of *Kailash Pati Shankar* placed inside a copy of the *Bhagvata Purana* by a wealthy landlord (illus. 75) allows us to glimpse, through Marriott's lens, one small fragment of the spatial shadow of popular images insinuating themselves into the smallest (indeed thinnest) everyday spaces. We see here in its purest form the emergence of a new form of authority (the mass-produced visual) in conjunction with the old (the rural 'oralization'[43] of texts by learned intermediaries), the local political consequences of which are described in more detail in chapter seven.

Some sense of how, from the late 1920s onwards, Nathdvara landscapes came to do an important part of the work of imagining the nation can also be had from the juxtaposition of images hung on the façade of Brijbasi's office in Karachi in the mid-1930s (illus. 76). Shrinathdasji and Shyamsunderlal Brijbasi are shown seated with their staff in front of the original oil paintings of their best-selling chromolithographs. In addition to portraits of Nehru and Gandhi there are also four images by Narottam: the two images just discussed, *Murli Manohar* and *Kailash Pati Shankar*,

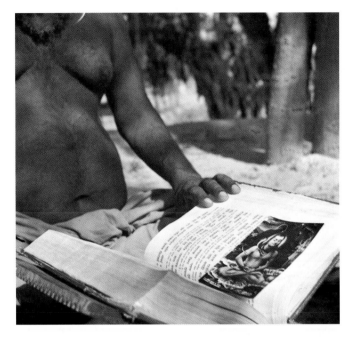

75 Postcard-size bromide print by S. S. Brijbasi of Narottam Narayan's *Kailash Pati Shankar* placed in a copy of the *Bhagvata Purana*, Aligarh district, Uttar Pradesh, early 1950s.

76 The staff of S. S. Brijbasi outside the firm's Bunder Road office, Karachi, mid-1930s. Shrinathdasji and Shyamsunderlal are seated in the centre.

but also images depicting Krishna travelling to Mathura and the perennially popular *Ayodhya Pati Ram*.

I have already suggested that the complex changes in Indian mass-produced popular art precipitated by Brijbasi's dissemination of Nathdvara images are marked by a number of transformations. These warrant reiteration. They include: fewer explicit attempts at linear perspective; less concern with foreshortening; a larger number of composite images; portraiture becomes much more frontal and symmetrical. Rather than a window on reality, the images become icons, the foundational rationale of which is an engagement with the viewer. Depth within the prespectival window becomes sub-servient to the need to produce an image that can function as a ritual object, a change that should also be partly explained through the growth of an increasingly rural market for images for whom the ritual utility of images became paramount. Parallel to the eclipse of the picture plane there is an increasing stress on the surface, rather than the depth of the image: a 'vernacular modernism'[44] emerges that challenges nineteenth-century colonial narratives. I do not claim that every Nathdvara image manifests these characteristics: far from it. This loose list helps identify a series of partial trans-formations, which, operating together in the broad ensemble of popular images, come to constitute what might be seen as a new aesthetic.

A key element in Peter van der Veer's study of what he calls 'religious nationalism', is the claim that it is the result of the compaction of the political discourse created by reactive religious reform movements with an enduring set of practices including ritual communi-cation and pilgrimage.[45] It is these practices that form the bedrock of an aesthetic that, in conjunction with refracted political discourses, establishes the frame within which politics is acted out.

The infrastructure of ritual communication and pilgrimage also put in place elements of an imaginary pan-Indian landscape, which would constitute an inestimable resource to the imagination of Indian religious nationalists. It was a landscape that could be mobilized in infinite domains: textually, orally, theatrically, pictorially. It was a landscape first crystallized by Bankim Chandra Chatterjee in the poem/song *Vande Mataram*:

> I bow to thee, Mother,
> richly-watered, richly fruited,
> cool with winds of the south,
> dark with the crops of the harvests,
> the Mother!
> Her nights rejoicing in the glory of
> the moonlight,
> her hands clothed beautifully with
> her trees in flowering bloom,
> sweet of laughter, sweet
> of speech,
> the Mother, giver of boons,
> giver of bliss.[46]

Nationalists continually invoked this metaphorical space throughout the freedom struggle and it remains a key reference for religious nationalists today: the translation above, by Shri Aurobindo, is taken from the Bharatiya Janata Party's website. But the landscape was also figured as an actual fecund moonlit terrain in countless millions of chromolithograph depictions. Nathdvara pastoralism gave embodiment to that richly watered, richly fruited utopian space of a free India and fused it with the erotics of *bhakti*.[47] It is perhaps not overstating the case to say that Nathdvara's aesthetic produced a national 'figure' whose effects were similar to the music of Verdi and Smetana for certain European nationalisms.

The political effectiveness of these images was in large part the result of their ubiquity. The scale of consumption emerges as equally important to the nature of what is consumed, for the performative reunification of the fragmented signs of the nation occurred untold hundreds of millions of times through the repetitive gestures of the devotee facing

his or her domestic chromolithographs, and through that same individual's awareness that around him numerous other citizens-in-the-making also possessed images coded in the same style. One might have *Kailash Pati Shankar* hanging on one's wall, and when you went to the temple to listen to a recitation from a text, in whose pages you see tucked a postcard version of the same image.

Many of the images of the divine were also clearly allegorical attempts to evade the proscriptional net of the colonial state and were required, like the recent black cultural forms described by Gilroy, to become 'impermeable or at least unrecognizably political' as a necessary precondition of their effectiveness.[48] The landscape through which the political was disguised is of course fragmented across a plethora of individual images but it is the act of consumption, the local reconstituting of the semantic 'train', that creates this ideal landscape and pieces together this parallel fragmented panorama of the nation. There is also a semiosis here, a conversation between media in which 'syntagmatic concatenations' are mutually established, their 'argumentative capacity' is greatly enhanced[49] and the political emerges from its disguise.

The main force of Nathdvara pastoralism's politicality operates thus in a highly subtle and deeply inserted manner. On some occasions, however, the political inflection of the work moves across the content/form division and the intentions of the paintings' producers are revealed with a particular clarity.

This is clearly the case with two pairs of paintings produced by Narottam Narayan. Both depict Maharana Pratap Singh and Shivaji. In the first set (of which I have been able to trace only Narottam's own black and white reference photographs)[50] these two symbols of resistance to Islam face each other on horseback. Shivaji gallops towards the left raising Bhavani's sword, and Pratap Singh's horse rears up from the left. In the second pair (published by Brijbasi and, like the first, clearly designed to be hung alongside each other), both Pratap and Shivaji wrestle

with a fiercesome tiger. Shivaji fends off the wounded tiger with his shield, ready to strike again with his blood-stained sword. Even more blood is evident in the Pratap Singh image (illus. 77), which depicts the tiger receiving Pratap's dagger up to the hilt as it tries to chew off his combatant's left hand. This fight takes place against a dramatic mountain backdrop, tempered slightly by that irrepressible sign of Nathdvara, floral luxuriance.

The spectator's eye is held by the violent struggle at the centre of the picture, the sheen of the tiger's coat and the lighter tone of Pratap's clothing. The mountain setting of the struggle then imprints its phenomenological trace, but what is perhaps the most significant element in the composition – a slaughtered cow[51] – remains camouflaged, lost in the tussle between the two central figures.

The Ravi Varma Press images, whose Cow Protection motifs were the subject of attempts at official censorship (see chapter 6), mapped out their elements semiologically in what was almost a two-dimensional space. Their mode of articulation was that of allegory in which the constituent parts operated almost as linguistic signifiers. Narottam Narayan's method is quite different and works through the gradual appearance of a ghostly figure that is impregnated into the density of the picture. The slaughtered cow, which is depicted beneath the upraised rear left foot of the tiger, is figurally imbricated in the folds of the landscape, opaque to the casual observer. The integration of the cow into the landscape was clearly designed to produce a partial invisibility in order to evade colonial prescription.

Narottam's fascination with the slippery distinction between form and content is further evident in a series of paintings and sketches he made – rather in the style of the sixteenth-century Milanese painter Arcimboldo – in which landscapes and other compositions are constructed out of animal forms. One shows two seated men listening to a suited guru whose hair is held by a figure behind him (illus. 78). Viewed from a distance the headwear of the two figures on the right

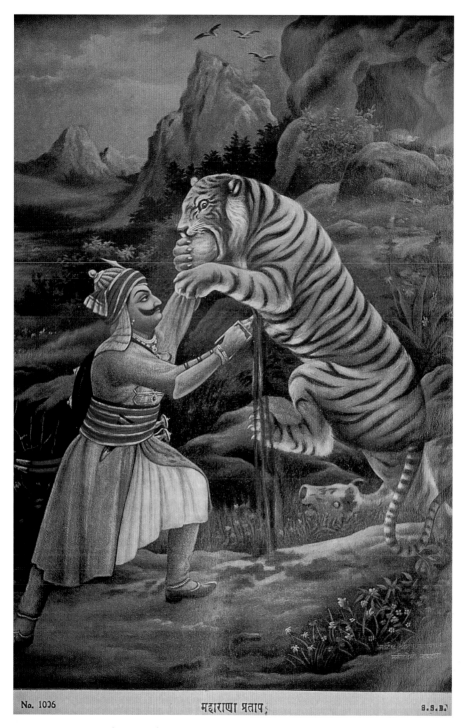

No. 1006 महाराणा प्रताप; S.S.B.

77 Narottam Narayan Sharma, *Maharana Pratap, c.* 1944. Published by S. S. Brijbasi.

becomes a camel's head and the guru's head part of its saddle. Narottam also produced several sketches and paintings of landscapes in which rivers tumbled over, or burbled alongside, rocks which on closer inspection reveal themselves to be crouching monkeys. These signify Hanuman's monkey army, which, as the *Ramayana* relates, rescued Sita from Lanka and whose actions helped restore the moral universe.

Narottam Narayan's images can be seen as a technician's experiment with a living landscape, in which he tests the capacity of different categories of being to invade and infest each other in a manner that recalls Arcimboldo. At one level this strategy develops a pre-existing concern with the mutually inclusionary capacity of visual forms to encompass the gods, which is apparent, for instance, in the 'Cow with 84 Deities' (illus. 79) and in a remarkable photographic montage of Gandhi (see illus. 100).

Narottam's experiments with the mutual imbrication of different domains are, however, accented in radically different ways. His monkey-landscape sketches are a positive affirmation of the Nathdvara pastoral aesthetic in which a figural excess signifies a religious repleteness. The monkey-landscapes work not through substitution but through addition – the river remains a river but is then revealed to be *also* a river *and* fragments of Ram's army. The monkey-

78 Unfinished sketch by Narottam Narayan Sharma, *c.* 1940.

landscapes thus exemplify a crucial quality of the figural density and multivalency of Nathdvara imagery. Narottam translates the task of representation from the modelling of objects within a three-dimensional space as a field of certainty (the colonial aspiration) into the presentation of cryptic elements on the picture plane. Depth is rejected in favour of the complexity of surface and clarity rejected in favour of uncertainty.

'NATIONAL FEELING'

My antiquarian enthusiasm for the work of artists such as Narottam and publishers such as Brijbasi might be read as an obscure argument about some obscure pictures. But I believe that they lay the foundation for some grander claims about nationalism, or as I would prefer to call it, following many nationalists' own usage, 'national feeling'.

Benedict Anderson's model of nationalism – like nearly all theories of nationalism – is a highly cerebral construct invoking flows of discourses in a world stripped of its materiality. Recent criticisms[52] have objected to its assumption that a 'modular' nationalism was reproduced globally (a claim that Anderson retracts in the second edition of *Imagined Communities*), and the elitism implicit in his stress on the cognitive dimensions of nationalist 'imaging', arguing instead for a subaltern messianic nationalism.

It is possible, however, to push these criticisms much further, and to edge to the centre of the nationalist stage a dangerous corporeality that 'national feeling' invokes.[53] Although in India, as elsewhere, nationalism had a life as a discourse, it also operated through the libidinous force fields that flowed around various embodiments. Embodiment is indeed crucial to the idea of the nation, embodiment in the form variously of gender, visual symbol, visual style, or sound. Nationalism indeed might be defined as culture materialized and embodied in the service of identity. I have already alluded to the argument that

political systems frequently create 'ecstatic aesthetic environment[s] . . . a kind of libidinal stimulation, an abundance of affect'.[54] In much the same way, Indian nationalism was driven by an intensely affective vision of the mother and her land.

In the 1920s and '30s both nationalist politics and mass-produced pictures found a new broader (and significantly rural) audience where religious modes of thought were tenacious: 'the peasants still needed to be represented by a saviour from above'.[55] Politics, like religion, was about 'an abundance of affect'. In pursuit of this affect, artists and publishers rejected colonial perspectival pedagogy. And, just as the poetry of Ossian or the music of Verdi or Smetana worked in a dimension beyond refutation and beyond contradiction,[56] so popular Indian imagery too came to occupy a powerful, and mass-disseminated, position situated in a domain beyond censorship, and beyond negation.

6 The politics of popular images: from cow protection to M. K. Gandhi, 1890-1950

The historical narrative presented in this book has delivered us to the mid-1930s. Via many twists and turns, it has taken us from the earliest moments of nationalist organization through to the period of the most intense anti-colonial activity by organizations that ranged from Congress to the Hindustan Socialist Republican Army.

Here I aim to present an overview of the political engagements of mass-produced images. We have seen that some presses (notably Chitrashala) had explicitly anti-British political agendas and we have seen that for many other presses commercial interest encouraged the production of images for diverse audiences that may well have simultaneously included anti-British and pro-British constituencies. I intend also to study these images *in circulation* in order to understand the complex and often cross-cutting interests that can be seen at play when we study their reception. In earlier chapters we have looked at images through the prism of specific printing presses. Here the method will be different, proceeding through the analysis of broad political movements and the colonial state's response to these. In pursuit of this we need to return to the late nineteenth century.

COW PROTECTION

The idea that the growth of nationalist sentiment was intimately linked to the development of what Benedict Anderson calls 'print capitalism' was prefigured in the conclusions of some British officials as they thought through the consequences of new media during the early 1890s. The Marquess of Lansdowne, the Viceroy, and others[1] expounded such a thesis in a memo in 1893. This was in part a response to the Earl of Kimberley's earlier question as to 'why . . . distur-bances are becoming more frequent than in past years' and Lansdowne argued that:

One of the causes [is] the greater frequency of communication and the interchange of news by

post and telegraph between different parts of the country . . .

This rapid dissemination of news and increasing activity of controversy, carried on through the Press, by public meetings, and by the addresses of itinerant preachers, is in some respects a new feature in Indian life, and is one which is likely to grow and add considerably to the difficulties of administration . . . pamphlets, leaflets . . . and placards of an inflammatory tendency have been disseminated throughout the country.[2]

In the later phases of the Cow Protection agitation, locally produced images were mobilized through collective action in a manner that prefigured the use of the ubiquitous Hindu chauvinist images of the 1980s and '90s. The historical record is unusually rich in the detail it provides of the consumption of visual images. There were two distinct phases to the Cow Protection agitation,[3] an earlier urban phase originating in the Punjab and after 1891 a later rural campaign focused in rural eastern districts bordering Bihar.[4] Ideological opposition to Muslim and Christian practice is more apparent in the early urban phase[5] and parochial inter-caste conflict emerges more strongly in the rural phase.[6] Dayananda Saraswati, the founder of the Arya Samaj, had formed the Gaurakshini Sabha (Cow-protecting Association) in 1882 and published a book (*Gokarunanidhi*) whose purpose, according to Farquhar, was 'to rouse Hindu feeling against Christians and Muhammadans on account of the killing of cows and oxen, and to present a monster petition to Government, begging that the practice might be prohibited.'[7]

The cow, an enormously potent and sacred sign, was to emerge as a symbol of the nation and these visual symbols were to play a vital role in the organization as well as the ideology of the Cow Protection movement. Cow Protection involved a struggle not only over a 'sacred symbol' but also, locally, over 'sacred spaces' and the specificity of local struggles also forged new senses of community: 'the

common experience of being incorporated in a "process of sanctification" defined group solidarity'.[8] At a regional level this spatialization took the form of a network of messengers and travelling preachers who could rapidly disseminate the cause over wide areas. Geographic reach was combined with the insertion of Cow Protection into the spaces of the everyday: 'no space, no occasion, it seemed, was inappropriate to organize and direct attention towards the issue of the cow'.[9] This colonization of quotidian space replicated the infestation of the body of the cow itself with the divine; in numerous lithographs the cow becomes a proto-nation, a space that embodies a Hindu cosmology. One of the earliest images was published by P. C. Biswas of Calcutta, and designs that had circulated in the 1890s were to be widely produced commercially after the turn of the century. These lithographs can be seen as mythic charters whose metaphors were instantaneously transformed into everyday spatial practice, an iconic mythopraxis that convulsed much of northern India.

In much of the visual imagery the cow encompassed all the gods, but was also depicted as succouring all the diversity of India's communities. In practice, however, and in the use made of these images, a more discriminatory message was stressed in which the cow came to represent a Hindu identity and nationality that required protection from non-Hindus. The riots of 1893, indeed, assumed an overtly communal flavour.

The elements of this strategy are apparent in a series of images depicting this cow, all of which share the common feature of the presence of 84 gods within the body of the cow and a group of figures kneeling beneath the udders. One sees in these images the literal inscription of the sacred onto the body of the disputed sign, a strategy that continued throughout the twentieth century.[10] One might also see these images as visual records of the foundational violence that, as Arjun Appadurai has suggested,[11] accompanies much locality building. The changing nature of the images vividly reveals the manner in which the cow became an inclusive symbol that was also grounded simultaneously in an exclusional foundational violence, which marked out Islam and Untouchable beef-eating practices as incompatible with this new space of the cow-nation.

Sometime after the P. C. Biswas image, the Ravi Varma Press issued two similar chromolithographs that developed the Cow Mother iconography (one of which is illus. 79). In both, Hindus, a Parsi, a European and a Muslim are seen accepting milk from the milkman with the slogan 'drink milk and protect the cow'. These, however, need to be considered in the context of other images, namely early Chitrashala prints and Ravi Varma's later painting *Milching a Cow*,[12] which was also produced in various chromolithographic variants. These record a splitting of the unified iconography of the Biswas image, a separation almost of the overtly political and the devotional, but it is easy to imagine how this separation also allowed for a more intense amalgamation in the viewer's mind as he or she internalized this spectrum of cow iconography.

Milching a Cow and its chromolithographic variants extract the woman who milks the cow in the earlier images, together with the small figure, identified as a 'Hindu', who leans against her back. In the latter rendition this woman is transmogrified into Yashoda, the small figure into Krishna.[13] By so transforming the 'Hindu' into Krishna, the Ravi Varma print undermines the putative democracy of the figures representing Hindus, Muslims, Parsis and Christians and opens the way for the communalist readings to which the image was subject in practice.

How were these images – or images very similar to these – used and read in the context of the Cow Protection movement of the 1890s? Fortunately several detailed documents exist that allow us partly to answer this question. The first of these, the memo from Lansdowne referred to above, provides a clear sense of the gamut of visual and performative signs that were made to do the work of cow protection during this period. I quote at length:

In addition to the inflammatory harangues delivered to meetings of Hindus, [wandering ascetics] have distributed throughout the country pictures of the cow, of a kind calculated to appeal strongly to the religious sentiment of the people. One of them, for instance, depicts a cow in the act of being slaughtered by three Muhammadan butchers, and is headed 'the present state'. Another exhibits a cow, in every part of whose body groups of Hindu deities and holy persons are shown, being assailed by a monster with a drawn sword entitled the 'Kali Yug' but which has been largely understood as typifying the Muhammadan community.

Another memo written in 1893, this time from Forbes, Commissioner of the Patna Division, to the Chief Secretary of the Government of Bengal, gives another description of the image after it had been seized in Champeran: 'the picture of a cow stamped with images of Gods, also contained a representation of a Musalman advancing to slay the cow and a Hindu beseeching him to refrain'.[14]

But these images did not simply freely circulate alongside written images, they were also used in contexts and events that constrained their meanings by providing a framework within which images could be read collectively. Freitag has also drawn attention to an account of a meeting in Azamgarh district in 1894, which provides invaluable data on how meanings were constructed in the process of consuming these images. A wealthy landholder named Ram Saran Singh organized the meeting in the town of Lar on 18 March 1893. A lithographed copy of rules adopted by other societies was circulated and amended after discussion. Attention then turned to the visual propaganda that the organizers had brought with them:

A cow picture was placed on a stool before the platform and copies of it were circulated. This picture represents a cow in whose body all the Hindu gods are depicted as residing. A calf is at her

udder and a woman sits before the calf holding a bowl waiting for her turn. This woman is labelled 'the Hindu'. Behind the cow, above her tail, is a representation as of Krishna labelled 'Dharmraj', and in front of the cow, above her head, is a man with a drawn sword labelled 'Kaliyug'. The Hindu who produced this picture expatiated on its meaning. The Hindu must only take the cow's milk after the calf has been satisfied. In the 'Dharmraj' of the Satyug no Hindu would kill a cow, but the Kaliyug is bent upon killing the cow and exterminating kine.

In the speaker's further explication we can delineate the structure of thought through which the 'cow' as a symbol of divinity and nationality would, within a mere ten years, be transformed into 'Mother India' (*Bharat Mata*) signifying nationality and divinity:

As every man drinks cow's milk just as he as an infant has drawn milk from his mother, the cow must be regarded as the universal mother, and so is called 'Gao Mata'. It is matricide to kill a cow. Nay more, as all the gods dwell in the cow, to kill a cow is to insult every Hindu. The Magistrate [at Deoria] found Muhammadans excited because they heard a picture was in circulation representing a Muhammadan with a drawn sword sacrificing a cow, and this they considered an insult.[15]

The 1915 Ravi Varma Press version of one of the images referred to in the reports, which would attract the attentions of the colonial censors (see below), is shown here (illus. 79). The figure with drawn sword is clearly labelled in the image as a representative of the *kaliyug*, presumably the demon *kali*. The caption above his head reads *he manusyaho! kaliyugi mansahari jivom ko dekho* ('mankind, look at the meat-eating souls of the kaliyug'), and the figure in yellow (labelled as *dharmaraj*) beseeches him with the words *mat maro gay sarv ka jivan hai* ('don't kill the cow, everyone is dependent on it').[16]

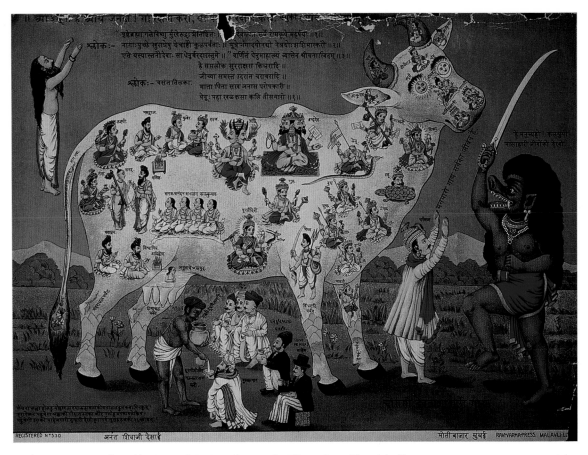

79 *Chaurasi Devata Auvali Gay* (the Cow with 84 Deities), *c.* 1912, Ravi Varma Press. The original image.

We can see here – in the use of the didactic image and its exegesis – the appropriation of missionary techniques of propaganda,[17] as befits a movement started by Dayanand Saraswati, who applied missionary rhetoric to Hindu concerns. Freitag notes that in addition to the distribution of pictures at meetings, plays were also staged and placards and pamphlets distributed.[18]

WORKING WITH THE 1910 PRESS ACT

The colonial state's response to the 'increasing activity of controversy' was the 1910 Press Act, which would become the chief means of controlling the 'native press' and the huge upsurge of topical broadsheets and visual images.[19] The colonial state's paranoia about the representational genii it had unleashed was expressed not only through the proscription of complete images but also in a pro-hibition of individual elements of images in an attempt to mitigate their power. However, although the colonial state could quite easily prohibit it could not interdict, since it could not unsay what it had itself helped to create and authorize. Proscription thus operated within a double-bind in which every denial was simultaneously a reinscription of represen-tational potency: to proscribe was also to specify a

powerful abject seemingly more powerful in its absence. This process can be seen clearly at work in a confrontation between the Bombay Government and the Ravi Varma Press. Ravi Varma had sold his interest in the press nine years earlier and it was now under the control of Fritz Schleicher, who had started work there as a litho transfer artist when the Press opened in 1894.[20]

In December 1911 the Bombay Government invoked section 12(1) of the Indian Press Act of 1910 to proscribe a Ravi Varma Press image titled *Ashtabhuja Devi* (illus. 80) and a month later proscribed matchboxes bearing 'a somewhat similar but less mischievous picture'.[21] Also in January 1912, the Local Government of the Central Provinces issued a notification under the Press Act to prevent the dissemination of the same *Ashtabhuja Devi* image. All copies of the picture found in the Central Provinces were to be forfeited to His Majesty. The justification for this was that the picture, in which:

> the Hindu Goddess called Ashtabhuja Devi is depicted riding a lion and furiously attacking two butchers who have apparently just decapitated a cow, printed at the Ravi Varma Press Karla and elsewhere,[22] contains visible representation likely to incite to acts of violence and to bring into hatred and contempt certain classes of His Majesty's subjects in British India . . .[23]

A memo from C. A. Kincaid, Secretary to the Government of Bombay, was to make clear that 'the picture was interpreted by the Government of the Punjab and by the Bombay Government as an anti-cow-killing document'.

In a petition to the Bombay High Court, Schleicher claimed that the description of the picture given in the notification of proscription was 'gravely erroneous and absolutely misconceived'. He argued that the image was no more than a mimetic visualization of an episode in the Mahabharata. Ashtabhuja Devi, otherwise known as Mahishasuramardini, rode on a lion to battle with the demon Mahishasur, whom Vishnu had requested she slay. Schleicher's petition continues:

> When she saw the extensive army of demons which occupied the ten directions, she was annoyed and assumed such a big form that her eight arms reached the eight directions and the crown on her head reached the sky above. The battle commenced and the result was that hundreds of thousand[s] [of] demons fell down and the bloodshed was so great, that even the elephant, chariots and foot soldiers in the demon's army were swept away in a flood of blood. Then Mahishasur with the assistance of his general Bidalaksha pushed forward to fight a duel with the great Goddess. The lion gave a blow to Bidalaksha with his paw and lay him flat on the ground. The Goddess pierced Mahishasur with her Trishul (trident). As soon as the demon was shot in his chest with the Trishul he assumed the form of a buffalo. The Goddess mounted on him and separated his head from his body.

The picture shows the lion springing on Bidalaksha and the Goddess is shown simultaneously severing Mahishasur's head, piercing the demon/buffalo with her trishul, and treading on the decapitated buffalo.

An initial reading suggests something hugely comic in a German businessman cobbling together this recension of the *Mahabharata* in an attempt to persuade anxious colonial officials that what they perceive to be an innocent cow is a demon buffalo in whose death the Hindu consumers of the image glorified.[24] Schleicher claims in his petition that 'it is erroneous to interpret the two demons shown in the picture as butchers and that it is also erroneous to interpret that they are apparently decapitating a cow'. But a closer look complicates the matter greatly, for the buffalo is very definitely cow-like in colouring and physiology. Similarly there is a subtle displacement of agency marked by the presence of blood on Bidalaksha's sword and its absence on the goddess's. The implication is clearly that it is the foregrounded

अष्टभुजादेवी

80 *Ashtabhuja Devi*, the original Ravi Varma Press chromolithograph.

figure with the sword who has just slain the buffalo/cow and upon whom the lion wreaks vengeance. In the absence of clear textual knowledge among the popular consumers of this image a reading that constructs it as the goddess's retribution upon two Muslim or Untouchable butchers who have just slaughtered a cow seems highly plausible.

The precise nature of the agreement reached between Schleicher and the Government indicates that those who sought to proscribe it had a clear sense of the deliberate mis-recognition that the image was seeking to provoke. Following advice to the Government that they were likely to be unsuccessful in their prosecution, they proposed that if Schleicher consented to 'make certain alterations in the pictures' and

withdrew his suit they would pay compensation for the pictures seized earlier by the police. In return Schleicher agreed that in future copies of the picture 'the blood stains on the sword of one of the two men will be removed and the animal will be coloured black'. Schleicher did this and the print was quickly reissued with these marginal changes (illus. 82).

A similar undertaking[25] was given in respect of another Ravi Varma Press picture that we have already seen (see illus. 79). This was but the latest in a line of similar images stretching back two decades, and under the terms of the compromise Schleicher agreed that in future copies 'the figure of the demon in front of the cow shall be removed'. Shortly thereafter a similar print was issued, this time in vertical portrait format, in which Dharmaraj beseeches the empty void where once the sword-wielding demon stood (illus. 81).

NATIONAL ALLEGORY AND THE RISE OF NATIONAL FIGURE

> . . . if it is through the historian one learns of national destiny, the paradigmatic figure of the national community is the artist.[26]

In early Calcutta lithography (for instance depictions of Nala Damayanti), and in the disputed Ravi Varma Press images described above, it is clear that the nation is invoked primarily through allegory. This is an allegory open to 'linguistic' decoding and was highly susceptible to colonial control. Within a few decades, however, it was superseded by what we might term 'figure' or the affective. In part, this history was determined by a dialectical constraint: figural affective intensities required the semiotic infrastructure of allegory and other political significations, which of necessity had recourse to substitution. Once allegory has done its laborious work, figure could transform these associations into immediate identifications.

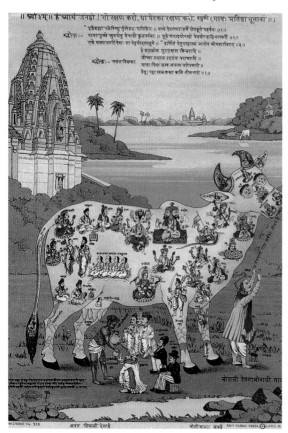

81 The amended version of the Ravi Varma Press *Chaurasi Devata Auvali Gay* (see illus. 80).

82 *Ashtabhuja Devi*, the revised Ravi Varma Press chromolithograph.

Allegory offers the theoretical possibility of closure. 'Meanings' can be specified and secured: producers and consumers can agree (or rather attempt to agree) that under the prevailing code a particular sign stands in for another sign. This is the basic mechanism of allegory, which the *Oxford English Dictionary* explains as the 'description of a subject under the guise of some other subject of aptly suggestive resemblance'.

Bharat Uddhar, a proscribed image from 1931 (illus. 83), presupposed knowledge of its missing allegorical referent: the story of Markandey. Images produced by Chitrashala and the Ravi Varma Press (illus. 84)

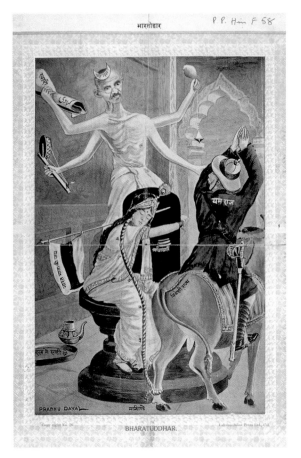

83 *Bharat Uddhar*. Prabhu Dayas. Published by Shyam Sunder Lal, Cawnpore. A proscribed image in which Gandhi saves Mother India from the depradations of colonial rule.

depicting Shiv saving the young Markandey from Yam, the lord of the dead astride a buffalo, had circulated widely since the 1880s. *Bharat Uddhar* appropriated this basic structure but substituted Mother India for Markandey, British Rule for Yam, and Gandhi for Shiv. With foreknowledge of the Markandey image, the viewer of *Bharat Uddhar* could readily translate the one narrative into the other.

Allegory's referentiality was certainly presumed by the colonial state, and its method of surveillance was (to use Dan Sperber's term) 'crypotological', that is predicated on the assumption that signs could be decoded for their 'true' meanings.[27] Thus Kunja Behari Gangopadhyaya's early twentieth-century Bengali drama *Matri Puja* was 'a seditious allegory on the present political situation of the country',[28] despite being 'ostensibly founded on a well-known incident of Hindu mythology'.

But the colonial state was also *ethnographically* concerned with audiences' reception of signs, seeking confirmation in the ability of the wider audience to decode the 'message': 'It will be clear from the newspaper criticisms printed at the end of the book that it has been generally understood as referring "to many present day political and social ideas"'.[29]

Many Home Political Department proscription orders describe pictures under a crypotological rubric,[30] assuming that the image can be disassembled and its signs checked off against their presumed referents. Alongside court judgements on the 'meanings' of contentious images, there are a number of remarkable adjudications on seditious poems and plays in which colonial judges turn their hands to practical criticism, minutely analysing the possible intentions and effects of words and phrases.

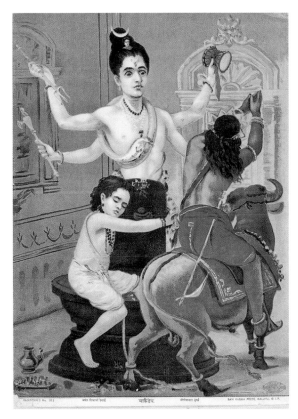

84 *Markandey*, c. 1900. Ravi Varma Press. The mythological template for the previous image.

OF STAMPS, DHOTIS AND THE EVERYDAY

Popular anti-colonial interventions appear to have created an increasingly congested circulation of signs continually available to public recall in this semi-otically saturated domain of the everyday. In this circulation, events and their representations criss-crossed media – from lithograph to theatre, from theatre to cinema, from cinema to leaflet, a pattern with which the reader will by now be familiar.

In July 1930 the Bombay Provincial Congress Committee issued stamps bearing the words 'Boycott British Goods' with the intention that its supporters would affix these to envelopes and postcards. The colonial state's response to these 'boycott stamps' was to throw into stark relief the difficulties it faced in regulating the visual 'everyday'.

Initially it appeared that there would be no objection to the use of such stamps. The Bombay Presidency Postmaster told the *Indian Daily Mail* on 4 July that 'You can write anything you like on your cover. If you like you may even affix your photograph to it. So long as it bears our usual stamp there can be no objection.' Such indifference caused concern to others in the Government and legal clarification was sought as to whether the slogan ('Boycott British Goods') might be considered 'seditious', 'scurrilous' or 'grossly offensive' under the relevant section of the Post Office Act. The advice given indicated that the Government could act if it wished, but it would then also have to proscribe slogans such as 'Shop with Selfridges'. Extensive correspondence between the Home Political Department and the Bombay Postmaster General ensued, and suggestions for further legislation were made before the Legal Department again pointed out the difficulties of isolating these specific stamps in any new proscription. 'I have found great difficulty' opined D. G. Mitchell, 'in devising a formula which is free from obvious objection':

I have tried several variants of the term 'political significance', but could not find one which did not cover harmless activities . . . The difficulties may be seen from a consideration of the following actual cases – or probable cases – (1) Photographs of Mr. Gandhi with no accompanying text; (2) reproductions of the 'national flag'; (3) the device of the Overseas League, from whom I have just received a communication; (4) an open post-card soliciting a vote at an election; (5) post-cards bearing the slogan 'Vote for Swaraj' (or any other political cause); (6) the device on the envelopes of the P. & O. [Company]

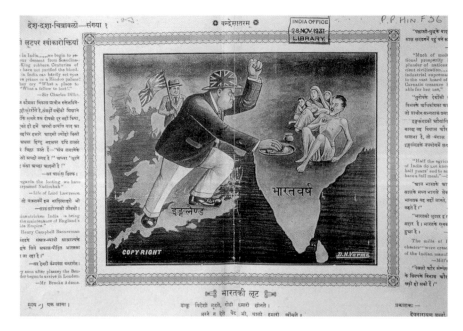

85 *Bharat Ki Lut*. Devnarayan Varma. A proscribed image from 1930: an engorged and rapacious England loots a starving India.

This domain of indeterminate 'political significance' is precisely the domain that 'national figure' comes to occupy.

Perhaps the most striking anti-colonial cross-media artefact was a *dhoti* sold in Calcutta in 1910, on which was printed a song in praise of Khudiram Bose, who had been executed in 1908 (see below). The Bengali text both began and ended with words that are still widely sung in Calcutta: 'Mother, farewell/ I shall go to the gallows with a smile./ The people of India will see this./ One bomb can kill a man./ There are lakhs of bombs in our houses./ Mother, what can the English do?'[31] The appearance of this *dhoti* triggered a surreal debate as to whether it could be considered a 'document' under section 2(6) of the Indian Press Act 1910 (it was finally deemed to be so and Notification no. 1350-P was published in the *Calcutta Gazette Extraordinary*, declaring that all such *dhotis* should be 'forfeited to His Majesty').

This is one of many examples of nationalist signs' continual challenge to the colonial state's ability to categorize and control them. Many Nathdvara images, such as Narottam's *Maharana Pratap* (see illus. 77),

presented a similar, though more successful, challenge: allegory (intentional politics) becomes 'figure' and is mutated into a realm of the unclassifiable, a corporeal domain beyond analysis and constraint. This process can perhaps be seen most clearly in the transformation of the artist Rup Kishor Kapur from allegorist to figuralist. His career is discussed in the next section.

My use of 'figure' here loosely follows the philosopher Jean-François Lyotard's use of it to connote a domain where 'meaning is not produced and communicated, but intensities are felt'.[32] Lyotard invoked 'figure' as the opposite of 'discourse', a domain of the knowable characterized by 'linguistic-philosophical closure'. My own usage of 'figure' differs from Lyotard, however, in not assuming the same ontological independence that he grants it. I use it to invoke, in a deliberately flexible manner, the densely compressed performative and the affectively and libidinally charged domain that escapes conventional signification.

GANDHI VERSUS BHAGAT SINGH

I opened this book questioning whether there might be a 'visual' history, that is a history constituted by the visual in which the visual was something other than simply a reflection of something already established 'by other means', to recall Carlo Ginzburg's phrase.

This question, with its implicit possibility of alternative historiographies, acquires its greatest saliency when thinking about the histories of two Indian freedom fighters, Gandhi and Bhagat Singh. M. K. Gandhi is of course an internationally recognized name, one of the few figures to have made it into the sanctum of global saintliness. Bhagat Singh is on the other hand probably an obscure name to many readers of this account. If indeed he is so, it could not be said that this necessarily reflects my readers' ignorance of Indian academic history, for in that version of history the reader will find very few clues as to the nature and actions of Bhagat.

When I first started research in India I was fascinated (but mystified) by the presence of a figure whom I often glimpsed in images for sale on vendors' stalls, or hanging in the offices of radical lawyers, or of certain trade unions. In some of these images he seemed to wear a trilby. In others he seemed to wear a Brahmanic sacred thread across his bare chest and clutch a pistol while nonchalantly twiddling his moustache. It was only after many, many months that I managed to grasp that these were in fact two quite separate persons – Bhagat Singh and Chandra Shekhar Azad – despite the fact they seemed to be presented with an identical physiognomy. Subsequently I have read what I have been able to find about these two individuals and the movement of which they were a part, but I have remained acutely aware that their historical trace has largely existed in India's public spaces rather than in institutional archives. Official history has diverged so fundamentally from the popular narrative that it has left us few tools with which to understand a figure such as Bhagat Singh. His pictures are, as we shall see, the greatest resource we

have and can give us some insight into the ways in which hugely significant visual traces can endure in the gaps between official forms of knowledge.

Once we start to examine the figure of Bhagat Singh, however, we will discover that his trace is one element in a longer train of signs and events that runs through the history of those who chose violence in their attempts to end British colonial rule. Bhagat's historical moment ineluctably tightens us to a chain of connecting events that seem to be locked into each other with a grim retributive inevitability. The echoes that resonate through this long chamber impel us to move back as far as 1908 when a series of events start to unfold.

On 30 April of that year, in Muzaffarpur, Khudiram Bose threw a bomb at a carriage that he believed contained Chief Presidency Magistrate Douglas Kingsford. In fact the carriage contained two women, a Mrs and Miss Kennedy, who were both killed. Within two days Khudiram was arrested. His accomplice shot himself dead on arrest; the following year the Sub-Inspector who arrested him would be shot dead (in Serpentine Lane, Calcutta) in revenge.[33] The naive Khudiram, who further implicated himself as he tried to defend himself at his trial, was found guilty and then executed on 11 August 1908. Chromolithographs of his trial and execution issued in the 1930s and '40s powerfully evoke the retributive technology of the state with its complex infrastructure of telephones, temporality and slow death (illus. 86, 87 & 88). It is likely that these are later renditions of images that were circulating shortly after Khudiram's execution, but these are the earliest to have survived.

They provide a powerful sense of the resonances that colonialism's techno-rational grid had acquired by the early 1940s. A Calcutta image (see illus. 86) depicting Khudiram Bose's trial shows Khudiram in the dock, but the grid here is more than simply the wooden cage that contains him. It is also made up of the coercive paraphernalia of the state: its personnel, such as the judge and court officials, systems of knowledge and communication signified by the judge

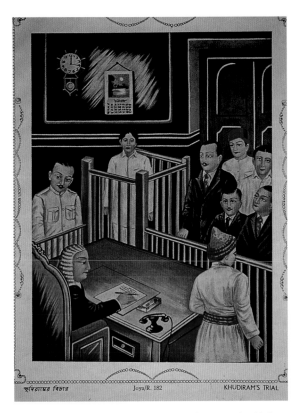

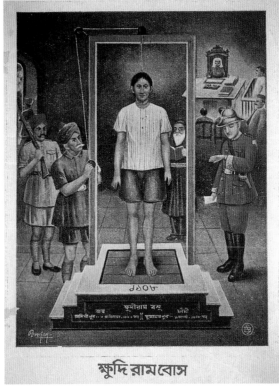

ক্ষুদিরামের বিচার Joya/R. 182 KHUDIRAM'S TRIAL

ক্ষুদি রাম বোস

86 *Khudiram's Trial. c.* 1940. Unknown Bengali artist and publisher. A later image depicting events in 1908. Note the clock and calendar at top left.

87 Brojen, execution of Khudiram, *c.* 1930s–40s. Unknown publisher. A barbarous colonial temporality again features prominently.

writing and the telephone to his right, and above all by systems of temporal regularity – the clock and calendar hanging on the wall behind Khudiram.

The image presents what is literally a carpentered universe – the perspectival regularities of the judge's desk expand to trap Khudiram within its wooden constraints, and this space of colonial jurisdiction is further defined through linear rigidities of the background wall and the door, which are arbitrarily truncated by a photographic framing. Unlike the Nathdvara idealized landscapes, whose completeness curls up and around the picture frame, the realist framing of 'Khudiram's Trial' suggests its relation to a continuum of other hostile spaces and this linkage is further suggested by the telephone, whose wire leads

out of the bottom of the picture, the recipient of the letter the judge is writing and the 'meanwhile' of all the other colonized spaces in which similar clocks tick away in this barbarous and violent 'empty homogenous time'.

Lithographs of Khudiram's execution continue to explore this confrontation with the 'calculating analytic'[34] of colonialism. Brojen's image (see illus. 87) traces the causal connection between the judgement shown in the top-right corner and the execution that is the main subject of the image, and counterpoises this on the left with an open doorway. The main part of the Brojen image shares much with a Rising Art Cottage lithograph (illus. 88): the retributive state technology of death is represented in detail, with

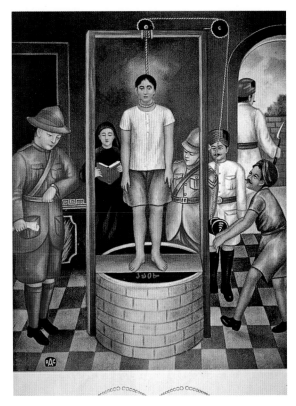

88 Khudiram's execution. Rising Art Cottage chromolithograph
c. 1940. The British figure on the left times the event precisely.

Khudiram suspended from a wooden frame and his
noose controlled by a complex system of pulleys.
Other foundations of the colonial state (the gun and
the bible) are shown, and controlling the whole event
is a red-uniformed, sola-topied English soldier who
looks at his watch, synchronizing this particular act of
barbarity with a 'meanwhile' of countless other
brutalities. In the Rising Art Cottage print the techno-
rationalist grid of this barbarity is mapped by the
chequered floor and the striations of the brick wall
over which, nevertheless, an Indian sky can be seen
and thus the immortal can be contrasted with the
temporal and corrupt.

'Among those', in the words of the 1918 Rowlatt
Sedition Committee Report, 'who united to excuse

Khudiram and to praise the bomb as a weapon of
offence against unpopular officials was Tilak', whose
connection with the Chitrashala Press from the late
1870s onwards we have already discussed (see chapter
3).[35] One of the manifestations of this was an article
entitled 'The Country's Misfortune', which appeared in
Kesari, the Marathi paper that Tilak himself edited, on
12 May 1908. In this, Tilak expressed his sorrow that a
country 'which by its very nature is mild and peace-
loving' has fallen into a condition akin to European
Russia. He noted that even Khudiram felt sorry for the
two women he had killed, but that since the partition
of Bengal 'the minds of the Bengalis have become most
exasperated' and that:

> under these circumstances, no one in the world,
> except the white officials, inebriated with the
> insolence of authority, will think that not even a
> very few of the people of Bengal should become
> turn-headed and feel inclined to commit excesses.
> Experience shows that even a cat shut up in a house
> rushes with vehemence upon a person who
> confines [it there] and tries to kill it.[36]

It was this article, together with a subsequent piece
published on 9 June 1908, bearing a title that translated
as 'These remedies are not lasting', that was the official
provocation for Tilak's trial in Bombay later in 1908,
following which he would be imprisoned for six
years.[37] 'These remedies are not lasting' forecast the
end of an iniquitous British rule in India. Earlier
oppressive and unjust colonizers such as the Mughals,
Tilak suggests, prompted discontent and extreme acts
of self-sacrifice but no report of this ever reached 'the
ears of the Government'.

In the twentieth century all this had changed: 'turn-
headed men' now had access to the bomb and could
make everyone sit up and listen. Tilak articulates this
historical transformation not simply in terms of the
oppressed's new access to weaponry but to the
dissemination of a very particular chimerical tech-
nology of vernacular bomb-making. 'The bomb', he

told *Kesari* readers, 'is not a thing like muskets or guns ... it is a simple sport of science':

> Muskets and guns may be taken away from the subjects by means of the Arms Act; and the manufacture, too, of guns and muskets without the permission of Government, may be stopped; but is it possible to stop or do away with the bomb by means of laws or the supervision of officials or the busy swarming of the detective police? The bomb has more the form of knowledge, it is a [kind of] witchcraft, it is a charm, an amulet.[38]

Tilak's argument appears to be that bombs should be thought of as a kind of 'knowledge' because their production was inscribed primarily through information rather than technology:

> It has not much the features of a visible object manufactured in a big factory. Big factories are necessary for the bombs required by the military forces of Government, but not much (in the way of) materials is necessary to prepare five or ten bombs required by violent turn-headed persons. Virendra's big factory of bombs [was stored in] one or two jars and five or ten bottles.

Vernacular bombs can be produced from materials stored in a few bottles. What is more, the knowledge need to produce vernacular bombs is simple: 'the formula of the bomb does not at all appear to be a lengthy one and [its] process also is very short indeed'. If the bomb, for Tilak, was significant because of its portability, non-industrial and essentially indigenous – or *swadeshi* – identity, it was also a technology that revealed itself to be an intellectual strategy. Its 'witchcraft' lay in its knowledge-based nature and its transformation of an infrastructural practice into an epistemological one.

The parallels with the small printing press are striking for, as Lansdowne and the colonial state had already nervously discovered as early as 1893, new informational flows ('the interchange of news') floating free of their earlier infrastructural constraints were potentially highly destabilizing.

In his summing up, the judge had sections of the disputed translations of Tilak's piece written out for him in what he termed a 'readable calligraphy'. The original of the passage translated as 'The bomb has more the form of knowledge, it is a kind of witchcraft, it is a charm, an amulet' was *hi ek jadu ahe// ha ek mantra todga ahe*.[39] In Marathi, as in Hindi, *jadu* connotes 'magic, sorcery, witchcraft'. Likewise, *mantra*, as in other north Indian languages, connotes 'a charm, an incantation'. For *todga* the *Arya-Bhushan Marathi-English Dictionary* gives 'Any wild, magical or superstitious device for the removal of demon[ic] influence or disease; a charm, an amulet, a spell'.[40] In its opening address the prosecution questioned 'How does a bomb become a witchcraft, or amulet or charm, unless it is intended to be used', and the judge suggested that 'in the similes you have the effects of the bombs explained [in] various ways'.

That the intent of this phrase should have become the central focus in the trial is intriguing and revealing. One reading might stress the ambivalent colonial anxiety centred on the possibility of a 'deformed' political theology – a fusing of Hinduism with a politics of alterity – in the analysis of which ordinary political theory would be useless. The prospect of this paradigmatic shift, which might transform rational political action into a cosmological strategy, was at once thrilling and terrifying.

Only a few months earlier, the colonial official Herbert Hope Risley had expressed severe anxieties about such a 'deformation' and would find in a chromolithographic image of Kali, seemingly garlanded with European heads, a prediction of the fall of the British empire.

'We are overwhelmed with a mass of heterogeneous material, some of it misguided, some of it frankly seditious', Risley had declared in 1907.[41] It was in pursuit of such material that Risley despatched his assistant, B. A. Gupte, to Dalhousie Square,

Calcutta, to monitor popular chromolithographs for seditious intent. Gupte wrote to Risley that 'Of those I could collect last evening, I feel that the one printed for a cigarette manufacturer is the most effective and significant.'[42] Gupte was referring to a Calcutta Art Studio lithograph of Kali (illus. 90) which had been in circulation in various forms since the late 1870s.[43] Gupte was alarmed, although quite why is sometimes hard to discern. He remarked on 'the artistically cunning "modulation" of the caste marks' on Kali's garland of heads, noting that some lacked these marks, Gupte's conclusions seemingly being that they must be Europeans. In a similar vein, Gupte notes 'the symbolical British lion couchant in the . . . N. W. corner, his fall in the N. E. corner and a decapitated *red coated* soldier in the S. E. corner'. 'The falling head near the toes of the prostrate "husband" [Shiv]', he continues, 'leaves no doubt as to the intention of the designer'.[44] Gupte concludes with the observation that he is 'promised more "editions"', and that they will be forwarded to Risley.[45] It was Risley's awareness of such 'seditious' material, freely available on the streets of Calcutta, that encouraged him to draft the 1910 Press Act.

For Tilak the sense of a technology that had 'more the form of knowledge' must have had an earlier resonance as the result of his intimate relationship throughout the 1870s and '80s with the picture publisher Vishnu Krishna Chiplunkar. Lithography itself, which had been so important in democratizing Indian print culture, might also be considered a technology that has 'more the form of knowledge'.

If the bomb was, for Tilak, especially attractive because of its new democratic technology, it was mobilized in counterpoint to a much older weapon – the sword. Like the bomb, the sword embodied a technological simplicity, but it was also a sign that linked the contemporary struggle to a mythic infrastructure that validated the freedom-fighters' actions. We have already seen some aspects of the complex pan-Indian linkages between images of Bhavani's sword that criss-cross from Maharastra to

Bengal and back again, and we will return to this shortly.

The 1908 trial is interesting in another respect: the verbatim proceedings published by Kelkar, the editor of *Mahratta*, had as its frontispiece a striking studio portrait of Tilak (illus. 89), beneath which was printed Tilak's proclamation that 'In spite of the verdict of the Jury, I maintain that I am innocent. There are higher Powers that rule the destiny of things and it may be the will of Providence that the cause which I represent may prosper more by my suffering than by my remaining free.' The photograph itself is attributed to 'Phalke and Co. Dadar Bombay'. It is impossible to be certain, but it is overwhelmingly likely that this was a

89 Portrait of Tilak by 'Phalke & Co.'. Pasted in photographic frontispiece to N. C. Kelkar's verbatim report on the 1908 trial.

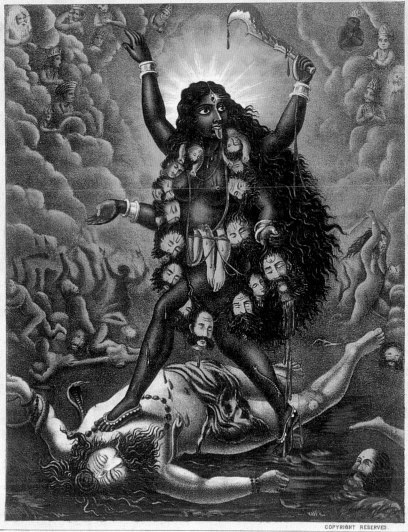

90 Calcutta Art Studio chromolithograph of Kali, collected by B. A. Gupte in Dalhousie Square, Calcutta, in December 1908. The advertising messages around the image urge Indians to buy Kali cigarettes 'to look after the interests of this country's poor and humble workers'.

product of D. G. Phalke's period working as a photo-grapher, before the founding of Lakshmi Art Printing Works, his work for the Ravi Varma Press and his emergence as the 'father' of Indian cinema (see chapter 4). We should recall that it would be Tilak's *Kesari* in which Phalke would announce the nationalist aspiration that had impelled him to make films: the desire to 'see Indian images on the screen'.[46]

Tilak's closeness to another major figure, Lala Lajpat Rai (the 'Punjab Kesari'),[47] was marked in some visual propaganda. The *Om Arya Kailendar* (illus. 91) for February 1919 pictures them both beneath a sword-wielding Mother India. The sword is inscribed 'shakti' and she bears a book inscribed 'vidya' (education). 'Awake brave Indians', the calendar (which was pro-scribed) implores. Each month of the year delivers a new energizing proclamation:

> Indians should now give up their natural hum-bleness . . . we must avoid expressing our demands in doubtful and ambiguous terms.
> Arise, Mother India! Awake, Mother India! Wipe the tears from your face! Do not be anxious. Your sons have determined to give their lives for your sake, if you require it.
> Be ready with body, mind, wealth and strength to obtain your birth right.[48]

During the widespread opposition to the Simon Commission's arrival in 1928 Lala Lajpat Rai was injured when police charged with lathis and subse-quently died. The Intelligence Bureau's *Terrorism in India 1917–1936* report claimed that his death was 'falsely alleged' to have been 'the result of his having been beaten by the police' but that 'in point of fact L. Lajpat Rai received no injury' at their hands. Contemporary press images, however, suggest the contrary (illus. 92).

The Hindustan Socialist Republican Army (HSRA), which had been founded two months earlier in September 1928,[49] then targeted J. A. Scott, the Senior Superintendent of Police in Lahore who was held to

91 *Om Arya Kailendar*, 1919, with vignettes of Tilak and Lala Lajpat Rai beneath Mother India. A proscribed publication.

be guilty of Lajpat Rai's death. On 17 December the HSRA assassinated Assistant Superintendent Saunders whom they mistook for Scott; Rajguru fired at him, causing him to fall from his motorbike, and Bhagat Singh shot Saunders several times as he lay on the ground. Chandra Shekhar Azad killed Head Constable Chanan Singh as they made their escape. Posters subsequently appeared (in Bhagat's hand-writing) announcing that 'Saunders is dead, Lalaji is avenged'. Following this Bhagat Singh went to Calcutta, seeking instruction in explosives technology from Jatindra Nath Das.

92 Newspaper image of Lala Lajpat Rai's wounds received while demonstrating against the Simon Commission in 1928 (source unknown). It is these wounds which led to Rai's death, triggering some of the actions of the HSRA.

is usually cited noting Bhagat's 'sudden and amazing popularity'. The *Terrorism in India 1917-1936* report also commented on this remarkable popular acclaim:

> Public opinion, unsettled by the Civil Disobedience Movement, ran wild and was further excited in favour of the revolutionaries under trial by most of the nationalist newspapers, which painted the accused as oppressed martyrs placed on their trial by an Imperialistic Government for purely patriotic acts. Bhagat Singh especially became a national hero, and his exploits were freely lauded in the nationalist press, so that, for a time, he bade fair to oust Mr. Gandhi as the foremost political figure of the day. His photograph was to be met with in many houses, and his plaster busts found a large market.[50]

Bhagat Singh has also been the subject of numerous chromolithographs since 1931 and of several films: Jagdish Gautama's *Shaheed-E-Azam Bhagat Singh* (1954); K. N. Bansal's *Shaheed Bhagat Singh* (1963); S. Ram Sharma's famous hit *Shaheed* (1965), starring Manoj Kumar; and most recently Rajkumar Santoshi's *The Legend of Bhagat Singh* (2002). At the time of writing there are a further three films on Bhagat due for release.

Bhagat remains prominent in many South Asians' consciousness: I. K. Gujral's speech on the fiftieth anniversary of India's independence commenced with his 'gratitude [to] those innumerable martyrs who suffered in jail', and he then listed Ashfaq, Bismil, Bhagat Singh, Rajguru and Shukhdev.[51] The Tamil Tiger leader Velupillai Pirabakaran, interviewed by a Jaffna literary magazine in April 1994 and quizzed as to what had impelled him to take up arms against oppression, replied that 'I developed a deep attachment to the Indian freedom struggle and martyrs like Subhash Chandra Bose, B[h]agat Singh and [Balgangadhar] Tilak'.[52] And this celebration by national figures has been reciprocated consistently at a grass-roots level. Thus, for instance, in November 1998 the Chandigarh

Further HSRA actions included Bhagat Singh and B.K. Dutt throwing bombs into the Legislative Assembly in April 1929. Bhagat was arrested, sentenced to death by a Special Tribunal under Ordinance No. III of 1930 and, together with Shukhdev and Rajguru, hanged on 23 March 1931 (illus. 93 & 94). The images of Bhagat Singh's execution complete, with Khudiram, the circle along the other arc of which lies Lala Lajpat Rai and Tilak.

Bhagat Singh's popular appeal was (and still is) enormous, and this is usually presented as an intriguing anomaly: Jawaharlal Nehru's *Autobiography*

93 Bhagat Singh, Rajguru and Shukhdev, anonymous print *c.* 1931. Watched over by Nehru and Gandhi at the top of the image, the three martyrs are depicted within a tomb to sacrifice.

94 Lahore Case Conspiracy Decision, *c.* 1931. The main protagonists offer their heads to Mother India on the left. Krishna hovers above and on the right a ship takes revolutionaries across the Bay of Bengal to incarceration in the Andaman Islands.

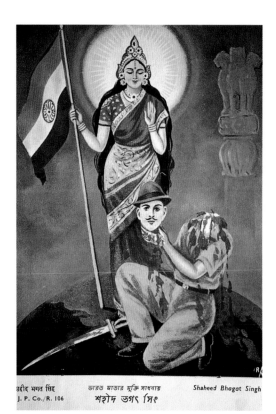

95 Shaheed Bhagat Singh, *c.* 1940. A later colour version that develops Rup Kishor Kapur's iconography. Published by Rising Art Cottage, Calcutta.

Bharatiya Vidyalaya celebrated its Annual Day (with Finance Minister Kanwaljit Singh presiding) by staging a play: *Bhagat Singh, Prince among Martyrs.*[53] Continuing buoyant sales for H. R. Raja's images (see chapter 7) suggest that this popular enthusiasm is pervasive, especially in the Punjab and Uttar Pradesh.[54]

Bhagat Singh's huge popularity is on the face of it very surprising, indeed it is one of the puzzles of twentieth-century Indian history. The HSRA represented the antithesis of Gandhianism not only because of its commitment to violence, but also in its militant atheism. This, as Sumit Sarkar notes, was most marked in Bhagat Singh (the HSRA member who most captured the popular imagination), who was 'marked by an increasingly deep commitment to Marxian

socialism and – equally remarkable, perhaps, given the strong Hindu religiosity of the earlier terrorists – militant atheism'.[55] Bhagat Singh's remarkable prison notebooks, which have been published recently, provide ample testament to his rigorous materialist mind.[56]

But this puzzle can be partly unravelled by attending to the images themselves and their chief feature – the trilby. In so doing we will find an echo of Tilak's trope of the bomb as 'a practice of knowledge' in Bhagat Singh's audacious mimicry. The trilby will emerge as the chief sign of Bhagat's ability to 'pass'.

Since the first popular images of him appeared in 1931, Bhagat has nearly always been depicted wearing a trilby. Although born into a Jat Sikh family and returning to the turban just prior to his execution, under the influence of Bhai Sahib Randhir Singh,[57] his popular visual incarnation has nearly always been as a mimic of the English sahab. His trilby, it transpires, has a historical explanation: pursued by the police, Bhagat Singh escaped disguised as a wealthy official.[58] J. N. Sanyal's proscribed 1931 publication gives this account:

> He dressed up as a young Government official, adopted a big official name, put labels on his trunk and portmanteau, and in the company of a beautiful lady, entrained a first class compartment at the Central Railway station in the face of those very CID officials who were specially deputed to arrest the assassin of Mr Saunders.[59]

Sanyal, we should remember, was sentenced to two years' imprisonment for the publication of this book. Other key texts in the Bhagat cult, such as those by K. K. Khullar[60] and Manmathnath Gupta, concur in emphasizing this episode. Gupta explains that Chandra Shekhar Azad, who is commonly represented with Bhagat, had to adopt a different disguise:

> Chandrashekhar Azad, owing to his unique personality, could not fit into this bourgeois set up.

The contours of his person were so sedulously imprinted on the minds of the policemen that he would have been immediately recognised. So he invented his own disguise. He joined a group of holy beggars and sang and danced out of the city, which had now become too hot for revolutionaries.[61]

In an illuminating consideration of the continuities and disjunctures between the images of Dalip Singh, M. K. Gandhi and Bhagat Singh, Simeran Gell has suggested that Bhagat Singh is such an especially alluring figure to many Indians precisely because of his mimicry – or rather his performative/deformative incarnation of the Englishman. She narrates her discomfort as a Delhi schoolgirl at being confronted with images of Gandhi in London – 'his emaciated frame and rickety legs strikingly exposed under a white "loincloth"'. This somatic transparency (the surface inscription of an interior moral truth) provoked mixed emotions – pride in a figure whom she had been taught to venerate but also embarrassment. Gandhi, she recalls was surrounded by 'British men in pin-striped suits set off with jaunty hats and solid, gleaming black shoes', but this picture sparked feelings of what she describes as 'racial ambivalence': 'I did not want to identify with this man but with his manly English protagonists, whose generosity in treating this seemingly poor, shambling man on a par with themselves was only too apparent.'[62]

Bhagat Singh was the antithesis of this 'poor shambling man'. Whereas Gandhi was thrown out of a first class compartment, Bhagat Singh, by 'impersonating a Britisher shortly after killing one' defiantly claims what is his by right. Simeran Gell suggests that:

Bhagat Singh's image broadcasts the fact that ultimately all confrontation is encountered and experienced at the personal level, and that the struggle against colonialism and racism should be regarded as a struggle against oppression in its elementary form: one person against another, one man against another, one body against another, not one 'race' or 'culture' or 'community'.[63]

Gell further argues that Bhagat Singh's popularity is due in large part to the fact that he symbolizes 'the triumph over the most insidious prison of all – the body' and that his strange image 'expresses the death of race'. One might propose Bhagat Singh as a universally appealing trope who symbolizes all of our desires to transcend our bodies and our identities: perhaps there is no more basic human fantasy. But Bhagat Singh bears a particular local inflection, not least because of his relation (and opposition) to Gandhi.

Gandhi also, of course, fought his own battle with the body, but it was one explicitly articulated within a neo-traditionalist paradigm that was branded 'made in India'. His attempt to make politics an experiment in truth, in which the surface was all you got, may well have tapped into powerful notions of bio-moral substance. My experience, however, has been that the sense of his irrelevance to contemporary India reflects judgements that the predicament of living in an era of globalization and/or the *kaliyug*[64] has simply invalidated that strategy as a practical option. By contrast, Bhagat Singh's strategy may be seen as a pragmatic reflection of the demands of modernity.

Bhagat Singh pushed mastery towards a powerfully deformative practice that struck at the very roots of the British colonial state's immune system. Recoding himself, like some dangerous RNA virus, he was able to trick that system and its defenders (the numerous CID officers who flooded Lahore railway station) because he no longer manifested any signs of a colonially instituted alterity. This, to echo Bhabha, is mimicry as menace.[65]

Bhagat Singh's popularity among Indians was reciprocated by a unique place given to his eulogies in the colonial archive of proscribed publications. Items related to him form the largest single categories in the

proscribed sections of both the India Office and the Indian National Archives. The peculiar anxiety that Bhagat Singh seemed to provoke in the colonial authorities needs to be understood precisely in terms of the potential collapse of differential identity that this mimic man posed. If Macaulay's minute on education was intended to produce a class of subjects who were, in Homi Bhabha's phrase, 'almost the same but not quite', the anxiety that was Bhagat Singh was produced through an uncanny and menacing mimic representation in which an emphatic non-Englishness could not be semiotically differentiated from Englishness itself. Bhagat Singh shook the very classificatory differences on which the Raj was built. His mimicry seemed to expose not merely some inconsequential gap in the system of the Raj, but rather some fundamental aporia, the exploitation of which promised a peculiarly modern freedom. It is this freedom, this same duplicitous ability to 'pass', that his images celebrate.

FROM BHAGAT SINGH TO DURGA

Just as Bhagat's images have proliferated in the proscribed files in the archives, more images by Rup Kishor Kapur (1893–1978) appear in the proscribed sections of the India Office and National Archives than those by any other single (known) artist. Born in Sambal, he moved to Kanpur where he worked as an art teacher in a middle school and was active in Congress. This was the period when the city was known as 'lal kanpur' (Red Kanpur) and Rup Kishor played his part in revolutionary activity. Then, as his grandson phrases it:

> The day Bhagat Singh was hanged, he painted in a day [a picture] of Bhagat Singh beheaded, giving his head on a plate to Bharat Mata. Bharat Mata is weep-ing. He painted it and [displayed it in Sambal] and shouted Bande Mataram and he was taken by the police and was imprisoned for one or two years.[66]

Rup Kishor would later move to Dehradun, and then to Mussoorie, where his studio in Mall Road was to be gutted by fire. The images produced in his Kanpur period include many images of the martyrs of the Lahore Conspiracy Trial.[67] *Sardar Bhagat Singh's Wonderful Presentation* depicts Bhagat Singh (behind whom stand Raj Guru and Shukhdev) giving his head on a plate to an enthroned Mother India (illus. 96); *Three Heroes in the Prison* depicts the three 'under-trials' chained and behind bars; another image depicts B. K. Dutt in prison; and *Azad Mandir*, one of Rup Kishor's most complex images, arranges vignettes of Bhagat, B. K. Dutt, Rajguru, Sukhdev and four other martyrs around a portrait of Chandra Shekhar Azad and the scene of his killing in Allahabad (illus. 97).

Azad Mandir is a fascinating assemblage of images whose dissemination was originally authorized, in many cases, by the colonial state through the press. The single portraits (with the possible exception of the corpse of Roshan Singh) were all police portraits and only in the public domain because they had been made available officially.[68] The Home Department contemplated court action against *The Pioneer*, the *Hindustan Times* and *Bande Mataram* (Lahore) for printing pictures of Bhagat Singh and B. K. Dutt, but this was only on the grounds that they did so before a second identity parade had been held and that this might potentially have been used by the defence to invalidate the parade (in fact they didn't and the Home Department's interest waned).[69]

It is unclear whether the photograph of Azad's corpse under a tree in Allahabad was released by the police (as seems possible) or was taken by a newspaper photographer and disseminated directly by the press. Whatever its origins, it quickly became potent propaganda once linguistically framed. The Home Political files in the National Archives in Delhi record, in exceptional detail, a public meeting held in memory of Chandra Shekhar Azad under the auspices of the Naujawan Bharat Sabha on 13 March 1931.[70] Songs and poems were sung and recited, and printed copies of the photograph of Azad's body under the tree were

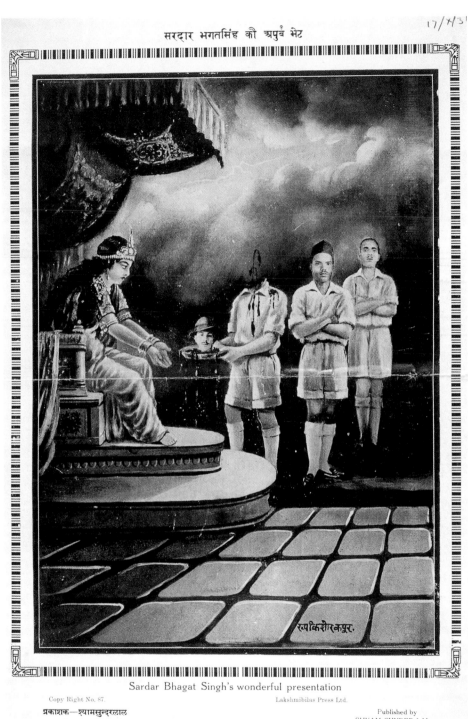

सरदार भगतसिंह की अपूर्व भेंट

17/4/31

रूपकिशोरकपूर.

Sardar Bhagat Singh's wonderful presentation

Copy Right No. 87.

Lakshmibilas Press Ltd.

प्रकाशक—श्यामसुन्दरलाल

पिक्चर मर्चेन्ट चौक कानपुर

Published by
SHYAM SUNDER LAL
Picture Merchant

*96 Sardar Bhagat
Singh's Wonderful
Presentation*, Rup
Kishor Kapur,
published by
Lakshmibilas Press,
Shyam Sunder Lal,
Cawnpore, 1931.

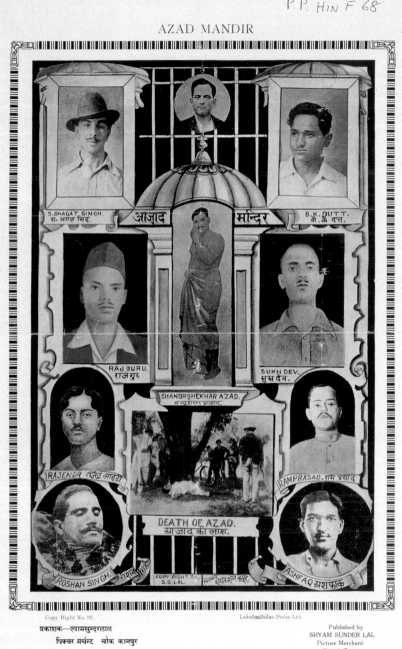

97 *Azad Mandir*,
Rup Kishor Kapur,
Published by
Lakshmibilas Press,
Shyam Sunder Lal,
Cawnpore, 1931.
The scene of
Chandra Shekhar
Azad's killing is
depicted in the
lower centre.

sold 'for one anna a copy'. These foolscap sheets reproduced the photograph with two lines of Urdu text above and below reading:

On the place of sacrifice for freedom
We shall have our name included in the
List of these living whilst dying
we shall save the honour of India.[71]

Rup Kishor Kapur undertakes a similar captioning in *Azad Mandir*,[72] but instead of words he frames the central image with other images, other celebrations of martyrdom, which create what Eco calls 'chains of syntagmatic concatenation imbued with argumentative effect'.[73] The argumentative effect is such that the image would surely have been immediately identified as seditious, even in the absence of the didactic title *Azad Mandir* (temple of freedom).

My conversations with the picture publishers and Rup Kishor's grandson (Kamal Kapoor), and the evidence of those Rup Kishor images lodged in the Proscribed section of the India Office Library, indicate that nearly all his early politically motivated images were proscribed and that he was imprisoned. In 1937–8 he met Kalicharan, the son of a blacksmith, with whom he would paint (under the imprimaturs 'Chitrashala Kanpur' and, later, 'Chitrashala Dehradun'):

[Kalicharan] saw my grandfather's religious paintings as well as Gandhiji, as well as Bharat Mata and Shahid Bhagat Singh. He came running from Jhansi to Kanpur. It was the afternoon, about 2 o'clock. A young boy of about twelve years old standing with a bag. A skinny boy with a dark complexion who touched his feet. He said 'Who are you?' 'I'm Kalicharan.' 'Why have you come here?' 'I've seen your paintings and I'm inspired by you. Please can you adopt me as your student?' He told Kalicharan 'I don't have a place and I don't have money to bring you up but I'll do it.'

In Chitrashala Kanpur and Chitrashala Dehradun images there is a striking transformation of the explicitly political and topical into the divine. But the powerful evocations of divine potency that Rup Kishor and Kalicharan jointly conjured seem to pursue politics by other means, a means that evaded the proscriptional net of the state. I do not wish to negate other factors that may have been at play. The Meerut painter Yogendra Rastogi recently observed that he no longer paints contemporary political subjects since they 'lack weight':[74] he has rejected the 'timely' in favour of the enduring.[75] In part this reflects Rastogi's increasing years and his desire to address the permanent, and it is reasonable to presume a similar preoccupation on the part of Rup Kishor. However, by the late 1930s a substantial anti-colonial allegorical and metaphorical infrastructure was sufficiently in place for politics to be articulated through 'religious' images. Thus Rup Kishor/Kalicharan's *Sudarshan Chakra*, depicting Krishna on the battleground, operated in a field conditioned by Tilak's discussions about political action and the *Mahabharata*, and their *Mahamaya Shakti* (illus. 98) belongs to a long line of political manipulations of the Mahishasuramardini trope.[76] These resonances, however, would have operated at the level of narrative and motif identification (i.e. Krishna on battlefield equals political action by Hindus). In *Mahamaya Shakti* and other images there is a repertoire of figural effects that work much more subtly and build upon an apocalyptic expressivity. One of the earliest mass-reproduced forms to demonstrate this quality is the Calcutta Art School lithograph of Kali (*c.* 1879; see illus. 90). I am suggesting that part of *Mahamaya Shakti*'s power lay in its ability to evoke a (by now easily recognizable) apocalyptic scene of destruction and cleansing by means, for example, of the shadowy sword-wielding armies in the background and the ominous clouds of smoke illumined by a (blood?) red sun. And all this, of course, in a securely 'religious' image, whose apparent lack of political content placed it beyond the reaches of the 1910 Press Act and its definitions of sedition. As with

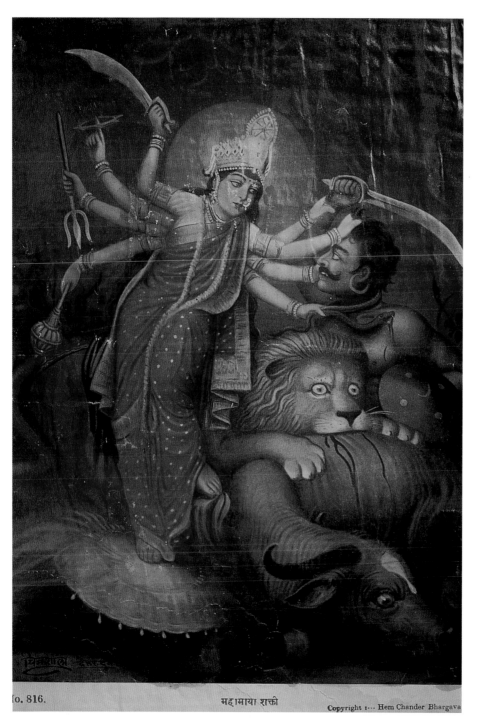

महामाया शक्ती

98 *Mahamaya Shakti*, 'Chitrashala Dehradun' (Rup Kishor Kapur and Kalicharan) *c.* 1940s. Published by Hem Chander Bhargava.

many Nathdvara images it was the figural (a certain range of colours, a certain sweep of the brush, a particular kind of stippling) that acquired the power to evoke an affective intensity. The informational flows that had so concerned many in the colonial state were not only proliferating beyond control, but changing in their modality into new forms that were simply not recognizable to those seeking to police their flow.

GANDHI, NEHRU, BOSE

The historian Shahid Amin has shown in wonderful detail how Gandhi was treated, by many, as a god. In one Bihar village a 104-year-old woman reportedly told Gandhi that 'Just as we had Ram and Krishna as avatars, so also Mahatma Gandhi has appeared as an avatar'. The Mahatma found himself trapped, to an extent, within 'existing patterns of popular beliefs'.[77] In 1921 the *Pioneer* newspaper commented on his 'unofficial canonization'. The rural public demanded to see and be seen by the great soul: 'The sight and sound of uncouth peasants invading the train carrying Gandhi, rending the sky with cries of "*jai*" and demanding *darshan* at an unearthly hour, could be annoying and unnerving.'[78]

Shahid Amin concludes his study by noting that, in eastern Uttar Pradesh and north Bihar, peasants' ideas about Gandhi's 'powers . . . were often at variance with those of the local Congress-Khilafat leadership and clashed with the basic tenets of Gandhism itself'.[79] Amin also stresses the way in which much of the nationalist press sought to distance itself from this popular messianism.

In popular visual culture of this period a similar split is apparent. The majority of colour prints produced by the larger presses generally depict Gandhi in a rational and empty space, whereas a very different engagement is apparent in some locally produced photographic montages.

The earliest chromolithographic Gandhi images are simple elaborations of the sort of photographic portraits used frequently in newspapers. The Ravi Varma Press's *Mahatma Gandhi*, which probably dates from about 1931, depicts him staff in hand. Two portraits published by the Modern Litho Works, Bombay, and dating from about the same time are also clearly modelled on photographs. Similarly Chitrashala Press's image of a thoughtful, seated Gandhi, inscribed 'D.B. Mahulikar. Artist. Ahmedabad.', is without doubt an over-painted photograph.

The most famous image of this period, Brijbasi's exquisite lithograph printed in Germany, was prepared by the artist M. C. Trivedi from a photograph taken as Gandhi left Karachi en route to the Round Table Conference (illus. 99). All these images establish Gandhi's purity and simplicity. Apart from the garlands in the Modern Litho Works's example there is nothing ostentatious in the images, indeed there is in fact almost nothing else apart from Gandhi. Only one of the images has any figurative backdrop (Chitrashala's *Mahatma Gandhi*), and this is simply a cushion propped against a wall. Some, especially Trivedi's wonderful image, have an auratic potency attached to them, but there is no obvious sense in which we might say – except with hindsight – that this was the beginning of a process of deification.

With a few odd exceptions this appears to be the case until Gandhi's assassination. There are isolated images that suggest his avatar-like status, but these are rare. For instance, one image in a 1930s booklet, a Gandhi panegyric detailing the Round Table Conference, depicts the 'S.S. Rajputana which carried Mahatmaji to London' and is captioned 'THE LUCKY SHIP'.[80] The perception of this vessel as some sort of peculiarly fortunate *vahan* (divine mount) suggests something of the aura that by this time surrounded Gandhi. It is also apparent in two photographic montages, probably dating from the mid-1940s and made in central India, possibly in Mhow.[81] One of these depicts a central figure of Gandhi, blessed from above by Krishna, and a flag-waving Mother India, whose body is infused with signs of political potency

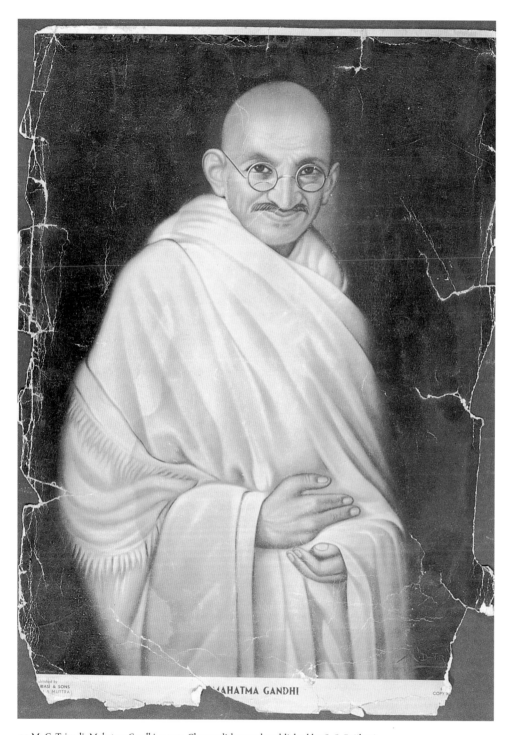

MAHATMA GANDHI

99 M. C. Trivedi, *Mahatma Gandhi*, c. 1931. Chromolithograph published by S. S. Brijbasi.

(illus. 100). These take the form of the montaged heads of contemporary national and international political leaders, including Nehru, Maulana Abul Kalam Azad, Subhash Chandra Bose, Hitler, Mussolini, Bhagat Singh, Tilak and many others. This unlikely cohort clearly share a common concern with power and efficacy, rather than ethics. A further montage from the same source, beneath the slogan 'Jay Hind' (victory to India) shows Gandhi on the right of the image pointing towards the central figure of Subhash Chandra Bose. Bose, as is customary in such images, is attired in the uniform of the Indian National Army (INA), with whose forces he hoped to free India (illus. 101). His auto-beheaded figure (of the sort we have

seen commonly used for Bhagat Singh) is captioned *Subhash balidan* (Subhash's sacrifice) and he kneels amidst the severed heads of others who have suffered or died in the struggle. Underneath the figure of Mother India, who is receiving Bose's gift, is a garlanded monument. Barely readable, this would have been immediately recognizable to Bose admirers as the INA martyrs monument to Bose, following his probable death in an air crash on 8 July 1945. Other figures included in this astonishingly complex montage are Chandra Shekhar Azad and Sardar Patel.

We are confronted with an interesting paradox: during Gandhi's lifetime chromolithography generally positioned him within the 'empty, homogenous time' of the documentary photographic image.[82] But local photographic practice, at least as evidenced by the two Mhow prints, was able much more easily to discard a disenchanted chronotope and inhabit a messianic space. The technology of production and its economic/ideological constraints may supply the answer to this: the artisanal montage techniques of the local photographer were more likely to reflect the popular messianism of the streets than the capital-intensive products of national colour presses.

An overview of local print culture suggests, however, that the 'official' vision of Gandhi as an inhabitant of an empty, homogenous, space is – in the broader scheme of things – the exception to the general messianic rule. We have already noted the prevalence of pictorial affirmations of Bhagat Singh's violent actions. Even more striking are the images that question the relationship between what we might term 'official' and 'unofficial' nationalism. Images commonly suggested the indebtedness of official nationalism to revolutionary terrorism. Among the Bhagat Singh related images proscribed in the early 1930s were some that depicted B. K. Dutt tearing open his chest to reveal the face of Bhagat Singh and other co-revolutionaries. This gesture, signifying devotion to one's personal master, has as its visual archetype the monkey-deity Hanuman's cleaving of his chest to reveal his master, the god Ram. Circulating alongside

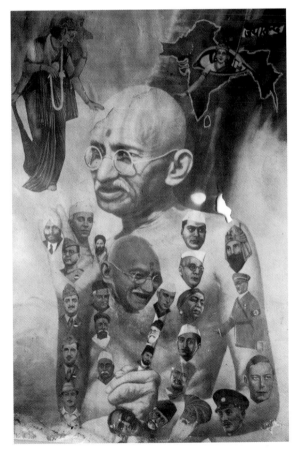

100 Photographic montage of Gandhi embodying other figures of political potency. *c.* mid-1940s, central India.

101 *Jay Hind*, photographic montage of Subhash Chandra Bose, Gandhi and others, *c.* mid-1940s, central India.

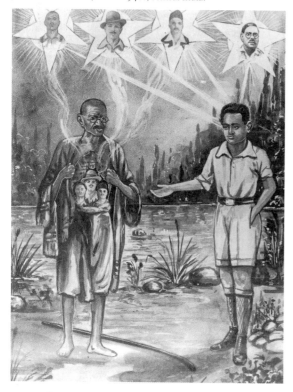

102 Gandhi reveals his true allegiances to B. K. Dutt, *c.* 1931. Just as Hanuman, the monkey-god tears open his chest to reveal his allegiance to his master, the god Ram, so here Gandhi tears open his (inferior) peaceful exterior to reveal his faith in revolutionary struggle.

these images of B. K. Dutt were even more astonishing ones that position B. K. Dutt opposite Gandhi (illus. 102). Gandhi, who has cast down his staff, is himself tearing open his chest to reveal Bhagat Singh, Rajguru and Shukhdev. In a similar way an image by Sudhir Chowdhury, *Shaheed Smirity* (Remembrance of martyrs), dating from about 1948 and published by the Calcuttan 'S.N.S.', shows Nehru as the recipient of the blessings of a free Mother India, made possible only through the sacrifices of revolutionary terrorists (including Bhagat Singh), whose severed heads are placed alongside a *lota* and *puja* lamp (illus. 103). Official nationalism may have decried the activities of revolutionary terrorists, but popular visual culture asserted the nation's debt to those prepared to kill and be killed in the cause of freedom.

A similar principle of the accession of non-violence to the power of violence is apparent in the Calcutta Rising Art Cottage's *Mata Ka Bandhan Mochan* (Mother's deliverance from bondage; illus. 104). This depicts Mother India giving (on either side) a spinning wheel to Gandhi, and the flag of Independent India to a crouching Nehru. But in the centre she bestows the *talvar* (sword) of freedom on Subhash Chandra Bose.

For consumers of this image, conditioned by similar images that show figures identified along the continuum of Bhavani/Bharat Mata giving a sword to Shivaji (the narrative that Tilak had propagated; see chapter 3), there could have been little doubt that this was the same sword, given once again. The doubling of Pratap/Shivaji and Bhagat Singh/Chandra Shekhar Azad (sometimes replaced by their Hindu rightist antinomies, K. B. Hedgewar and M. S. Golwalkar) and the occasional interpolation of a mediatory Subhash Chandra Bose, establishes a messianic time in which persons and objects leap across empty, homogenized time. *Mata Ka Bandhan Mochan* establishes a commensurability between Gandhi's freedom through spinning, Nehru's freedom through conventional statist politics and Netaji's liberation through the sword.

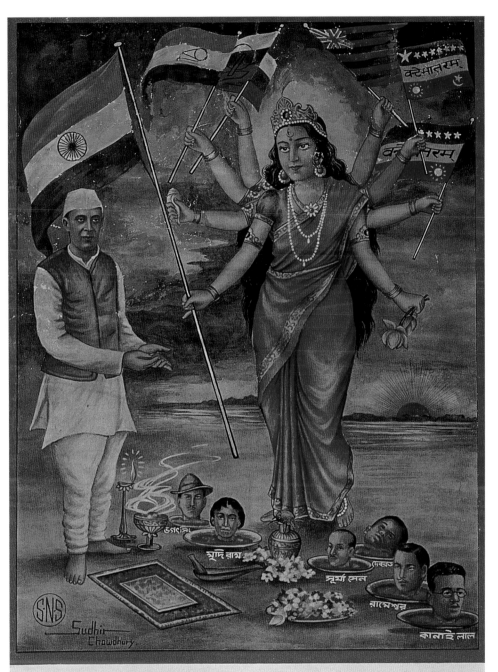

শহীদ-স্মৃতি

Shaheed-Smirity.

103 Sudhir Chowdhury, *Shaheed Smirity*, late 1940s. The sacrifices of slaughtered revolutionaries permit Nehru to receive Mother India's blessing.

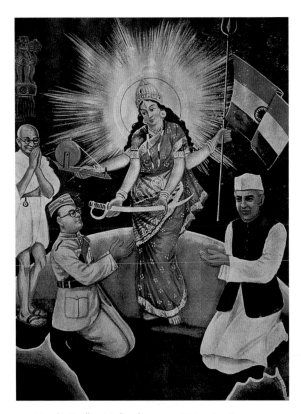

104 *Mata ka Bandhan Mochan*, late 1940s. Rising Art Cottage, Calcutta. Bose accepts Bhavani's sword, repeating earlier imagery in which Shivaji received the same sword.

The major presses' unwillingness to affirm Gandhi as an avatar during his lifetime rapidly decayed with the grief of his assassination on 30 January 1948. The images issued after this event are radically different in style and substance and can be divided into 'apotheosis' images and 'avatar cycle' images. The former depict Gandhi ascending to heaven in the manner of eighteenth-century European Imperial heroes, and the latter present a central atemporal form around which a biography in the form of 'descents' appears.

Brijbasi's *Gandhiji ki swargyatra* (Gandhiji's journey to heaven) shows Gandhi hovering above the heads of Nehru and Patel as he is borne up to heaven in a celestial *rath* drawn by two *apsaras* (illus. 105). This mode of locomotion is also present in a similar

image (probably by Sudhir Chowdhury), but here the Buddha and Jesus take the places of the *apsaras*, waiting to welcome Gandhi into a realm of renunciatory beatitude.

Gandhiji ki swargyatra was painted by that great Nathdvara image-maker Narottam Narayan Sharma and in the intriguing detail of the image he conveyed much about the nature of the relationship between the Brijbasi business and Gandhi. Margaret Bourke-White witnessed the scene that Narottam painted at close quarters and has left a moving record:

Nehru, Patel and Baldev Singh, the Defence Minister, performed the final touches on the bier . . . At the burning ground I made my way to the pile of sandalwood logs where the cremation would take place. Three Hindu priests were pouring pails of ghee . . . on the logs . . . Then an oddly assorted little group came and sat down cross-legged on the ground, as though facing a camp fire. Among them were Lord and Lady Mountbatten, the Chinese Ambassador, Maulana Azad, the Muslim scholar who had been so close to Gandhi, Mrs Naidu, the warm-hearted poet, who in happier days called Gandhiji her 'Mickey Mouse', and Raj Kumari, literally bowed down with grief.

Suddenly these watchers had to rise to their feet and cling together to keep from being trampled on. The procession was approaching, the crowds about it surging, uncontrollably, close to the pyre. Although I was within a few feet of the sandalwood logs, my view of Gandhi's body was blocked off by the crush of people desperately eager for one last look before their Mahatma was given over to flames. Sometimes I could catch sight of Nehru's haggard face as he stood by the edge of the bier, then a glimpse of Patel in his toga-like robe . . . The flames rose high into the sky now, and the million people seemed to have sunk into a low bowl of darkness.[83]

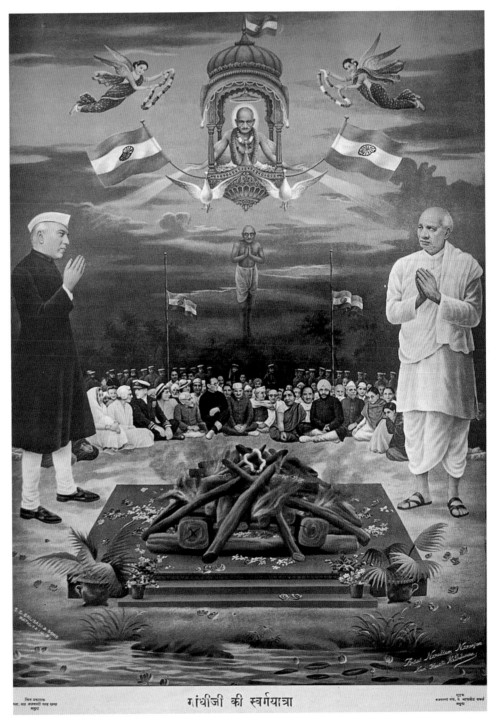

गांधीजी की स्वर्गयात्रा

105 Narottam Narayan Sharma, *Gandhiji ki Svargyatra* ('Gandhi's Heavenly Journey'), 1948. Published by S. S. Brijbasi.

Narottam Narayan's image gives little sense of the grief-stricken panic that Bourke-White evokes so well, but he provides a remarkably accurate record of the individuals present at the cremation. We may presume that he relied on some photographic reference[84] for most of this: Nehru and Patel are given prominence on either side of the pyre, and in the background we can see the Mountbattens, Baldev Singh and others. Among these, however, there is a curious, though familiar, interpolation: the face of Shrinathdasji Brijbasi (see also illus. 112) can be seen peering between the Chinese Ambassador and Maulana Abul Kalam Azad (see detail in illus. 106). Narottam here, perhaps inevitably, conjoined two men who were arguably equally dependent on each other: Srinathdasji, the businessman who found in Gandhi a saleable icon who also animated the divine landscape that his images constructed; Gandhi, who in Srinathdasji unknowingly found the ideal liaison officer in the production of the poetic landscape of a morally pure and independent India.

Brijbasi images also depicted Gandhi's arrival in the world of the gods. *Devlok* (illus. 107), painted by the Nathdvara artist K. Himalal, shows Gandhi at the front of a group of deceased nationalists who are being honoured by a group of ancient *rishis* (sages). All this takes place under the benign watch of the three major deities: Brahma, Vishnu and Shiv. The formal symmetry of the image is accentuated by the framing arch that contributes to

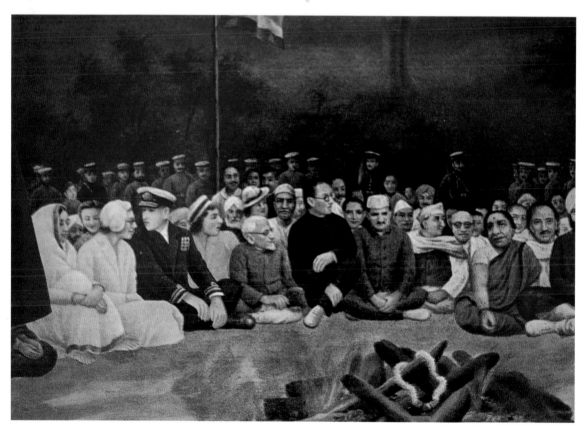

106 Detail of illus. 105. The face of Shrinathdasji Brisjbasi is shown peeping between Abul Kalam Azad and the Chinese Ambassador to Delhi.

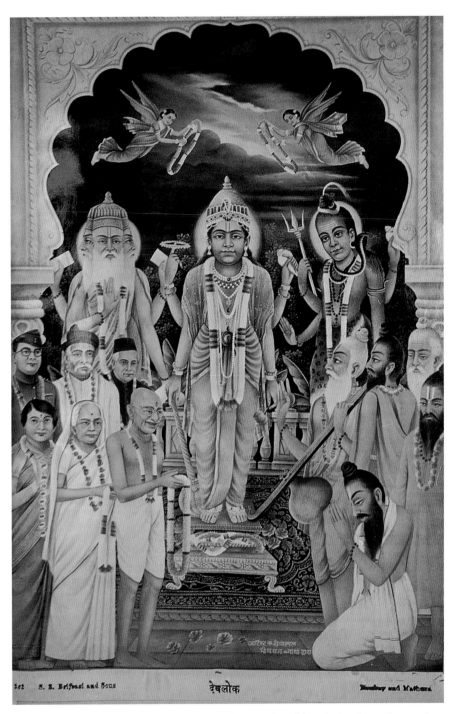

देवलोक

107 K. Himalal, *Devlok*, *c.* 1948. Published by S. S. Brijbasi. Gandhi, Tilak, and other deceased nationalists meet with the *rishis* under the gaze of Brahma, Vishnu and Shiv.

the creation of a meaning-saturated space, which stands in sharp contrast to the empty homogenous time of elite nationalist politics.

Ashis Nandy has argued that Gandhi was in many respects as much 'Christian' as 'Hindu'.[85] This provocative and troubling suggestion seems to have been taken as axiomatic by painters in the late 1940s, for a recurring theme is that of the parallelism between Gandhi and Christ and between Gandhi's assassination and the crucifixion of Christ.

This visual metaphor occurs in a painting by B. Mohar, distributed by Hem Chander Bhargava, which depicts Gandhi seated on top of the world. Behind his manifest fleshy form is a shadow in which the yogic contours of the Buddha encompass the silhouette of the Crucifixion. This morphological similarity was also used by the prolific artist M. L. Sharma in an image in which Gandhi's posture and raised hand are mirrored by those of the Buddha behind him.

Some images do posit a divine Hindu identity. In one he is shown standing on top of the world in a pose associated with Hanuman. Other images make the association more explicit: an anonymous print from Tower Half Tone Calcutta positions Gandhi in front of a celestial *Om* – the transcendent syllable – above the clouds. This connotes Gandhi's absorption into the void of Brahma, but it also draws on a long tradition of similar imagery dating as far back as Ravi Varma and, more recently, two Narottam Narayan portraits of Krishna depicted within the sacred syllable.

Perhaps the most revealing images, however, are those that suggest Gandhi's status as an avatar through their appropriation of the pictorial forms of avatar representation. Since the 1880s, prints have been in circulation depicting Vishnu and his avatars. All of these have a common pictorial structure: Vishnu is depicted at the centre and around this, usually in a clockwise order, are represented his various avatars (most commonly 10, but sometimes 22 or 26). The same structure is also used to reveal the narrative of a particular avatar: Krishna may be given the central

place and his biography then unfolds in a clockwise set of vignettes. These images give form to the notion that the enduring abstract form of Vishnu is periodically made manifest through different incarnations who descend to play their role in the affairs of man.

This established template has been used to document the lives of many major nationalist figures following their death. Several images by different publishers position Gandhi within this avatar-template.[86] In the artist Dinanath's *Evolution of Gandhi* (illus. 109), published by Kananyalal Lachoomal of Delhi, the circle of Gandhi's life is mediated by his corpse shrouded in a flag (bearing his last words, 'Hare Ram') at the bottom of the picture. At the start of the circle at the bottom left we see his birth from a lotus, his early years as a suited barrister, the Dandi salt march at the top and

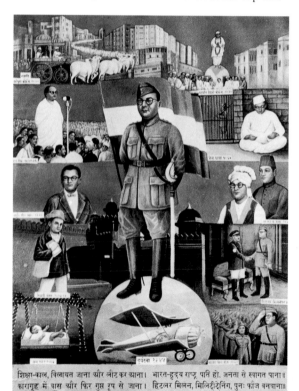

शिक्षा-काल, विलायत जाना और लौट कर आना। भारत-हृदय राष्ट्र पति हो, जनता से स्वागत पाना॥
कारागृह में वास और फिर गुप्त रूप से जाना। हिटलर मिलन, मिलिट्रीट्रेनिंग, पुनः फौज बनाना॥
वीरों युवकों की सेना सजा देश हित लड़ना। रक्तदान हस्ताक्षर, दिल्ली चलो, तुना पर चढ़ना॥
आजादी की वेदी पर प्राणों की भेंट चढ़ाना। श्री सुभाष की यही अमर गौरव से भरी कहानी॥

108 The ten *avatars* of Subhash Chandra Bose, *c.* 1950.

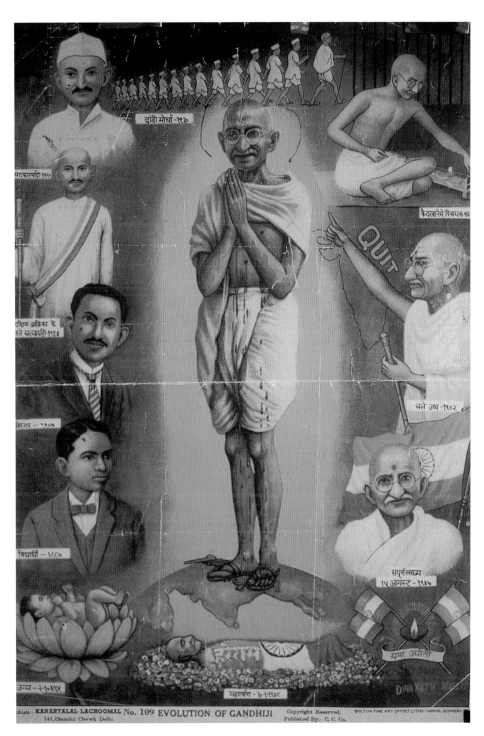

109 Dinanath, *Evolution of Gandhi*, c. 1948. Published by Kananyalal Lachoomal, Delhi.

so on. The same circular biographical visualization is apparent in a late 1940s image of Subhash Chandra Bose in which, instead of his corpse, we are shown the plane in which he mysteriously disappeared (illus. 108). To the left of this he is shown as a baby in a cot in a style suggestive of popular imagery of the baby Krishna. On the right, above the last scene in which he salutes his Indian National Army troops, we are shown him meeting Hitler (*Hitler milan*).

Taken together, these images serve to show in a powerful form that, as Ranajit Guha has written, 'Indian nationalism of the colonial period was not what elite historiography had made it out to be . . . it derived much of its striking power from a subaltern tradition going a long way back before the Mahatma's intervention in Indian politics . . . or Nehru's discovery of the peasantry of his home province'.[87] That historiography privileged certain kinds of textual archival sources. A new historiographic practice grounded in the study of popular visual representations reveals with startling clarity the powerful presence of radically different preoccupations.

7 Half-seen in Advance: picture production in independent India, 1950-2000

505 – SHREE MAHAVISHNU

India gained independence in 1947. The trauma of Partition was never visually represented by the commercial picture production industry. Some images explicitly reflected freedom from colonial rule (illus. 110), and the elaboration of freedom fighters' deeds and iconography gave rise to substantial numbers of images that began to institutionalize the revolutionary struggle. The bulk of pictures, however, addressed themselves to small town dwellers in search of images of glamour, and an increasingly rural market that demanded images of deities capable of intervening efficaciously in the daily predicaments of subsistence existence.

Sardar Patel was the only serious contender to Jawaharlal Nehru's dominance of Indian national politics and, following Patel's death in 1950, Nehru's hold was soon complete.[1] Prime Minister from Independence until his death in 1964, his approach to India was, as he had himself written, similar to that of a 'friendly westerner'. He was 'anxious to change her

outlook and appearance and give her the garb of modernity'.[2] High-profile heavy engineering projects and a centralized administration were marks of his success (illus. 111), but most of India's rural population, while venerating him as a deity-like figure,[3] experienced the state as a distant presence and their most pressing problems were those predicaments of poverty that had previously afflicted them. A small group of Nehru's supporters ('the Syndicate') ensured his succession as Prime Minister by Lal Bahadur Shastri and, two years later, by Nehru's daughter Indira Gandhi in 1966. Her dictatorial excesses during the 1975–7 Emergency were followed by various regimes, often short-lived, and Indian politics from the mid-1980s has been characterized by an increasingly right-wing, anti-Islamic and fascistic quality. The political temperament of twenty-first century India seems infinitely distant from that of the newly independent nation of 1947. Many of the visual needs of its citizens, however, have changed relatively little.

110 Mother India breaks her chains, c. 1947–8. Mother India shows her delight as Nehru in the foreground raises the flag of an Independent India.

Modern Age No. 48

111 *Modern Age*, 1948. The image shows the triumph of a Nehruvian modernity. Gandhi's non-industrial path is given only an ethereal presence in the top third of the picture.

One of the most intriguing documents of the state of picture publishing in newly independent India is a photograph taken during the course of Ramesh Brijbasi's wedding at Brijbasi Bhavan, Mathura, in 1952 (illus. 112). Among the publishers who gathered for the occasion was Harnarayan of Jodhpur. In considering this astonishing gathering of those who controlled the print culture of a newly Independent India, Shrinathdasji, the host (seated at the centre of the group), must have had a special place in his heart for Hem Chander Bhargava (by now deceased and represented by his son Kishorilal) and Harnarayan, who had founded his press shortly after the Brijbasis received their first German-printed images in the late 1920s.

Like the Brijbasis, Harnarayan had also run a picture-framing business before deciding to publish his own images. He had first worked on the railways

as an apprentice carpenter before turning his woodworking skills to frame-making. His company's first print is dated May 1929 and was the result of a visit to Nathdvara to commission Pushtimarg artists (i.e. followers of Shrinathji), again following the Brijbasi pattern. Some of Harnarayan's earliest images echo those of Brijbasi, for example Narottam Narayan's studies of Krishna as Gopal appearing through apocalyptic clouds. Narottam's output also mixed a similar blend of portraits of Gandhi and Nehru with more orthodox religious images. But Harnarayan's images also reflected a very regionally specific concern with figures in the Rajasthani pantheon.

The company's reference prints (retained by his son Hemant in Bombay) reveal that almost half of the press's early output (from 1929 to *c.* 1940) were images of the Rajasthani figure Ramdevji, usually depicted in profile seated on a horse with two devotees (illus. 113), or entombed in his *samadhi* ('living grave') at Ramdevra (illus. 114). Harnarayan clearly diagnosed astutely the devotional needs of his Jodhpuri clients. He himself was not narrowly sectarian or orthodox. As Hemant explained, he was 'broad minded and did not believe in pandits'.[4] As a member of a middle-status vegetarian caste he had few problems with the commercial celebration of Ramdevji imagery. Ramdevji was a medieval renouncer king who was entombed in Ramdevra in the desert near Jodhpur and had attracted an especially enthusiastic Untouchable (or Scheduled Caste) following. He was in many ways a medieval Gandhi who combined miraculous powers of intercession with a strongly egalitarian ethos.

Few of these early Harnarayan images have the figural density and richness of Brijbasi images of the same period, but Harnarayan had the good fortune to employ a Nathdvara painter named Giridharilal and, later, his son Bhanwarlal. Bhanwarlal Giridharilal Sharma (*b* 1924), or B. G. Sharma as he would soon come to sign his images, would rapidly emerge as the most important figure in the popular Indian art

ON THE AUSPICIOUS OCCASION OF MARRIAGE PARTY
OF
MR. RAMESH CHANDRA AGRAWAL
AT BRIJBASI NIKETAN, MATHURA ON 17-2-1952

From left to right :
On Chairs : L. Ramomal Ji (*Ramomal Gupta, Delhi*), Seth Chiman Lal Ji (*Chiman Lal Chhotalal & Co., Ahmedabad*), B. Kishori Lal Ji (*Hem Chandra Bhargava, Delhi*)
L. Shri Nath Das Ji (*S.S. Brijbasi & Sons, Mathura*), B. Har Narain (*Harnarain & Sons, Jodhpur*) L. Lachhomal Ji (*Kashyalal Lachhomal, Delhi*)
B. Madan Lal (*Ark Print Co., Calcutta*).
1st row Standing : L. Shorey Lal Ji (*Manager, Swastik Picture House, Delhi*), L. Anant Ram Ji (*Anant Ram Gupta, Delhi*), L. Chhanga Mal Ji (*Chhanga Mal Suresh Chandra, Delhi*)
L. Satya Paul (*Laxmi Picture Co., Delhi*), L. Kundan Lal (*Manager, Hem Chandra Bhargava, Delhi*), Kamal Babu (*L.K. Chowdhary & Bros., Calcutta*)
L. Damoder Das (*Girdhar Das & Sons, Benaras*).
2nd row Standing : L. Kapur Chand Bansal, L. Madan Lal (*Roshan Lal Madan Lal, Delhi*) Pt. Pyarey Lal, Pt. Ram Bharose (*Ram Bharose Lal Sharma, Haridwar*),
L. Moti Lal (*Moti Calander Co., Delhi*) L. Dwarka Das (*Ganesh Das Dwarka Das*) L. Raja Ram (*Bajaram Katihar, Kanpur*),
BHARAT STUDIO
Mathura

112 Wedding party photographed at Brijbasi's Mathura factory in 1952. Harnarayan and Kishorilal Bhargava are seated either side of Shrinathdasji.

world of the 1950s and '60s. He was also the artist who precipitated my interest in the genre of images that this book documents.

BHANWARLAL GIRIDHARILAL SHARMA: THE RETURN OF ALLUREMENT AND TACTILITY

I first encountered B. G. Sharma's work in the form of chromolithographs in the village in central India that forms the focus of the following, final chapter. When talking with local factory employees,

mainly Untouchables, during my doctoral research on the impact of industrial time regimes, I would often find myself gazing up at the rows of framed and unframed images of deities with which many of them adorned the walls of their mud houses. Often, when talk about exploitative factory contractors or the current film showing in Kiran Talkies subsided, we turned to discussions of these images – the magical deeds of Ramdevji would be narrated, or the potency of Shiv extolled. Many of the iconographically most complex and aesthetically pleasing images were by B. G. Sharma and

113 *Ramdevji ki Guru Bhet*, 'D. L.' c. 1929. Harnarayan & Sons.

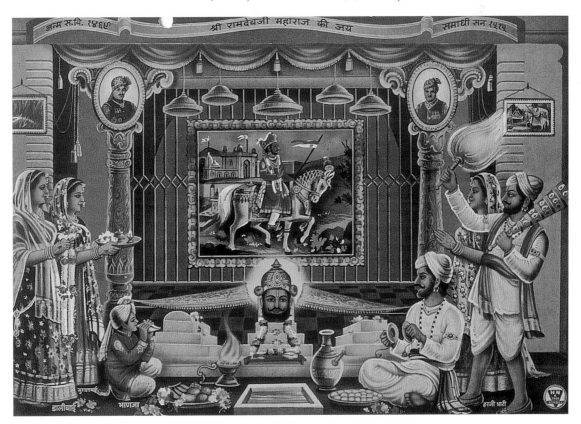

114 *Ramdevji Samadhi*, c. 1940s. Harnarayan & Sons.

published by a Bombay company, Sharma Picture Publications.

Many years after my first fieldwork I went in homage to the Bombay offices of Sharma Picture Publications. Situated in Princess Street in the heart of bustling Kalbadevi, the headquarters of this company whose influence reached out into the furthest corners of rural India was a shockingly small and tumbledown office. The proprietor was flattered to hear of the genealogy of my visit and revealed himself to be the brother of B. G. Sharma, with whom he had founded the company in the mid-1950s.

B. G. Sharma, I later discovered, lives in opulent and well-earned splendour in a massive personal museum near the beautiful Sahelion ki Bari gardens in Udaipur (illus. 115). Hanging on the marble walls are trophies of elite patronage – a framed letter from Nancy Reagan and a photograph of Sharma with two Roger Moores dating from the time when the James Bond film *Octopussy* was filmed in Udaipur (one Roger Moore is the stunt double). Since the mid-1950s Sharma has done much to change the aesthetics of chromolithographs, pushing them further towards the use of primary colours and popularizing many regional western Indian deities. His press release suppresses the hybridity of his work, declaring: 'Reproductions of his work can be found in many homes because both the subject matter as well as the handling is a continuation of the great tradition of Indian painting'.

Today, however, Sharma paints miniatures on ivory for sale to the elite and acts as an authorized representative of the Indian tradition at overseas Festivals of India, having attended those in London and Washington. His earlier populism is the source of unease, and he refers to his 1950s work as the sort of thing one might encounter on 'the footpath'. He is proud of the enormous popularity of his images, recognizing that there is probably not a single village in the country in which his chromolithographs do not hang, but he describes his earlier paintings as 'low *kam*' (work) and his present as 'high *kala*' (art). Late in his life he realized that no one was producing pictures of the quality of those 'from Mughal times' or from the 'Raja's courts' and decided that it would be his task to recapture that lost age of perfection. Art was his

115 Bhanwarlal Giridharilal Sharma holds a 1950s gouache of Vishnu in his Udaipur home in 1994.

'bhagwan' and he considered it his duty to leave an example for the generation to follow. When I initially met him we talked about his time studying at the J.J. Art School in Bombay just after Independence and then we looked through his testimonial books. They are crammed with the comments of the famous. Rajiv Gandhi wrote 'I'm delighted that the ancient Indian artistic spirit has once again come alive'.

Bhanwarlal was raised in Nathdvara and both his father and grandfather undertook commissions from local courts. It was his grandfather who taught B. G. Sharma the art of painting. In Nathdvara he became familiar with Narottam Narayan, Hiralal and Ghasiram. During his childhood he saw many Ravi Varma chromolithographs: several hung in his family home.

In 1947 B. G. Sharma started studying at the J. J. School of Art in Bombay, but had to cut short his studies after less than a year because of the disruption and violence that accompanied Partition. Perhaps some sense of the artistic environment of Bombay during this period can be had from Beverley Nichols's severe assessment of his experiences in 1943–4. Nichols, a modernist in search of Indian expressions of an international style, observed pessimistically that 'we now come up against a blank wall. The blank wall is Art in Bombay'.[5] There were, he concluded, no artists, no collections of note, no studios, critics or publications of worth. The one organization he was directed to, the Bombay Art Society, disappointed equally and 'in no other country in the world would [their products] be given wall space'. These 'depressing daubs' fell into two classes: most were in Revivalist style ('slavish imitations of the Ajanta frescoes and the Moghul and Rajput schools') and the rest were 'equally slavish imitation[s] of the French impressionists up to Renoir'. But for Nichols the sole gleaming exception to this was the J. J. School of Art: 'However, everything good in it happens to be British. Its principal, Charles Gerrard, is himself a distinguished artist, and occasionally hypnotizes his pupils into following his lead. Doris Gerrard, his wife, is a sculptress of genius,

completely wasted in India.'[6] Nichols's jaundice blinds him, however, to a host of other creative influences at the school, many of which B. G. Sharma would have found more conducive. Bhanwarlal's cousin, the almost equally renowned artist Indra Sharma, went with him to J. J. School:

We came down together but the living down here didn't suit him and he went. He went after one year.[The J. J. School] was the best for painting, but they didn't do modern there. They did realistic, systematic work. Nowadays they do modern. But then it wasn't like that. The Principal then was [Charles] Gerrard. A European. There were 300 students; 50 students in each class. After B. G. Sharma went there weren't any other Nathdvara students.

Nichols, of course, would have been equally antipathetic to Sharma's remarkable work since he stands in many respects as the antithesis of modernism. B. G. Sharma is as much a product of colonial hybridity as Ravi Varma, but unlike several other artists (Pednekar and Mulgaonkar would be good examples) B. G. Sharma's mass-produced work has been subject to extremely little stylistic variation. Looking through those designs that survive from the 281 published by Sharma Picture Publishers (149 are currently in print), one is struck by the lack of any stylistic trends over the 25 years of output. In some of the earliest prints the colour range and type of moustache is distinctive and a cluster of mid-1950s designs have identifiable qualities, but these account for only about a dozen out of the total. All the other images are stylistically indistinguishable. Although the artist is able to date most of them precisely from memory, his consumers are quite unable to do so.[7]

B. G. Sharma's historical significance lies in his having reversed the Sanskritizing trajectory established by Ravi Varma and intensified by figures such as Narottam Narayan Sharma, and in pioneering a new colour range marked by stronger contrasts. We

might also add his important role in popularizing multi-frame narrative compositions. Tracing aesthetic developments after Ravi Varma, as I have attempted to do in this book, rather softens the apparent newness of Sharma's work, but he remains one of the most significant twentieth-century artists within this genre.

Some of these new trends, and also some of the continuities, are apparent in his earliest paintings. One of his first published images was of Ramdevji's *samadhi*, published by Harnarayan and Sons in 1947. I have already suggested that Harnarayan was producing a profusion of Ramdevji prints from the late 1920s onwards. Some of these were almost certainly the work of Bhanwarlal's father, Giridharilal, but in the absence of dates and signatures a miasma of doubt envelops this large body of early work. Interviewed in 1991, B. G. Sharma claimed that an image of Ramdevji then still in print from Jain Picture Publishers was a copy of his original Ramdevji design.

Despite this confusing information, however, we can position groups of images within specific time bands with certainty where there is a congruence of dates supplied by both artists and publishers, and where the stylistic analysis and assessment of the paper quality and other conservational factors also converge.[8] In the light of this it is possible to assert firmly that Bhanwarlal was producing images of Ramdevji and Mahavir in the late 1940s and early 1950s. These received such positive feedback from the public that by 1955 he was in a position to form his own, eponymous company: Sharma Picture Publications (illus. 116).

These subjects – a Jain *tirthankara* and a radical figure chiefly popular among Untouchables – suggest that Bhanwarlal, as a Brahman painter from a Nathdvara lineage, was receptive to Harnarayan's commercial catholicity. Indeed, this was to be a characteristic of the rest of Bhanwarlal's career. A further example of it can be seen in the image *Amba Bhairav*, which bears the imprimatur of Sharma Picture Publications but which also bears marks of its earlier appearance as a Harnarayan image.

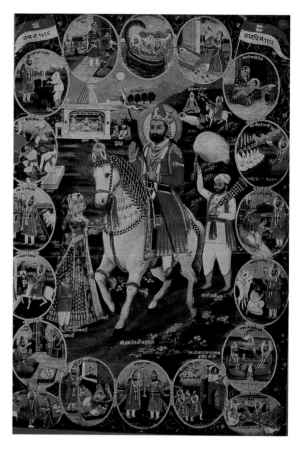

116 Bhanwarlal Giridharilal Sharma, *Ramdevji ka Choubis Parcha* (Ramdevji's 24 proofs), 1970s print of an early 1950s image. Sharma Picture Publications, Bombay.

B. G. Sharma also published at least two images depicting *satis* (divine female immolations) in the mid-1950s. One was *Sati Mata* (illus. 117), published in 1954 by Kishan Narain and Sons, a company run by Harnarayan's eldest brother, and the other was an elaboration upon this that fused the *sati* image (which we can assume would have appealed primarily to Rajputs) with Ramdevji (presumably of primary appeal to Untouchables). This was an experiment of exceptional boldness: an attempt by Harnarayan, we may surmise, to synthesize a new egalitarian Rajasthani symbol for a new Independent India (illus. 118).

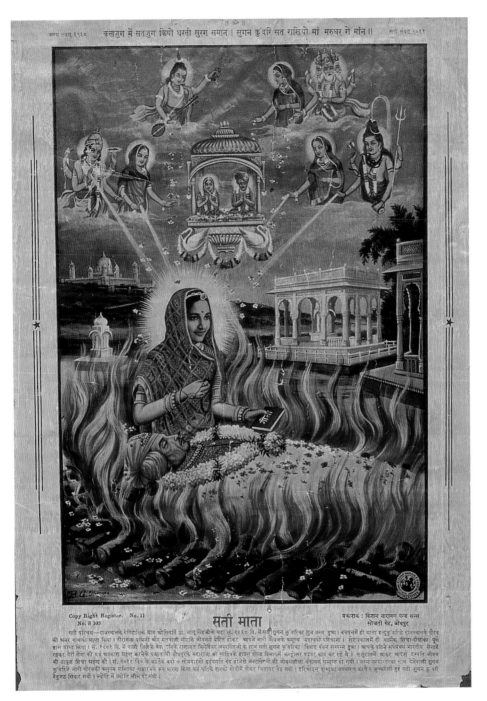

117 Bhanwarlal Giridharilal Sharma, *Sati Mata, c.* 1954. Kishan Narain and Sons. Part of the text reads:
'Born Samvat 1968 [CE 1911]. In the *kal[i]yug* it is equivalent to *sat[ya]yug* and this land has become like heaven. Sugan Kunvari [the name of the sati depicted on her pyre] has kept the respect of the desert. Sati Samvat 2011 [CE 1954]'.

118 Bhanwarlal Giridharilal, *Sati Mata Ramdevji*, mid-1950s. Harnarayan & Sons. Sati Mata and Ramdevji were united in this remarkable picture.

One of the major puzzles in reviewing Bhanwarlal's career is the dating of his painting of *Santoshi Ma* (illus. 119), the obscure goddess who was catapulted to north Indian fame by the appearance of a low-budget mythological film in 1975. Both the artist and knowledgeable publishers have at times indicated that it significantly predated the film and at other times contradicted this.[9]

Whereas the continuity between courtly and temple representational traditions and early Nathdvara imagery as disseminated by S. S. Brijbasi is clear enough (recall Narottam Narayan's and Hiralal's portraits of Shrinathji and the haveli *goswamis*) many of Bhanwarlal's designs were based on woodcuts he had seen in *puja* booklets. Interviewed in 1991, he stressed the role of these designs. For instance the Ramadevji design was seen in a book purchased at a *mela* (fair), and he attributed his Santoshi Ma design to a similar illustration. This influence of local print culture is perhaps nowhere more apparent than in his Sharma Picture Publications print *Nav Grah* (Nine Planets), where he sets the conventionalized representations of planets – of the type still to be found depicted with

woodcuts in local *panchangs* (almanacs) – against a backdrop of enclosing clouds. Bhanwarlal has also alluded to continuities with *par* paintings (painted scrolls), which in Rajasthan are chiefly used to represent two folk deities, Pabuji and Dev Narayan.[10] This relationship also occasionally comes full circle, as in the case of a travelling storyteller seen at the 1992 Kumbh Mela in Ujjain bearing a framed B. G. Sharma *Ramdevji ki Samadhi* on a pole. As earlier bards narrated hand-painted scrolls of Pabuji, so he delivered the story of the great king Ramdev and gestured at the printed image (illus. 120).

Bhanwarlal also located the origin of his complex image of Shravan Kumar in folk designs seen on walls during Rakshabandhan. His design (still in print) is very similar to the one that M. K. Gandhi described as having seen as a child (see page 15). As these examples indicate, Bhanwarlal's imagery has been exceptionally open to, and reflective of, a diverse range of public, popular and folk conventions. This, and his frequent reliance on hieratic templates taken directly from imagery in *puja* booklets, endows Bhanwarlal's work with a particular appeal to rural consumers who seek

119 Bhanwarlal Giridharilal Sharma, *Santoshi Ma*, c. 1960s? Sharma Picture Publications. Santoshi Ma would achieve a phenomenal popularity through film.

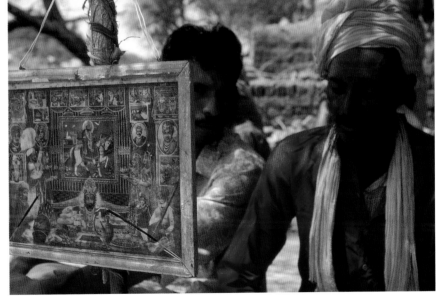

120 A travelling bard with a copy of B.G. Sharma's *Ramdevji ki Samadhi* at the Ujjain Kumbh Mela, April 1992. Industrially produced chromolithographs are reintegrated into enduring narrative and performance traditions.

in images efficacy and directness. If Ravi Varma's 'slyly civil' appropriation of history painting was in part undone by the Nathdvara painters championed by S. S. Brijbasi, we might conclude that in B. G. Sharma's work the colonial 'absorptive' heritage is almost completely dismantled in favour of the *darshanic* and 'theatrical'. We could add to this the suggestion that in B. G. Sharma's work the radically brighter colours create a sense of tactility. Like all bright colours 'they look at you'[11] and the sense of sticky mutuality[12] they create between image and viewer decisively breaks the colonial separation of pictures and beholders that most earlier images still desired.

Other commentators in the business are careful to stress the profound challenge that his aesthetic and his commercial operation posed to the rest of the picture publishing industry, and often bemoan what they see as an aesthetic 'lowering' of the market. M. L. Garg of Brijbasi has stressed the decisive role played by Bhanwarlal in changing colour preferences across the entire market. The brighter colours he pioneered proved greatly more popular than the subdued Nathdvara styles of the 1930s associated with artists such as Narottam Narayan Sharma,[13] Hiralal, Khubiram and Ghasiram. After the founding of Sharma Picture Publications in 1955, Brijbasi lost their dominance in this hugely competitive market for almost fifteen years until they too adopted designs with a greater predominance of primary colours. M. L. Garg first saw B. G. Sharma's work in 1958 and recalls their vibrancy: 'It looked nice! It had pleasing colours . . . people liked it and it sold [but] he was popular only because of the brightness of the colours. It made some of our images look old-fashioned.' Others in the industry are more embittered, dating the slump in their fortunes and the destruction of what they see as aesthetic value to the tidal wave of Sharma Picture Publications images.

In the 1990s B. G. Sharma was keen to distance himself from this earlier work, having found a new idiom through which to express his talent. He is now working in a different style (*yeh work alag hai*). He wants

to improve upon the Mughal style. 'Nowadays I do very little work in this style, I do most in [Mughal style] . . . large cloth paintings, on ivory or watercolours on paper'. He characterizes his current work as 'traditional' and in the Mughal style. Whereas his earlier 'commercial' work was 'rough' and 'ordinary', his present 'classical' work requires *kafi peshens and kafi sikna* (much patience and training). Whereas the early prints would be encountered on a 'footpath', the current work would be found only in a museum.

In the opening section of this discussion of B. G. Sharma, I stressed the 'history' (or more properly the 'historicity') of a certain type of production by Nathdvara artists. What emerges strongly when talking with others in the industry about B. G. Sharma is a sense of 'before' and 'after' with respect to the founding of Sharma Picture Publications. Here, by contrast, I will focus on a rather different model of temporality and production. This will involve an examination of a narrative of commercial image production, the ideological inflections of which have been caught in a complex process of inversion, archaicism and temporal disjunction. Facilitated by the archives of early images maintained by most artists, popular visual symbols lack any clear sedimentation. Forming part of a relatively closed repertoire they migrate endlessly, cutting back and forth across new times and contexts.

A NATHDVARA LINEAGE IN BOMBAY

In the late 1960s an aspiring nuclear physicist in India was offered a doctoral scholarship to study in New York. He already had an MSc in Physics and Electronics (with distinction) from Bombay University and had worked briefly for the Atomic Energy Authority of India. He completed his visa application and took it to the American Consulate who refused it. He reapplied and lobbied the Consulate through various Maharashtrian politicians but to no avail. He

stayed in India and for several years, without success, tried to obtain a reasonable post with an Indian electronics company. During this period he returned to a craft he had learned as a child and started once again to assist his father with his paintings. By 1973 he had started signing paintings in his own name and had fully reconciled himself to the life of an artist.

The name of this nuclear-physicist turned artist is Narottam Lakshminarayan Sharma (N. L. Sharma), the son of Lakshminarayan Sharma (L. N. Sharma) and the grandson of the artist Khubiram, whose importance as part of the Nathdvara 'revolution' was touched on in chapter 5.

A central argument developed in earlier chapters of this book is that the hybrid styles associated with certain early Calcutta presses and the painter Ravi Varma should not be accepted (as they frequently are) as part of a foundational moment that came to determine for evermore the nature of this genre. My account places great stress on the significance of Brahman painters from Nathdvara whose distinctive styles were introduced into the mass-produced market in the late 1920s. In the Nathdvara 'neo-traditionalist' idiom, eternity is territorialized. Hieratically depicted deities inhabit claustrophobic organic spaces that came to articulate the emerging space of a Hindu nation.

One of the most significant figures in the early days of this Brahman painting community's encounter with mass reproduction was Khubiram. He was to be the first of three generations of painters, all closely linked aesthetically. His son, Lakshminarayan Sharma, was a leading painter of the 1950s and '60s and his son in turn, Narottam Lakshminarayan the aspiring nuclear physicist, is currently a major popular artist.

According to the testimony of Narottam, Khubiram's father was not an artist: he was engaged in some other occupation, although he does not know what. It was through his own efforts that Khubiram came to supply work for three major courts – those of the Nizam of Hyderabad, Chapra of Bihar, and of Udaipur, the major city just south of Nathdvara from where the caste of Adi Gaur painters, to which

Khubiram's family belonged, are thought to have emigrated.

During this time Khubiram had his own studio in Nathdvara and orders for paintings were sent to him from these courts. Although the results of these commissions were frequently dispatched by post, he also led an itinerant existence, often visiting these widely dispersed courts and taking his son Lakshminarayan as his assistant.

Current family mythology concerning Khubiram's identity during this period is illuminating for it seeks to affiliate him with the much more famous figure of Ravi Varma, yet simultaneously distance him through his different and superior Indian-ness. Khubiram's 'standing Lakshmi' was a work commissioned by Hem Chander Bhargava to be 'like' Ravi Varma's early image. The commercial artist Yogendra Rastogi, whom we will hear from later, had very clear views about the differences between these two paintings. According to him, Ravi Varma had been 'rich' and had learnt from English artists whereas Khubiram had had only his own inspiration. 'Ravi Varma's mind was a bit European: he was inspired by Europe, but Khubiram was an original Indian artist.' Rastogi argued with passion that the Khubiram standing Lakshmi was *not* a copy of Ravi Varma's image, it was in Khubiram's own 'style'.

Khubiram's son, Lakshminarayan, who was to establish an equally prominent reputation as a producer of framing pictures, calendar commissions and portraits, was born in May 1915 and was painting almost full time by the age of eight to ten years old. Lakshminarayan's son Narottam was likewise creating his own images independently by the age of eight. In the common tradition, however, neither of these young filial artists signed their own names on images. As Narottam explained: 'so long as the father exists we don't write our name. I too did the same thing.'

Thus, for instance, the legend 'Khubiram and sons' often appears on paintings from the 1940s, indicating a co-operative effort between Khubiram and one or more of his six sons, all of whom were artists. Until

1950, for example, Lakshminarayan lived in Nathdvara and worked as Khubiram's assistant, producing images under the name 'Khubiram and sons'. In that year, however, Lakshminarayan moved to Bombay so that he could work closely with the Bombay branch of S. S. Brijbasi.

He arrived in Bombay in July of that year and, after two years' labour for Brijbasi, he entered into an agreement with a new company, Picture Publishing Corporation (PPC), who assured him that they would purchase all his paintings if he worked closely according to their commissions and suggestions for modifications. PPC was founded in 1952 by P.[Parmanand] S. Mehra and his brothers, who had come to Bombay from Sukkur Sind[14] after Partition. According to Narottam, one day his father was sitting in Brijbasi's Kalbadevi office when Mehra arrived. His was a new company on the make, poaching established artists. He placed an order for various designs and subsequently contracted him exclusively (until 1956). Narottam calculates that L.N. Sharma made two to three thousand paintings for PPC during this period.

One of the earliest designs from this Bombay period was an image of Buddha painted in 1952 for PPC. This was signed by the artist in Hindi – *chitrakar Lakshminarayan Khubiram Sharma, Nathdvara*. The publisher complained that this was a very long name, and was of the opinion that it was inappropriate to write it in Hindi. In response, Lakshminarayan tried signing his pictures 'L. K. Sharma',[15] but quickly shifted to 'L. N. Sharma'.

Narottam and his father kept their own family archive of early prints and other photographic and published sources to enable them to refer to earlier referents in their creation of new designs. We may note here an example of pictorial perpetuity that stretches across the three generations of Khubiram, Lakshminarayan and Narottam. In 1961 Narottam worked extensively on an image of Viswarup, which had been commissioned by Hem Chander Bhargava. While painting this, Narottam drew upon an image that his father had painted with Khubiram (published

by Hem Chander Bhargava in the 1940s). Narottam described the relationship between old and new image: 'we have to stick to the conventions – we can't change it – the main figure is the same, but everything else is changed.'

Another example of this kind of perpetuity is *Sudarshan Chakra*. Khubiram's rendition of this was published as a bromide postcard-sized image in 1927 (illus. 121). In the mid-1950s the young Narottam worked with L. N. Sharma on a reworking of this image for PPC in which the continuities are strikingly obvious. The family archive included copies of the earliest workings of this image and these were used as a

121 Khubiram, *Sudarshan-Chakra*, c. 1927, bromide postcard-sized print. Published by S. S. Brijbasi, printed in Germany.

122 L. N./N. L. Sharma, *Shri Shiv Parsana* ('Shiv's Delight'), mid-1950s, published by P.P.C. Bombay.

reference in constructing the new image. It should be noted, however, that although there is a recognized group of images, first perfected by Khubiram and repeatedly reworked by his descendants, they do not have exclusive rights over these images. All artists and publishers feel at liberty to copy directly or rework images produced by anyone. The *Sudarshan Chakra* image also formed the basis of a near-copy by Rup Kishor Kapur, by then painting under the byline of 'Chitrashala Dehradun' (see chapter 6).

Khubiram's descendants in turn also widely copied the work of artists outside their family. *Shri Shiv Parsana*

(illus. 122) dating from 1953-54 demonstrates Lakshminarayan's almost chameleon qualities, since it is heavily marked by the 1950s' *filmi* style[16] usually associated with the Maharashtrian painters Mulgaonkar and Pednekar with whom Lakshminarayan and Narottam were in contact. In the case of this image the publisher had given them an explicit instruction to reproduce an earlier best-selling image by Mulgaonkar. From the mid-1950s to the early '60s, the top end of the market was largely dominated by the seamless and slick sentimental images of Mulgaonkar and Pednekar (and later S. M. Pandit). It is often said that Mulgaonkar made

123 Pednekar, *Shri Jagdamba Bahucharaji* ('Chubal'), mid-1950s, published by S. S. Brijbasi. A goddess who has come to be associated with *hijras*, India's 'third sex'.

Nevertheless, there remains some truth in the suggestion. Mulgaonkar, Pednekar and S. M. Pandit articulated a new visual idiom that gave a *filmi* gloss to the lifestyles of the Republic of India's new citizens. They were represented by alluring females, erotic substitutes for the wider nation (illus. 123). Their saris were generally tighter and wetter, their smiles whiter, their prospects seemingly assured. One can almost sense the relief at not having to paint Bhagat Singh or Gandhi.[17] Images such as Mulgaonkar's wonderful *Agricultural Beauty* (illus. 125) fuse the productivist concerns of central government with the male viewers' desire for visual pleasure.

Crucially, this group of artists also produced primarily for the calendar market, which grew

124 The painter Indra A. Sharma (*right*) with fellow artist S. M. Pandit and the then director of the J.J. School of Art. Mid 1950s.

collages from faces cut from movie magazines, which he then airbrushed to produce optimistic images of exuberant young mothers with bouncing babies or synthetic clear-skinned gods cooing over spouses and progeny.

It is tempting to suggest that if the tenacity of the Nathdvara idiom parallels the legacy of Gandhi (with its appeal to enduring moral and divine issues), then the group of artists associated with Mulgaonkar parallel the Nehruvian vision for an independent India. Such a claim would need to be heavily qualified, and the mutual influences and friendship between key practitioners of both idioms recorded.

125 Mulgaonkar, *Agricultural Beauty*, mid-1950s calendar.

exponentially following Independence.[18] Pictorial calendars had been printed since at least 1901 – the Calcutta printers P. M. Bagchi still have, hanging in their main office, a copy of one they printed in that year featuring Sarasvati. Isolated examples also exist from the 1920s, but it was in the 1950s that production dramatically increased. An independent and 'modern' existence intensified the pleasure and particularity of each year.

Images commissioned for calendars are likely to differ in various ways from those commissioned for framing. Quite apart from size and proportion (framing images are generally 'portrait' format, whereas calendar images are squarer to permit space at the bottom for overprinting with a commercial slogan and calendrical information; illus. 126), framing images will nearly always end up fulfilling a devotional purpose. The non-devotional and ephemeral nature of calendars thus opened a new space in commercial picture production where one

505 - SHREE MAHAVISHNU

out-sourced child-labour working in dangerous conditions. By the late 1970s there were 350 photo-offset machines and approximately one thousand litho and letterpress units operating in the town.[19] The printing industry originally developed as an adjunct to firework production, producing colourful labels (see illus. 1) and major Sivakasi printers such as Coronation Litho were significant forces by the early 1960s. A detailed history of south Indian print-culture and Sivakasi printing remains to be written but there is some evidence of very early print production (for example, illus. 127 is certainly early twentieth century). It has been suggested that the generation of south Indian artists associated with Kondiah Raju (1898–1976) entered lithographic picture production after early careers producing painted scenery for Tamil theatre groups specializing in stories such as Harishchandra.[20] While I do not doubt, however, that there are significant regional differences in picture production, most artists based around Sivakasi have largely reproduced north Indian styles pioneered by the artists discussed in detail in this present account.[21]

However, inasmuch as this book has invoked an episodic dominance – of Ravi Varma, of Nathdvara, of B. G. Sharma and so on – it has perhaps risked an homogenization of an idiom of picturing that does

126 Indra A. Sharma, *Shree Mahavishnu*, c. 1960. Publisher Coronation Litho, Sivakasi. The blank area at the bottom of the page is for overprinting with advertising material and a calendar. Images like these are mass-produced in Sivakasi and then customised for individual clients by local letterpresses.

is much more likely to encounter erotic and politically and socially topical images.

The success of Pednekar, Mulgaonkar and S. M. Pandit (all based in Maharashtra) in the 1950s, the founding of the Madras press J. B. Khanna in 1954, together with the emergence of Sivakasi as the major printing centre in India, signal a minor geographic reorientation of picture-production in India. Sivakasi, a small town in Tamil Nadu, has for long been India's main source of fireworks and is notorious for its use of

127 *Whole Murti of Rameswaram*, early 20th century. National Litho Press, Sivakasi. Hanuman's monkey army constructs a bridge from Rameswaran to Lanka so that Ram and Lakshman might rescue Sita.

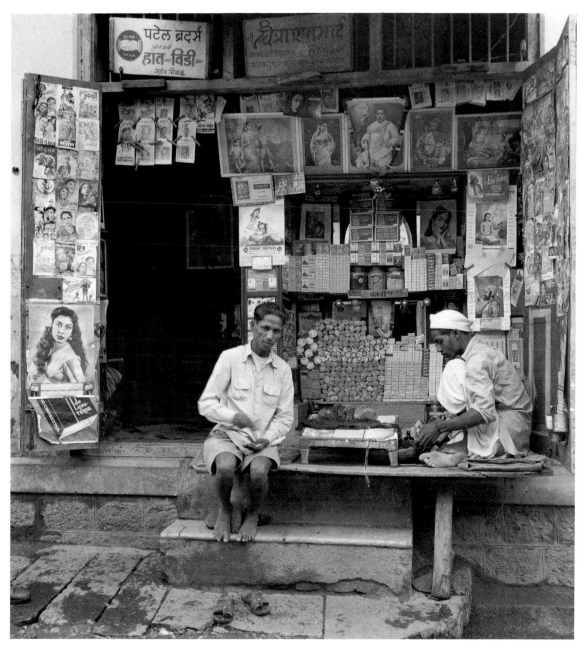

128 A Maharastrian *pan* shop decorated with pictures. Images of Tilak and Shivaji are displayed alongside images of gods and advertising material. Wai city, Satara district, 1956.

retain some significant peripheral regional traditions. Rather like India's commercial film industry, in which vibrant regional cinemas (such as those in the Telugu and Tamil languages) coexist alongside the Bombay-based 'national' genre, so localized visual traditions have cohabited with the pan-Indian reach of the relatively standardized output of major companies such as Brijbasi and Sharma Picture Publications. Were this book longer, and had I the opportunity to conduct fieldwork among image consumers in southern or eastern India, more would have been said about these regional traditions.

In some cases 'localization' has taken the form of the customization of a national prototype, as in the reversal of goddesses' nosepins for the southern market, and the 'enfleshing' of their eyes. We have also seen that certain regional figures (such as Ramdevji) have achieved a dramatic north Indian reach through their adoption by leading artists and publishers. By contrast, certain key figures and motifs in regional traditions have remained resistant to incorporation within emergent national genres. Hence, within India the Bengali goddess Mansha (illus. 129), for instance, is still only to be found circulating in Bengal, the product of small Bengali presses.

Mansha Devi has a more than local significance, however, for she is exemplary of the 'rhizomatic' global patterns of image circulation that exceed conventional orders of scale. It has been suggested that a chromolithographic image from India, invoking her iconography, was one of the contributing elements to the emergence of current *mami wata* imagery in Africa.[22] *Mami wata* is a water spirit widely worshipped in West Africa. Recognized as 'exotic', her worship draws in other elements of popular Hindu practice: her altars, and the 'use of books, papers, and note pads in communication with the spirits' find their inspiration from chromolithographs of Lakshmi,[23] and images of Hanuman, Dattatreya and Shiv are commonly displayed.[24] Mansha Devi is a case of a local figure having almost no national profile, yet enmeshed in an international imagescape.

129 *Mansha Puja*, showing the narrative associated with, and the worship of the Goddess Mansha c. 1980. Unknown Bengali publisher. This goddess and her imagery have had a profound impact in Bengal and much of West Africa, but not the rest of India.

She also exemplifies those cultural flows that elude the West.[25]

Lakshminarayan Sharma ended his agreement with PPC in 1956. After this date he operated as a standard freelance. Narottam was responsible for much of the work bearing his father's 'L. N. Sharma' signature from the mid-1950s onwards. Looking at a copy of a 1956 portrait of *Maharana Pratap* (illus. 130), Narottam exclaimed 'My brush is also in this painting!':

Except for the face, and finishing, I did everything. I did the filling, and finishing was done by my father. I also used to visit customers with my father. If customers came to our studio they would

130 L. N. Sharma, *Maharana Pratap*, mid-1950s, published by W. W. Wagh.

talk with me and say we want such and such a subject. Afterwards I would do the drawing, the customer would approve it and I would fill the colours. Then only the finishing was done by my father. And we used to write the name L. N. Sharma. If you had asked my father about this he wouldn't remember because he was only finishing! Because I have done nearly all the work I remember!

This image develops the striking profile of this figure of Hindu independence first popularized by Ravi Varma and pushes it in a direction that is simultaneously different from the earlier Ravi Varma or Nathdvara styles. For a more traditionalist treatment of the image we can turn to Hiralal's *Maharana Pratap of Udaipur* (1933; illus. 131), published by Harnarayan. Hiralal presents a formal profile of Maharana Pratap shown within a medallion set against a hill fort. Above, within another medallion, is a depiction of the multi-faced Shivling at Eklingji, which lies midway between Udaipur and Nathdvara. At the bottom of the picture two narrative episodes are depicted in a manner suggestive of later representations of the god Ramdev's *parche* ('proofs'). This hierarchically arranged image has echoes in several of the others considered in this book (for example H. R. Raja's 1982 Bhagat Singh and Chandra Shekhar Azad, see below). It involves three planes – an uppermost divine realm, a central timeless icon of the main figure, and at the bottom an allusion to embodied history.

The movement from Hiralal's earlier conception to L. N. Sharma's later depiction maps a profound transformation. This is so not only at a formal visual level: Hiralal's rather quaint conventionalism is dislodged by a filmically abrupt depth of field so that the background in the L. N. Sharma image is rendered only in shadowy strokes. But Pratap also becomes a figure of embodied, violent and emulatory action, the historical alibi for action in the present.

In Maharashtra during the 1950s Maharana Pratap, along with Shivaji, was becoming an increasingly sectarianized figure, appropriated by the extreme-

131 Hiralal, *Maharana Pratap of Udaipur*, 1933. Published by Harnarayan & Sons.

rightist Rashtriya Swayamsewak Sangh. Founded in 1925, the RSS, under its chief ideologue M. S. Golwalkar, had advanced virulently anti-Muslim politics since the late 1930s and had directly inspired Nathuram Godse, the assassin of Mahatma Gandhi. In the 1950s the RSS was building its organizational cells throughout Maharashtra, training young cadres in martial arts and laying the seeds of a cultural nationalism that would ultimately control the national government before the end of the century. A photograph taken by the anthropologist McKim Marriott in a provincial Maharastrian town in 1957 records one of the ways in which imagery fed into this shadowy movement. It shows several lines of young recruits sitting cross-legged facing four framed images, garlanded with marigolds, arranged either side of a flagpole and apparently the subject of a peroration delivered by a

young man standing on the right of the scene. The images in the frames are portraits of (from left to right) K. B. Hedgewar, the RSS's founder, Shivaji, Rana Pratap and M. S. Golwalkar, the then leader of the movement (illus. 132).[26] This ritual engagement with political figures reflected Golwalkar's position that it was the nation itself that was sacred: 'nationalism subsumed and transcended religion'.[27]

In the late 1950s, inspired by the success of Sharma Picture Publications, L. N. Sharma, together with a younger brother, T. K. Sharma, founded his own company, Sharma Kala Niketan, which published 27 designs between 1958 and 1962. The company, however, could not rival B. G. Sharma's and following its collapse Narottam worked mainly for Jain Picture Publishers, a dealer turned publisher, for several years. Sometime between 1960 and 1962 Narottam was commissioned by Gokulnathdasji of Joshi Art Works, who insisted that he put his own name on the image, rather than his father's. This was an isolated instance, however, and it was not until 1973 that Narottam routinely started to sign his own name; he estimates

132 RSS instruction with pictorial aids in Wai city, Maharashatra, 1957. Garlanding portraits was a regular ritual.

that between this date and 1995 he produced more than 15,000 paintings (although at 2.5 paintings per day this seems vastly improbable).

Narottam made a distinction between his commercial work and the work he does exclusively for his own satisfaction, but most of his time is taken up responding to commercial orders that require him to work in a variety of styles:

> we prepare according to the customers' taste. Today you give me an order that you want such and such mythological subject according to such and such taste – we are living in the market – and we prepare according to the request. And of course we can prepare in our own style also – we can do both.

The chameleon-like agility that the diverse demands of the market impose have 'diluted' the Nathdvara style to the extent that Narottam's *oeuvre* lacks any clearly definable characteristics. In this respect it contrasts sharply with the work of Rastogi and especially Raja (discussed below), whose work, although foundationally commercial and market-driven, is exceptionally formalized and immediately recognizable.

Both Rastogi and Raja have created markedly original genres and subsequently maintained distinctively stable styles over long periods. Narottam, by contrast, was part-inheritor of a family tradition and a corpus of images that had to struggle increasingly in a volatile market. The history he describes involves a series of endless pragmatic adjustments to the changing tastes of the market.

Both Yogendra Rastogi and H. R. Raja live in the city of Meerut, an industrial centre 70 kilometres north-east of Delhi. The careers of both artists have traversed menial sign-painting and commercial design, in addition to images for calendars and framing prints that intersect more directly with the products of the Nathdvara tradition.

The images produced by those working within

the Nathdvara tradition have been subject to very significant changes, which allow one to date a specific image, for example, to 1935 or 1955. Despite these transformations they retain a continuing identity that would allow one to identify them all as 'Nathdvara' (or perhaps neo-Mewar), part of a tradition encompassing several hundred years, and which one would identify immediately as Indian. Other currents of popular imagery, however, while participating intimately in India's own contemporary history, have been less aesthetically anchored to that locality. The calendar images discussed in the rest of this chapter are part of a public, exhortatory art that has many similarities with images produced elsewhere in the world.

YOGENDRA RASTOGI: VISUALIZING MODERNITY

Rastogi is a self-taught artist who runs Yogendra Publicity Service, a flourishing commercial design and painting studio in Meerut. In contrast to the working spaces of most Indian popular artists, his office is a spotless air-conditioned area equipped with all facilities. Behind this impressive and prosperous façade lies a history of struggle and determination during which the young Rastogi clawed his way up from the world of the commercial sign-painter to his current status as one of the most expensive and sought-after calendar artists of the day.

Aware of his own talent as a child, it was only his father who encouraged him in his aesthetic ambitions. Lacking any family tradition in this work, or acquaintanceship with other artists, there was no recognition that painting might be a respectable profession resulting in what Rastogi described as 'world fame' (such English phrases recur in the tapes of our predominantly Hindi coversation). 'There is no-one who I could describe as my guru. There is no one individual or any institution. I was inspired by one or two artists of course . . . There was an artist named S. M. Pandit.'

It was this renowned artist – eulogized by many other painters as the finest technician among them – whom Rastogi sought to meet when, aged fourteen, he journeyed to Bombay in 1951. He had left Meerut without his parents' permission and spent one week in Bombay before returning ticketless in a state of great dejection. There he had approached Pandit (in Rastogi's view the most talented artist since Ravi Varma) and pleaded with him to be taken on as his assistant. Pandit refused in an act of negation that Rastogi has never been able to forgive and he still speaks of his bitterness. He then approached Mulgaonkar, also without success.

Due to the illness of his merchant father, the family lived in poverty and Rastogi was unable to continue his education. Little by little, and in the absence of funds to purchase either adequate paint or paper, Rastogi developed his painting skills. As the eldest son, and in an attempt to feed the family, he started decorating and sign-painting in Meerut, taking whatever work was available.

Meerut is a much larger city than R. K. Narayan's fictional south Indian town of Malgudi but we can imagine the young Rastogi facing the same challenges and disappointments as Raman, the hero of *The Painter of Signs* faced twenty years later:

Must design and finish that piece of work for the Family Planning, Raman told himself one evening. He took down the plank from the wall, ran his fingers over it . . . He took from his pocket a piece of paper and studied the message on it. 'Family Planning Centre. Free Advice.' . . . He told himself: I am not doing the right thing in carrying on with this sign-board painting. I took it up because I loved calligraphy; loved letters, their shape and stance and shade. But no one cares for it, no one notices these values. Like that bangle-seller and the lawyer and the other, who demand their own style and won't pay otherwise. Compromise, compromise; and now this family planner wants – God knows what – black and white, or white and black, shaded or plain? A job anyone could do . . .[28]

Rastogi continued to do this menial work for many years until he had accumulated sufficient funds to devote several months to his own painting. Then, in 1961–2 he had his first great commercial success in the world of picture publishing when he sold six paintings for the incredible sum of one thousand rupees. His father was astounded, disbelieving that one person could earn such a sum simply through painting. Two of these were then published by Mehta Offset Printers – an image of a boy member of the National Cadet Corps and a portrait of Gandhi – and proved very popular.

In the following year Rastogi had an even greater success with an image he describes as 'the hit picture of that period', originally printed by Coronation Litho, Sivakasi, and then pirated by thirteen other presses. Still they could not supply the demand, Rastogi records. The picture was captioned, in English, 'Land to Defend' and depicted an impossibly young member of the National Cadet Corps holding a rifle against a background landscape of Indian troops trudging through the Himalayas (illus. 133). This background, as also that of another NCC image in which soldiers are depicted on manoeuvre, scaling cliffs with rope ladders and dismantling artillery, was based on photographs he obtained from the Press Information Bureau. In both these images an unusual feature that figures heavily in the later work of his disciple H.R. Raja is apparent – a literal picture frame within which some of the composition is set. This feature and several other characteristics of Rastogi's work reflect his formative experiences as a sign-painter. Much of his work is highly emblematic and incorporates textual material. Frequently the juxtaposition of images and the use of lettering suggest some public signifier designed to be apprehended immediately. In some images the continuity with the forms of Nehruvian public exhortation that a 1950s sign-painter would have often painted is apparent. In others the combination of figures, symbolic backdrops and textual captions gives the work a highly allegorical flavour, by which I mean the communicative modality

133 Yogendra Rastogi, *Land to Defend*, 1963.

of the images is essentially discursive, rather than figural. The visual image gives body to what is initially formulated as a linguistic message. In Rastogi's work there is little of the *figural* density or richness that we have seen in the work of Narottam Narayan, where colours and textures produce effects of luscious eroticism, or for that matter in the later work of B. G. Sharma. Rastogi's images by contrast are figurally *thin*, the colours are weak, pastel shades that border on the transparent as though determined not to eclipse the discursive linguistic allegory constructed through Rastogi's careful drafting of the composition.

The relationship to the everyday yet semiotically dense world of sign-painting is perhaps no more apparent than in Rastogi's mid-1960s portrait of Lal Bahadur Shastri, who served a brief interregnum as Prime Minister between Nehru's death in 1964 and the succession of his daughter in 1966. The following year, in the course of the war with Pakistan, Shastri raised the slogan 'Jai Jawan, Jai Kisan' (Victory to the soldier, victory to the farmer). In a speech in October 1965 he declared:

> The nation cannot afford to relax. It is difficult to say what the future holds for us . . . The duty of the nation is, therefore, clear. The country's defences have to be strengthened. The people should spare no efforts to strengthen . . . defences. Side by side, food production has to be increased. Food self-sufficiency is as important as a strong defence system. It was for this reason that I raised the slogan: 'Jai Jawan, Jai Kisan'. The Kisan is as much a soldier as the Jawan.[29]

The Shastri *jawan/kisan* image positions the central portrait against a dual backdrop (illus. 134). At the bottom we see signs of the Green Revolution as tractors replace bullocks while pumps irrigate the land. This realm of the heroic *kisan* is overlain with a parallel realm of the *jawan*, who are depicted on an allegorical cartouche, which scrolls down from the top of the frame and reveals soldiers firing towards the

134 Yogendra Rastogi 'Jai Jawan, Jai Kisan', 1965.

Pakistani combatants. The play upon the medium of signification has recurred since the inception of the genre. In Rastogi's (and, as we shall see, H. R. Raja's) work the frames fall, so to speak, within the image and clearly mark his own experience as a commercial artist. The scroll upon which the *jawan* half of Shastri's *jawan/kisan* allegory is delivered is presumably that of a poster being unfurled, ready to be pasted over the other half of its own sign. Once again we are alerted to the public spaces of signification that recur in Rastogi's work.

The centrality of the linguistic allegorical signification of the image is connoted within the picture by Shastri's open mouth: the picture makes visible a fragment of his speech equating farmers with soldiers and this image – designed for public display on the walls of shops and offices – broadcasts this, just as a radio, or loudspeaker might.

All these images have a common form: a central portrait is set in front of or above a symbolic landscape. These two foci serve to contextualize each other politically and historically. The same device is apparent in a later image that celebrates India's first nuclear explosion at Pokaran in 1974 (illus. 135). A

smiling Indira Gandhi, then the Prime Minister, is shown against a background of English, Hindi and Urdu newspaper reports of the underground explosion.

In 1973, following the second war with Pakistan, he painted a calendar image (*Heros* [sic]; illus. 136), which developed some of the earlier *jawan/kisan* themes and clearly demonstrates the recombinative character of much of his work. Whereas the earlier image had simply visualized Shastri's repeated comparison of the two, these later images parachute the perennially young NCC boy, last seen fighting the Chinese a decade ago, into a new alliance with an equally young farmer. They also, it should be noted, bear the inter-ocular traces of the films of Manoj Kumar,[30] which gave cinematic form to such patriotic fervour. Rastogi claimed this as his own original design, which clearly develops the earlier NCC imagery within the political concerns of the time. As with the earlier images he incorporated photographic referents into the work. It is in these images that we can also see coming together many of the skills that Rastogi had perfected earlier in his life. The NCC figure had been much practised in earlier work, and his agricultural counterpart had

136 Yogendra Rastogi, *Heros* (sic), c. 1973.

been developed in the series of Shastri portraits. The artillery and military hardware was modelled on offical photographs that Rastogi purchased for reference, and the landscape backgrounds are colonized by the technology he had learned to represent during the years of painting signs for tractor dealers, pump repairers and fertilizer merchants in the Green Revolution city of Meerut. Indeed I was struck by how familiar the flat, intensely farmed land around Meerut looked. I had of course already seen it many times in Rastogi's calendars.

Other topical images can be noted in passing. Between 1960 and 1974 Rastogi produced numerous composite political portraits, which in various configurations gave contemporary leaders appropriate

135 Yogendra Rastogi, Indira and news coverage of the Pokaran explosion, 1974.

political lineages and mythic charters. Within his *oeuvre* one can also find figures who are rarely depicted within this genre, such as Jay Prakash Narayan and Morarji Desai. (When I re-interviewed Rastogi in December 1999, he observed that he no longer paints contemporary political subjects since they 'lack weight': he has rejected the 'timely' in favour of the enduring: 'Who remembers who Morarji Desai was these days?' he asked. With a fine precision, Rastogi observed that in the 1990s the public wanted generalized, historically removed and conceptually abstracted figures that in a very loose and eternal way symbolize the nation.) There were also, in the 1960s and '70s, inevitably a vast number of Indira images; she is shown with Jawaharlal Nehru, with Sanjay, against the national flag. One series, strongly inflected with a Soviet socialist realist aesthetic, depicts scenes from the life of contemporary India within decorative interlocking cogs suggestive of a huge mechanized India. Heroic peasants clutching sheaves of wheat and sickles are juxtaposed with vast hydroelectric projects, the Trombay reactor, heavy engineering works and scenes of high-tech laboratories peopled by white-coated technicians. Wendy O'Flaherty once commented on the Shivling-like contours of the Trombay reactor, suggesting that a postage stamp that bore its image depicted it within a religious frame. Be that as it may, some Hindu deities have always engaged intimately with modernity. Vishvakarma – a traditional deity of artisan castes – has long been worshipped through special *pujas* in steel and other factories throughout India, and it is appropriate that Rastogi, of all artists, should have commemorated this relationship by depicting this immediately recognizable deity within the sort of structure described above (illus. 137). Represented in various cogs beneath him are a carpenter, a welder working with an oxy-acetylene torch, a man working at a lathe and a hydroelectric dam, and all these are set against a background of the marshalling yard of some heavy industrial plant and high-rise buildings under construction. Finally we may note a further example of Rastogi's recombinative

137 Yogendra Rastogi, *Vishvakarma, c.* mid-1970s.

images in which he depicts two small children situated within the sort of technical realm that Rastogi had explored in numerous earlier images. Here, however, the difference/unity fraction is not marked by occupation (soldier versus farmer) but by gender, for in this series a brother and sister are depicted in the context of a well-equipped doctor's surgery. Such an image, which to a non-Indian viewer may appear excessively sentimental, explores the sibling relationship posited in the *jawan/kisan* series in the literal realm of kinship and is prefigured also by Rastogi's images depicting a sister tying a *rakhi* on her brother on the occasion of *rakshabandan* (illus. 138). The 'sentimentality' needs to be understood clearly in the context of Indian family values and the domestic spaces that such images were intended to occupy. But there is also in these images a political optimism about the future that is the direct antithesis of any sentimentality based on nostalgia. 'Splitting', for instance into the good and bad brother, has long been a means by which popular film mediated questions of social and biological destiny.[31] In Rastogi's work the identity of face and body seem to suggest a commonality fostered by the nation, and the meritocratic possibilities of modernity.

138 Yogendra Rastogi, a young sister anoints her brother beneath the approving gaze of Indira, mid-1970s.

Rastogi makes no great claims for his own originality: indeed he wryly claims that he is 'not original' and that he only 'copies in [his] own style'. The 'newness' in his work stems from the novel combinations he created, particularly of political portraits.

But Rastogi feels imprisoned by his earlier success: he feels he is unable to experiment within the genre to which he has contributed so successfully, and now paints calendar images only occasionally, though he still usually produces a new Durga image every year (these are famous for their 'superfine finish'). Nowadays he finds the constraints suffocating:

> There are so many restrictions. Suppose we are preparing a scene with figures, we can't have any weeping, any anger, anything like this. The images a person wants for his *puja* room cannot depict anything cruel. Calendar pictures are not concerned with art. They are concerned only with images that can be worshipped . . . Gods or Goddesses giving their blessings (*ashirvad*) with a smile.
>
> Suppose I am painting a picture of a boy studying. He should be looking down at his book, but we have to paint him so that he is looking at the person looking at the picture. But if he is studying, how can he look at you?

Rastogi acknowledged that profiles could be used but never in such a manner that the viewer is 'cut' from the God or other subject. As he said in another interview with Kajri Jain, 'Bold colours, bold figures, front looking – these are the most important things'.[32] *Freedom Fighters* (illus. 139), a popular print of a Rastogi painting showing a patriotic boy reading a history of the Indian freedom movement, was a compromise that retained some signs of its creator's intransigence: the boy's eyes look not at the viewer, but obliquely to the left. Rastogi's complaints suggest that the struggle between absorption and theatricality (for which see the Introduction, pages 21–3) is a real one for many commercial artists.[33]

139 Yogendra Rastogi, *Freedom Fighters*, mid-1970s. Published by J. B. Khanna, Madras.

H. R. RAJA: PATRIOTISM AND COMMERCIALISM

When I first visited Meerut, in April 1994, it still bore the marks of caste riots, which had erupted following the removal of a statue of Ambedkar by the local authorities. Dalit outrage led to riots in which two people had been killed; several weeks later the additional troops and Rapid Action Forces that had been drafted into the area were still very much in evidence.

Raja is a rare thing in the contemporary popular Indian art scene: a Muslim (illus. 140). This identity is partly masked by the Sanskritized English

transliteration of his name (so, 'Raja', rather than 'Raza'). It is similarly subdued in his work, which is largely political, although his studio also produces copious quantities of religious designs – Mahavir, Guru Nanak and Krishna are among his specialities. It is his political designs, however, that are most distinctive and will concern me here.

Raja was a long-time friend of Yogendra Rastogi and they had known each other since 1951, when they worked together as sign-painters. Shortly after Rastogi met public acclaim as a calendar artist he hired Raja as an assistant, preparing background colours for him between 1963 and 1968.

We have already seen in the previous chapter some of the efflorescence of Bhagat Singh and Chandra Shekhar Azad images that Rup Kishor Kapur

140 H. R. Raja, photographed in Meerut, 1994.

produced in the early 1930s. It is these same two freedom fighters who came to preoccupy H. R. Raja to a remarkable degree (he claims to have painted more than 150 joint portraits). One early image reuses elements from the China war picture and places Bhagat Singh and Chandra Shekhar Azad (improbably) above the Himalayas. A slightly later image, a *trimurti* including Subhash Chandra Bose, is signed 'Rastogi Studio' but is in fact largely Raja's work, Rastogi having added the final two or three hours' brushwork (illus. 141).

In all these images a slippery mimicry and ability to efface identity is celebrated repetitively. This is a slipperiness that in the case of Bhagat (as we have seen) permitted him to pass as an English sahib. Like Rup Kishor Kapur, Raja continues to emphasize the trilby. In the case of the dyad (Bhagat and Azad) there is a further kind of slipperiness. He invariably depicts Chandra Shekhar Azad with a wristwatch and sacred thread, and Bhagat Singh with the aforementioned trilby. These serve as markers to differentiate identical physiognomies. Their identical faces suggest a somatic transparency and interchangeability of identity grounded in the inconsequentiality of Azad's Brahman and Bhagat's Jat Sikh identities in the face of their mutual Indian-ness. We can also see in their somatic interchangeability an echo of the *jawan/kisan* co-identity that had been perfected by Raja's initial employer, Rastogi.

The vocabulary of Raja's images hardly alters through all his work and his path of creativity involves a re-assemblage of these constituents within slightly different structures, which are always constrained by a specific formula. Indeed the patterns have been established with such a generality that – Hume's problem of induction aside – one might forecast with some degree of specificity what any future dual image of Bhagat Singh and Chandra Shekhar Azad might or might not look like. All the previous images I have seen contain a number of standardized features. Stereotyped representations of Bhagat Singh and Chandra Shekhar Azad dominate the image. Bhagat

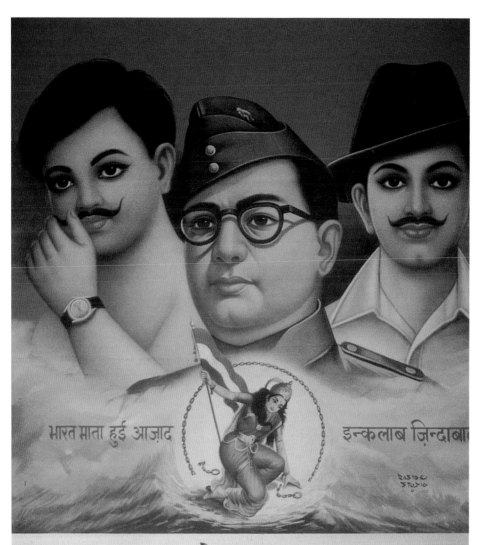

भारत माता हुई आज़ाद इन्कलाब ज़िन्दाबाद

❀ गुजराती वैद्य - सलाह मुफ्त ❀

छ्वाजन (एग्जिमा) दाद, खुजली, बवासीर, खूनी व बादी, कान के रोग
स्वास (दमा) गठिया, पेशाब में जलन, स्वेत प्रदर, रक्त प्रदर
चौबीस खम्बा देवी के पास, उज्जैन (म० प्र०)

141 'Rastogi Studio' (Yogendra Rastogi and H. R. Raja), calendar image of Chandra Shekar Azad, Subhash Chandra Bose, and Bhagat Singh, 1980s reprint of a mid-1960s image.

Singh always wears a trilby and a shirt, and is always depicted frontally; likewise Azad is always bare-chested, rolls his moustache with the fingers of his left hand, and wears a wristwatch and sacred thread. These iconographic traits are all invariant, apparent in at least 27 images.

Beyond this we might highlight other features. Both Bhagat Singh and Azad are always represented in a 'non-realist' space completely devoid of any depth cues. It would be tempting to suggest that they inhabit a de-temporalized domain, but this would be misleading. Raja frequently temporalizes the different 'layers' of the images in what are sometimes extremely complex and sophisticated techniques.

However, where there are elements derived from particular historical events and moments they are placed within a mixture of other time frames, which nullify the overall 'realist' effect. The most immediately apparent fact is that the diversity of elements from which Raja's images are derived preclude any fusion within a single time/space configuration. This is quite clearly a realm of allegory or montage that does not aspire to represent any phenomenological experience of what Nelson Goodman calls the ready made world. There are a number of different backdrops but they all participate in this denial of a fused time and place. There are plain coloured backdrops, cloud effects, darkened skies, floral patterns, flames, granulated walls and abstract geometric patterns. Within this atemporal dimension an array of additional symbols is brought to bear: the *shahid* memorial, a *Shivling*, a 'torch' or 'flame of freedom', and an image of *Bharat Mata* (Mother India) breaking her chains.

Temporality *does* appear in some of these images but always through very specific devices that establish the historical context of Bhagat's and Azad's claim to fame. These devices are shadowy depictions of Chandra Shekhar Azad's shoot-out, Bhagat Singh waving a nationalist flag at the head of an anachronistic 'Quit India' demonstration, Singh and Azad together with other freedom fighters seated at a large table, and Bhagat Singh's execution. This last is

represented either through a silhouette depiction of three bodies hanging from gallows, or a more detailed image in which Bhagat Singh is shown either hanging from the gallows or about to be hanged. On his right stands a *rakshas*-like figure wielding a large sword (illus. 142).[34] Some other Raja images also show Bhagat Singh's face inside a noose that hangs down from the top of the picture frame, or just an empty noose. Such images recall the opening sequence of Manoj Kumar's 1965 film *Shaheed*.

These images contrast remarkably with the fecund claustrophobia of some of the images produced by Nathdvara artists. Raja's work is concerned with contingency, chance and historicity. But this random

142 H. R. Raja, calendar image of Chandra Shekhar Azad and Bhagat Singh, 1978. Publisher Anant Ram Gupta.

contingency of history seems to be offset by a stress on the body: the bodies of Bhagat Singh and Azad become stable signs of belonging in this technical and deterritorialized space.

The double images are just one aspect of H. R. Raja's Bhagat Singh and Chandra Shekhar Azad portraiture, for the two also appear in combination with other 'freedom fighters' (illus. 144), most commonly Bose, Rana Pratap Singh and Shivaji, but also sometimes with the Rani of Jhansi. Raja also pulls in other lesser figures in India's violent struggle for freedom. Uddham Singh, for example, appears in several Raja images joining the select company of 'Indian lions' (illus. 144). As with Rup Kishor's work, Raja taps into an enduring vein of subaltern messianic nationalism.

Pastiche and *bricolage* are two terms that one might want to invoke in thinking about these images, but they also suggest that feature of mass culture described by Jameson as it responds to new situations of repetition.[35] The repetitive volatilization of popular texts ensures that we never experience them for the first time: it is always (like the new hit song) already half-heard, half-seen as we encounter it in its ubiquity in our daily lives. What I have not yet stressed sufficiently is that Raja, like Rastogi, works almost exclusively for the calendar industry, which wants 'new' designs each year that do not test the limits of their genre. This provides a further frame through which these images are already always half-seen in advance, since each year's new calendar replaces the fraying remains of last year's.

Both Rastogi and Raja work within a paradigm that stresses the recuperation of knowledge, what Jonathan Parry describes as the salvaging of elements from an already known divine original, rather than its creation.[36] Their work also suggests a musical parallel, that of *ragalap* in a genre of north Indian vocal music

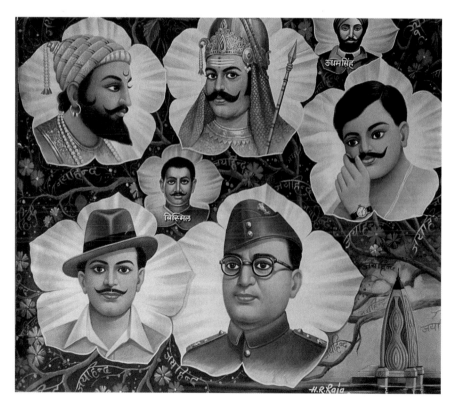

143 H. R. Raja, calendar image from early 1980s, depicting (clockwise) Shivaji, Rana Pratap, Uddham Singh, Chandra Shekahar Azad, Subhas Chandra Bose, Bismil, and Bhagat Singh.

144 H. R. Raja, *Bharatiya Sher* ('Indian Lions'), mid-1980s.

called dhrupad, which develops its material through 'internal scalar expansion'.[37] Here, as Richard Widdess puts it, 'it may be necessary to repeat material several times, gradually transferring emphasis from the original final note to a new final note [and] in extended performance, greater length is attained by the varied repetition of material.'[38] We have seen that both Rastogi and Raja inhabit much more highly specialized representational niches than the Nathdvara painters we touched on earlier. In Rastogi's early work we saw the constraints of advertising and sign-painting; Raja's work demonstrates an even more restricted and 'arthritic' aspect, comprising variations within a formalized language. N. L. Sharma, by contrast, has developed an extraordinary aesthetic

agility and his ritual images display a great diversity of form and content. Here it is the market that appears as archaic and impoverished, and closeness to traditional authority by Brahman Nathdvara painters that authorizes greater choice. Correct repetition is more obvious in the commoditized revolutionary images produced by H. R. Raja.

While most of Raja's images circulate the fixed vocabulary of revolutionary nationalists, he has also over the years painted many portraits of Indira Gandhi, and subsequently of her son Rajiv. Following Indira's assassination in 1984 by her Sikh bodyguard, Raja set to work on an image that depicts her garlanded with the quotation *mere khun ka har katara desh ko mazbut karega* ('every drop of my blood will strengthen the nation'). Indira is reported to have said this at a rally in Orissa shortly before her death and her supporters believed this to be her premonition of her own murder.

As an heir to the Rastogi tradition, Raja mirrors this linguistic message with a visual trace of Indira's blood – several drops and rivulets at the bottom left of the image – on what must be the surface of the image (illus. 145). Like all his (and Rastogi's) images this picture lacks depth. Indira is not a body located in three-dimensional space but a flat representation looking out at the viewer, and the most significant space of the image is not behind the picture plane, but *in front*, where the blood drips.

Raja's image marks a decisive point in the struggle that has occurred throughout the history outlined in this book: the struggle between the space 'inside' the picture (the virtual space behind the picture plane) and the space between the surface of the image and viewer. In Raja's portrait the only space that matters is that between Indira and the viewer, the space determined by her gaze meeting one's own and in which the viewer can reach out and touch the blood on the surface of the image. Whereas the space behind the picture plane was susceptible to rationalization and disenchantment (recall that this was after all the cause of Richard Temple's enthusiasm for perspective), the

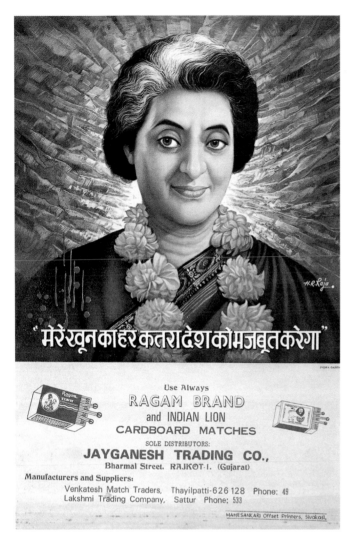

मेरे खून का हर कतरा देश को मजबूत करेगा

145 H. R. Raja, *Mere*
Khun Ka Har Katara
Desh Ko Mazbut
Karega, 1984.

space between the picture and viewer is much more inclined to an affective intensity.

This rebirth of a space of involvement and desire out of the thwarted colonial imposition of a space of analysis and detachment has been one of the chief threads in this book. But this rebirth remains to be seen in operation ethnographically. The following chapter attempts to do this in its description of how images are consumed within one central Indian village. In the discussion above we have seen that,

as Fried once wrote, 'one primitive condition of the art of painting [is] that its objects necessarily imply the presence before them of a beholder'.[39] In what follows we will try and get much closer to the experience of some of these beholders.

8 what pictures want now: Rural consumers of images, 1980-2000

It was the insistence by village friends, during my first research in India in the early 1980s, that I must attend to the needs of various printed images in my possession of deities that first alerted me to the significance and complexity of Hindu chromolithographs. Their concern awoke an interest that led me back to India on many occasions and to some of the fruits presented in this book. The perceived demands made by images in that Madhya Pradesh village, and in a nearby industrial town, is one of the central concerns of this chapter. This is a very particular slice of contemporary India and the information presented in this chapter is, almost certainly, radically different from what one would encounter if one was studying image practices in an elite south Delhi suburb, or a Scheduled Caste neighbourhood in a large Maharashtrian city. It is not intended to represent all of modern India. It is as yet, however, the only detailed ethnographic investigation into the use of these images anywhere in India.

A BRIEF ETHNOGRAPHY

The name of the village is Bhatisuda, located on the Malwa plateau in Madhya Pradesh, roughly halfway between Bombay and Delhi. Chromolithographs are popular across all castes and religious groups. Jains and Muslims own images as well as Hindus, and Scheduled Caste Chamars and (warrior) Rajputs or (priestly) Brahmans own similar numbers of images. (Across the village as whole there is an average of seven images per household.)[1]

Bhatisuda's population is spread through 21 castes, and although village income is still overwhelmingly derived from agriculture (the main crops being maize, sorghum and wheat), the presence of the largest viscose rayon factory in Asia a mere 6 kilometres away in the town of Nagda has had an enormous impact on the economic fortunes of landless labourers, and has structured local discourses on history and the nature of progress. The village cosmology reflects the nature of popular Hinduism in this area and there are temples

and shrines to the main gods: Ram, Hanuman, Krishna, Shiv, Ganesh, Shitala; and also to local deities: Tejaji, Ramdevji, Jhujhar Maharaj, Bihari Mata, Lal Mata, Rogiya Devi, Nag Maharaj and many more.

In 1991 (the date of the most recently available census figures), 531 of the total population of 1,366 were members of the Scheduled Castes (Bagdi, Bargunda, Chamar, Bhangi).[2] By far the largest single landholding group are Rajputs (owning 37 per cent of village land) but the 'dominant caste' is a very small number of Jains, descendants of the last zamindar who administered the village in the final years of the village's existence within the princely Gwalior State. It is the Jains – ex-urbanites now returning to city life – who own the best agricultural land (although only 8.5 per cent), have for long dominated the village council (the panchayat) and continue to exert a pervasive influence over the central public space of the village.

The horizontal and vertical arrangement of the village encodes a symbolic separation and hierarchization of the diverse caste (jati) groupings that make up Bhatisuda. Higher caste households are predominantly built on higher ground in the centre of the village and most Scheduled Castes live in caste-specific neighbourhoods (mohallas) on the south side of the village. Among Scheduled Caste groups, Chamars live nearest the village in compact groups of small huts, and Bagdis inhabit a more dispersed mohalla, which forms a spur spreading from the village down towards the River Chambal.

Approximately one third of the images are 'framing pictures', chromolithographs printed on thin paper, which have been framed by a local supplier. Most will have been purchased ready framed, although some will have been bought as prints and then framed subsequently. About another third are unframed paper prints; most of these are large glossy laminated prints (20 x 30 inches), which are pinned or sometimes pasted to walls (illus. 146). The remaining pictures consist of a mixture of images printed directly on glass, engraved in aluminium, embossed on plastic, or are ephemera featuring deities (such as the packaging for incense

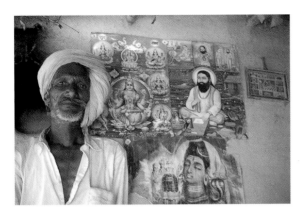

146 Bherulal Ravidas in front of his domestic images, including one of Ravidas. 1994.

sticks), postcards, stickers or, in a few cases, sheets of multiple images pirated and distributed free as part of a local newspaper. The interior of the house belonging to Biharilal, a Banjara[3] villager, gives a good idea of the rich mix of different media to be found on the walls of most village homes (illus. 147). Sometimes postcards are displayed inside elaborate small glass temples, which have been made specially for this purpose. There is a further class of images, which I have not attempted to document systematically, worn on the body in the form of engraved small silver or bronze amulets, or laminated necklaces and wristbands.

The oldest images are owned by a Brahman family (Basantilal's) and probably date from the late 1940s,

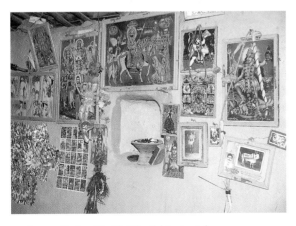

147 Images displayed inside Biharilal Banjara's house. 1993.

about the same date as the oldest photograph, which is owned by a Jain family and represents Khubchand the Jain zamindar.[4] As we shall see, the majority of images are of much more recent provenance and some households replace all their images each year during the festival of Divali.

The figure of (on average) seven images per household conceals both regularities and disjunctions in the ownership and use of images. Most strikingly there are some strong similarities between *jatis* at opposite ends of the caste hierarchy. For instance, the figures for (high-status) Rajputs and (Scheduled Caste) Chamars who, together with Scheduled Caste Bagdis, form by far the largest groups in the village demonstrate an uncanny similarity in the average numbers of images owned. Conversely, one could juxtapose other castes where sample households exhibited dramatically different numbers of images displayed, but it would be difficult to relate this in any way to caste or economic hierarchy. There are, however, (and this is not a surprise) certain patterns of deity choice that are clearly caste specific.

There are thus regularities in caste ownership. The averages, however, mask a huge divergence in the images owned by individual households. To give just one example, the average of three images owned by Mukati (high-status agriculturalists) households is the average of all the five households in the village, which individually owned zero, two, two, three, and eight images respectively. I am tempted to claim that the unpredictability of image ownership demonstrates the purely personal factors that dictate distribution between households. I found myself completely unable to predict the numbers of images that might be concealed behind the wooden doors of the mud houses of which Bhatisuda is almost exclusively comprised. The devotionalism, or questioning irascibility, of villagers was no guide to the number of images they might display within their homes.

Chromolithographs assume a specific importance for Scheduled Caste members who, in Bhatisuda as in

many other Indian villages, are still prevented from entering village temples. Although many Scheduled Castes have their own caste specific shrines (*autla*, *sthanak*) they are generally unable to enter village temples to the main gods. The data from my village survey records a democracy of the printed image in which Scheduled Castes, denied access to most village temples, are able to control their own personal pantheon. Some isolated Scheduled Caste households, such as Bhangi and Bargunda, pursue this strategy with particular enthusiasm.

Deities accessible to all castes – meat-eating as well as higher caste vegetarians – are often described as *sarvjanik* (universal, common, public). Chromo-lithography makes vegetarian deities accessible to Untouchables but only in the realm of the home. These mass-produced images permit a new *sarvjanik* ritual practice but only in the private sphere. The public sphere remains hierarchically exclusive but in ways, as we shall see, that are increasingly tenuous.

'Clean' castes may enter temple precincts but Scheduled Castes are required to squat outside, at some distance. Channu and Lila Mehta, the village Bhangis,[5] were quite explicit that it is this denial that necessitates their domestic engagement with the gods through chromolithographs. Confirming that her family was still unable to enter most of the village temples, Lila remarked, 'for this reason we have made a temple inside our house'.

Channu and Lila Mehta live in a low mud house on the eastern periphery of Bhatisuda, overlooking a steep gully that drops down to a Chamar neigh-bourhood. The most striking feature inside the house is a small black and white television, a gift from one of Channu's brothers, who lives in Nagda. To the right of this, two-thirds of the way up the wall, is a display (sometimes, but not always, referred to as a *jhanki*) of fifteen assorted images, together with a few clay *murtis* (three-dimensional images). In the sort of arrangement common in the village, lines of images are displayed above and below wooden shelves bearing an assort-ment of three-dimensional images, colourful

decorations and steel cups. Among Channu and Lila's display there are large laminated prints depicting Lakshmi and Ganesh, Arjun, Ram, Sita and Lakshman, a large black *Shivling*, and various images of Lakshmi showering wealth from the palms of her hands. There are also two framed prints of Ramdevji (see chapter 7) and the Krishnalila, a large glittered image of Satyanarayan in a wooden shrine-like structure, and a mirrored glass panel depicting the local Krishna incarnation Samvaliyaji. The *jhanki* is completed by a couple of postcards of Shiv and the Buddha and paper prints of Durga and Shiv, plaster images of Ganesh and Shiv, two women with their hands folded in a welcoming *namaste*, a couple of mirrors, some peacocks, tinsel and sundry other plastic decoration, together with a flock of green plaster parrots of the sort that are often sold at local fairs.

With the exception of the glass mirrored image these were all purchased in Nagda, the nearby town, where there are two shops and a stall specializing in 'framing prints'; before the festival of Divali these are supplemented by about a dozen small stalls and itinerant tradespersons selling religious images. Most of Channu and Lila's images were purchased on successive years just before Divali, and this was reflected in the predominance of images of the goddess Lakshmi who is worshipped during this festival, which marks the start of the financial year.

The glass mirrored image depicts Samvaliyaji, Avari Mata and Bhadva Mata, who are the subject of a recently flourishing cult in Mandsaur District. Channu and Lila had visited their main pilgrimage temples several years ago and purchased the image from a stall there. At Samvaliyaji, and also at Pavargadh in Gujarat, which they had recently visited, Channu and Lila's *madhyam* (low)[6] *jati* and *uttam* (high) *jatis* are indistinguishable, for here there is no *chhuachhut* (untouchability) or *bhed bhav* (hierarchy).

Lila's testimony clearly marked out pilgrimage as an egalitarian activity, not only because many *tirth* (i.e. pilgrimage) sites operate in liminal, relatively caste-free spaces, but also because the dislocations of

travel and the anonymity of the crowd nullifies any attempt at the sort of *jati* identity that is so entrenched and enforceable in a stable village community. In view of this it is not surprising that a substantial minority (18 per cent) of all the images in the survey households were purchased at pilgrimage sites and depict deities associated with those.

The connection between pilgrimage and image ownership is also apparent in the case of Biharilal Banjara, a man I first knew when he worked as a bonded labourer for one of the Jain families in 1982. Since then he has been employed in the factory and succeeded in securing the post of village chowkidar (watchman). Despite their status in Madhya Pradesh as a Scheduled Tribe, Banjaras – like Bagdis – have a rather anomalous status in the Bhatisuda *jati* hierarchy. As a result Banjaras, although they live right next to the Bhangi, are permitted to use the *uttam* well, that is the well normally reserved for the use of higher status *jatis*.

In his single-roomed house, Bihari displayed a profusion of images including a large framed and garlanded Kali, a framed Sharma Picture Publications Satyanarayan, sheets of miniature film posters, two pieces of incense-stick firework packaging depicting Shiv and various framed photographs (illus. 147).[7] The largest and most impressive image, however, was the central Ramdevji image, placed above a small alcove in which Bihari regularly lit a sacrificial fire (*havan*) and purchased on pilgrimage to Ramdevra in Rajasthan a few years earlier. This was a Sharma Picture Publications image, *Ramdevji ka Jivan Lila*, which the Ramdevra vendor had placed in a mirrored frame.

Some households have no, or very few, images. Perhaps the most extreme example was Bherulal Kachrulal, a Chamar who lives in a house built by the side of a *nulla* (ditch) behind the Bhangi house. Abutting onto his front wall is a small stone marking the presence of a goddess, known variously as Khokha Mata and Bhukhi Devi, who is adept at eradicating phlegm in young children and effecting general cures. The only image he kept in his house

was a tiny studio portrait of his late father Kachruji,[8] who had worked as a bonded labourer for one of the Jain families. Bherulal had no images of gods. He had thrown out Kachruji's old pictures and had been unable to replace them because his mother had been ill. Bherulal had casually thrown these old images into the *nulla*: this was an act expressive of his frustration and disgust and was the sole contravention I encountered of a powerful consensus concerning the proper disposal of images. Several households, including Rup Singh's, owned only one image. In his case it was a brand new print by the Madras company J. B. Khanna of the goddess Lakshmi, whose worship during the festival of Divali is a route to prosperity (illus. 148).

The majority of households lie between these extremes. The most popular images are, as one would expect, of Lakshmi. Most of these are of a single standing figure of the goddess, the most obvious enduring trace of the early presses described in the earlier chapters of this book. Although Lakshmi *puja* finds its most extravagant manifestation in the practices of urban merchant castes, who inaugurate new ledger books and go to elaborate lengths to ensure the goddess's presence during the coming financial year, nearly all village households observe Lakshmi *puja* on (or one or two days before) Divali.

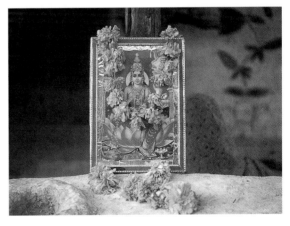

148 Rup Singh's only image: a small framed J. B. Khanna Lakshmi.

The second most popular class of images are depictions of Shiv, either on his own or with other members of his family (i.e. Parvati and Ganesh). There were 78 images of Shiv, including that on a large calendar displayed in the *puja* room of one of the Jain households (illus. 149). Also visible at the bottom left is a Sharma Picture Publications *Divali Pujan* and at the top left of the Shiv calendar is a glass mirrored image of Samvaliyaji, whose image is the third most commonly to be found in the village.

All of the 62 Samvaliyaji images in Bhatisuda were printed on plain or mirrored glass. None of them was printed on paper or could technically be termed a 'chromolithograph'. Samvaliyaji is described as an avatar of Krishna (who in turn is an avatar of Vishnu) and lies at the centre of an efficacious local cult that has recently mushroomed: all the images documented

during a major survey of village images in 1993/4 were brought back from pilgrimages within the last ten years to the Samvalayaji temple near Neemuch on the Madhya Pradesh/Rajasthan border.

Most of the Bhatisuda Samvaliyaji images depict him either seated alone on a throne, or with two associated goddesses, Avari and Mahamaya Bhadva Mata, or at the centre of a larger number of other deities (Avari, Bhadva, Lakshmi, Shani Maharaj, Amba, Krishna with Vasudev, Hanuman, Ramdev and Ganesh). Only one image among the 62 relates the 'proofs' or 'tests' (*parche*) of Samvaliyaji. This is owned by Hariram Ravidas (a Chamar) and depicts a Gujar man named Bholi Ramji, tending his cows (*gay charane*) and having a vision of the God. In addition the miraculous effects of faith in Samvaliyaji are depicted and one can see in particularly explicit form a

149 Puja room in Prakash Jain's house. Hindu images co-exist with images of Jain *tirthankars* and renouncers.

pragmatic strategy to be found within popular Hinduism: poor men are turned into rich men (*garib ko dhanvan banaya*) and dry crops are made green (*sukhi phasal ko hari banai*). Samvaliyaji can also confer immunity from an oppressive state: Bholi Ramji is shown being interrogated by two policemen who suspected he had grown opium (illus. 150). When they looked in the large barrel depicted they found that the illegal crop, which is widely grown in this part of Madhya Pradesh, had been transformed into jaggery (*aphim ka gud banaya*).

There are also striking absences in the images to be found in the village. Perhaps most remarkable is the almost complete lack of political imagery in the village. Two calendars (depicting Shivaji and Rana Pratap Singh, and Bhagat Singh, Chandra Shekhar Azad and others) in the house of a Rajput, Madan Singh, were the only political images I encountered (illus. 151). We have seen in the previous chapter that historical political images constitute a large element of the major picture publisher's output and its absence in this rural realm is intriguing. Less surprising, but worth commenting on, was the complete absence of images of the Scheduled Caste political icon B. R. Ambedkar (1893–1956). The key historical figure of Dalit self-assertion, his image is seemingly

151 Madan Singh's display of political imagery. 1994.

omnipresent in parts of western India, and in Scheduled Caste wards in urban settlements throughout north India (illus. 152). But in Bhatisuda he is completely invisible.[9]

Equally interesting is the paucity of images of Santoshi Ma, the *filmi* goddess: in Bhatisuda there were only six images of her. Santoshi Ma was famously 'created' by the popular, low-budget, mythological film *Jai Santoshi Ma* (see chapter 7). This was released in 1975 and is still shown regularly in cinemas in Nagda, the nearby town. One striking aspect of the film, well analysed by Lawrence Babb,[10] was the intense visual engagement between the goddess and Satyawadi, the central figure, which the cinematography captured in a particularly compelling manner (see below). Prior to the release of the film there were few documented Santoshi Ma shrines; subsequently many thousands appeared.

In relation to the ownership of images by different castes there are two contradictory and striking patterns that must be immediately highlighted. The first of these is the overall similarity of deity choice by different *jatis*. There are no remarkable disjunctions in image ownership and, *ipso facto*, ritual practice. The most popular deities are so across a wide range of castes.

However, the pattern is by no means homogenous. Despite the problems inherent in using such a small sample there are differences in deity ownership that

150 Samvaliyaji turns a farmer's opium into jaggery when the police arrive. Detail of a Samvaliyaji image.

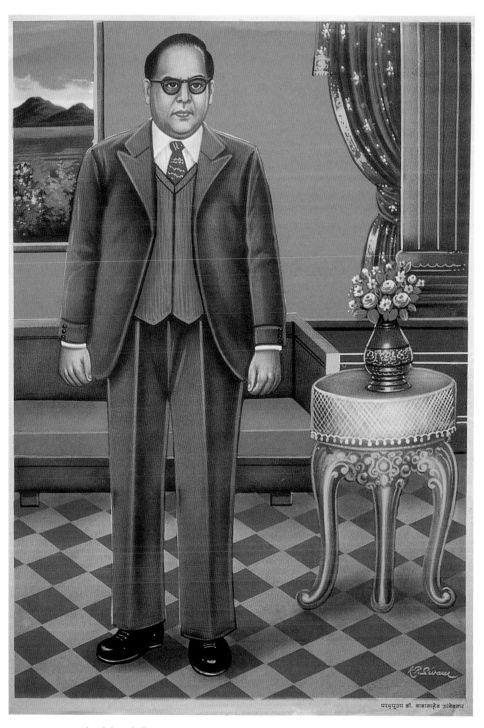

परमपूज्य डॉ. बाबासाहेब आंबेडकर

152 K. P. Siwam, *Babasaheb Ambedkar, c.* 1990. An image with India-wide circulation, but not to be found in Bhatisuda.

highlight differences of emphasis in ritual practice. For instance, there are almost twice as many images of Lakshmi in Rajput households than in the similarly sized Chamar household sample group. By contrast there are more Samvaliyaji images among Chamar households than among Rajputs. While there is no question of exclusivity there is evidence here of different, *jati*-determined, choices between mainstream mass-produced deities. Rajputs are more likely to seek *barkat* (see below for discussion of this key concept) through the longer established and more orthodox conduit of Lakshmi; Chamars are more likely to seek their *barkat* through the less orthodox Samvaliyaji.

Even clearer divergent strategies are evident in the ownership of deities standing on the periphery of the mass-produced pantheon, which are frequently very closely related to caste-specific pilgrimage networks.

This divergence on the margins is most evident in the case of three figures associated with Chamars. The first of these is Ravidas, a caste-specific guru whose five images are exclusively, as one would expect, owned by Chamars. As elsewhere in north and central India, most Bhatisuda Chamars describe themselves as 'Ravidasi' rather than 'Chamar'. All the various images of Ravidas show him making shoes (the traditional caste occupation of Chamars) and it would be inconceivable for a non-Chamar to want to purchase and display such an image.

The Ravidas image owned by Bherulal, which is pasted to an exterior wall in the courtyard of his house along with other images (see illus. 146), depicts Ravidas (at the top centre of the large image at the top right) cutting his chest open to reveal a sacred thread, proof of his Brahman status in an earlier life. This action can be seen much more clearly in a contemporaneous calendar (illus. 154) and reflects a position associated with a text known as the *Bhaktamala* (Garland of Devotion). Ravidas displayed powers that rivalled those of Brahmans. The question for the reactionary *Bhaktamala* is how, as a Chamar, he was able to do this. Elsewhere in India, urban Chamar intellectuals argue that this reflected his asceticism: 'He is the ultimate

Indian representation of the triumph of spirit over the physical body, and of the perfect "unbounded" ascetic.'[11] The *Bhaktamala*, on the other hand, reasserts the prevailing order: Ravidas was able to act like a Brahman because 'really' he was a Brahman. The original Brahman Ravidas had mistakenly offered polluted food[12] to a deity and was consequently reborn as a Chamar; when asked to explain how he was able to perform his miraculous deeds he cut open his chest and revealed the Brahmanic sacred thread of his earlier identity. He was not 'really' a Chamar. These competing narratives were the subject of fierce contestation by the Lucknow Chamar intellectuals among whom R. S. Khare worked. Bhatisuda Chamars do not take an oppositional stance on this but do dispute caste hierarchies in many other ways.

The second figure is Ramdevji (see chapter 7) of whom there were 33 images in the village. Five of these were to be found in Rajput households, to whom the figure of a Rajput king appeals. Small numbers of images were also to be found in Brahman, Gujar and Banjara households, but it is in Chamar homes – where there are 13 – that the largest number of Ramdevji pictures can be found (illus. 153). Although it is frequently claimed that figures like Ramdevji are believed by all castes (for they are true *devs* and *devatas*),

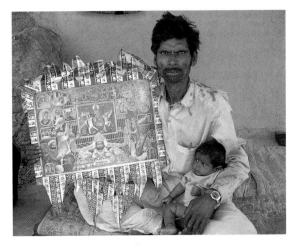

153 Naggu Ravidas and baby son with an ornately decorated Sharma Picture Publications *Ramdevji ki Samadhi*.

it is simultaneously acknowledged that Chamars have a greater belief in Ramdevji (*chamar zyada mante*). The clearly articulated reason for this is Ramdevji's egalitarianism and opposition to caste inequality and Untouchability, made explicitly clear in the narrative associated with him. One booklet of songs (*bhajans*) in praise of Ramdevji, printed in Ajmer but purchased in Nagda, includes the observation that 'in this middle period Shri Ramdevji Maharaja performed in these discourses and this path what Mahatma Gandhi did in the twentieth century'.[13]

The third case is the Gujarati pilgrimage site at Pavagadh, the location of a powerful shrine to the goddess of smallpox, Shitala. Twelve out of the eighteen images to be found in Bhatisuda are in Chamar homes, and once again this should come as no surprise since Shitala is associated with the village's Chamars.[14] The most obvious connection is through the activities of Kannaji, a Chamar medium (*bhopa*) who regularly assumes the form of Shitala and maintains a regionally renowned *autla* or shrine to the goddess in the Chamar area of Bhatisuda. Shitala functions here, as elsewhere, as a specific mani-festation of a much wider alliance between Scheduled Castes and powerful peripheral goddesses.

This relationship is also borne out in the data on the distribution of the goddesses Kali, Durga and Amba. Kali is a hot and uncontained goddess and in Nagda those roadside restaurants that serve meat are immediately recognizable by the presence of images of Kali. These are also on display in the Nagda liquor shop, while the largest Kali image in Bhatisuda (purchased at the huge cost of Rs 105) is owned by Shankar Bagdi, a Scheduled Caste retailer of locally produced alcohol on the southern periphery of the village. Set against this context it is intriguing, but hardly surprising, that none of the 27 Kali images in Bhatisuda is owned by Brahmans, yet they own five of the 56 Durga and Ambaji images, these being more benign forms of the goddess, lacking the hot and over-energized qualities of Kali who is so closely associated with meat-eating Scheduled Castes.

THE QUEST FOR PLENITUDE

In Bhatisuda visual forms are desired for the access they facilitate to divine energy and to *barkat*, or plenitude. Although it is undoubtedly true that in certain key respects popular Hinduism mobilizes a recuperative idiom within a decaying universe, it is fundamentally constructed by what the playwright Brian Friel (in a very different context) once described as a 'syntax opulent with tomorrows'.[15] Mass-reproduction gives formerly excluded classes access to all the high gods, whom they can approach directly without the intercession of priests. In evaluating the potentiality of images *barkat* emerges as the key concept. Villagers are not interested in what images 'look like', but only in what they can 'do' – the nature and extent of the *barkat* that they capable of conducting.[16]

Villagers have hardly any interest in the producers or publishers of the images that adorn almost every home. Occasionally, following meetings with artists I particularly admired, I was unable to resist remarking to a village friend that the image hanging on his wall was the work of an individual with whom I had some personal connection. But this information was never greeted with any fascination, and there was never any attempt to uncover further information about the artist or his work. The blank indifference my immodest claims provoked indicated a profound and utterly deep indifference to the circumstances in which these all important images were created. This reflected villagers' engagement with images as the sources of future interventions, rather than as embodiments of past intentionalities.

In a similar way, most aspects of form did not feature in any significant way in any of the hundreds of conversations with villagers about their pictures. Instead of exegesis about the nature of the image's execution, there was comment about content, efficacy, and about the praxis that surrounded the acquisition and ongoing maintenance of pictures. They were interested not in what artists had put into pictures, but

in what they as supplicants – with all their complex predicaments – could get out of the images.

The 'syntax opulent with tomorrows' that emerges in Bhatisuda practice is one that springs from a corporeal practice in which it is the devotee's visual and bodily performances that contribute crucially to the potential power – one might say completion – of the image. Most villagers 'seat' their pictures without the assistance of Brahmans, although some will call a Brahman to install newly purchased images. On these occasions the priest will swing the image in front of a mirror and perform a *sthapana* (installation) of the deity.

Most, like Lila Mehtarani, are the sole authors of the pictures' conversion from mere paper to divine simulacra. When asked about pictures of deities lying on market stalls in Nagda (deities jumbled up with film stars and 'scenery', Hindu with Muslim images, Sikh with Jain) she responded: 'It's just paper . . . [they haven't] been seated'. She then pointed to the images in her own domestic *jhanki*: 'You see those pictures that are seated? Those are paper but by placing them before our eyes, energy (*shakti*) has come into them . . . We entreat the god and the god comes out because the god is saluted. That's how it is.'

Some Bhatisuda images are thought to be more opulent with tomorrows than others. Samvaliyaji is an example par excellence of a deity who gives *barkat*. Whereas orthodox deities such as Shiv are considered essential to *alaukik labh* ('disinterested, or unworldly, profit'), that is transcendental concerns, Samvaliyaji can produce *bhautik labh*, that is material, worldly or physical profit. *Bhautik* problems (for instance, uncertainties relating to wealth, bodily health and illness, matters relating to employment and agricultural productivity) are the ones that most concern villagers.

Like the vast majority of villagers Pannalal Nai, a retired factory worker, lights incense sticks in front of his images at sunrise and dusk. He asks for the protection of all that is most valuable to him: 'give *barkat*, food, water, children, small children, protect all

this'. As Pannalal performs this *puja*, appealing for a protective plenitude in the face of harsh uncertainties, he murmurs to himself, waves his incense sticks, rings a small bell and crumbles whatever marigolds might be lying on the *puja* shelf in front of his images. As he does this his eyes maintain an intense visual intimacy with the gods and his body describes a gentle swaying, yearning, movement as though caught in the force field around the image.

Every conversation about images is likely to invoke the term *barkat*. But there are other ways of expressing the efficacy of images. *Chamatkari* (miraculous, wondrous) suggests an extramundane power that exceeds the quotidian requirements of *barkat*, and *akarshan* (allurement) is a way of describing the particular ability that certain images have to call to the devotee in ways that are often disruptive of daily life.

The interconnectedness of these terms was apparent in the response of Pukhraj Bohra (a Jain landlord living in the central square of Bhatisuda) to a question about the special powers of images in the locality:

> Nageshvar Pareshavar near Alod [a Jain pilgrimage site] is a very *chamatkari murti* (image) . . . When I first went there fifteen years ago I made a *man* (wish). I asked that my business should go well, that the crops should prosper and then I came back. But there was some *mansik* (psychic) effect from this, some *akarshan* (allurement) born in the image. When I was away I felt that I had to go back and see the image, had to see it again and again.

The consumption of images by Bhatisuda villagers needs to be understood in terms of these processes of bodily empowerment, which transform pieces of paper into powerful deities through the devotee's gaze, the proximity of his/her heart and a whole repertoire of bodily performances in front of the image (breaking coconuts, lighting incense sticks, folding hands, shaking small bells, the utterance of *mantras*).

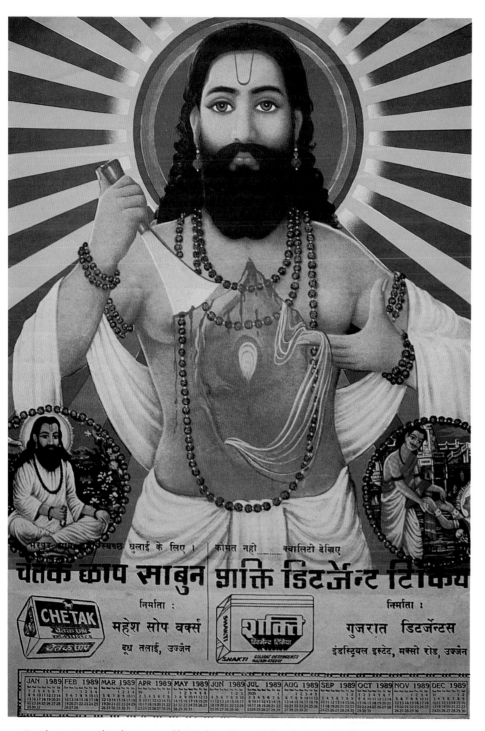

154 Ravidas cuts open his chest to reveal his Brahmanic sacred thread. 1980s calendar image.

ELEMENTARY ASPECTS OF PEASANT VISUALITY

The most fundamental mark of the images' sensory quality – their predisposition to this corpothetic regime – is their non-absorptive directness (see chapter 1). The vast majority of images behold their owners directly, engaging and returning their vision. As Diane Eck observes, the primacy of sight as the idiom of articulation between deity and devotee is lexically marked so that devotees will usually stress that they are going to the temple for *darshan*, to see and be seen by the deity: it is this 'exchange of vision that lies at the heart of Hindu worship'.[17]

However, as was suggested in the Introduction, the *darshanic* relationship that devotees cultivate engages vision as part of unified sensorium. The eye in *darshan* is best thought of as an organ of tactility,[18] an organ that connects with others.

Walter Benjamin's observation that 'everyday the urge grows stronger to get hold of an object at very close range by way of its likeness, its reproduction'[19] has generally been read as a sign of the ineluctability of encroaching media practices that have increasingly virtualized the world. The anthropologist Michael Taussig, however, has suggested another approach that reconstitutes Benjamin' work as centrally relevant for an ethnography such as this.

Taussig chooses to see Benjamin's notion of the 'optical unconscious' not as 'ebullient Enlightenment faith in a secular world of technological reason' in which 'magic' is replaced by 'science', but rather as a visceral domain in which objects become sensorily emboldened in a 'magical technology of embodied knowing'.[20] Taussig's re-reading of Benjamin permits us to rethink the ways in which local consumers 'get hold' of mechanically produced images and to at last recognize the significance of Valéry's claim (with which Benjamin prefaced his essay 'The Work of Art'): 'In all the arts there is a physical component which can no longer be considered or treated as it used to be'.[21]

One of the strategies through which peasants are able to 'get hold' of images is through the creation of a zone of mutuality that encompasses devotee and image: the 'locking in' of vision to which we keep returning. This relationship is clearly expressive of *darshan*, which is after all predicated on the mutuality of 'seeing and being seen' by the deities in the images one worships. However, it would be misleading to conclude that this is simply the specific outcome of this particular 'cultural' practice. Local understandings of *darshan* must certainly nuance and finesse our understanding of popular Indian visuality, but underlying this there is a much more widespread practice of what I term 'corpothetics' (sensory, corporeal aesthetics). This local Indian practice is certainly on the face of it dissimilar to dominant class 'Western' practices, which privilege a disembodied, unidirectional and disinterested vision, but not strikingly unlike a whole range of culturally diverse popular practices that stress mutuality and corporeality in spaces as varied as those of religious devotion and cinematic pleasure. So while the power and specificity of local discourses is clearly crucial I would resist the wholesale reduction of meaning to such discourses. Rather than create a specifically Indian enclave of *darshan*-related practices we should also be aware of the continuities and resonances with popular visual practice elsewhere. The choice here should not be seen as simply one between a universalism and a cultural specificity[22]: rural Indian corpothetics exist in a space that is less than universal and more than local.

THE DOUBLE SENSATION

The villagers' chief requirement is for images of deities that can see them. It was this demand, we may recall, that presented itself as such a burden to Yogendra Rastogi, who felt trapped by the commercial market's desire to meet the needs of its largely rural customers. This desire to be seen necessitates hieratic frontal images in which the deities stare forth at their beholders. Ballu Bagdi had purchased six postcards

separately in Nagda and then taken them to a framing shop (of which there are several in the town). The resulting artefact (illus. 155) clearly embodies this rural preference for the non-absorptive and theatrical (to recall, respectively, Fried and Diderot's terminology). The turn away from colonial absorption is here absolute. The deities in all six images invite a reciprocating gaze; none of them permits of any 'indirectness'.

The profound mutuality of perception that such images make possible has parallels with what the phenomenological philosopher Merleau-Ponty terms the 'double sensation' of touching and being touched. In his *Phenomenology of Perception* he considers what occurs when he touches his right hand with his left and the resulting 'ambiguous set-up in which both hands can alternate the roles of "touching" and being "touched".'[23] Each hand has the double sensation of being the object and subject of touch. Merleau-Ponty then applies this model of the double sensation (and of the reversibility of the flesh) to vision, arguing that, 'he who looks must not himself be foreign to the world that he looks at. As soon as I see, it is necessary that vision . . . be doubled with a complementary vision or with another vision . . . he who sees cannot possess the visible unless he is possessed by it'.[24]

The commercial cinema of Bombay frequently invokes a mutuality of vision that presupposes this 'double sensation'. The celebrated *Jai Santoshi Ma* (1975) included several sequences in which the desperate heroine Satyawadi implores the assistance of Santoshi Ma. In these sequences the goddess's vision is shown as a physical extrusive force (a beam of scorching fire). In two key episodes in which the heroine beseeches the goddess to intervene, intercut shots of Satyawadi's and Santoshi's faces are used repetitively to inscribe the mutuality of vision that binds the devotee to the goddess, and the camera also pans in between their gaze, further accentuating this crucial axis.[25]

In *Amar Akbar Anthony*, released two years later in 1977, the process of *darshan* is literally vision enhancing: being seen becomes the ground from

which one's own vision is possible. Chased by ruffians, the blind elderly mother of the three central characters is attracted by the noise of an ecstatic song in praise of the Shirdi Sai Baba conducted, in keeping with the ecumenical spirit of the film, by her son Akbar. (For recondite reasons the three sons have been raised in different religions.) While the congregation praises the visibility of god in Sai Baba and his ability to relight lamps and turn dark nights of sorrows into brightness, the blind mother is ineluctably drawn by some mutual corporeal attraction towards the image in the temple. Although blind, she is drawn compulsively to the face and body of Sai Baba who – as the song proclaims the relighting of lamps – reciprocates her devotion with his own brightness in the form of two flames that migrate from his eyes to hers, liberating her from blindness. Touching Sai Baba's feet she proclaims her ability to see and to have *darshan* of the god, and tells Akbar that it is thanks to his devotion (*bhakti*) and the Baba's 'magic' (*chamatkar*).

I have proposed the use of the term 'corpothetics' as opposed to 'aesthetics' to describe the practices that surround these images. If 'aesthetics' is about the separation between the image and the beholder, and a 'disinterested' evaluation of images, 'corpothetics' entails a desire to fuse image and beholder, and the elevation of efficacy (as, for example, in *barkat*) as the central criterion of value.

The consequences on the form of images of the desire for fusion – for the subject/object dissolution of the 'double sensation' – is nowhere more apparent than in the many mirrored images that are to be found in Bhatisuda, such as an image of Badrivishal purchased at Badrinath (illus. 156); most images of this type were purchased at pilgrimage sites. Ramdevji is also commonly treated in this manner, as we saw in the case of the image hanging in Biharilal's house (see illus. 147).

This is a common mode of customization that allows local artisans to add value to machine-printed images, which become crafted relics of the spiritually charged place. The key figures from

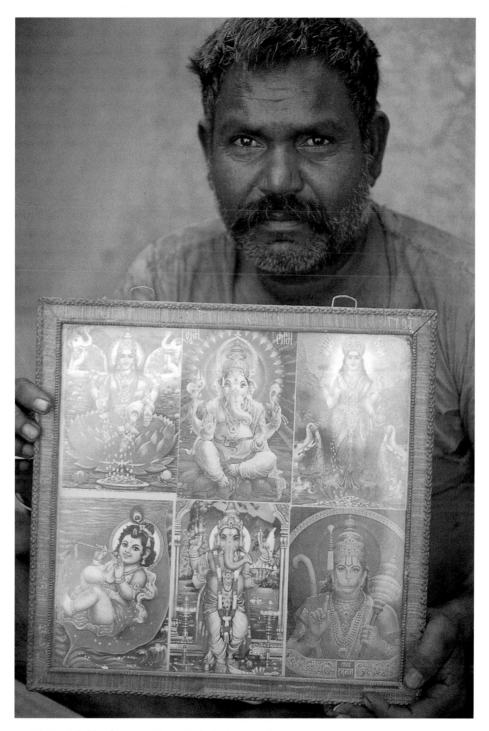

155 Balu Bagdi holds a frame containing six *darshanic* postcards, 1994.

156 A mirrored image of Badrivishal.

chromolithographs are cut out, pasted behind glass and the remaining clear glass is silvered to produce a mirror. But the additional benefit from the purchasers' point of view is that they can now visually inhabit the space of the picture, alongside the deity with whom they desire the double sensation. Mirrored images allow the devotee to (literally) see him or herself looking at the deity. In the case of mirrored pilgrimage images there is what might be termed a double corporeality; firstly of the devotee's movement through space on pilgrimage where she or he bought the image; secondly of the devotee's visual elision with the deity when he places himself in front of the image.[26]

Other modes of image customization – such as the application of glitter, or *zari* (brocade) or the adhesion of paper surrounds (see illus. 153) or plastic flowers – might also be considered as corpothetic extensions that move the image closer to the devotee, transforming the ostensible representation or window into a surface deeply inscribed by the presence of the deity.

Objects of value are also occasionally introduced onto this surface. 'Found' banknotes, which are considered auspicious, may be pasted on the glass of framed images, and Muslims may similarly attach banknotes containing the auspicious sequence '786' in their serial numbers.[27] The dressing of images takes the place of words. Instead of exegesis, instead of an outpouring of language, there is a poetics of materiality and corporeality around the images.

The progressive empowerment of images through daily worship involves a continual burdening of the surface with traces of this devotion. Although some households replace all their images every year at Divali, the majority retain old images, which continue to accumulate potency as they become accreted with the marks of repeated devotion. These marks include vermilion *tilaks* placed on the foreheads of deities, the ash from incense sticks, smoke stains from burning camphor, remnants of marigold garlands and other traces of the paraphernalia of *puja*.

Even at the end of its life, a picture's trajectory is determined by corpothetic requirements, in this case the necessity of ensuring that the image never comes into contact with human feet. Lila Mehtarani explains the constraint:

[The images] are paper and when they have gone bad (*kharab*) we take them from the house and put them in the river. That way we don't get any sin (*pap*) . . . we don't throw them away. You take them out of the house and put them in the river or in a well, and place them under the water.[28] This way they won't come under anyone's feet. You mustn't throw them away or they will get lost. That's the proper (*tamizdar*) way to do it – in the river or well. In our *jat* we say *thanda kardo* – make cold. That way they won't come under [anyone's] feet.

In Hindi the phrase *pair ankh se lagana* literally signifies to look at the feet, and idiomatically 'to respect, venerate' and to touch someone's feet is to physically express one's obeisance. Certain images in Bhatisuda encode this hierarchical relationship in which the devotee submits his body, through his eyes, to the feet of the deity. Photographs of holy persons' feet (illus. 157) permit this physical acting out of the devotee's obeisance. Correspondingly, it is fundamentally important to Bhatisuda villagers that the bodies of the

157 A photographic image of the feet of Sathya Sai Baba.

deities that they have so carefully brought to life should not suffer the dangerous indignity of having this relationship reversed.

SUBALTERN VISUAL PRACTICE?

The democratic praxis that chromolithography engenders is thus one that in certain key respects recapitulates the protocols and hierarchical codes of orthodox Hindu practice. But it also occasionally comes close to destabilizing long-established ritual and social hierarchies. Formally, all deities, and the different media through which they manifest themselves, are conceptualized as part of a complementary and harmonious project. A common response by villagers when questions of differences between deities is discussed is to throw up their hands and say *ek hi maya hai* ('it is all (just) one illusion', one 'play'). They mean by this that 'ultimately' all the differences are resolvable into a single central imaginary form. In this sense villagers affirm that the various gods can be thought of as variations on a central, common theme.

But rather in the same way that I have suggested we need to theorize a bodily praxis in order to understand the reception of Hindu chromolithographs, we need also to position the formal discourses and representational conventions described in the paragraph above in the context of the chaotic physical enactments of being Hindu in Bhatisuda village. Once we do this, the formal articulations and synoptic overviews start to assume the same marginal position that 'aesthetics' has in relation to everyday 'corpothetics'.

During Nauratri (two periods of nine nights each year associated with goddesses) some Scheduled Caste households remove their domestic chromolithographs and place them in the Jhujhar Maharaj *autla*, which is maintained by Badrilal, a Bagdi (Scheduled Caste) *pujari* (ritual officiant). The (usually framed) prints spend nine lunar days nestled against the red stones and paraphernalia that form the centre of the shrine (illus. 158) and accumulate an additional power from the excess

158 Badrilal, the pujari of the Jhujhar Maharaj *autla*. Domestic chromolithographs placed by villagers in the shrine for the duration of *Nauratri* can be seen in the background.

energy of the consecrated shrine during this period. Domestic images are also installed in the Bihari Mata shrine, which also lies in the Bagdi *mohalla*. Bihari Mata lives under a *nim* tree on the southern fringe of the village; large laminated prints of Durga and Kali are nailed to the trunk of the tree and an old framed image of Durga is propped behind several red tridents that sprout from the base. This Durga image (illus. 159) is taken in the parade around the village at the conclusion of the nine nights along with the bowls of wheat shoots (*javara*), which will be cooled at the end of the procession. However, the relationship between chromolithographs and consecrated images, and that between those villagers who 'thrash' – who become possessed by the goddesses – and consecrated images, is not always so tranquil.

Nauratri is a very dangerous period: it is 'hot' (*tamsik*) and vast numbers of *bhut pret* (ghosts and spirits) thicken the air. They live 'with a free hand' (*khuli chhut rehte*) and 'play' without restraint. The unpredictability of events is intensified by the numbers of villagers who thrash (illus. 160). Several *bhopas* or *ojhas* (mediums) will thrash without fail, and a further dozen or so villagers (some predictable, some not) will also thrash with sundry goddesses, spirits of ancestors who met violent deaths, and *jhujhars* and

159 Hemraj with his framed Durga image, two days prior to the Nauratri procession.

sagats. These are warriors who died from either a single blow to the neck, or several blows, respectively.

The danger implicit in this period reached a frightening intensity in the village in late 1993. The predominantly Bagdi procession, which had set out from the Bihari Mata shrine, was outside Mohan Nai's house near the central *chauk*. The goddess Bihari Mata had possessed the body of Hemraj and she was wearing a green veil and holding a lime-tipped sword. She danced wildly around Lal Mata, who had by now possessed the body of Badrilal, the *pujari* of the Jhujhar Maharaj *autla*. Mixed in this mêlée was a *sagat* in the body of the Rajput Balwant Singh. Two girls carried pots of *javara* (wheat sprouts) and between them a

Bagdi boy carried Hemraj's framed Durga picture, which had until then been displayed in the Bihari Mata shine. As this swirling mass of people made its way down anticlockwise through the village, various people knelt down to have their afflictions cast out. This involved a curative fanning effected with the bedraggled peacock whisks held by the two goddesses. Every so often Badrilal would appear to choke and then, with cheeks bulging, a lime would appear from his mouth.

What happened next showed the extent to which this frenzied outpouring of ecstatic energy was capable of fracturing the normally hierarchical ordered space of the village. Outside the house of Kalu Singh, the Rajput sarpanch, Badrilal swirled in a particularly aggressive manner as the goddess succumbed to some intense rage and it seemed as though everyone would invade the premises. Then the procession veered suddenly away toward the nearby Krishna temple, where the ferociously angry goddess ordered that the *javara* and the image of Durga be taken inside. The *javara* were then placed on the platform at the front of the temple and at this stage Jagdish Sharma, the Brahman *purohit* who lives just to the left of the temple, shot across the front of his verandah and started to plead with the goddess in Badrilal. In a frenzy, Badrilal shouted and spluttered, his cheeks bulging as though his throat would at any moment disgorge more limes.

This was an extraordinary and dangerous moment. Jagdish was clearly terrified. For about ten seconds it seemed completely probable that Badrilal might try to chop off Jagdish's head with his sword, but in the event he retreated. Marigold and rose petals were scattered over the front of the temple and the procession moved on through the Bagdi neighbourhood south-west towards the Lal Mata *autla* and the River Chambal.

Later, discussing this incident, Mohan Singh and Pukhraj Bohra (both of whom are non-drinking vegetarians), opined that Jagdish Sharma had

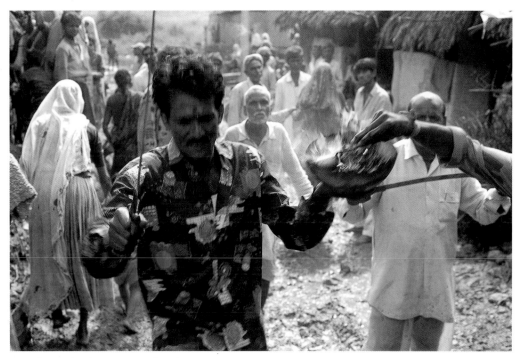

160 Villagers 'thrashing' (possessed) in the Nauratri procession.

imposed his *rok-tok* (restriction/ obstruction) because Badrilal was drunk, and if he had polluted the purity of the temple space that protected the Krishna *murti* there would have been *nuqsan* (destruction). The Krishna *murti* was imperilled, and it was to protect this that Jagdish had risked his life. Badrilal produced a corpothetic engagement with the Krishna *murti* (via the agency of his own possession and the presence of the chromolithographic form of the goddess in the procession) that threatened the dominant order. The rule of 'one illusion' (*ek hi maya*) failed to suture the conflict between (Scheduled Caste) chromolithograph and (Brahman) temple statue.

To attempt to study 'corpothetics' rather than 'aesthetics' is necessarily complex. If there is no 'meaning' capable of easy linguistic extraction, the evocation of significance becomes a matter of subtle observation, what Carlo Ginzburg calls the 'venatic' or 'divinatory' reading of gestures and other phenomenological traces.[29] Often this will entail the study of a quiet praxis such as a villager, at dusk, whispering to his gods as he shakes a bell and slowly waves an incense stick. But at other times, as in the case of Badrilal's attempted incursion into the Krishna temple, events unfold with a dramatic intensity and clarity. The predicaments that villagers face are inextricably determined by the social and economic hierarchy that in large part encompasses them. The corpothetic engagement with the efficacy of images guarantees their collision with the everyday, and unjust, world around them.

Epilogue: The Recursive Archive

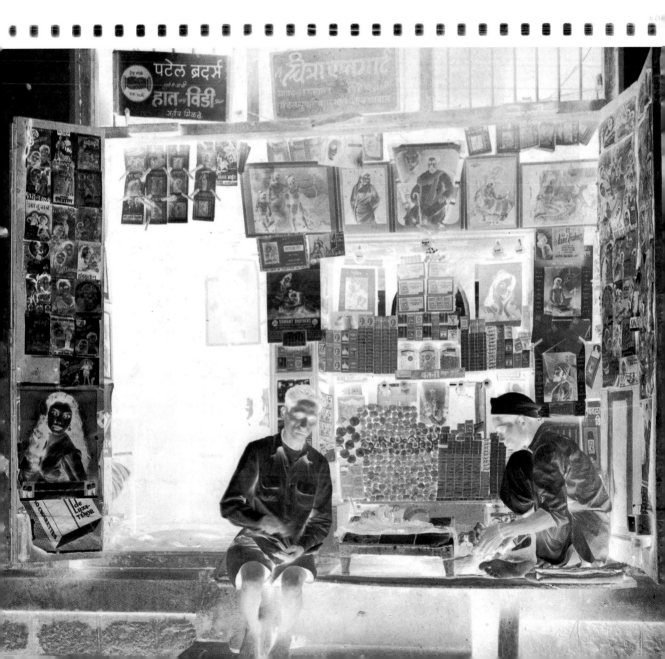

Once, in the Rajasthani city of Udaipur (having just interviewed one of Narottam Narayan's sons), I found myself sitting in a cafe beneath a large laminated poster on which was presented a remarkable image, and an even more remarkable caption. The image depicted a blonde woman furiously whipping a set of horses who were dragging her carriage through an inhospitable desert landscape. The text below this image read (in English): 'The happiest nations, like women, are those that have no history.'

I have no idea where in the worldwide circuit of global kitsch this image originated, and of course I may well have misremembered the details, for it was ten years ago that I sat there gazing in fascination. Whatever the case, it was an image and text that recalled the Sanskritist Sheldon Pollock's observation that it is not those who forget, but rather those who 'remember' the past who are condemned to repeat it.[1]

The visual history I have presented in this book should make us doubt the strong claims that are sometimes made for the decisive impact of new technologies and the dramatic newness of the 'post-Nehruvian' moment. Much of what seems so new and so specific to the 1980s and '90s can be seen to have precise parallels in earlier periods.

India has emerged in recent theoretical writing as the site of one of modernity's gravest implosions. A Nehruvian and post-Nehruvian moment stands at the moment of eclipse, threatened by a sinister efflorescent Hindu chauvinism (hereafter 'Hindutva'). Despite Hindutva's origin at the heart of the modern there has been an understandable fascination with this nostalgic politics' alliance with new visual technologies ranging from the mobile video *rath* (chariot) to the superabundance of colour posters. This is propelled in part by journalistic clichés that claim a paradox through the juxtaposition of the 'medieval' and the 'modern': the apparent contrast between Hindutva's 'archaicism' and its love of new technologies seems to further emphasize the 'newness' of those media.

But we could also add to this the impact of secularist accounts that are only capable of constructing

popular media as antagonistic to its own project. The forest of signs that covers contemporary Indian politics currently suffers from an under-informed epidemiology that naïvely links formal content with ideological effect through (to recall Carlo Ginzburg) 'physiognomic' readings.[2] Conclusions are determined in advance ('by other means') and even those who might otherwise struggle to hear the voice of 'subalterns' are unwilling to treat images as subaltern, or to search for an image's 'face'.[3]

The history *through* images that I have attempted in this book allows me to draw two central conclusions. The first of these is concerned with what text-based histories leave out. Visual history restores a vein of popular messianism that has been severely neglected in orthodox historiography. It also permits us to situate modern image usage (and the claims for their historical uniqueness) within a broader context in which there are frequently striking echoes and resonances. Secondly, although the political commitments of particular artists and publishers has I hope been clearly established, these images are the product of a *commercial* industry. The need for commercial survival introduces an extreme degree of contingency to the relationship between intention and artefact.

Text-based histories and critical approaches, especially in the 1980s and '90s, have focused on what has been presented as a qualitatively new relationship between politics and images. The growth of Hindu chauvinism within Indian politics during this period has often been discussed in terms of the proliferation of images. For instance, the authors of *Khaki Shorts and Saffron Flags*, a deservedly influential pamphlet about the rise of the Hindu right, singled out the deluge of images that accompanied Hindutva's growth. They argued that, since the alliance of right-wing groups claims to have appropriated all Hindus:

signs of this occupation have to be made visible all over the Hindu world. The movement therefore works its way from the overtly political domain into

everyone's everyday life, primarily through the innovative use of small icons, derived from calendar art . . . Slickly produced in a variety of garish colours, at one time they could be seen all over North Indian cities and towns and also in many villages. They could be pasted anywhere – on vehicles, offices, houses, or on school blackboards. Their reach extended much beyond that of posters or wall-writing. They swamped individuals in their ubiquity, contriving a sense of the irresistible tide of Hindutva.[4]

It is tempting to see the colonization of India's public and domestic spaces by such images as marking some qualitatively different phase, some new condition of post-modernity in which the density of images pro-duces a new kind of politics, a claim made most eloquently by Arvind Rajagopal. In this account, by contrast, I have tried to document a complex tradition of image production and dissemination, which casts a rather different light on the use of images in current political struggles.

Seen in the light of this history one is struck by the powerful continuities in practice: the ubiquity of images of the Ram mandir[5] recalls the ubiquity of Cow Protection images, and the iconography of Bhagat Singh remains unchanged from 1931 through to the early twenty-first century.

Four Hindi films narrating the actions of Bhagat Singh were released in the year 2002–3.[6] While Bombay cinema does still occasionally espouse a modernizing 'Nehruvian' inclusivity (for example in Amir Khan's *Lagaan*),[7] it is very striking that no films about Nehru or Gandhi were due for release in this year (nor have any been released in any other year since Independence).[8] This is a remarkable and fundamental fact about the nature of the visual history presented here that bears reiterating: textual histories of the freedom struggle in India focus overwhelmingly on 'official' practitioners such as Nehru and Gandhi; visual histories celebrate 'unofficial' practitioners such as Bhagat Singh.

How can this be explained? I would suggest that one key aspect is the alliance between conventional historiography's affirmation of the state, and its preference for discursive, 'linguistic-philosophical closure'. A top-down historiography of nationalist struggle that privileges literate elites and the state, as the rational projection of that elite, lacks the strategies to engage with embodied and performative politics. Conversely, a bottom-up visual history, open to the popular messianism that drove much of the nationalist struggle, is much more alert to the affective intensities of the popular and the visual.

These two, partial and exclusionary histories might also be seen as a manifestation of what Rajagopal has perceptively labelled a 'split public'. The introduction to this book briefly alludes to Boris Groys's argument concerning the 'total art' of Stalinism. His argument for the centrality of the aesthetic at the core of political transformation was embraced, but a caution was added about the obvious difference between a Soviet-style system grounded in the absolute hegemony of the ruling elite and India where, as Ranajit Guha has argued, the elite has failed spectacularly to incorporate the masses.

Rajagopal, writing about the impact of the tele-vision serialization of the *Ramayan* in the late 1980s, suggests that we think about a 'split public' charac-terized by 'different languages of politics'.[9] I find Rajagopal's modernist narrative of a rupture before and after this screening problematic. However, his analysis of the different audiences for different media within India is enormously suggestive. He dwells on the way in which different constituencies were addressed by, on the one hand, the English press, and on the other, the Hindi press. The former was concerned with the 'truth-value of news, as information serving a critical-rational public', while for the latter 'neutrality [was] but one of a variety of possible relationships to political power'[10] in its concern to dramatize the narrative dimension of news. The opposition that emerged through this splitting served to reproduce a 'structured set of misunderstandings'.[11]

Rajagopal's ideas can help us comprehend why it is that textual histories find it so difficult to comprehend visual history and why the image, and those who seek relationships with the image, so frequently appear as the embodiment of a 'pre-rational' and 'enchanted' politics. The 'split' that characterizes the Indian public, and Indian politics, is reflected in historiography between accounts that, on the one hand, seek linguistic-philosophical closure and those that, on the other, seek out spaces where 'intensities are felt'. The appeal of such intensities needs also to be understood as the result of a historical process. What I have traced in the book is the emergence of an alternative modernity facilitated by the increasing velocity and referentiality of images during the last century and a quarter. This alternative modernity (as distinct from a non-modernity) takes the form of a popular historicity configured by a rejection of arbitrary colonial signs in favour of a dense 'semioticity'. We have seen repeated movements (such as Ramakrishna's embrace of a 'mythological-real', and Nathdvara's recreation of an enchanted landscape) that involve the rejection of colonial rationalities. The visual forms described in this book are not manifestations of some enduring Indian psyche: they are the products of very complex historical confrontations and refutations. It is in this sense that the term non-modernity (with its sense of a 'lack' and 'priorness') is rejected, and 'alternative modernity' preferred.

Narratives of modernity and nationalism frequently assume an inevitable reproduction of Western models. The empirical substance of this account suggests that, rather than some inevitable disenchantment, there is a contest between different schemata and a complex process of negation, contradiction and critique. The Nathdvara aesthetic, for instance, expressed a naturalized innocence, which stemmed from its knowledge of and rejection of an earlier 'Romanization'; it pursued a 'deformation of mastery' that contained the possibility of 'a release from being possessed'.[12] It is in this sense that it is best viewed as 'neo-traditional', part of an 'alternative modernity'.

Benedict Anderson has argued that nationalism was one product of the 'harsh wedge between cosmology and history';[13] as a visual practice, picturing the nation has revealed itself as the recombination of history and cosmology in the face of a distilled history that suited the rationalistic world-conquering instincts of colonialism. The alternative modernity I have tried to describe here saw the future, and it didn't like it.

One of the most striking examples of a historiographic voice speaking into the void that defines this split is Anuradha Kapur's celebrated analysis of the 'muscularization' of the god Ram.[14] Starting in the late 1980s a series of popular images (illus. 161) appeared depicting a vengeful saffron-clad Ram (often towering above a new imaginary Rama temple in Ayodhya). Ram was endowed with a muscular armature to rival that of his simian assistant, Hanuman, and Sylvester Stallone. For Kapur, such images are labelled merely 'poster from Ayodhya', as though they were symptoms whose malignancy and relevance lay exclusively in their geographic occurrence at the site of the destruction of the Babri *masjid*. While emphatically concurring that a text's (or chromolithograph's) unity lies (at least in part) in its destination rather than its origin,[15] that origin does need to play some role in our analysis. The angry Rama image, for instance, was first produced by the Vishva Hindu Parishad in the late 1980s[16] and, following the publication by S. S. Brijbasi of a commissioned copy by the Bombay artist Ved Prakash and then by Rajan Musle, several other companies produced similar images.

The critical focus on these images, while enormously stimulating and raising issues of vital political importance, is nevertheless frequently a victim of a textual historiography that establishes its evidence 'by other means'. Because it has decided in advance that these images are a visual manifestation of an ideological force, it is unable to catch hold of the ways in which the materiality of representation creates its own force field. Consequently a very straightforward 'Durkheimianism' emerges in which the image somehow draws together and exemplifies, as a social

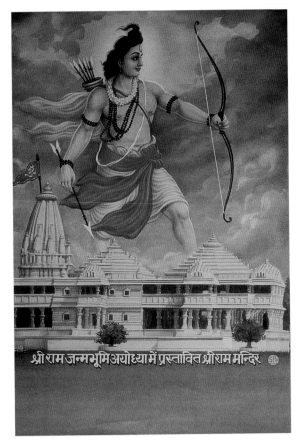

161 A muscular Ram flexes his bow above the proposed Ramjamnabhumi mandir in Ayodhya. The slogan reads: *shri ram janma bhumi ayodhya mem prastavit shri ram mandir* (proposed Shri Ram birthplace temple in Ayodhya), *c.* 1994.

suggesting is that images are not simply, always, a reflection of something happening elsewhere. They are part of an aesthetic, figural, domain that can constitute history, and they exist in a temporality that is not necessarily co-terminous with more conventional political temporalities.

The images I have described might be seen as moving through a pathway of what Roland Barthes has called 'wavy meaning', in which their materiality impresses itself upon the surrounding world. While these images are in certain contexts amenable to recoding, they can never be plucked from that pathway and sutured in any simplistic way with the 'socio-logical' or 'political' reality of any particular historical moment. Barthes made the point that most histories of objects are not histories of *the object* at all. He recalls narratives, supposedly of objects, with titles like *Memoirs of an Armchair,* or *The History of my Pipe,* and argues that these are in fact stories of objects passed from hand to hand.[17] Likewise one might say that a conventional historiography, which determines the nature of images 'by other means', simply passes objects from historical moment to historical moment, discovering that the object exemplifies its own particular historical moment. The precondition for the complex task of escaping the tautology of this relationship is the recognition that the visual and material will always 'exceed' the present. The account presented here is certainly still trapped within an inescapable residue of the 'physiognomic' but I hope to have made at least a small break in the tenacious circularity of such arguments.

The 'recursivity' of popular picture production, its refusal always to conform precisely to its own present, also reflects the producers' assessments that their consumers require images for tasks that remain relatively historically uninflected: the desire for *barkat* endures and demands the broad repetition of an established iconography. Clearly there is a history to these images, but it is a history determined in large part by an accretive dynamic within the practice of image production.

representation, everything that can be identified as potentially determining it, and which the historian wishes to have deposited in the image as the validation of his/her supposition. This displaces the other strategy I have attempted to delineate in this account: one in which images are treated as unpredictable 'compressed performances' caught up in recursive trajectories of repetition and pastiche, whose dense complexity makes them resistant to any particular moment. I do not at all wish to imply that images are completely disconnected from everyday history: this study is replete with such historical connectivity. What I am

Because, as one producer said, images should be 'new, but not too new', most commercial artists maintain archives of early images. In the case of Indra Sharma, for instance, this amounted to several thousand images. Indeed significant elements of the chronology expounded here have been established through working in these artists' archives: they exceed in range and number anything to be found in public institutions.

The visual possibilities stored in these archives lack any clear sedimentation. The entire institutional art world infrastructure of galleries, curators and historiography has (until very recently) passed these images by. Consequently few of them look 'quaint' or so marked by a process of dating and sedimentation that they are excluded from the possibility of one day once again becoming 'new'. No images ever die, they all remain alive, on stand-by. Images migrate endlessly, cutting back and forth across new times and contexts. Publishers assert that the market is ever eager for a 'new' image, and artists have constantly to produce a new tranche of images each year. But as was perhaps most clearly argued in chapter 7, each year's new images tend to reconstitute images that have already been 'half seen in advance'. Sometimes this involves repainting an earlier image. In the mid-1990s Brijbasi commissioned Rajan Musle to repaint several Mulgaonkar and Pednekar images from the 1950s. The publisher had kept the original gouaches and despatched these to the artist with precise instructions to revivify certain colours in a 1990s idiom and to modify other minor features.

Images pastiche and reconstitute other images: they are already 'half-seen in advance'. Often this reconstitution will make a link with an image from the previous year, or previous few years. Sometimes, however, an image will jump several decades or even centuries. The provocative print reproduced here was published by the Bombay branch of S. S. Brijbasi in 1994 and shows Shivaji standing astride the slaughtered body of Afzal Khan as a saffron flag flutters in the background (illus.

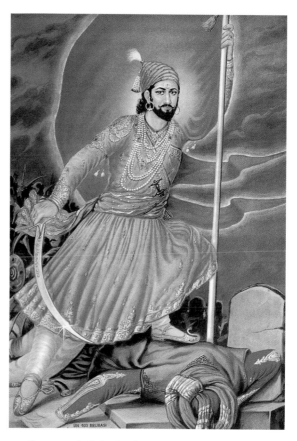

162 Shivaji astride the body of Afzal Khan, Rajan Musle, *c.* 1994. Laminated print published by S. S. Brijbasi.

162). The painting is by Rajan Musle, whose muscular Ram image has already been noted, and this image too is, on the face of it, a 'symptom' of 1990s anti-Muslim Hindutva. The publisher gave the following account of the circumstances of its creation:

We are always looking for some radical changes but it can't be so radical because [then] they will be out of tradition – you can't be radical with religion or radical with history. This one was actually [a] Roman Emperor, this you must have realised is not entirely Indian. This is not Indian [. . .] the lower part – his dress could be anywhere in the world and there was this Roman Emperor standing with his

foot like this and Musle had come out with some art book and was just going through some Roman paintings and he got this reference and he was saying why don't we make this with Shivaji treading on Afzal Khan? . . . This entire thing except the figure has been changed, it was a Roman thing, he [put] Shivaji into this.[18]

This image's Roman antecedents are not known to me and I am unsure whether any other image predates its close model by Louis Dupré, a pupil of David, which was first published as a hand-coloured lithograph in 1825 (illus. 163).[19]

The laminated poster *The Sons of Bharat Mata* (illus. 165) produced in 2000 relies in a similar way on earlier referents, in this case two posters from the 1960s and

163 Plate from Louis Dupré, *Voyage à Athènes et à Constantinople, ou Collection de portraits, des vues, et des costumes grecs et ottomans* (1825).

164 Mother India and heroes of the freedom struggle, calendar image, 1972.

'70s. Triangulated in this manner it is clear that the (unknown) creator of *Sons of Bharat Mata* extracted the central Mother India image from a 1972 calendar (illus. 164), a copy of which he must have had in his personal archive, together with some of the portrait heads (to which were added Indira and Rajiv Gandhi, and Prime Minister Atal Behari Vajpayee), and photographically interpolated battle scenes of the sort that (in painted form) have been common in calendar images since the work of Yogendra Rastogi in the early 1960s (illus. 166).

But it would be wrong to over-stress the constraints of popular visual culture: some images appear with very different lineages. Greeting cards produced first in 1998 referring to the nuclear weapons tests in May of

165 *The Sons of Bharat Mata*, laminated print, 1999. Publisher unknown.

166 Calendar image depicting Lakshmi Swaminathan (a female Indian National Army officer) urging 'lahor chalo' (Let's go to Lahore), c. 1965.

that year proclaimed *Ham kisi se kam nahin* ('we are not less than/inferior to anyone').[20] A mapped image of India and collaged photographic images of Prime Minister Vajpayee, together with defence research chief A. P. J. Abdul Kalam and R. Chidambaram, chief of the Department of Atomic Energy, among others,[21] are set against a fiery background (illus. 167). This startling image compresses a whole set of anxieties about metaphorical and literal stature, the Indian national phallus, and the delirious pleasure of fire. Its aesthetics seem to derive more from music videos than the pictorial genres discussed in this study.

While many images produced by the Hindu right reflect the constraints of the 'recursive archive' and are variations on a familiar theme, the apocalyptic

blankness of this image has few visual antecedents. Yogendra Rastogi's image celebrating India's first nuclear test explosion in 1974, which we have discussed above (see illus. 135), put a smiling face on India's leadership. Through its mixture of Hindi and English press response to the event Rastogi revealed the media not as 'split', but as part of a unified, and essentially beneficent, civil society. 'Peaceful' and producing 'no radioactive dust' the headlines proclaimed, in their collective desire to believe the state fiction of 'nuclear necessity'. The 1998 image, by contrast, makes no appeal to civil society: its justification is simply the reassurance given to an anxious self.

The period covered by this present book, from the late 1870s to the end of the twentieth century,

हम किसी से कम नहीं

167 *Hum kisi se kam nahin*, 2000, printed card.

seems in retrospect to have retained a visual coherence. The aesthetic changes during these 120 years have certainly been dramatic but so have the continuities and coherences. Enduring concerns, and the visual strategies used to address these, are easy to identify. A fluid yet identifiable cultural nationalism extends across this period, together with extremely diverse popular practices of Hinduism. The 1998 image suggests the possibility that a new political era, with its own distinct aesthetic modality, is in the process of emerging. The *fin de millénnium* moment, which has been the present of this book's writing, may come to be seen as more than simply a coincidental end point for its narrative.

References

INTRODUCTION

1 Carlo Ginzburg, 'From Aby Warburg to E. H. Gombrich: A Problem of Method', in *Clues, Myths and the Historical Method* (Baltimore, 1989), p. 35.
2 Or as Ginzburg might say, citing the object of his critique, Fritz Saxl, a 'mirror' or 'reaction ... to the events of contemporary history': Ginzburg, 'From Aby Warburg ...', pp. 34–5.
3 Cited by Rosalind Krauss, 'Welcome to the Cultural Revolution', *October*, 77 (1996), p. 95. Patrick Wright has recently suggested that the nineteenth-century painter Abbot Thayer should more properly be credited.
4 Groys proposes that the Soviet order was 'a work of state art': 'The world promised by the leaders of the October Revolution was not merely supposed to be a more just one or one that would provide greater economic security, but it was also and in perhaps even greater measure meant to be beautiful' (*The Total Art of Stalinism: Avant-Garde, Aesthetic Dictatorship, and Beyond* (Princeton, NJ, 1988), pp. 12, 3). Jacques Attali's *Noise: The Political Economy of Music* (Minnesota, 1985) likewise proposes a transformative role for the aesthetic, but in this case of music over the visual: 'the noises of a society are in advance of its images and material conflicts' (p. 11).
5 Roy Wagner, *Asiwinarong: Ethos, Image, and Social Power among the Usen Barok of New Ireland* (Princeton, NJ, 1986), p. 216, cited by Marilyn Strathern, 'Artefacts of History: Events and the Interpretation of Images', in Jukka Siikala, ed., *Culture and History in the Pacific* (Helsinki, 1990), p. 36.
6 Anthony Forge, writing about the Abelam of Papua New Guinea, suggests that the purpose of the exposure of a young initiate to art in this society is 'not so that he may consciously interpret it but so that he is directly affected by it' (cited by Diane Losche, 'The Sepik Gaze: Iconographic Intrepretation of Abelam Form', *Social Analysis*, XXXVIII (1995), p. 47.
7 W. J. T. Mitchell, 'What Do Pictures *Really* Want?', *October*, 77 (1996), pp. 74.
8 *Ibid.*, p. 72.
9 Lawrence A. Babb, 'Glancing: Visual Interaction in Hinduism', *Journal of Anthropological Research*, XXXVII/4 (1981), p. 400.
10 Arvind Rajagopal, *Politics after Television: Hindu Nationalism and the Reshaping of the Indian Public* (Cambridge, 2001), p. 73.
11 Sandria B. Freitag, 'Visions of the Nation: Theorizing the Nexus between Creation, Consumption, and Participation in the Public Sphere', in Rachel Dwyer and Christopher Pinney, eds, *Pleasure and the Nation: The History, Politics and Consumption of Public Culture in India* (Delhi, 2000), pp. 35–77.
12 Rajagopal, *Politics after Television*, p. 278.
13 Sandria B. Freitag, 'Contesting in Public: Colonial Legacies and Contemporary Communalism', in David Ludden, ed., *Making India Hindu: Religion, Community, and the Politics of Democracy in India* (Delhi, 1996), p. 212.
14 Adorno is referring here to 'high' and 'low' art: Theodor W. Adorno, letter to Walter Benjamin, 18 March 1936, *Aesthetics and Politics* (London, 1980), p. 123.
15 Vladislav Todorov, cited by Alla Efimova, 'To Touch on the Raw', *Art Journal* (Spring 1997), pp. 72–80.
16 Groys, *The Total Art of Stalinism*, p. 9

17 Ranajit Guha, *Dominance without Hegemony: History and Power in Colonial India* (Cambridge, MA, 1997), p. xii (citing an argument first made in volume I of *Subaltern Studies*).
18 Benedict Anderson, *Imagined Communities: Reflections on the Origins and Spread of Nationalism* (London, 2nd edn, 1991), p. 11.
19 *Ibid.*, p. 24.
20 *Ibid.*, p. 22.
21 *Ibid.*, p. 36.
22 *Ibid.*, p. 81.
23 *Ibid.*, p. 140.
24 *Ibid.*, pp. 183–4.
25 My critique of *Imagined Communities* here parallels Peter van der Veer, *Religious Nationalism: Hindus and Muslims in India* (Berkeley, 1994), pp. 15–16, and Ranajit Guha, 'Nationalism reduced to "Official Nationalism"', *Asian Studies Association of Australia Review*, IX/1, pp. 103–8 (thanks to David Arnold for this reference). However, contra Guha, I have tried to trace an alternative popular *visual* print capitalism whose ideological modality was quite different to Anderson's elite nationalism.

1 INDIAN IMAGES UNDER THE SHADOW OF COLONIALISM

1 Barnett Freedman, 'Every Man His Own Lithographer', in R. S. Lambert, ed., *Art in England* (Harmondsworth, 1938), p. 107.
2 Graham Shaw, 'Calcutta: Birthplace of the Indian Lithographed Book', *Journal of the Printing Historical Society*, XXVII (1998), pp. 89.
3 See Mildred Archer and Ronald Lightbown, *India Observed: India as Viewed by British Artists 1760–1860* (London, 1982), p. 142, where they describe it as the 'only known picture showing a Kalighat painting on the wall of a hut'.
4 Rev. John Pool, *The Land of Idols, or Talks with Young People about India* (London, 1895), pp. 14–15.
5 M. K. Gandhi, *An Autobiography, or The Story of my Experiments with Truth* (Ahmedabad, 1991 [1927]), p. 6.
6 Rev. J. E. Padfield, *The Hindu at Home, Being Sketches of Hindu Daily Life* (Madras, 1896), p. 21.
7 Henry D. Baker, *British India, with Notes on Ceylon, Afghanistan, and Tibet*, Special Consular Reports no. 72, Bureau of Foreign and Domestic Commerce (Washington, DC, 1915), p. 7.
8 *Ibid.*, p. 17.
9 *Ibid.*, p. 142.
10 Hans Belting, *Likeness and Presence* (Chicago, 1994), p. 1.
11 The bulk of images in the book, however, are two-dimensional line drawings.
12 Anuradha Kapur, 'Deity to Crusader', in Gyanendra Pandey, ed., *Hindus and Others: The Question of Identity in India Today* (New Delhi, 1993), p. 99.
13 Cited by Susan Buck-Morss, 'Aesthetics and Anaesthetics: Walter Benjamin's Artwork Essay Reconsidered', *October*, 62 (1992), p. 6.
14 For details see Partha Mitter, *Art and Nationalism in Colonial India 1850–1922* (Cambridge, 1994), pp. 30–31.
15 *Ibid.*, p. 32.

16 Though he notes that students were also encouraged to 'fix their gaze on the antique remains of Indian art' (Richard Temple, *India in 1880* (London, 1880), p. 154).

17 This and the previous cited phrase come from Richard Temple, *Oriental Experiences*, cited by Mitter, p. 32.

18 *Ibid.*, p. 32.

19 A phrase used by Martin Jay, 'The Scopic Regimes of Modernity', in Hal Foster, ed., *Vision and Visuality* (San Francisco, 1988).

20 Cited in S. A. Pillai, *Ravi Varma and his Art* (1928), pp. 19–20, cited in turn in Vinayak Purohit, *Arts of Transitional India*, II: *Twentieth Century* (Bombay, 1988), p. 647.

21 Cited by Purohit, p. 647.

22 O. Chandu Menon, Preface to *Indulekha* (1888), cited by Meenakshi Mukherjee, *Realism and Reality: The Novel and Society in India* (Delhi, 1985, rev. 1994), p. 187.

23 Cited by Meenakshi Mukherjee, *ibid.*

24 'History, it would seem, has decreed that we in the postcolonial world shall only be perpetual consumers of modernity … Even our imaginations must remain forever colonized … The most powerful as well as the most creative results of the nationalist imagination in Asia and Africa are posited not on an identity but on a *difference* with the "modular" forms of the national society propogated by the modern West.' Partha Chatterjee, *The Nation and its Fragments: Colonial and Post-Colonial Histories* (New Delhi, 1995), p. 5.

25 Fredric Jameson, *The Political Unconscious: Narrative as a Socially Symbolic Act* (London, 1983), p. 152.

26 Cited in Meenakshi Mukherjee, *Realism and Reality*, p. 15.

27 Franz Roh, 'Magic Realism: Post-Expressionism', in Lois Parkinson Zamora and Wendy B. Faris, eds, *Magical Realism: Theory, History, Community* (Durham, NC, 1995), pp. 15–31.

28 Alejo Carpentier, 'The Baroque and the Marvelous Real', in Zamora and Faris, eds, *Magical Realism*, p. 93.

29 *Ibid.*, p. 94.

30 *Ibid.*, p. 93.

31 Luís Leal, 'Magical Realism in Spanish American Literature', in Zamora and Faris, eds, *Magical Realism*, p. 121. Leal argues that the magical realist 'doesn't create imaginary worlds in which we can hide from everyday reality: In magical realism the writer confronts reality and tries to untangle it, to discover what is mysterious in things, in life, in human acts.'

32 Amaryll Chanady, 'The Territorialization of the Imaginary in Latin America: Self-Affirmation and Resistance to Metropolitan Paradigms', in Zamora and Faris, eds, *Magical Realism*, p. 133. See also Arjun Appadurai, 'Afterword', in Arjun Appadurai, Frank J. Korom and Margaret A. Mills, eds, *Gender, Genre and Power in South Asian Expressive Traditions* (Philadelphia, 1991), pp. 467–76.

33 Chanady is here quoting from José Vasconcelos's 1925 essay *The Cosmic Race*. Chanady, 'Territorialization', p. 135.

34 Partha Chatterjee, *The Nation and its Fragments* (Delhi, 1995), p. 55.

35 Buck-Morss, p. 43.

36 Jean-François Lyotard, cited by David Carroll, *Paraesthetics: Foucault, Lyotard, Derrida* (New York, 1987).

37 Walter Spink, 'The Ecology of Art: India and the West', in Madhav L. Apte, ed., *Mass Culture, Language and Arts in India* (Bombay, 1978), pp. 92–3.

38 Tomas Kulka, *Kitsch and Art* (Pennsylvania, 1996), p. 26, emphasis in original.

39 David Morgan, *Visual Piety: A History and Theory of Popular Religious Images* (Berkeley, 1998), p. 25.

40 *Ibid.*, p. 30.

41 See Norman Bryson, *Vision and Painting: The Logic of the Gaze* (Cambridge, 1983), p. 106.

42 *Ibid.*, p. 107.

43 Michael Fried, *Absorption and Theatricality: Painting and Beholder in the Age of Diderot* (Chicago, 1980), p. 5.

44 W. J. T. Mitchell, 'What Do Pictures *Really* Want?', *October*, 77 (1996), p. 79.

45 Cited by Fried, *Absorption*, p. 95.

46 Cited in W. E. Gladstone Solomon, *The Bombay Revival of Indian Art* (Bombay, n.d.), pp. 79–80.

47 *Ibid.*, p. 87.

48 *Ibid.*, p. 88.

49 *Ibid.*, p. 91, fn.

50 Mitter, *Art and Nationalism*, p. 32.

51 Solomon, *Bombay Revival*, p. 14.

52 Cited by Mitter, *Art and Nationalism*, p. 32.

53 Solomon, *Bombay Revival*, p. 4.

2 STAGING HINDUISM: LITHOGRAPHS AND POPULAR THEATRE IN CALCUTTA, 1870–1885

1 i.e. Mahadev (Shiv).

2 Moncure Daniel Conway, *My Pilgrimage to the Wise Men of the East* (London, 1906), p. 225. Conway is describing a visit to Calcutta in 1884.

3 This account is summarized from notes made by Tulu Biswas from a conversation with his grandfather, Nabocoomer [Nabakumar] Biswas, recounted to me in November 1996.

4 Partha Mitter, *Art and Nationalism in Colonial India 1850–1922* (Cambridge, 1994), p. 296. Bagchi, a former student of the Goverment Art School, had illustrated Rajendralal Mitter's *Antiquities of Orissa* (1869–70) and won praise for his entrants to various exhibitions in the 1870s. In 1876 he was employed to teach lithography, appears to have left the school to set up the Studio (among other ventures) and then returned to the Art School as head master. See Mitter, *Art and Nationalism*, p. 108, and Tapati Guha-Thakurta, *The Making of a New 'Indian' Art: Artists, Aesthetics and Nationalism in Bengal, c. 1850–1920* (Cambridge, 1992), p. 81ff.

5 Graham Shaw, *Printing in Calcutta to 1800: A Description and Checklist of Printing in Late 18th-Century Calcutta* (London, 1981), p. ix.

6 W. G. Archer, *Bazaar Paintings of Calcutta* (London, 1953), p. 7. See also Natasha Eaton, 'Excess in the City'?: The Consumption of Imported Prints in Colonial Calcutta, c. 1780–1795', *Journal of Material Culture* (March 2003), pp. 45–74.

7 Archer, *Bazaar Paintings*, pp. 7–8. The reference is to William Hodges's *Select Views in India*, 48 aquatints issued between May 1785 and April 1788; see Giles Tillotson, *The Artificial Empire: The Indian Landscapes of William Hodges* (London, 2000), p. 8.

8 Nikhil Sarkar, 'Calcutta Woodcuts: Aspects of a Popular Art', in Ashit Paul, ed., *Woodcut Prints of Nineteenth Century Calcutta* (Calcutta, 1983), p. 14.

9 Mitter, *Art and Nationalism*, p. 14.

10 Sarkar, 'Calcutta Woodcuts', pp. 31–2.

11 In the author's collection.

12 Copy in the Victoria and Albert Museum, London. See *The Arts of Bengal: The Heritage of Bangladesh and Eastern India*, ed. Robert Skelton and Mark Francis (London, 1979), p. 52, and a reference to its 'virulently coloured composition'.

13 Copies in the Royal Anthropological Institute Photographic Collection, which were collected in Calcutta in 1907.

14 Mukharji, *Art-Manufactures of India* (Calcutta, 1888), cited by Archer, *Bazaar Paintings*, p. 11.

15 Mukharji, cited by Sarkar, 'Calcutta Woodcuts', p. 44.

16 See P. Thankappan Nair, *A History of Calcutta's Streets* (Calcutta, 1987), p. xx.

17 Writing in 1905, Kathleen Blechynden observed that 'Bow Bazar with its spacious width was long a fashionable quarter and many of the old houses, given up now to squalor and decay, still show traces of their ancient splendour in their large and lofty rooms, beneath whose decorated ceilings ladies in hooped skirts and powdered hair once tripped lightly in the dance with gallant partners in lace ruffles and wigs, or passed through the tall doors and down the wide stairs to their sedan chairs or high swinging chariots, to be marshalled home by *mussalchies* with flaming torches.' *Calcutta Past and Present*, ed. N. R. Ray (Calcutta, 1978 [1905]).

18 Thanks to William Radice and Bhaskar Mukhopadhyay for clarifying this. Mitter, *Art and Nationalism*, p. 178, gives the English title 'Begging India Back from England'.

19 The distance between these intellectual projects and ongoing popular practices is striking. See Sumanta Banarjee, *The Parlour and the Streets: Elite and Popular Culture in Nineteenth Century Calcutta* (Calcutta, 1989), p. 71.

20 cf. Homi K. Bhabha, *The Location of Culture* (London, 1994), pp. 93–101.

21 *Sri Ramakrishna, The Great Master*, trans. Swami Jagadanada (Mylapore, 1956), pp. 15–16.

22 This is quoted from several pages of preliminary written material tipped into a bound folio of early Calcutta Art Studio prints in the Ashmolean Museum, Oxford (Ashmolean 1966.53).

23 Romila Thapar, 'Syndicated moksha', *Seminar*, 313 (1985), pp. 14–22, cited by R. E. Frykenberg, 'Emergence of Modern "Hinduism"', in Gunther D. Sontheimer and Hermann Kulke, ed., *Hinduism Reconsidered* (Delhi, 1991), p. 41.

24 Heinrich von Stietencron, 'Hinduism: On the Proper Use of a Deceptive Term', in Gunther D. Sontheimer and Hermann Kulke, ed., *Hinduism Reconsidered* (Delhi, 1991), pp. 11–28.

25 Some images were issued in the form of loose prints, sometimes in variant designs. In the Ashmolean there are two images depicting Shiv receiving alms from Annapurna. One is no. 11 in Series A of the 'Hindu Sacred Pictures' and is a hand-coloured lithograph bound into the volume of other similar prints. The other is a loose chromolithograph pasted on board and there are subtle yet significant differences in the modelling of the figures and the nature of the backdrop. The bound print has a wispy, translucent feel to it, reflecting the careful use of watercolour and white gouache to highlight the folds in Annapurna's sari and the patterns in the carpet. The loose print has a much flatter feel to it with denser, more finely graduated colours that result from the use of different colour lithostones. It is evident, however, that while taking the opportunity to change certain incidental features (a large column in the background, for instance), the artist/artisan has faithfully reproduced the earlier design in many particulars.

26 Rudyard Kipling, *The City of Dreadful Night* (Leipzig, 1900), pp. 32–3.

27 Brian Rotman, *Signifying Nothing: The Semiotics of Zero* (London, 1987), pp. 88–97.

28 Homi K. Bhabha, 'Signs Taken for Wonders: Questions of Ambivalence and Authority under a Tree outside Delhi, May 1817', in *The Location of Culture* (London, 1994), pp. 102–22.

29 Linda Nochlin, *Realism* (Harmondsworth, 1971), p. 20.

30 The reference here is to Walter Benjamin's sense of translation as a continual passage and movement (see Homi Bhabha, *The Location of Culture*, p. 212).

31 John Berger, *Ways of Seeing* (London, 1972), p. 101.

32 The Kalighat *Nala and Damayanti* reproduced by Archer is dated *c.* 1880

and it is by no means certain that this design existed in the Kalighat repertoire prior to its appearance in the Calcutta Studio lithograph.

33 A copy in the Victoria and Albert Museum, London, is dated 1882.

34 *Nalopakhyanam*, trans. Monier Williams (Oxford, 1879), p. 53. The Kali referred to here is the demon (with short vowels), as opposed to the goddess Kali (with long vowels).

35 The current, and basest, epoch.

36 Guha-Thakurta, *The Making*, p. 101.

37 *Ibid.*, p. 101–2.

38 *Ibid.*, p. 100.

39 Variously dated at between 1878–80 and 1882 by Guha-Thakurta (*The Making*, p. 92) and Robert Skelton and Mark Francis, eds, *The Arts of Bengal: The Heritage of Bangladesh and Eastern India* (London, 1979), p. 53.

40 Sushil Kumar Mukherjee, *The Story of the Calcutta Theatres 1753–1980* (Calcutta, 1982), p. 65.

41 *Ibid.*, p. 794.

42 D. P. Bagchi, *Calcutta Past and Present* (Calcutta, 1939), p. 29.

43 R. K. Yajnik, *The Indian Theatre: Its Origins and its Later Developments under European Influence, with Special Reference to Western India* (London, 1933), p. 87.

44 Mittra, 1873, cited by Yajnik, *Indian Theatre*, p. 87.

45 Cited by Yajnik, *Indian Theatre*, p. 88.

46 Brajendra Nath Banerji, cited by Yajnik, *Indian Theatre*, p. 264.

47 Yajnik, *Indian Theatre*, p. 89. This date is flatly contradicted by Mukherjee's account.

48 We shall see Rana Pratap and Shivaji juxtaposed again, later in this study.

49 Yajnik, *Indian Theatre*, p. 89.

50 Mukherjee, *Calcutta Theatres*, p. 51.

51 Moncure Daniel Conway, *My Pilgrimage to the Wise Men of the East* (London, 1906), p. 226.

52 *Ibid.*, pp. 226–7.

53 See Yajnik, *Indian Theatre*, p. 181.

54 Conway, *My Pilgrimage*, p. 229.

55 H. S. J. Cotton, *New India, or India in Transition* (London, 3rd edn, 1886), pp. 4–5.

56 Conway, *My Pilgrimage*, p. 228.

57 Saturday 21 March 1908.

58 These printed notices are in the collection of E. Alkazi (Delhi), to whom thanks.

59 Banerjea would later be knghted. See Sir Surendranath Banerjea, *A Nation in the Making: Being the Reminiscences of Fifty Years of Public Life* (Oxford, 1925).

60 *Seetar Banabas* (17 September 1881), *Avimanyu Badh* (26 November 1881), *Lakshman Barjan* (31 December 1881), *Seetar Bibaha* (11 March 1882), *Ramer Banabas* (15 April 1882), *Seeta Haran* (22 July 1882) and *Pandaber Agyantabas* (13 January 1883): Mukherjee, *Calcutta Theatres*, p. 52.

61 Which was premiered on 2 August 1884 (Mukherjee, *Calcutta Theatres*, p. 65).

62 J. N. Farquhar, *Modern Religious Movements in India* (London, 1924), p. 293.

63 *Ibid.*, p. 47.

64 Mukherjee, *Calcutta Theatres*, p. 66.

65 *Ibid.*, p. 66.

66 Farquhar, *Modern Religious Movements*, p. 189.

67 cf. *Gospel of Ramakrishna*, cited by Farquhar, *Modern Religious Movements*, p. 197, fn.1.

68 Max Müller, cited by Farquhar, *Modern Religious Movements*, p. 189.

69 Binodini had earlier played the part of Damayanti in the 1883 *Nala Damayanti* (Mukherjee, *Calcutta Theatres*, pp. 65–6).

70 Chaitanya is sometimes translated as 'inner consciousness'. Binodini

Dasi, *My Story and My Life as an Actress*, ed. and trans. Rimli Bhattacharya (Delhi, 1998), p. 95.

71 Mahendranath Gupta, *The Gospel of Sri Ramakrishna*, trans. Swami Nikhilananda (New York, 1984), pp. 551–2.

72 *Ibid.*, p. 553.

73 *Ibid.*, p. 556.

74 *Ibid.*, p. 677.

75 *Ibid.*, p. 678.

76 Mukherjee, *Calcutta Theatres*, p. 66.

77 Bhaskar Mukhopadhyay, personal communication.

78 Gupta, *Gospel*, pp. 798–800.

79 cf. W. J. T. Mitchell, 'What do Pictures'.

3 PESHWAS, PARROTS AND BOMBS: LITHOGRAPHS AND POLITICS IN WESTERN INDIA, 1870–1885

1 The earliest presses in Poona from which images survive date from around 1870. They are simple one-colour lithographs that retain the vigour of ink sketches and it is easy to imagine the impact on their consumers a few years later of multi-colour 'naturalistic' lithographs. The Wellcome Institute's extensive collection includes a diptych of *Siva, Markandey* and *Khandoba* printed by Bhagwan Singh and Ananda Singh of Poona. Other images by the same publishers include *Durga* and *Dattatreya*. Some lithographs produced by Bombay presses pre-date the Poona ones by a few years. One print in the Wellcome Institute (London) is a diptych of *Satyanarayan* (a form of Vishnu) and *Lakshmi* (probable date 1868) published by the Chitrapriyaprakash Company, whose press was at Kondevadi Mumbai (Bombay). Another from the same date is an image of *Khandoba* (labelled *Khanderav* in the print), the Maharasthrian warrior figure, published by the Bambe Nya Pres (New Bombay Press). Bombay was also the location of the Jayprakash Press, whose diptych of *Hanuman and Bhima* is also in the Wellcome Institute. The Janaradna Vasudev Bambe Siti Presamta (Janaratna Vasudev Bombay City Press) at Girgaum was producing handsomely hand-coloured lithographs by 1871 (again this is a proba-ble date). The Wellcome Institute example is a large image of Ganesh with his wives surrounded by the ten avatars of Vishnu, which are set in medallions whose chronology traces an anti-clockwise ellipse around the central image.

2 Ashis Nandy, *The Intimate Enemy* (Delhi, 1983); Sudipta Kaviraj, *The Unhappy Consciousness: Bankimchandra Chattopadhyay and the Formation of Nationalist Discourse in India* (Delhi, 1995).

3 Partha Mitter, *Art and Nationalism in Colonial India 1850–1922* (Cambridge, 1994), pp. 8–9.

4 Sumit Sarkar, *Modern India 1885–1947* (Basingstoke, 2nd edn, 1989), p. 48.

5 Anil Seal, *The Emergence of Indian Nationalism: Competition and Collaboration in the Later Nineteenth Century* (Cambridge, 1968), p. 235.

6 Richard Cashman, *The Myth of the Lokmanya* (Berkeley, 1975), p. 29.

7 Minute by Temple, 31 July 1879, cited by Gordon Johnson, *Provincial Politics and Indian Nationalism: Bombay and the Indian National Congress* (Cambridge, 1973), p. 54.

8 Sarkar, *Modern India*, p. 99.

9 Proper name Vishnu Krishna Chiplunkar, popularly known as 'Vishnu Shastri'. N. C. Kelkar, 'Character Sketch of Mr Bal Gangadhar Tilak', in *Full and Authentic Report of the Tilak Trial (1908) Being the Only Authorised Verbatim Account of the Whole Proceedings with Introduction and Character Sketch of Bal Gangadhar Tilak Together with Press Opinion* (Poona, 1908), p. 1.

10 Charles H. Heimsath, *Indian Nationalism and Hindu Social Reform* (Princeton, NJ, 1964), pp. 243–4.

11 N. C. Kelkar, 'Character Sketch', pp. 1–2.

12 N. C. Kelkar, *Vishnu Krishna Chiplunkar: A Sketch of his Life and Career* (Madras, n.d.), p. 32.

13 R. P. Kanitkar, *Chitrashalecha Itihas 1878–1973* (Pune, 1975).

14 Kelkar, *Vishnu Krishna Chiplunkar*, pp. 17–18.

15 *Ibid.*, pp. 24–5.

16 Writing in his *Nibandha Mala* (Kanitkar, *Chitrashalecha Itihas*, p. 1).

17 It is highly likely that the figure reproduced here is from the earliest version of the print. However, similar prints were also issued by Chitrashala in different formats with later numbers (see 'No. 10 Rampanchaytam', Ashmolean 29; and 'No. 73 Rampanchayatam', Ashmolean 73).

18 Kanitkar quotes Kelkar: 'around 1882, colour prints published by Chitrashala came to Miraj [a city south of Poona] and most of these prints could be found displayed in shops' (Kanitkar, *Chitrashalecha Itihas*, p. 7).

19 See Anil Seal, *The Emergence of Indian Nationalism*, pp. 234–44.

20 N. C. Kelkar, *Vishnu Krishna Chiplunkar*, p. 32.

21 Cashman, *Myth of the Lokmanya*, p. 8. Cashman also cites Chiplunkar describing the Brahman adoption of Kshatriya roles as a 'remarkable change in which the people of Prashurama's land demonstrated their bravery all over the country'.

22 *Ibid.*, pp. 8-9.

23 This was a hereditary post in Nana's family.

24 See 'Madhu Rao Narayan, the Maratha Peshwa, with Nana Fadnavis and Attendants', in C. A. Bayly, ed., *The Raj: India and the British 1600–1947* (London, 1990), p. 161. Wales had run what Mitter describes as 'the first "western" art school', founded by Charles Malet *c*. 1798 in Poona (Mitter, *Art and Nationalism*, p. 30).

25 See Bayly, ed., *The Raj*, pl. 173.

26 Mildred Archer and Ronald Lightbown, *India Observed* (London, 1982), p. 39.

27 Kelkar writes that the portraits were 'painted about a hundred years ago from life by a European artist at the instance of Mr. Malet of the British Political Agency in the time of Sawai Madhav Rao, were pre-served at Menavli in the private wada of Nan Fadnawis himself, and … were regarded as the only genuine portraits of the time of the Peshwas that were handed down to later generations' (Kelkar, *Chiplunkar*, p. 32). This must be the 'family heirloom' to which the Chitrashala text refers – a copy in oils of the original painting. It is also possible that Balkrishna Vasudev Joshi's personal archive or 'collection of interest-ing paintings, pictures [and sketches]' may have been the source. Perhaps Joshi's archive included preliminary sketches which at Malet's suggestion the young Peshwa had commissioned from Wales (Archer and Lightbown, *India Observed*, p. 38), or the artists may have had access to British engravings of these works. The legacy of Joshi's picto-rial archive is perhaps evident in other Chitrashala images. The Wellcome Institute collection includes three crude hand-coloured lithographs, one of Narayan Rao Peshwa, one of Dhakate Bajirava Saheb and of Malharrav Holkar. These are interesting for their exper-iments with perspective and the contrast of flat areas with heavily sculpted features. Inscriptions on the reverse of the first two of the Wellcome copies record 'from the Chitra Shala Press Poona 1888'. Although purchased in that year (on one of the prints what is presum-ably their place of purchase – 'Jellepure, Khandesh' – is faintly inscribed) these prints probably date from the earliest days of Chitrashala production.

28 The Wellcome Institute and Ashmolean Museum preserve 51 images, the latest of which bears the serial number '133'.

29 Cashman, *Myth of the Lokmanya*, p. 11. See also the plates in Gunther-Dietz Sontheimer, *Pastoral Deities in Western India* (New York, 1989).

30 Sontheimer, *Pastoral Deities*, p. 125.
31 Valentine Chirol, in *Indian Unrest* (London, 1910), p. 40 – the publication that Tilak would launch an unsuccessful libel action against at the end of his life – described Ranade as the 'most conspicuous' among those 'by no means servile apologists of British rule [who] fully realized that their primary duty was not to stir up popular passion against alien ruler, but to bring Hindu society into closer communion with the higher civilization which those rulers, whatever their shortcomings, undoubtedly represented'.
32 Cited by Cashman, *Myth of the Lokmanya*, p. 10.
33 *Ibid.*, p. 12.
34 'The exponents of the Bhakti school in their impatience to reach what appeared to them to be the ultimate, induced the belief that the penultimate – human existence on earth – can be neglected and ignored. This impatience cost Maharashtra dear as it would cost dear any society. The impatience made men in Maharashtra averse to the task of social organisation in whose absence resistance to the dehumanising rule of Muslim sultans was out of the question.' S. L. Karandikar, *The Rise and Fall of the Maratha Power*, I: *1620–1689 (Shahaji, Shivaji, Sambhaji)* (Pune, 1969), pp. 35–6.
35 'He used to stand for hours together every day in the sacred waters of the river Godavari and observe penance by chanting the thirteen lettered mantra "Shriram Jayram Jayjayram".' N. K. Behere, *The Background of the Maratha Renaissance in the 17th Century* (Bangalore, 1946), p. 158.
36 On whom see G. S. Sardesai, *The Main Currents of Maratha History* (Bombay, 1933), pp. 38–41.
37 Cashman, *Myth of the Lokmanya*, p. 16. My discussion of Ramdas relies on Cashman's valuable summary.
38 Behere, *Background*, p. 160.
39 *Ibid.*, p. 168.
40 *Ibid.*, p. 163.
41 N. R. Phatak, *Shri Ramdas*, cited in Cashman, *Myth of the Lokmanya*, p. 16.
42 Behere, *Background*, p. 164.
43 Karandikar, *Rise and Fall*, p 81.
44 Writing in 1975, Cashman noted that 'the picture of Shivaji receiving the sword from Bhavani adorns many of the Maharashtrian homes. It ranks, with that of the equestrian Shivaji, as one of the more popular pictures of this leader.' *Myth of the Lokmanya*, p. 104, fn. 21.
45 Cashman, *Myth of the Lokmanya*, pp. 103–4.
46 M. G. Ranade, *Rise of the Maratha Power* (Bombay, n.d.), pp. 104–5.
47 N. C. Kelkar, *Life and Times of Lokmanya Tilak* (Madras, 1928), p. 369.
48 Vishnu Krishna Chiplunkar, *Amchya Deshachi Sthiti*, a reprint of *Nibandhamala*, 77–84 (June–November 1881), p. 25, cited in Stanley A. Wolpert, *Tilak and Gokhale: Revolution and Reform in the Making of Modern India* (Berkeley, 1962), pp. 1–11.
49 Guha-Thakurta, *The Making*, p. 106.
50 Ravi Varma's son, quoted in Nayar's Malayalam biography, cited by Guha-Thakurta, *The Making*, p. 106. Partha Mitter quotes the same son explaining that Bombay was chosen as a site for the press because 'people had to be weaned from the Poona pictures' (*Art and Nationalism*, p. 209).
51 Krishna Chaitanya, *Ravi Varma* (Delhi, 1984), p. 5.
52 In turn repeated in Guha-Thakurta, *The Making*, p. 186.
53 E. M. J. Venniyoor, *Raja Ravi Varma* (Trivandrum, 1981), p. 41.
54 Cited in *ibid.*, p. 34. See also Mitter, *Art and Nationalism*, p. 209. A copy of the image referred to is in the private collection of Edwin Neumayer, Vienna.
55 G. W. Steevens, *In India* (London, ?1899), p. 48.

4 LITHOGRAPHS AND THE CAMERA IN BOMBAY AND DELHI, 1890–1925

1 H. D. Love, *Descriptive List of Pictures in Government House and the Banqueting Hall, Madras* (Madras, 1903), p. 132.
2 His 1880 portrait of the Duke of Buckingham and Chandos (Governor of Madras, 1875–80) was applauded as 'well executed and an excellent likeness' by the colonial cataloguer of the Government Banqueting Hall, Madras, in which it hung. Love, *List of Pictures*, p. 112.
3 Partha Mitter, *Art and Nationalism in Colonial India 1850–1922* (Cambridge, 1994), p. 212.
4 On the political context see Bipan Chandra, *India's Struggle for Independence* (New Delhi, 1987), and Peter Heehs, *India's Freedom Struggle: A Short History* (Delhi, 1988).
5 'Of realists and surrealists', *Indian Express*, 18 May 1993.
6 'PM pays tribute to Raja Ravi Varma', *Patriot* [New Delhi], 18 May 1993.
7 'Indian art to be exhibited properly: Rao', *Hindustan Times*, 18 May 1993.
8 'Of realists and surrealists', *Indian Express*, 18 May 1993.
9 'Damaging to the spirit of man', *The Pioneer*, 26 June 1993.
10 Ernst Kris and Otto Kurz, *Legend, Myth, and Magic in the Image of the Artist: A Historical Experiment* (New Haven, CT, 1979), p. 1.
11 Key writings on Ravi Varma include Partha Mitter, *Art and Nationalism*, pp. 179–218, which also draws on Kris and Kurz; Tapati Guha-Thakurta, 'Westernisation and Tradition in South Indian Painting in the Nineteenth Century: The Case of Raja Ravi Varma (1848–1906)', *Studies in History*, n.s., II/2 (1986), pp. 165–95; Guha-Thakurta, *The Making of a New 'Indian' Art: Artists, Aesthetics and Nationalism in Bengal, c. 1850–1920* (Cambridge, 1992), *passim*; E. M. J. Venniyoor, *Raja Ravi Varma* (Trivandrum, 1981); R. S. Sharma and Rupika Chawla, eds, *Raja Ravi Varma* (New Delhi, 1992); Patricia Uberoi, 'Feminine Identity and National Ethos in Indian Calendar Art', *Economic and Political Weekly* (28 April 1990), pp. 41–8; R. Nandakumar, 'The Missing Male: The Female Figures of Ravi Varma and the Concepts of Family, Marriage and Fatherhood in Nineteenth Century Kerala', *South Indian Studies*, 1 (January 1996), pp. 54–82.
12 Anon, *Ravi Varma the Indian Artist* (Madras, 1911), p. 16.
13 Juri Lotman, cited in Ranajit Guha, *Elementary Aspects of Peasant Insurgency in Colonial India* (Delhi, 1983), p. 37.
14 Geeta Kapur, 'Ravi Varma: Representational Dilemmas of a Nineteenth Century Indian Painter', *Journal of Arts and Ideas*, XVII–XVIII (1989), p. 40, cited by Patricia Uberoi, 'Feminine Identity and National Ethos', p. 43.
15 Not to be confused with Ravi Varma's younger brother who bore the same name.
16 Venniyoor, *Raja Ravi Varma*, p. 2. Similarly, S. N. Joshi (*Half-Tone Reprints of the Renowned Pictures of the Late Raja Ravivarma*, Poona, 1911) records that 'it was the habit of the young Ravi Varma to draw crude figures with chalk or coal on the walls of his family dwelling. All the relatives and elders of Ravi Varma's family had no sympathy whatever with the budding artists's favourite hobby. But he had an uncle … who was himself a votary of the pencil and it was he who encouraged his young nephew to persist in his endeavours of acquiring perfection in the pictorial art.' Compare this with Kris and Kurz's description of biographical motifs in accounts of Renaissance artists: 'several biographies tell of how the master first gave evidence of his gifts by sketching the animals he herded as a shepherd. Then a connoisseur happened to pass by, recognized the extraordinary talent in these first artistic endeavours, and watched over the proper training of this young shepherd, who later emerged as this or that far-famed genius' (p. 8).
17 Venniyoor, *Raja Ravi Varma*, p. 4.
18 Anuradha Kapur, 'The Representation of Gods and Heroes: Parsi

Mythological Drama of the Early Twentieth Century', *Journal of Arts and Ideas*, XXIII–XXIV (1993), pp. 98–9.

19 Venniyoor, *Raja Ravi Varma*, p. 5.

20 This term refers technically to a varnished chromolithograph having a tactility akin to that of an oil painting. It is also frequently used as a synonym for chromolithography.

21 Venniyoor, *Raja Ravi Varma*, p. 30.

22 Rao Bahadur Govindbhai H. Desai, *Visitor's Guide to Baroda* (Baroda, 1916), pp. 43–4.

23 Gulam Mohammed Sheikh, in *Raja Ravi Varma*, ed. Sharma and Rupika Chawla (Delhi, 1992), p. 78.

24 Venniyoor, *Raja Ravi Varma*, p. 29.

25 *Ibid.*, pp. 29–30.

26 S. N. Joshi, *Half-Tone Reprints*, p. 5.

27 Venniyoor, *Raja Ravi Varma*, p. 38.

28 See copy in Wellcome no. 235.

29 Venniyoor, *Raja Ravi Varma*, p. 38.

30 The 22 prints donated to the Cambridge University Museum of Archaeology and Anthropology in 1920 range from 'registered numbers' 68 to 643. Later images – dating from 1928 – bear serial numbers ranging as high as 1001, and a series of postcards printed by the 'Ravi Varma Press, Karla' includes a depiction of 'Gaja-Gauri' numbered 804.

31 Venniyoor, *Raja Ravi Varma*, pp. 35, 37.

32 The bibliographic complexity is compounded by the existence of reprints of Ravi Varma images produced by different publishers and presses, and with different inscriptions and serial numbers. There are eight versions of Ravi Varma's *Tilottam* in the Wellcome Institute collection in London. All feature Ravi Varma's signature, but two (W.223 & 226) also include the date (1896) in Ravi Varma's hand, below his signature. Different printers are recorded: 'Ravi Varma F.A.L. Press Karli [sic] Bombay' (W.223), 'Ravi Varma Press, Karla Lonavla' (W.224). W.225 is printed by Ravi Udaya F.A.L. Press, Ghatkopar, Bombay. The former gives 'registered no. 19', the latter records 'Registered no. 514'. One copy (W.224) names Anant Shivaji Desai as the distributor, but an otherwise identical version (W.223) doesn't. W.225 is distributed by A. K. Joshi & Co.; one of the prints (W.226) gives the name and address of Anant Shivaji Desai as distributor but is also marked with the ink stamps of Desai and A. K. Joshi & Co. (V 45138).

33 Beatrice M. W. Grautoff, *Glimpses of a Land of Sun and Sadness* (London, n.d.), p. 59.

34 Anuradha Kapur, 'Deity to Crusader: The Changing Iconography of Ram', in Gyan Pandey, ed., *Hindus and Others: The Question of Identity in India Today* (New Delhi, 1993), p. 100.

35 Venniyoor, *Raja Ravi Varma*, p. 20.

36 *Ibid.*, p. 21.

37 Homi K. Bhabha, *The Location of Culture* (London, 1994), p. 121.

38 Ranjani Rajagopal, 'Raja Ravi Varma: A Biographical Sketch', in Sharma and Chawla, eds, *Raja Ravi Varma*, p. 134.

39 Cited by Aravind Gururao Ganachari, 'The Contribution of Marathi Theatre to the Growth of Nationalism 1897–1913', *Proceedings of the Indian History Congress: 54th Session, Mysore, 1993* (New Delhi, 1994), p. 582. Thanks to Raminder Kaur for this reference.

40 Valentine Chirol, *Indian Unrest* (London, 1910) p. 337.

41 Ganachari, 'Marathi Theatre', p. 586.

42 Reproduced in S. N. Joshi, *Half-Tone Reprints*, pp. 48, 49 and Sharma and Chawla, eds, *Raja Ravi Varma*, respectively.

43 S. N. Joshi, *Half-Tone Reprints*, p. 50.

44 *Ibid.*, p. 51.

45 *Ibid.*, p. 52.

46 It is likely that the whole series was, but I have only traced printed images of numbers '2' and '4'.

47 Strife among the Peshwas was a theme he returned to in the plays *Baykanche Bund* and *Bhaubandaki* in 1909. Vasant Shantaram Desai, 'Years of Glory', *The Marathi Theatre: 1843–1960* (Bombay, 1961), p. 26.

48 King Virata had agreed that the *sairandhri* should be taken to the Bairoba temple and left there.

49 Cited by Chirol, *Indian Unrest*, p. 338.

50 Chirol, *Indian Unrest*, pp. 338–9.

51 *Ibid.*, p. 339.

52 Desai, 'Years of Glory', p. 25. As Yajnik notes this play owed much to *Macbeth*, and he describes Ramasastri as 'a sort of Hindu Macduff'. *Indian Theatre*, (London, 1933), p. 223.

53 Homi K. Bhabha, 'Signs Taken for Wonders: Questions of Ambivalence and Authority under a Tree outside Delhi, May 1817', in *The Location of Culture* (London, 1994), p. 120.

54 Alejo Carpentier, 'The Baroque and the Marvelous Real', in Lois Parkinson Zamora and Wendy B. Faris, eds, *Magical Realism*, p. 93.

55 Partha Chatterjee, *The Nation and its Fragments: Colonial and Post-Colonial Histories* (New Delhi, 1995), p. 56.

56 Anuradha Kapur, 'Deity', p. 99.

57 Partha Chatterjee, *Nation and its Fragments*, p. 55.

58 Mitter, *Art and Nationalism*, p. 179.

59 Firoze Rangoonwalla, *75 Years of Indian Cinema* (New Delhi, 1975), p. 25.

60 *Ibid.*, p. 27.

61 *Ibid.*, p. 28.

62 Directed by S. N. Patankar, V. P. Divekar and A. P. Karandikar. *Ibid.*, p. 29.

63 *Ibid.*, p. 30.

64 See Ashish Rajadhyaksha's brilliant 'The Phalke Era: Conflict of Traditional Form and Modern Technology', *Journal of Arts and Ideas*, XIV–XV (1987), pp. 47–78, reprinted in Tejaswini Niranja, P. Sudhir and Vivek Dhareshwar, ed., *Interrogating Modernity: Culture and Colonialism in India* (Calcutta, 1993), pp. 47–82.

65 Ashish Rajadhyaksha, 'Phalke Era', p. 48; other accounts suggest that Phalke ran his own works in Lonavala.

66 Guha-Thakurta, *The Making*, p. 140.

67 cf. Christopher Pinney, *Camera Indica: The Social Life of Indian Photographs* (London, 1997), pp. 96–7.

68 'Hindu Sacred Pictures', Series A, Number 4.

69 J. B. H. Wadia, 'The Indian Silent Film', in T. M. Ramachandran, ed., *70 Years of Indian Cinema (1913–1983)* (Bombay, 1985), p. 24.

70 B. V. Dharap, 'Dadasaheb Phalke: Father of Indian Cinema', in Ramachandran, ed., *70 Years of Indian Cinema*, p. 43.

71 Erik Barnouw and S. Krishnaswamy, *Indian Film* (New York, 1963), p. 15.

72 Dharap, 'Dadasaheb Phalke', p. 43.

73 Wadia, 'Silent Film', p. 24.

74 Patricia Uberoi, 'Feminine Identity and National Ethos'.

75 It should be noted that it is comparatively more difficult to establish the chronology of Hem Chander images on the basis of their serial numbers because of the company's propensity to give different-sized images separate numbers.

76 This date is arrived at on assumption that the image was topical and is extrapolated from the dates of birth given for the individuals represented in the image.

77 C. A. Bayly, ed., *The Raj: India and the British 1640–1947* (London, 1990), p. 337.

78 Sidney Low, *A Vision of India* (London, 1911), p. 199.

79 W. H. McLeod, *Popular Sikh Art* (Delhi, 1991), p. 19.

80 Erich Auerbach, *Mimesis*, p. 64; cited by Benedict Anderson, *Imagined Communities: Reflections on the Origins and Spread of Nationalism* (London, 2nd edn, 1991), p. 24.

81 V & A, I.M.2(11)-1917; reproduced as plate 3 in McLeod.

82 Anderson, *Imagined Communities*, p. 24.

83 Conventions apparent in both Indian and British practice.

84 Judith Mara Gutman, *Through Indian Eyes* (New York, 1982), p. 129.

85 'Indian artists . . . faced massive formal, really ethical, problems'. Ashish Rajadhyaksha, 'Phalke Era', p. 53.

86 Ashis Nandy, *The Intimate Enemy: Loss and Recovery of Self under Colonialism* (Delhi, 1983), pp. 107ff.

5 PASTORAL REALISM: THE NATHDVARA DEVOTIONAL AESTHETIC, 1925–1935

1 R. R. Bhandari, *Jodhpur Railway* (New Delhi, 1982), p. 21.

2 Alan W. Entwistle notes that Braj is derived from the Sanskrit *vraja* meaning 'an enclosure or station of herdsmen' and that it is defined by contemporary local specialists as 'the place where cows roam'. *Braj: Centre of Krishna Pilgrimage* (Groningen, 1987), p. 1.

3 Robert Skelton, *Rajasthani Temple Hangings of the Krishna Cult* (New York, 1973), p. 12.

4 Cited by Amit Ambalal, *Krishna as Shrinathji: Rajasthani Paintings from Nathdvara* (Ahmedabad, 1987), p. 42.

5 Skelton gives the following account: 'At first only one arm was visible but on the day of Vallabha's birth the face also appeared. and from this time it was fed miraculously each day by a cow which poured milk into its mouth. Sadupande, the owner of the cow, suspecting theft, followed the animal to discover why it was always dry when he tried to milk it. On seeing the miracle he made daily offerings to the image' (Skelton, *Temple Hangings*, p. 13).

6 This paragraph and the next is summarized from Ambalal, *Krishna as Shrinathji*, pp. 51–2.

7 Ambalal, *Krishna as Shrinathji*, p. 52.

8 This date is from Ambalal (*Krishna as Shrinathji*, p. 52). Skelton suggests that this happened one year earlier (*Temple Hangings*, p. 26).

9 There is a small third group, the *Purbia*, who claim to have migrated from Delhi and Alwar (Skelton, *Temple Hangings*, p. 26).

10 *Ibid.*, p. 26.

11 *Ibid.*, p. 27.

12 *Ibid.*, p. 27.

13 *Ibid.*, pp. 27–8.

14 See Andrew Topsfield, *Court Painting at Udaipur: Art under the Patronage of the Maharanas of Mewar* (Zürich, 2002); Renaldo Maduro, *Artistic Creativity in a Brahmin Painter Community*, Berkeley, Center for South and Southeast Asia Studies, 1976; Tryna Lyons, 'Women Artists of the Nathadwara School', in Vidya Dehejia, ed., *Representing the Body: Gender Issues in Indian Art* (New Delhi, 1997), pp. 102–23, and Chiranjivlal Sharma, 'Banas Valley Painting', unpublished typescript, *c*. 1994.

15 cf. Alan W. Entwistle, 'The Cult of Krishna-Gopal as a Version of the Pastoral', in Diana L. Eck and Françoise Malison, eds, *Devotion Divine: Bhakti Traditions from the Regions of India: Studies in Honour of Charlotte Vaudeville* (Groningen and Paris, 1991), pp. 73–90.

16 This claim is made in the photographer's stamp in a later pilgrimage print (*Shribadris panchayatan*), author's own archive.

17 For instance, E. Osborn Martin's *The Gods of India* (London, 1914) credits 'Bharat Hitaishi & Co., Muttra' with numerous illustrations, and there are examples in the author's personal archive.

18 This homology should not be overstated: one could also contrast Gandhi's celibacy and austerity with the sensual and fecund aspects of Vallabha worship.

19 The extant images are all gouaches (interview with M. L. Garg, March 1994).

20 My thanks to M. L. Garg for his generosity in making this available to me.

21 The registration declaration asserted Brijbasi's sole right to sell these images in British India and a sample of each postcard was submitted for registration.

22 Ambalal, *Krishna as Shrinathji*, p. 85.

23 This must surely refer to Kundanlal, and is probably a result of an error in transcription from the original manuscript diary.

24 *Raja Ravi Varma*, ed. R. S. Sharma and Rupika Chawla, pp. 190–91.

25 Ambalal, *Krishna as Shrinathji*, p. 88.

26 *Ibid.*, p. 89. This quality is certainly apparent in the beautiful images Ambalal reproduces, but is less clear in the early Ghasiram chromolithographs I have been able to trace.

27 M. L. Garg suggested that Ghasiram and Khubiram drew extensively on European landscape prints (interview 1994).

28 When sent to Germany for reproduction Brijbasi's instructions requested 'scenery dark colours'.

29 And also a very similar study reproduced in Ambalal, *Krishna as Shrinathji*, p. 145.

30 A. Ramachandan in *Raja Ravi Varma*, ed. Sharma and Chawla, p. 21.

31 Here I have found Erwin Panofsky's *Perspective as Symbolic Form* (Eng. trans., New York, 1991) exceptionally helpful for it describes a transformation that in many ways parallels events in India. Panofsky notes the perspectival experiments which occurred during Antiquity, and the subsequent retreat from this in later styles. At the close of Antiquity 'we can observe quite plainly the disintegration of the perspectival idea: not merely plants, but indeed the formations of the earth, which in the Odyssey landscapes were cut off by the edge of the picture as if by a window frame, must now accommodate themselves to the curve of that edge'. The parallels between late Antiquity's abandonment of perspective and late Mewar painting's repudiation of the perspectival experiments of Indian art in the late nineteenth century are striking.

32 O. P. Joshi, *Gods of Heaven, Home of Gods* (Jaipur, 1994), pp. 4–11.

33 Anderson, *Imagined Communities*, p. 30.

34 cf. John Stratton Hawley, *At Play with Krishna: Pilgrimage Dramas from Brindavan* (Princeton, NJ, 1981).

35 cf. for instance the image of a Mewar prince by Narottam, reproduced in Pinney, *Camera Indica*, p. 81.

36 cf. Amabalal, *Krishna as Shrinathji*, pp. 90–91.

37 *Annkut* is the offering of food during the month of *kartik*.

38 Ashish Rajadhyaksha, 'Phalke Era', p. 58.

39 This is theologically unorthodox since Krishna is himself a primary avatar of Vishnu, Satyanarayan a 'sub-avatar' of Vishnu.

40 Anderson, *Imagined Communities*, pp. 35–6.

41 *Ibid.*, p. 24.

42 This argument is developed ethnographically in C. Pinney, 'Moral Topophilia: The Significations of Landscape in Indian Oleographs', *The Anthropology of the Landscape: Between Space and Place*, ed. E. Hirsch and M. O'Hanlon (Oxford, 1995), pp. 78–113.

43 cf. Philip Lutgendorf, *The Life of a Text* (Berkeley, 1991).

44 On postcolonial photographic parallels see Christopher Pinney, 'Notes from the Surface of the Image', in Christopher Pinney and Nicolas Peterson, eds, *Photography's Other Histories* (Durham, NC, 2003).

45 Peter Van der Veer, *Religious Nationalism: Hindus and Muslims in India* (Berkeley, 1994).

46 Translation by Sri Aurobindo, from the BJP home page (www.bjp.org/vande.html)

47 See Kajri Jain's brilliant *Gods in the Bazaar* (forthcoming). The erotic density of Nathdvara//bhakti is much more marked and systematic than in Tamil language devotion. Sumathi Ramaswamy, *Passions of the Tongue: Language Devotion in Tamil India, 1891–1970* (Berkeley, 1997), 114ff.

48 Paul Gilroy, *There Ain't No Black in the Union Jack* (London, 1987), p. 160.
49 Umberto Eco, 'Critique of the Image', *Thinking Photography*, ed. V. Burgin (London, 1982), p. 38.
50 In the archive maintained by his son Anandalalji in Udaipur, to whom thanks.
51 In fact its bovine physiognomy suggests a buffalo, a animal deemed less 'communal' by the colonial state.
52 Partha Chatterjee, *Nation and its Fragments*; Pinney, 'The Nation (Un)pictured? Chromolithography and "Popular" Politics in India, 1878–1995', *Critical Inquiry*, xxiii/4 (1997), pp. 834–67.
53 I draw here also on Sandy Freitag's implicit critique of Habermasian cognitivism through her stress on the performative domain of the procession, and Raminder Kaur's brilliant development of this in the context of Ganesh Chaturthi in Bombay: *Performative Politics and the Cultures of Hinduism: Public Uses of Religion in India* (Delhi, 2003).
54 Vladislav Todorov, cited by Alla Efimova, 'To Touch on the Raw', *Art Journal* (Spring 1997), pp. 72–80.
55 Sumit Sarkar, *Modern India: 1885–1947* (Basingstoke, 2nd edn, 1989), p. 182.
56 This transformation can perhaps be most clearly seen in the varied responses to the poetry of Ossian, which was initially presented to the public (in 1760) as the authentic voice of a Gaelic bard, but which was soon revealed to be the work of the writer James McPherson. Ossian commentaries increasingly sidestepped the question of falsity/veracity, choosing instead to stress its 'authenticity'. The question of authorship ceased to be important: Ossian had spoken and its performative and illocutionary force was at the service of a national figure (see Malcolm Chapman, *The Gaelic Vision and Scottish Culture*, London, 1978, pp. 29–52).

6 THE POLITICS OF POPULAR IMAGES: FROM COW PROTECTION TO M. K. GANDHI, 1890–1950

1 A. E. Mills, H. Brackenbury, C. B. Pritchard, J. Westland and A. P. MacDonnell.
2 Memo dated 27 December 1893. IOR. L/P & J/6/365, file 84, p. 4.
3 Sandria B. Freitag, *Religious Rites and Riots: From Community Identity to Communalism in North India, 1870–1940*, PhD diss., University of California, Berkeley (Ann Arbor, 1980), p. 126.
4 *Ibid.*, p. 139.
5 Freitag (*Religious Rites*, p. 128) notes a report from *Dinkar Prakash* describing how at a meeting organized by the Cow Protection Society of Lucknow 'an image of Jesus Christ suspended by the neck' was displayed and it was said that 'the image was that of the God of the Christians who was struck with shoes and who was the son of an unchaste woman . . .'.
6 Freitag, *Religious Rites*, pp. 127–8.
7 J. N. Farquhar, *Modern Religious Movements in India* (London, 1924), p. 111.
8 Anand A. Yang, 'Sacred Symbol and Sacred Space in Rural India: Community Mobilization in the "Anti-Cow Killing" Riot of 1893', *Comparative Studies in Society and History*, XXII/4 (1980), p. 582.
9 *Ibid.*, p. 587.
10 I have in mind, for instance, the inscription of sacred sites in disputed land through the overnight construction of temples. These interventions or colonizations then inscribe the inviolability of the area. An example of this strategy was recently reported in the Indian press: a discontented resident arranged for an image of Shiv to be painted against an external wall on which passers-by habitually urinated; the nuisance then ceased.
11 Arjun Appadurai, 'The Production of Locality', *Counterworks*, ed. R.

Fardon (London, 1995), p. 208.
12 S. N. Joshi, *Half-Tone Reprints of the Renowned Pictures of the Late Raja Ravivarma* (Poona, 1911), pl. 41.
13 Joshi's caption reads: 'Yashoda, Krishna's mother, is milking a cow and little Krishna approaching from behind is demanding his little share of the fresh milk'.
14 File 84 for 1894 dated 27 October 1893.
15 'Note on the Cow-Protection Agitation in the Gorakhpur District', 1894, IOR, file 84, pp. 1–2. See Freitag, *Religious Rites*, pp. 130–31.
16 The putative equality and community of the ethnicized milk-drinkers in the early cow mother images was split by the hierarchizing and communal strategies of early cow protection agitators. In the 1960s a calendar image by Sapan Studio re-appropriates the image in the cause of national integration, a dominant theme of calendar art of the time. The image (in the collection of Patricia Uberoi) shows a cow from whose udders come streams of milk. These find their way to four representations of the Hindu, Muslim, Christian and Sikh religion, whose identity is caricatured in their clothing and echoed by the religious buildings depicted behind them (temple, mosque, church and gurudwara). The caption reads *desh dharma ka nata hai. gay hamari mata hai* ('the nation is the ally of religion. The cow is our mother').
17 In this respect the otherwise absurd comments by the Church Missionary Society compiler of the Ashmolean collection of Calcutta Art Studio lithographs (see chapter 2) were perhaps correct.
18 Freitag, *Religious Rites*, p. 134.
19 See N. Gerald Barrier, *Banned: Controversial Literature and Political Control in British India 1907–1947* (Columbia, MO, 1974), p. 46, and Graham Shaw and Mary Lloyd, eds, *Publications Proscribed by the Government of India: A Catalogue of the Collections in the India Office Library and Records and the Department of Oriental Manuscripts and Printed Books, British Library Reference Division* (London, 1985), p. viii.
20 Partha Mitter, *Art and Nationalism in Colonial India 1850–1922* (Cambridge, 1994), p. 212. Mitter notes that an agreement to sell the Press was reached in 1901, but that the formal handover did not occur until November 1903 (p. 213).
21 National Archives, Delhi, file no. 7–13/May 1912, B, Home Pol. I am deeply indebted to Charu Gupta for her help with this.
22 The Ashmolean Museum, Oxford, has a close copy of the Ravi Varma Press print produced by a rival (anonymous) publisher.
23 Notification by E. A. deBrett, Chief Secretary to the Chief Commissioner, central Provinces, Nagpur, 23 January 1912. National Archives of India, file no. 86-104/February 1912, B, Home Pol. My thanks again to Charu Gupta.
24 Schleicher's intervention might be considered a perfect example of 'capitalist realism', and the politics of this German in India just before the First World War can only be guessed at. We do not know what the relation was between Schleicher and the artists and block-makers (such as M. V. Dhurandar and D. G. Phalke).
25 Barrier notes that the government 'almost banned' the picture but 'finally backed away because the item had circulated for almost a year and was not overtly antagonistic to Muslims'. A note in the file on the image concluded that 'we tolerate the agitation as long as it does not become too violent, and I should not describe the picture as a particularly violent manifestation of it' (cited in Barrier, *Banned*, p. 61).
26 John Hutchinson, 'Cultural Nationalism and Moral Regeneration', excerpted in *Nationalism*, ed. John Hutchinson and A. D. Smith (Oxford, 1994), p. 123.
27 Dan Sperber, *On Symbolism* (Cambridge, 1974), where he uses the term in relation to anthropologists' (misguided) attempts to analyse the meanings of symbolic and ritual action.
28 National Archives of India, Home Pol. 1909 110-117A, p. 7

29 *Ibid.*, p. 8.

30 For example, No.11661-2-S.B., of 17 February 1931, ordered to be fore-feited every copy, wherever found, of a picture entitled 'Struggle for Swarajya' depicting: soldiers with a canon and rifles, representing the Bureaucracy; a ditch in which several leaders are immersed, representing jail; a portion of the ditch in which several people are immersed, representing bloodshed; policemen beating and arresting congressmen who are shown as preaching the boycott of liquor and foreign cloth . . .

31 National Archives of India, Home Pol. April 1910 36-39A, p. 3.

32 This summary comes from David Carroll's excellent account, *Paraesthetics* (New York, 1987), p. 31.

33 *Sedition Committee Report* [aka Rowlatt Report] (Calcutta, 1918), p. 32.

34 Partha Chatterjee, *The Nation and its Fragments: Colonial and Post-Colonial Histories* (New Delhi, 1995), p. 65.

35 *Sedition Committee*, p. 6.

36 N. C. Kelkar, *Full and Authentic Report of the Tilak Trial (1908) being the Only Authorised verbatim Account of the Whole Proceedings with Introduction and Character Sketch of Bal Gangadhar Tilak Together with Press Opinion* (Poona, 1908), p. 4.

37 For a general account of the trial and its wider context see the Soviet historian A. I. Chicherov's 'Tilak's Trial and the Bombay Political Strike of 1908', in I. M. Reisner and N. M. Goldberg, eds, *Tilak and the Struggle for Indian Freedom* (Delhi, 1966), pp. 545–626.

38 Kelkar, *Full and Authentic*, Exhibit D.

39 Kelkar, *Full and Authentic*, 'Judge's Summing Up', p. 12.

40 Shridhar Ganesh Vaze, *The Arya-Bhushan School Dictionary Marathi-English* (Poona, 1928), pp. 206, 443, 263. (Appropriately this is published by the Arhya-Bhushan Press, founded by Chiplunkar).

41 Cited by Barrier, *Banned*, p. 16.

42 Letter dated 11 December 1908 from Gupte to Risley in the Royal Anthropological Institute Photographic Collection, London.

43 The Calcutta Art Studio in Bowbazar Street still had copies of these prints for sale in 1996.

44 Strangely, Gupte did not mention what Partha Mitter describes as 'the hidden message in its colour symbolism of the black goddess dominating a supine white-skinned Siva' (*Art and Nationalism*, caption to colour pl. XII).

45 See B. A. Gupte, *Hindu Holidays and Ceremonials* (Calcutta, 1916), p. xliii, for a letter from Risley written in February 1910 in which he notes his exhaustion as a result of his work on the Press Bill, and his concession that 'Whatever credit I have gained in Europe in the departments of Ethnology and Archaeology is, I feel, due in large measure to your indefatigable industry and careful judgement in furnishing me with materials and in drawing attention to the points of importance.'

46 Cited by Ashish Rajadhyaksha, 'The Phalke Era: Conflict of Traditional Form and Modern Technology', *Journal of Arts and Ideas*, XIV–XV (1987), p. 48.

47 Peter Heehs, *India's Freedom Struggle* (Delhi, 1988), p. 105.

48 British Library India Office Records (henceforth BL-IOR), PP Hin F-10

49 See *Terrorism in India 1917–1936*, Intelligence Bureau, Home Department, Government of India (Simla, 1937), pp. 73ff for details of HSRA.

50 *Terrorism*, p. 78.

51 cf. www.india50.com/speech.html

52 cf. www.tamilnation.org/vp/vp94velicham.html

53 *Indian Express*, 25 November 1998 (www.indian-express.com/ie/daily/19981125/32951584.html)

54 One interesting study also indicates his popularity in Saurasthra (Gujarat). Cf. Peter Maddock, 'Idolatry in Western Saurasthra: A Case Study of Social Change and Proto-Modern Revolution in Art', *South Asia*, XVI (1993), pp. 101–26.

55 Sumit Sarkar, *Modern India: 1885–1947* (Basingstoke, 2nd edn, 1989), p. 268.

56 Bhagat Singh, *A Martyr's Notebook: Notes and Extracts from Books Read by Shaheed Bhagat Singh during his Prison Days, 1929–31*, ed. Bhupendra Hooja (Jaipur, 1994).

57 Bhagat Singh is quoted: 'I am really ashamed and am prepared to tell you frankly that I removed my hair and beard under pressing circumstances. It was for the service of the country that my companions compelled me to give up the Sikh appearance …'. Randhir Singh concludes: 'I was glad to see Bhagat Singh repentant and humble in his present attitude towards religious symbols'. *Autobiography of Bhai Sahib Randhir Singh*, trans. Trilochan Singh (Ludhiana, n.d), p. 422.

58 G. S. Deol –*Shaheed Bhagat Singh: A Biography* (Patiala, 1969), p. 35 – notes that Bhagat 'got himself shaved, and borrowed a good woollen suit and hat from a friend'; S. R. Bakshi – *Bhagat Singh and his Ideology* (New Delhi, 1981) – notes that 'Bhagat Singh was wearing a felt hat and an English style suit. He was quite unrecognisable in those clothes'.

59 J. N. Sanyal, *Sardar Bhagat Singh*, cited by Simeran Gell, 'L'Inde aux deux visages: Dalip Singh et le Mahatma Gandhi', *Terrain*, 31 (September 1998), p. 20.

60 K. K. Khullar, *Shaheed Bhagat Singh* (New Delhi, 1981), p. 47.

61 Manmathnath Gupta, *Bhagat Singh and his Times* (Delhi, 1977), p. 145.

62 Simeran Gell, 'L'Inde aux deux visages', citation from author's own English original ms., p. 1.

63 Simeran Gell, 'L'Inde aux deux visages', ms., p. 22.

64 The current epoch. The notion of modernity as the basest of the four *yugs* continues to have great saliency in rural north India.

65 Homi K. Bhabha, *The Location of Culture* (London, 1994), pp. 85–92.

66 Interview with Kamal Kapoor, Mathura (1996).

67 All four images described here were published by Shyam Sunder Lal, Cawnpur.

68 For instance, Bhagat Singh's portrait was reproduced in the centre of the front page of *The Tribune* [Lahore] for Wednesday 25 March 1931 under the headline 'Bhagat Singh, Rajguru and Sukhdev Executed'.

69 See National Archives of India, Home Pol. 1930 28A, pp. 284–284A and photographic annexures.

70 National Archives of India, KW to 159/1931, pp. 1–10.

71 I am indebted to Vinay K. Srivastava for translating this.

72 Proscribed originally by the United Provinces No. 2887/VIII-1340, dated 3 October 1931.

73 Umberto Eco, 'Critique of the Image', *Thinking Photography*, ed. V. Burgin (London, 1982), p. 38.

74 Interview, Meerut, 2 December 1999.

75 See chapter 7.

76 See illus. 82 and 83.

77 Shahid Amin, 'Gandhi as Mahatma: Gorakhpur District, Eastern UP, 1921–2', in Ranajit Guha, ed., *Subaltern Studies III: Writings on South Asian History and Society* (Delhi, 1989), pp. 3–4, 2.

78 *Ibid.*, p. 2; cf. also his *Event, Metaphor, Memory: Chauri Chaura 1922–1992* (Berkeley, 1995), p. 167.

79 Shahid Amin, 'Gandhi as Mahatma', p. 55.

80 Mohandas K. Gandhi, *India's Case for Swaraj: Being Selected Speeches, Writings, Interviews, Etcetera of Mahatma Gandhi in 1931*, ed. Wamn P. Kabadi (Bombay, n.d.), pl. opposite p. 16.

81 These were purchased by the author in Ujjain in the mid-1990s from a framing shop whose proprietor believed them to have come from the town of Mhow.

82 Though see the earlier example of *Bharat Uddhar* (illus. 84).

83 Margaret Bourke-White, *Interview with India* (London, 1951), pp. 191–2.

84 The Nehru Memorial Library, Delhi, has an image depicting all these figures in conversation during the immolation (neg. NML 27943).

85 Ashis Nandy, *The Intimate Enemy* (Delhi, 1983), pp. 49–51.

86 Subsequently the template is applied to improbable figures such as Nehru and Indira Gandhi. The Mahatma's aura seems to have provoked the first use of this structure, and once established it was pirated for others to whom it was less obviously suited.

87 Ranajit Guha, *Elementary Aspects of Peasant Insurgency in Colonial India* (Delhi, 1983), p. 335.

7 HALF-SEEN IN ADVANCE: PICTURE PRODUCTION IN INDEPENDENT INDIA, 1950–2000

1 Paul R. Brass, *The New Cambridge History of India*, VI/1: *The Politics of India since Independence* (Cambridge, 1990), pp. 36ff.

2 Cited in Sunil Khilnani, *The Idea of India* (London, 1998), p. xix.

3 Brass, *Politics of India*, p. 22.

4 Interview with Hemant Mehra, Bombay, October 1996.

5 Beverley Nichols, *Verdict on India* (London, 1944), p. 109.

6 *Ibid.*, p. 111.

7 In the course of two interviews (1991 and 1994), Bhanwarlal vouchsafed the following dates for his major Sharma Picture Publications images: 1955 Divali Pujan (the press's first print); Shankar Parvati Ganesh; Saraswati; 1956 Ganesh Mahima (Ridhi Sidhi); Dattatraya Puja; Sita Varamala; Dip Laksmi; 1957 Paravati Varamala; Shiv Shakti; 1958 Shiv Shambu; 1960 Kaliya Mardan; 1961 Kaushalaya Putra Ram; 1962 Sindhi figure on fish; Shri Gayatri; 1966 Ram Bhakt Hanuman; 1970 Shravan Kumar; two different Rama images.

8 They can also be contrasted with two definitely dated images in Bhanwarlal's own museum: a pair of 1949 images of Radhakrishna, and a 1951 Shiv and Parvati.

9 When I first interviewed him he confirmed the publisher M. L. Garg's recollection that he (Garg) had commissioned a painting by L. N. Sharma based on B. G. Sharma's popular design of the goddess in 1964. When I interviewed him in 1994 he noted that he had only completed his painting in the mid-1970s at about the same time that the film *Jai Santoshi Ma* was released.

10 cf. John D. Smith, *The Epic of Pabuji: A Study, Transcription and Translation* (Cambridge, 1991), and O. P. Joshi, *Painted Folklore and Painters of India: A Study with Reference to Rajasthan* (Delhi, 1976).

11 David Batchelor, *Chromophobia* (London, 2000).

12 See Alfred Gell, *Art and Agency* (Oxford, 1998), p. x.

13 Not to be confused with the older Narottam Narayan of the Jangir subcaste.

14 As were Nanumal Riayatmal & Co. ('Picture Publishers, Sukker, Sind'), whose print of Shiv by 'A.H.B. Nathdwara, Mewar' is in the author's collection.

15 i.e. for 'Laksminarayan Khubiram'.

16 i.e. an aesthetics predicated on the conventions of Bombay's commercial film industry.

17 See Kajri Jain, *Gods in the Bazaar* (forthcoming).

18 For an excellent discussion of calendars, see Kajri Jain, 'Producing the Sacred: The Subjects of Calendar Art', *Journal of Arts and Ideas*, XXX–XXXI (1997), pp. 63–88.

19 Stephen R. Inglis, 'Suitable for Framing: The Work of a Modern Master', *Media and the Transformation of Religion in South Asia*, ed. Lawrence A. Babb and Susan Wadley (Philadelphia, 1995), p. 62.

20 Inglis, 'Suitable for Framing', p. 59.

21 While I lack the south Indian language skills to investigate some key sources in the history of the industry in the south, I have visited J. B. Khanna in Madras twice and visited nearly all the major producers in Sivakasi. Despite this I retain my sense of the cultural dominance of

northern picture production.

22 cf. Fritz Kramer, *The Red Fez: Art and Spirit Possession in Africa* (London, 1993), pp. 226–8. Kramer also reproduces a photograph by Tobias Wendl of a *mami-wata* altar in Togo in which a framed print of Narottam Narayan's *Kailash Pati Shankar* can be seen (p. 238).

23 Henry John Drewal, 'Mermaids, Mirrors, and Snake Charmers: Igbo Mami Wata Shrines', *African Arts*, 21/2 (1988), p. 45.

24 cf. Henry John Drewal, 'Performing the Other: Mami Wata Worship in Africa', *Tulane Drama Review*, XXXII/2 (Summer 1988), pp. 160–85, and Dana Rush, 'Chromolithographs in Vodunland', *African Arts*, XXXII/4 (1999), pp. 60–75.

25 This point is made by Brian Larkin, 'Indian Films and Nigerian Lovers: Media and the Creation of Parallel Modernities', *Africa*, LXVII/3 (1997), p. 407. Other parts of this global imagescape are now starting to engage the 'West'. This account has focused on one half of a reciprocal movement that is still unfolding. It has traced the introduction and translation of a colonial mimesis, and its complex afterlife. A subsequent study might document the current complementary reverse movement through which the visual forms that resulted are being re-exported to a wider world. Some of these movements, such as the occasional residencies by Nathdvara artists at the International Society for Krishna Consciousness's New York offices, are mirror inversions of the conversional projects of nineteenth-century Government Art Schools in India: ISKON now uses their imagery as part of its desire to redeem a deficient west. But translational slippage also gives rise to new, twice-hybridized, forms such as the the artwork of Luigi Ontani, Francesco Clemente, the photography of Pierre et Gilles, MTV logos, and the art work for Krishna Beat CDs that draw upon a refracted Nathdvara aesthetic. Re-exported from India the hybrid aesthetic with which this book is concerned operates within a new field of cultural dislocation. Whether it will succumb to the force of commodity flows, or operate as a source of aesthetic and cultural transformation, is still undecided.

26 See also line drawings in M. S. Golwalkar, *Bunch of Thoughts* (Bangalore, 1966), facing p. xxxiv and p. 414.

27 Arvind Rajagopal, *Politics after Television: Hindu Nationalism and the Reshaping of the Indian Public* (Cambridge, 2001), p. 58.

28 R. K. Narayan, *The Painter of Signs* (Harmondsworth, 1976, rev. 1982), p. 27.

29 In September 1965 a cessation was declared in an undeclared war between India and Pakistan and one month later, after continuing ceasefire violations by Pakistan, Shastri gave a speech warning the nation that it could not afford to relax; see *Selected Speeches of Lal Bahadur Shastri* (Delhi,1964), pp. 349–50.

30 A former actor and the director of *Roti, Kapada aur Makan* (Bread, Cloth and Shelter, 1974) which was also the title of a Rastogi image, and *Shaheed*, 1965, a biopic of Bhagat Singh.

31 See Sudhir Kakar, 'The Ties that Bind: Family Relationships in the Mythology of Hindi Cinema', *India International Centre Quarterly*, VIII (1981), and Christopher Pinney, *Camera Indica: The Social Life of Indian Photographs* (London, 1997), p. 194.

32 Jain, 'Producing the Sacred', p. 78.

33 On Rastogi see also Gayatri Sinha, 'Behind a Million Images', *The Hindu*, 12 February 1999.

34 This is a fascinating development from an earlier image depicting a British soldier with a lathi. Raja's later images transform this figure into a mythical figure of evil.

35 Fredric Jameson, 'Reification and Utopia in Mass Culture', *Social Text*, 1 (1979), pp. 130–48.

36 Jonathan P. Parry, 'The Technology of the Intellect', *Reason and Morality*, ed. Joanna Overing (London, 1985).

37 Richard Widdess, 'Aspects of Form in North Indian alap and dhru-
pad', *Music and Tradition: Essays in Asian and other Musics Presented to
Lawrence Picken*, ed. Richard Widdess and R. F. Wolpert (Cambridge,
1981), p. 168. This parallel could also stress the affinity between Raja's
pastiche and *chhotaa khyaal* in which melodic repetition has a central
importance.
38 Widdess, 'Aspects of Form', pp. 155, 159.
39 Michael Fried, *Absorption and Theatricality: Painting and Beholder in the
Age of Diderot* (Chicago, 1980), p. 4.

8 WHAT PICTURES WANT NOW: RURAL CONSUMERS OF IMAGES, 1980–2000

1 I surveyed 117 households in October/November 1993 and
March/April 1994 and counted a total of 810 images, giving an average
of 6.9 images per household. As is clear from the following figures,
my sample can only be taken as a statistically significant guide to the
practices of Rajputs (a high caste group who were traditionally war-
riors) and Chamars (an Untouchable or Scheduled Caste who were
traditionally tanners). I recorded data on 32 and 28 households respec-
tively, providing a reasonable comparative base for these two jatis,
which lie near the top and the bottom of the local caste hierarchy. My
next largest sample was of Scheduled Caste Bagdi households (10), fol-
lowed by Brahmans (8). All the other caste samples consist of lower
numbers and a full seven consist of only one household. In isolation
these clearly generate statistically insignificant numbers, but collec-
tively do provide useful indicators. It should also be noted that the
data provides, in some instances, complete samples (there are, for
example, only one Bhangi, one Lohar and only two Bargunda house-
holds in the whole village). The following list is arranged by average
number of images by *jati* and gives the size of the sample for each *jati*
in parentheses. It should be noted in this connection that there were
individual Brahman, Jain, Gosain, Banjara and Chamar households
who had equal or larger numbers of images than the sole Bhangi
household that heads the list: Bhangi 16 (1); Lohar 14 (1); Darzi 14 (1);
Bairagi 14 (1); Banjara 12 (4); Jain 12 (3); Gosain 11.3 (3); Gujar 10 (4);
Bargunda 9 (2); Nai 9 (2); Kumhar 8 (3); Mina 7 (3); Teli 7 (1); Brahman
6.4 (8); Chamar 6.4 (28); Rajput 6.3 (32); Sutar 6 (1); Muslim 5 (2); Gari
4 (1); Mukati 3 (5); Bagdi 3 (10).
2 This group is also sometimes described as 'Untouchabled', 'ex-
Untouchable', 'Harijan' or 'Dalit'. Scheduled Caste is the administra-
tive term and derives from a list of oppressed groups appended as
'schedule' to the 1935 Government of India Act.
3 Notionally a Scheduled Tribe.
4 cf. Christopher Pinney, *Camera Indica: The Social Life of Indian Photographs*
(London, 1997), p. 144.
5 Sweepers, and removers of what is usually euphemistically referred to
as 'nightsoil' (human excrement).
6 Literally 'middle', metaphorically, 'low'.
7 cf. Pinney, *Camera Indica*, pp. 164–5.
8 cf. *ibid.*, pp. 153–4.
9 cf. the frontispiece to R. S. Khare, *The Untouchable as Himself: Ideology,
Identity, and Pragmatism among the Lucknow Chamars* (Cambridge, 1984),
for a good example of the kind of wall-painted image of Ambedkar to
be found in many of India's public spaces.
10 Lawrence A. Babb, 'Glancing: Visual Interaction in Hinduism', *Journal
of Anthropological Research*, XXXVII/4 (1981), p. 400.
11 Khare, *Untouchable as Himself*, p. 42.
12 Specifically, he 'collected alms in the form of uncooked food … from
a Bania shopkeeper who kept business relations … with a Chamar'.

Khare, *Untouchable as Himself*, p. 43.
13 *Us madhya mem shri ramdevji maharaja ne kiya vahi updesh aur vahi marg is
bisavin shatabdi mahatma gandhi ne kiya.* Swami Mahatma Gokuldasji
Maharaja, *Shri Ramdevji Maharaja ke Jama Jagaran Vidhi* (Ajmer, n.d.),
p. 10 of preface.
14 However, note that there are no images depicting Shitala as a central
deity. Images of her astride a donkey appear to circulate only within
Bengal.
15 Brian Friel, *Translations* (London, 1981), p. 42.
16 This recalls Diane Losche's suggestion that to ask the Abelam of
Papua New Guinea about the way their images 'look' is as meaningful
as asking a EuroAmerican what their refrigerator 'means'. Diana
Losche, 'The Sepik Gaze: Iconographic Interpretations of Abelam
Form', *Social Analysis*, XXXIX (1995), pp. 47–60.
17 Diana L. Eck, *Darśan: Seeing the Divine Image in India* (Chambersburg,
PA, 1981), p. 5.
18 See also Michael Taussig, *Mimesis and Alterity: A Particular History of the
Senses* (New York, 1993), p. 21.
19 Walter Benjamin, 'The Work of Art in the Age of Mechanical
Reproduction', *Illuminations* (London, 1992), p. 217.
20 Taussig, *Mimesis and Alterity*, p. 24.
21 Cited by Benjamin, 'The Work of Art', p. 211.
22 As is implied by Richard Davis in his excellent *The Lives of Indian Images*
(Princeton, NJ, 1997), p. 265, n.5.
23 Maurice Merleau-Ponty, *Phenomenology of Perception*, trans. Colin Smith
(London, 1962), p. 93.
24 *Ibid.*, pp. 134–5.
25 cf. Lawrence Babb's detailed analysis in 'Glancing'.
26 This corpothetics is often reinscribed as the owner traces the journey
either with his eyes or his fingers as she or he recalls the journey.
Bhavaralal Ravidas pointed out various parts of his Pavagadh image,
'there is a temple here that you can't visit because there's a tiger living
near the path'.
27 cf. Pinney, *Camera Indica*, p. 171.
28 In the local Malwi dialect this is referred to as *paraba*, in Hindi as
visarjan.
29 Carlo Ginzburg, 'Clues: Morelli, Freud, and Sherlock Holmes', *The Sign
of Three: Dupin, Holmes, Peirce*, ed. Umberto Eco and Thomas A. Sebeok
(Bloomington, IN, 1988).

EPILOGUE: THE RECURSIVE ARCHIVE

1 Sheldon Pollock, 'Ramayana and Political Imagination in India', *Journal
of Asian Studies*, LII/2 (May 1993), p. 292.
2 Carlo Ginzburg, 'From Aby Warburg to E.H. Gombrich: A Problem of
Method', in *Clues, Myths and the Historical Method* (Baltimore, 1989), p.
35.
3 See W. J. T. Mitchell, 'What do Pictures *Really* Want?', *October*, 77 (1996),
and my discussion of this in the Introduction.
4 Tapan Basu *et al.*, *Khaki Shorts and Saffron Flags: A Critique of the Hindu
Right* (New Delhi, 1993), p. 60.
5 i.e. images depicting Ram with the proposed new Jamnabhumi
temple.
6 *The Legend of Bhagat Singh*; *23rd March 1931 – Shaheed*; *Shaheed Bhagat
Singh*; and *Shaheed-e-Azam*.
7 In which two of the central (cricketing) characters are, respectively, an
Untouchable and a Muslim.
8 Ashish Rajadhyaksha and Paul Willeman record P. V. Pathy's *Mahatma
Gandhi* (1948) and Vithalbhai Jhaveri's *Mahatma: Life of Gandhi* (1968),
but these were both documentaries (*Encyclopedia of Indian Cinema*,

Delhi, 1994, pp. 160, 368).

9 Rajagopal, *Politics after Television*, p. 25.

10 *Ibid.*, p. 153.

11 *Ibid.*, p. 25.

12 Houston Baker, *Modernism and the Harlem Renaissance* (Chicago, 1987),
 p. 56, cited by Homi Bhabha, 'Conclusion: "Race", Time and the
 Revision of Modernity', *The Location of Culture* (London, 1994), p. 241.

13 Benedict Anderson, *Imagined Communities: Reflections on the Origins and
 Spread of Nationalism* (London, 2nd edn, 1991), p. 36.

14 Anuradha Kapur, 'Deity to Crusader', in Gyanendra Pandey, ed.,
 Hindus and Others: The Question of Identity in India Today (New Delhi,
 1993)

15 Roland Barthes, 'The Death of the Author', *Image-Music-Text*, trans.
 Stephen Heath (London, 1977), p. 148.

16 For a brilliant analysis of the Hindu right's exploitation of new media,
 and the resonances with an earlier image repertoire, see Christiane
 Brosius, 'Empowering Visions: A Study on Videos and the Politics of
 Cultural Nationalism in India (1989–1998)', unpublished dissertation
 submitted to the Europa-Universität Viadrina Frankfurt (Oder), 1999.

17 Roland Barthes, 'The Metaphor of the Eye', appended to Georges
 Bataille, *Story of the Eye* (Harmondsworth, 1982), p. 119.

18 Conversation with Ravi Agrawal, March 1994. As will be evident this
 conversation was in English.

19 As a plate in *Voyage à Athènes et à Constantinople, ou Collection de portraits,
 des vues et des costume grecs et ottomans* (Paris, 1825).

20 Thanks to Rachel Dwyer for showing me examples in her collection.

21 'Blast Force', *India Today*, 19 August 2002, p. 16.

select bibliography

Ambalal, Amit, *Krishna as Shrinathji: Rajasthani Paintings from Nathdvara* (Ahmedabad, 1987)

Amin, Shahid, *Event, Metaphor, Memory: Chauri Chaura 1922–1992* (Berkeley, 1995)

—, 'Gandhi as Mahatma: Gorakhpur District, Eastern UP, 1921-2', in *Subaltern Studies III: Writings on South Asian History and Society*, ed. Ranajit Guha (Delhi, 1989), pp. 1–61

Anderson, Benedict, *Imagined Communities: Reflections on the Origins and Spread of Nationalism* (London, 2nd edn, 1991)

Appadurai, Arjun, 'The Production of Locality', *Counterworks: Managing the Diversity of Knowledge*, ed. R. Fardon (London, 1995)

—, Frank J. Korom and Margaret A. Mills, eds, *Gender, Genre and Power in South Asian Expressive Traditions* (Philadelphia, 1991)

Apte, Madhav L., ed., *Mass Culture, Language and Arts in India* (Bombay, 1978)

Archer, Mildred, and Ronald Lightbown, *India Observed: India as Viewed by British Artists 1760–1860* (London, 1982)

Archer, W. G., *Bazaar Paintings of Calcutta* (London, 1953)

Attali, Jacques, *Noise: The Political Economy of Music* (Minnesota, 1985)

Babb, Lawrence A., 'Glancing: Visual Interaction in Hinduism', *Journal of Anthropological Research*, XXXVII/4 (1981), pp. 378–410

Bae, James H., *In a World of Gods and Goddesses: The Mystic Art of Indra Sharma* (San Rafael, CA, n.d.)

Baker, Henry D., *British India, with Notes on Ceylon, Afghanistan, and Tibet*, Special Consular Reports no. 72, Bureau of Foreign and Domestic Commerce (Washington, DC, 1915)

Banarjee, Sumanta, *The Parlour and the Streets: Elite and Popular Culture in Nineteenth Century Calcutta* (Calcutta, 1989)

Barnouw, Erik, and S. Krishnaswamy, *Indian Film* (New York, 1963)

Barrier, N. Gerald, *Banned: Controversial Literature and Political Control in British India 1907–1947* (Columbia, MO, 1974)

Barthes, Roland, 'The Metaphor of the Eye', appended to Georges Bataille, *Story of the Eye* (Harmondsworth, 1982)

Basu, Tapan, et al., *Khaki Shorts and Saffron Flags: A Critique of the Hindu Right* (New Delhi, 1993)

Batchelor, David, *Chromophobia* (London, 2000)

Bayly, C. A., ed., *The Raj: India and the British 1600–1947* (London, 1990)

Behere, N. K., *The Background of the Maratha Renaissance in the 17th Century* (Bangalore, 1946)

Belting, Hans, *Likeness and Presence* (Chicago, 1994)

Benjamin, Walter, 'The Work of Art in the Age of Mechanical Reproduction', in *Illuminations*, trans. Harry Zohn (London, 1992), pp. 211–44

Berger, John, *Ways of Seeing* (London, 1972)

Bhabha, Homi K., *The Location of Culture* (London, 1994)

Bourke-White, Margaret, *Interview with India* (London, 1951)

Brass, Paul R., *The New Cambridge History of India*, VI/1: *The Politics of India since Independence* (Cambridge, 1990)

Brosius, Christiane, 'Empowering Visions: A Study on Videos and the Politics of Cultural Nationalism in India (1989–1998)', diss., Europa-Universität Viadrina, Frankfurt [Oder], 1999

Bryson, Norman, *Vision and Painting: The Logic of the Gaze* (Cambridge, 1983)

Buck-Morss, Susan, 'Aesthetics and Anaesthetics: Walter Benjamin's Artwork Essay Reconsidered', *October*, 62 (1992), pp. 3–41

Carroll, David, *Paraesthetics: Foucault, Lyotard, Derrida* (New York, 1987)

Cashman, Richard, *The Myth of the Lokmanya* (Berkeley, 1975)

Chaitanya, Krishna, *Ravi Varma* (Delhi, 1984)

Chandra, Bipan, *India's Struggle for Independence* (New Delhi, 1987)

Chatterjee, Partha, *The Nation and its Fragments: Colonial and Post-Colonial Histories* (New Delhi, 1995)

Chirol, Valentine, *Indian Unrest* (London, 1910)

Conway, Moncure Daniel, *My Pilgrimage to the Wise Men of the East* (London, 1906)

Dasi, Binodini, *My Story and My Life as an Actress*, ed. and trans. Rimli Bhattacharya (Delhi, 1998)

Davis, Richard, *The Lives of Indian Images* (Princeton, NJ, 1997)

Del Bonta, Robert J., 'Calendar Prints and Indian Tradition', *Shastric Traditions in Indian Arts*, ed. Anna Libera Dallapiccola (Stuttgart, 1989), I, pp. 453–79.

Deol, G. S., *Shaheed Bhagat Singh: A Biography* (Patialia, 1969)

Eaton, Natasha, 'Excess in the City?: The Consumption of Imported Prints in Colonial Calcutta, c. 1780–1795', *Journal of Material Culture* (March 2003), pp. 45–74.

Eck, Diana L., *Darśan: Seeing the Divine Image in India* (Chambersburg, PA, 1981)

Eco, Umberto, 'Critique of the Image', *Thinking Photography*, ed. V. Burgin (London, 1982), pp. 32–8

Efimova, Alla, 'To Touch on the Raw', *Art Journal* (Spring 1997), pp. 72–80

Entwistle, Alan W., *Braj: Centre of Krishna Pilgrimage* (Groningen, 1987)

Farquhar, J. N., *Modern Religious Movements in India* (London, 1924)

Fried, Michael, *Absorption and Theatricality: Painting and Beholder in the Age of Diderot* (Chicago, 1990)

Freitag, Sandria B., 'Visions of the Nation: Theorizing the Nexus between Creation, Consumption, and Participation in the Public Sphere', in *Pleasure and the Nation: The History, Politics and Consumption of Public Culture in India*, ed. Rachel Dwyer and Christopher Pinney (Delhi, 2000), pp. 35–77

—, 'Contesting in Public: Colonial Legacies and Contemporary Communalism', in *Making India Hindu: Religion, Community, and the Politics of Democracy in India*, ed. David Ludden (Delhi, 1996), pp. 211–34

—, 'Religious Rites and Riots: From Community Identity to Communalism in North India, 1870–1940', PhD diss., University of California, Berkeley, 1980

Ganachari, Aravind Gururao, 'The Contribution of Marathi Theatre to the Growth of Nationalism 1897–1913', *Proceedings of the Indian History Congress: 54th Session, Mysore, 1993* (New Delhi, 1994)

Gandhi, M. K., *An Autobiography, or The Story of my Experiments with Truth* (Ahmedabad, 1991 [1927])

Gell, Alfred, *Art and Agency* (Oxford, 1998)

Gell, Simeran, 'L'Inde aux deux visages: Dalip Singh et le Mahatma Gandhi', *Terrain*, 31 (September 1998), pp. 129–44

Ginzburg, Carlo, 'From Aby Warburg to E.H. Gombrich: A Problem of Method', *Clues, Myths and the Historical Method* (Baltimore, 1989), pp. 17–59

—, 'Clues: Morelli, Freud, and Sherlock Holmes', in *The Sign of Three: Dupin, Holmes, Peirce*, ed. Umberto Eco and Thomas A. Sebeok (Bloomington, IN, 1988), pp. 81–118

Groys, Boris, *The Total Art of Stalinism: Avant-Garde, Aesthetic Dictatorship, and Beyond* (Princeton, NJ, 1988)

Guha, Ranajit, *Dominance without Hegemony: History and Power in Colonial India* (Cambridge, MA, 1997)

—, *Elementary Aspects of Peasant Insurgency in Colonial India* (Delhi, 1983)

Guha-Thakurta, Tapati, *The Making of a New 'Indian' Art: Artists, Aesthetics and Nationalism in Bengal, c. 1850–1920* (Cambridge, 1992)

—, 'Westernisation and Tradition in South Indian Painting in the Nineteenth Century: The Case of Raja Ravi Varma (1848–1906)', *Studies in History*, n.s., II/2 (1986), pp. 165–95

Gupta, Mahendranath, *The Gospel of Sri Ramakrishna*, trans. Swami Nikhilananda (New York, 1984)

Gupta, Manmathnath, *Bhagat Singh and his Times* (Delhi, 1977)

Gutman, Judith Mara, *Through Indian Eyes* (New York, 1982)

Hansen, Thomas Blom, *The Saffron Wave: Democracy and Hindu Nationalism in Modern India* (Princeton, NJ, 1999).

Hawley, John Stratton, *At Play with Krishna: Pilgrimage Dramas from Brindavan* (Princeton, NJ, 1981)

Heehs, Peter, *The Bomb in Bengal: The Rise of Revolutionary Terrorism in India 1900–1910* (Delhi, 1993)

—, *India's Freedom Struggle: A Short History* (Delhi, 1988)

Heimsath, Charles H., *Indian Nationalism and Hindu Social Reform* (Princeton, NJ, 1964)

Inglis, Stephen R., 'Suitable for Framing: The Work of a Modern Master', *Media and the Transformation of Religion in South Asia*, ed. Lawrence A. Babb and Susan Wadley (Philadelphia, 1995), pp. 51-75

Jain, Kajri, *Gods in the Bazaar: The Economies of Indian Calendar Art* (Durham, NC, forthcoming)

—, 'Producing the Sacred: The Subjects of Calendar Art', *Journal of Arts and Ideas*, XXX–XXXI (1997), pp. 63–88

—, 'Of the "Everday" and the "National Pencil"', *Journal of Arts and Ideas*, XXVII–XXVIII (March 1995), pp. 57–90

Jameson, Fredric, *The Political Unconscious: Narrative as a Socially Symbolic Act* (London, 1983)

—, 'Reification and Utopia in Mass Culture', *Social Text*, I (1979), pp. 130–48

Jay, Martin, 'The Scopic Regimes of Modernity', *Vision and Visuality*, ed. Hal Foster (San Francisco, 1988), pp. 3–27

Johnson, Gordon, *Provincial Politics and Indian Nationalism: Bombay and the Indian National Congress* (Cambridge, 1973)

Joshi, O. P., *Gods of Heaven, Home of Gods* (Jaipur, 1994)

—, *Painted Folklore and Painters of India: A Study with Reference to Rajasthan* (Delhi, 1976)

Joshi, S.N., *Half-Tone Reprints of the Renowned Pictures of the Late Raja Ravivarma* (Poona, 1911)

Kanitkar, R. P., *Chitrashalecha Itihas 1878–1973* (Pune, 1975)

Kapur, Anuradha, 'Deity to Crusader', *Hindus and Others: The Question of Identity in India Today*, ed. Gyanendra Pandey (New Delhi, 1993), pp. 74–109

—, 'The Representation of Gods and Heroes: Parsi Mythological Drama of the Early Twentieth Century', *Journal of Arts and Ideas*, XXIII–XXIV (1993), pp. 85–107

Kapur, Geeta, 'Ravi Varma: Representational Dilemmas of a Nineteenth Century Indian Painter', *Journal of Arts and Ideas*, XVII–XVIII (1989), pp. 59–80

Karandikar, S. L., *The Rise and Fall of the Maratha Power*, I: *1620–1689 (Shahaji, Shivaji, Sambhaji)* (Pune, 1969)

Kaur, Raminder, *Performative Politics and the Cultures of Hinduism: Public Uses of Religion in India* (Delhi, 2003)

Kaviraj, Sudipta, *The Unhappy Consciousness: Bankimchandra Chattopadhyay and the Formation of Nationalist Discourse in India* (Delhi, 1995)

Kelkar, N. C., *Life and Times of Lokmanya Tilak* (Madras, 1928)

—, *Full and Authentic Report of the Tilak Trial (1908) being the Only Authorised verbatim Account of the Whole Proceedings with Introduction and Character Sketch of Bal Gangadhar Tilak Together with Press Opinion* (Poona, 1908)

—, *Vishnu Krishna Chiplunkar: A Sketch of his Life and Career* (Madras, n.d.)

Khare, R. S., *The Untouchable as Himself: Ideology, Identity, and Pragmatism among the Lucknow Chamars* (Cambridge, 1984)

Khilnani, Sunil, *The Idea of India* (London, 1998)

Khullar, K. K., *Shaheed Bhagat Singh* (New Delhi, 1981)

Kipling, Rudyard, *The City of Dreadful Night* (Leipzig, 1900)

Kramer, Fritz, *The Red Fez: Art and Spirit Possession in Africa* (London, 1993)

Krauss, Rosalind, 'Welcome to the Cultural Revolution', *October*, 77 (1996), pp. 83–96

Kris, Ernst, and Otto Kurz, *Legend, Myth, and Magic in the Image of the Artist: A Historical Experiment* (New Haven, CT, 1979)

Kulka, Tomas, *Kitsch and Art* (Pennsylvania, 1996)

Larkin, Brian, 'Indian Films and Nigerian Lovers: Media and the Creation of Parallel Modernities', *Africa*, LXVII/3 (1997), pp. 406–40

Lepowitz, Helena Waddy, *Images of Faith: Expressionism, Catholic Folk Art and the Industrial Revolution* (Athens, GA, 1991)

Losche, Diane, 'The Sepik Gaze: Iconographic Intrepretation of Abelam Form', *Social Analysis*, xxxviii (1995), pp. 47–60

Love, H. D., *Descriptive List of Pictures in Government House and the Banqueting Hall, Madras* (Madras, 1903)

Lutgendorf, Philip, *The Life of a Text* (Berkeley, 1991)

Lyons, Tryna, 'Women Artists of the Nathadwara School', *Representing the Body: Gender Issues in Indian Art*, ed. Vidya Dehejia (New Delhi, 1997), pp. 102–23

McLeod, W. H., *Popular Sikh Art* (Delhi, 1991)

Maduro, Renaldo, *Artistic Creativity in a Brahmin Painter Community* (Berkeley, 1976)

Merleau-Ponty, Maurice, *Phenomenology of Perception*, trans. Colin Smith (London, 1962)

Mitchell, W. J. T., 'What Do Pictures *Really* Want?', *October*, 77 (1996), pp. 71–82

Mitter, Partha, *Art and Nationalism in Colonial India 1850–1922* (Cambridge, 1994)

Morgan, David, *Visual Piety: A History and Theory of Popular Religious Images* (Berkeley, 1998)

Mukherjee, Meenakshi, *Realism and Reality: The Novel and Society in India* (Delhi, 1985, rev. 1994)

Mukherjee, Sushil Kumar, *The Story of the Calcutta Theatres 1753–1980* (Calcutta, 1982)

Nandakumar, R., 'The Missing Male: The Female Figures of Ravi Varma and the Concepts of Family, Marriage and Fatherhood in Nineteenth Century Kerala', *South Indian Studies*, 1 (January 1996), pp. 54–82

Nandy, Ashis, *The Intimate Enemy: Loss and Recovery of Self under Colonialism* (Delhi, 1983)

Nichols, Beverley, *Verdict on India* (London, 1944)

Nochlin, Linda, *Realism* (Harmondsworth, 1971)

Padfield, Rev. J. E., *The Hindu at Home, Being Sketches of Hindu Daily Life* (Madras, 1896)

Panofsky, Erwin, *Perspektive als symbolische Form* (Hamburg, 1927; Eng. trans., New York, 1991)

Parry, Jonathan P., 'The Technology of the Intellect', *Reason and Morality*, ed. Joanna Overing (London, 1985)

Paul, Ashit, ed., *Woodcut Prints of Nineteenth Century Calcutta* (Calcutta, 1983)

Pinney, Christopher, 'Notes from the Surface of the Image', *Photography's other Histories*, ed. Christopher Pinney and Nicolas Peterson (Durham, NC, 2003)

—, 'The Nation (Un)pictured? Chromolithography and "Popular" Politics in India, 1878–1995', *Critical Inquiry*, XXIII/4 (1997), pp. 834–67

—, *Camera Indica: The Social Life of Indian Photographs* (London, 1997)

—, 'Moral Topophilia: The Significations of Landscape in Indian Oleographs', *The Anthropology of the Landscape: Between Space and Place*, ed. E. Hirsch and M. O'Hanlon (Oxford, 1995), pp. 78–113

Pollock, Sheldon, 'Ramayana and Political Imagination in India', *Journal of Asian Studies*, LII/2 (May 1993), pp. 261–97

Purohit, Vinayak, *Arts of Transitional India*, II: *Twentieth Century* (Bombay, 1988)

Rajadhyaksha, Ashish, 'The Phalke Era: Conflict of Traditional Form and Modern Technology', *Journal of Arts and Ideas*, XIV–XV (1987), pp. 47–78

Rajadhyaksha, Ashish, and Paul Willeman, *Encyclopedia of Indian Cinema* (Delhi, 1994)

Rajagopal, Arvind, *Politics after Television: Hindu Nationalism and the Reshaping of the Indian Public* (Cambridge, 2001)

Ramachandran, T. M., ed., *70 Years of Indian Cinema (1913–1983)* (Bombay, 1985)

Ramaswamy, Sumathi, ed., *Beyond Appearances? Visual Practices and Ideologies in Modern India* (New Delhi, 2003)

—, *Passions of the Tongue: Language Devotion in Tamil India, 1891–1970* (Berkeley, 1997)

Rotman, Brian, *Signifying Nothing: The Semiotics of Zero* (London, 1987)

Rush, Dana, 'Chromolithographs in Vodunland', *African Arts*, XXXII/4 (1999), pp. 60–75

Sardesai, G. S., *The Main Currents of Maratha History* (Bombay, 1933)

Sarkar, Sumit, *Modern India 1885–1947* (Basingstoke, 1989)

Seal, Anil, *The Emergence of Indian Nationalism: Competition and Collaboration in the Later Nineteenth Century* (Cambridge, 1968)

Shaw, Graham, 'Calcutta: Birthplace of the Indian Lithographed Book', *Journal of the Printing Historical Society*, XXVII (1998), pp. 89–112

—, *Printing in Calcutta to 1800: A Description and Checklist of Printing in Late 18th-Century Calcutta* (London, 1981)

—, and Mary Lloyd, eds, *Publications Proscribed by the Government of India: A Catalogue of the Collections in the India Office Library and Records and the Department of Oriental Manuscripts and Printed Books, British Library Reference Division* (London, 1985)

Singh, Bhagat, *A Martyr's Notebook: Notes and Extracts from Books read by Shaheed Bhagat Singh during his Prison Days, 1929–31*, ed. Bhupendra Hooja (Jaipur, 1994)

Skelton, Robert, *Rajasthani Temple Hangings of the Krishna Cult* (New York, 1973)

—, and Mark Francis, eds, *The Arts of Bengal: The Heritage of Bangladesh and Eastern India* (London, 1979)

Smith, H. Daniel, 'Impact of "God Posters" on Hindus and their Devotional Traditions', *Media and the Transformation of Religion in South Asia*, ed. Lawrence A. Babb and Susan S. Wadley (Philadelphia, 1995), pp. 24–50

Smith, John D., *The Epic of Pabuji: A Study, Transcription and Translation* (Cambridge, 1991)

Solomon, W. E. Gladstone, *The Bombay Revival of Indian Art* (Bombay, n.d.)

Sontheimer, Gunther-Dietz, *Pastoral Deities in Western India* (New York, 1989)

Sontheimer, Gunther D., and Hermann Kulke, eds, *Hinduism Reconsidered* (Delhi, 1991)

Strathern, Marilyn, 'Artefacts of History: Events and the Interpretation of Images', *Culture and History in the Pacific*, ed. Jukka Siikala (Helsinki, 1990), pp. 25–44

Taussig, Michael, *Mimesis and Alterity: A Particular History of the Senses* (New York, 1993)

Temple, Richard, *India in 1880* (London, 1880)

Terrorism in India 1917–1936, Intelligence Bureau, Home Department, Government of India (Simla, 1937)

Tillotson, Giles, *The Artificial Empire: The Indian Landscapes of William Hodges* (London, 2000)

Topsfield, Andrew, *Court Painting at Udaipur: Art under the Patronage of the Maharanas of Mewar* (Zürich, 2002)

Uberoi, Patricia, *From Goddess to Pin-Up: Icons of Femininity in Indian Calendar Art* (Fukuoka, 2000)

—, 'Times Past: Gender and the Nation in "Calendar Art"', *Indian Horizons*, xlvi–xlvii (2000), pp. 24–39

—, 'Feminine Identity and National Ethos in Indian Calendar Art', *Economic and Political Weekly* (28 April 1990), pp. Ws41–8

Veer, Peter van der, *Religious Nationalism: Hindus and Muslims in India* (Berkeley, 1994)

Venniyoor, E. M. J., *Raja Ravi Varma* (Trivandrum, 1981)

Vitsaxis, Vassilis G., *Hindu Epics, Myths and Legends in Popular Illustrations* (Delhi, 1977)

Wagner, Roy, *Asiwinarong: Ethos, Image, and Social Power among the Usen Barok of New Ireland* (Princeton, NJ, 1986)

Widdess, Richard, 'Aspects of Form in North Indian alap and dhrupad', *Music and Tradition: Essays in Asian and other Musics Presented to Lawrence Picken*, ed. Richard Widdess and R. F. Wolpert (Cambridge, 1981), pp 143–81

Wolpert, Stanley A., *Tilak and Gokhale: Revolution and Reform in the Making of Modern India* (Berkeley, 1962)

Yajnik, R. K., *The Indian Theatre: Its Origins and its Later Developments under European Influence, with Special Reference to Western India* (London, 1933)

Yang, Anand A., 'Sacred Symbol and Sacred Space in Rural India: Community Mobilization in the "Anti-Cow Killing" Riot of 1893', *Comparative Studies in Society and History*, XXII/4 (1980), pp. 576–96

Zamora, Lois Parkinson, and Wendy B. Faris, eds, *Magical Realism: Theory, History, Community* (Durham, NC, 1995)

acknowledgements

When I first started research in Madhya Pradesh in India in 1982–3, I was collecting data on village-resident industrial workers. After a few months, I purchased a large collection of calendar images of the goddess Kali. The violent allure of these pictures - what villagers called 'photos of the gods' (*bhagvan ke photo*) - captivated me. For some time I displayed these on the walls of my house. I then tired of them and replaced them with others, less-demanding. Presently, a villager observing my bundle of Kali images expressed concern about their fate: they were powerful things and I should treat them with caution, he advised, and I should certainly ensure that they were worshipped regularly.

Following the completion of my doctoral reasearch I did not return to India for several years. But during that period I often thought about the images of deities I had collected. I often looked at them and came to realize that I needed to see more of them. The colours and compositions seemed to compress an incredible power and I felt myself caught in their gaze.

This slow-release enchantment was the origin of the present study. As I acquired more of these images I understood that I needed to discover more about their history, and their producers and consumers. In snatched periods of months and weeks during many subsequent trips to India I was able to interview artists and publishers, investigate archival collections and spend considerable periods in the village where I first worked, but looking this time at the consumption of these popular images. Along the way I have accumulated many debts:

Among publishers I must single out the persistent kindness and generosity of M. L. Garg of Brijbasi in Delhi, Ramesh and Ravi Agarwal of Brijbasi in Bombay, Chandra Bhanu Garg of Brijbasi's Mathura section, Kishorilal Bhargava (with thanks for many delightful afternoons spent in Chandni Chowk), Hemant Mehra of Harnarayan and Sons (now in Bombay), Rambhai Patel of the Patel Paper Co. Pune for generous access to what remained of the Chitrashala Press; the much missed V. M. Mote of Budhwar Peth, Pune, Tulu and Soumya Biswas at Calcutta Art Studio. The time and patience that they have all extended to me, and their generosity concerning the use of images, are profoundly appreciated. Some, such as M. L. Garg and Kishorilal Bhargava have allowed me to meet with them numerous times and have answered endless questions.

Among artists I am extremely grateful to B. G. Sharma, N. L. Sharma, Indra Sharma, M. K. Sharma, Rajan Musle, Yogendra Rastogi, and H. R. Raja and his family for the time they took to discuss their careers, let me photograph their work, and images from their extensive working archives. I record my thanks for the kindness of Chiranjeevlal Sharma, Chimanlal Hiralal, and Raghunath Narottam Sharma in Nathdvara, and Anandalal Narottam Sharma and Bhagvatilal Narottam Sharma in Udaipur for their insights into painting in Nathdvara. Kamal Kapoor increased my knowledge about his grandfather, Rup Kishor Kapur, immeasurably.

In Bhatisuda village I am, as ever, indebted to Lila Mehtarani, Pukhraj Bohra, Bihari, Lakshman, Bherulal, Badrilal, Hemraj, Prakash Jain, Ballu, Naggu, Madan Singh, Rup Singh and many others.

I have learnt enormously from my fellow investigators in this field and their unfailingly generosity is remembered: Dan Smith, Patricia Uberoi, Kajri Jain, the late R. P. Gupta, Amrit and Rabindra Kaur, Raminder Kaur, Christiane Brosius. The following allowed me to copy images from their collections, R. P. Gupta, Patricia and J.P.S. Uberoi, Ebrahim Alkazi, H. S. Swali, Amrit and Rabindra Kaur, Rachel Dwyer, O. P. Joshi.

I was able to explore some of the issues presented in this book while teaching under the aegis of the Committee for the History of Culture at the University of Chicago in 1999 and I would like to record my appreciation of the hospitality and intellectual stimulation offered by Rob Nelson, Dipesh Chakrabarty, Homi Bhabha, Arjun Appadurai and Carol A. Breckenridge, Bernard Cohn, McKim Marriott, Sheldon Pollock, Tom Cummins and especially Andy Rotman and Will Elison. My understanding of the relationship between images and political struggle has also benefitted from conversations with Michael Godby and Sandra Kloepper while teaching at at the University of Cape Town.

My students and former students who have worked, and are working on allied issues have taught me a great deal: Helle Bundgaard, the late Khalid Mansoor Basra, Raminder Kaur, Christiane Brosius, Sophie Hawkins, Nayanika Mookherjee, Shaila Bhatti, Tracey Black, Alex Aisher.

I thank McKim Marriott for his wonderful photographs and with regret that I couldn't use more (please publish a volume of them, Kim), the late Norman Cutler for kindness with matters Tamil, William Radice for help with Bharat Bhiksha, Anish Ahuliwalia for help with Chitrashala's Marathi history, Sumathi Ramaswamy for great insights, Partha Mitter, Woodman Taylor, Sujit Patwardhan in Pune for helping me locate the Chitrashala premises, O. P. Joshi in Jaipur, Ashis Nandy, Atlury Murali, Ravi Vasudevan, Rachel Dwyer, Francesca Orsini, Simeran Gell, Rupert Snell for a kind gift, Brain Durrans, Marcus Banks, Ranajit Guha, Jonathan Parry, C. A. Bayly, Philip Woods, Vinay Srivastava, Bhaskar Mukhopadhyay, Natasha Eaton, Sandria Freitag, Charu Gupta, Graham Shaw, Jeremiah Losty, Clare Harris, Jimmy Weiner, Mike Rowlands, Norman Bryson, Mark Leichty, Ronald B. Inden, Arvind Rajagopal, Jonathan Lamb, Bridget Orr, RAQs collective, Kekoo Gandhy of Chemold Gallery Bombay; Mukulika Banerjee, Richard Blurton, Deborah Swallow, Mr. R. Piplani of the Nehru Trust, Mark Pinney, Mazakazu Tanaka, Michael Roberts for comments on Sarlis, Cheryl Kominsky, Erwin Neumayer, The Nuffield Foundation. To those whom I have forgotten, my apologies.

For useful comments at seminar presentations of this material: Valentine Daniel, Greg Denning, Nicholas Dirks, Don Gardner, Faye Ginsberg, Chris Gregory, Donna Merwick, Klaus Neuman, Roger Benjamin, Norbert Peabody, Anupama Rao, Susanne and Lloyd Rudolph, the late Burton Stein, Michael Taussig, Nicholas Thomas, Harish Trivedi, J, Bernard Bate, Lee Schlesinger, Rich Freeman.

A 1992 trip to Sivakasi, the printing centre in Tamil Nadu, was turned into a wonderful experience through the generosity of the Station Master Mr K. Vijayarajah who exemplifies in a particularly memorable way the astonishing kindness that a traveller will frequently experience in India.

I am also extremely grateful to the following additional publishers who helped me in various ways during visits to their premises, often with gifts of samples of their entire inventory. In Bombay: Gopal Jain of Jain Picture Publishers; C. N. Sharma of Sharma Picture Publishers; Shailesh Shah of Bharat Laxmi Press. In Delhi: Subhash Calendar Co.; Subhash Picture Publishers; Oswal Picture Centre; Prakash Chand and Sons; Ratna Posters; Swastik Picture Co. In Calcutta: U. C. Jain, Printers Corner; A. K. Sharma, Bombay Picture Company (sic). In Madras: Rajesh Khanna of J.B. Khanna (Madras), Srinivasa Frameworks. In Trivandrum: Mathew Koshy at Polyprint Offset Press. In Sivakasi: Screen Calendar Company;

C. S. Ramalingam of Vidhya Enterprises; Sankarlingam Trading Co.; Coronation Litho; Lakshmi Paper Agencies; R. Jagadeesa Sanker of Orient Litho Press; A.M.S.G. Ashokan of Arasan Group. In Colombo, Sri Lanka: Nalini Stores/ Colombo Picture Publishers.

During archival research I benefited from help from numerous individuals at the following: IOLR, National Archives Delhi, Bengal State Archives, National Library Calcutta, Dr Bhau Daji Lad Museum Bombay, Bird Library Syracuse, Regenstein Chicago, Andrew Topsfield at the Ashmolean Museum, Oxford, William Schupbach at the Wellcome Institute and David Jones for his handlist to their collection, Arkadiusz Bentkowski at the Royal Anthropological Institute Photographic Collection, British Library, and Oriental Antiquities BM, Susanne Knödel and Beatrix Hanser at the Hamburgisches Museum für Völkerlennde, Suresh Chabria at National Film Archive of India, Mr Sharma and A. K. Avasthi of Nehru Memorial Library, Anita Herle and Sudeshna Guha at University Museum of Archaeology and Anthropology, Cambridge.

Rachel Dwyer and Bhaskar Mukhopadhyay gave me the benefit of a detailed reading of the final manuscript.

I am again grateful for the expert and friendly help of the staff at Reaktion.

Finally, to Trudi, Robert and Thomas for putting up with all the clutter and the absences.

A NOTE ON TRANSLITERATION

Citations preserve a variety of different transliterations of place names and deities. Consequently, consistency is neither possible or desirable. I have also used conventionalised forms appropropriate to the period under discussion (for instance Poona, rather than Pune). In the ethnograpic sections I have omitted diacritics in the interests of readability and have aimed for a phonetic clarity, at the risk of offending Indologists.

List of Illustrations

Where no artist's name is given, it is unknown; all sources and photographs are courtesy of the author unless otherwise indicated.

118 Bhanwarlal Girdharilal, *Sati Mata Ramdevji*, mid-1950s. Harnarayan & Sons. Bird Library, University of Syracuse, New York, H. Dan Smith Collection.

119 Bhanwarlal Girdharilal Sharma, *Santoshi Ma*, c. 1960s(?) Sharma Picture Publications.

120 A travelling bard with a copy of B. G. Sharma's *Ramdevji ki Samadhi* at the Ujjain Kumbh Mela, April 1992.

121 Khubiram, *Sudarshan Chakra*, c. 1927, bromide postcard-size print, published by S. S. Brijbasi, printed in Germany.

122 L. N./N. L. Sharma, *Shri Shiv Parsana* (Shiv's Delight), mid-1950s, published by P.P.C. Bombay.

123 Pednekar, *Shri Jagdamba Bahucharaji* (Chubal), mid-1950s, published by S. S. Brijbasi.

124 The painter Indra A. Sharma with fellow artist S. M. Pandit and the then director of the J. J. School of Art, mid 1950s. Courtesy of Indra A Sharma.

125 Malgaonkar, *Agricultural Beauty*, mid-1950s calendar.

126 Indra A. Sharma, *Shree Mahavishnu*, c. 1960, published by Coronation Litho, Sivakasi.

127 *Whole Murti of Rameswaram*, early 20th century. National Litho Press, Sivakasi.

128 A Maharastrian *pan* shop decorated with pictures, Wai city, Satara district, 1956. Photo: McKim Marriott.

129 *Mansha Puja*, showing the narrative associated with, and the worship of, the goddess Mansha, c. 1980 (unknown Bengali publisher).

130 L. N. Sharma, *Maharana Pratap*, mid-1950s, published by W. W. Wagh.

131 Hiralal, *Maharana Pratap of Udaipur*, 1933, published by Harnarayan & Sons.

132 RSS instruction with pictorial aids in Wai city, Maharashatra, 1950s. Photo: McKim Marriott.

133 Yogendra Rastogi, *Land to Defend*, 1963. Courtesy of Yogendra Rastogi.

134 Yogendra Rastogi, 'Jai Jawan, Jai Kisan', 1965. Courtesy of Yogendra Rastogi.

135 Yogendra Rastogi, Indira and news coverage of the Pokaran explosion, 1974. Courtesy of Yogendra Rastogi.

136 Yogendra Rastogi, *Heros* (sic), c. 1973.

137 Yogendra Rastogi, *Vishvakarma*, c. mid-1970s. Courtesy of Yogendra Rastogi.

138 Yogendra Rastogi, a young sister anoints her brother beneath the approving gaze of Indira, mid-1970s.

139 Yogendra Rastogi, *Freedom Fighters*, mid-1970s, published by J. B. Khanna, Madras.

140 H. R. Raja, photographed in Meerut, 1994.

141 'Rastogi Studio' (Yogendra Rastogi and H. R. Raja), a calendar image of Chandra Shekhar Azad, Subhash Chandra Bose and Bhagat Singh, a 1980s reprint of a mid-1960s image.

142 H. R. Raja, a calendar image of Chandra Shekhar Azad and Bhagat Singh, 1978, published by Anant Ram Gupta. Collection of Patricia and J.P.S. Uberoi.

143 H. R. Raja, a calendar image from the early 1980s, depicting (clockwise) Shivaji, Rana Pratap, Uddham Singh, Chandra Shekhar Azad, Subhash Chandra Bose, Bismal, and Bhagat Singh. Courtesy of H. R. Raja.

144 H. R. Raja, *Bharatiya Sher* (Indian Lions), mid-1980s. Courtesy of H. R. Raja.

145 H. R. Raja, *Mere Khun Ka Har Katara Desh Ko Mazbut Karega*, 1984. Courtesy of H. R. Raja.

146 Bherulal Ravidas in front of his domestic images, including one of Ravidas, 1994.

147 Images displayed inside Biharilal Banjara's house, 1993

148 Rup Singh's only image: a small framed J. B. Khanna Lakshmi.

149 Puja room in Prakash Jain's house.

150 Samvaliyaji turns a farmer's opium into jaggery when the police arrive. Detail of a Samvaliyaji image.

151 Madan Singh's display of political imagery, 1994.

152 K. P. Siwam, *Babasaheb Ambedkar*, c. 1990.

153 Naggu Ravidas and baby son with an ornately decorated Sharma Picture Publications *Ramdevji ki Samadhi*.

154 Ravidas cuts open his chest to reveal his Brahmanic sacred thread, a 1980s calendar image.

155 Balu Bagdi holds a frame containing six *darshanic* postcards, 1994.

156 A mirrored image of Badrivishal.

157 A photographic image of the feet of Sathya Sai Baba.

158 Badrilal, the pujari of the Jhujhar Maharaj *autla*, with domestic chromolithographs in the background.

159 Hemraj with his framed Durga image, two days prior to the Nauratri procession.

160 Villagers 'thrashing' (possessed) in the Nauratri possesion.

161 A muscular Ram flexes his bow above the proposed Ramjamnabhumi mandir in Ayodhya, c. 1994.

162 Shivaji astride the body of Afzal Khan, Rajan Musle, c. 1994, laminated print published by S. S. Brijbasi.

163 Plate from Louis Dupré, *Voyage à Athènes et à Constantinople, ou Collection de portraits, des vues, et des costumes grecs et ottomans* (Paris, 1825). Photo courtesy of Sotheby's, London.

164 Mother India and heroes of the freedom struggle, a calendar image of 1972. Courtesy of Patricia and J.P.S. Uberoi.

165 *The Sons of Bharat Mata*, 1999, laminated print.

166 Calendar image depicting Lakshmi Swaminathan (a female Indian National Army officer) urging '*lahor chalo*' (Let's go to Lahore), c. 1965. Courtesy of Patricia and J.P.S. Uberoi.

167 *Ham kisi se kam nahin*, 1958, printed card. Courtesy of Rachel Dwyer.

index

Sanskrit and vernacular forms (which may differ in the text) are
conflated in the index. *Italics* indicate illustration numbers.